GAUGUIN AND THE PONT-AVEN SCHOOL

GAUGUIN AND THE PONT-AVEN SCHOOL

Wladyslawa Jaworska

with 250 illustrations, 39 in colour

THAMES AND HUDSON · LONDON

English translation by Patrick Evans
© 1972 Thames and Hudson Ltd., London

First published as 'Paul Gauguin et l'Ecole de Pont-Aven'
© 1971 by Editions Ides et Calendes, Neuchâtel, Switzerland
Artistic rights: Spadem, Paris, and Cosmopress, Geneva

Printed and bound in Switzerland

ISBN 0 500 23169 9

Contents

Introduction

The picture as a plane surface covered with colours assembled in a certain order; art as the sanctification of nature; expression through the work itself and not through the subject represented.

Maurice Denis

The subject of this book is the activity of an international group of painters who, in Brittany, during the years 1886–96, under the leadership of Paul Gauguin, constituted a kind of closed artistic community and eventually worked out a new formula for painting which became known as Syntheticism. Despite being centred at different places at different times, the group has entered history – individual reservations or objections notwithstanding – as the 'Pont-Aven School'. The name no doubt springs from the fact that it was to Pont-Aven that Gauguin and Charles Laval went in 1886 when, in a sense, they shook the dust of Paris off their feet, and that it was also at Pont-Aven that Gauguin met Emile Bernard, a highly significant encounter in view of what followed.

Although French historians, whenever occasion offers, stress the group's importance and prestige, and although the names of some of its members keep cropping up in exhibitions devoted to Gauguin or his group, this is a page in art history which has never been explored independently and in depth. In fact it has never been explored at all except in relation to Gauguin.

The reasons are many. The first is that the artistic movement in question was short-lived; there is even a doubt whether it ever really existed or, if it did, whether it was rightly named. If there was a 'school' at all, why name it after Pont-Aven and not one of its other rallying-points, such as the Petit-Boulevard, or the rue Clauzel, or Le Pouldu? Again, putting pedantic quibbles about locality on one side, the term 'school' implies pupils and masters; here too there is disagreement, most critics and historians nominating Gauguin as the school's 'founder' and sole leader, but others according the priority to Bernard. As for listing collaborators, the very attempt arouses fresh difficulties and controversies.

An acute shortage of facts is what makes it so hard to solve the essential problems of what the school was and to analyse objectively what it did. A large number of studies, of unequal value, have been published about Gauguin; and thanks to written testimony left by the founders and members of the school, and by their families, documentation is available on the life and work of Bernard, Sérusier and Maurice Denis. But there is little or no third-party material about the work of other artists, such as Laval, Séguin, Meyer de Haan, Filiger or Jourdan; and if they themselves wrote anything, it has not survived.

It is therefore not surprising that some of the published studies are fragmentary and marginal, and that appreciation and evaluation of even the most significant events and aspects is in many cases quite arbitrary. Painters whose contribution was far from negligible are dealt with by mere enumeration, sometimes without so much as their first names, and, indeed, are lucky to escape dismissal under the blanket phrase, 'and many others'.

I certainly do not claim to say the last word on any of the complex problems surrounding the school of Pont-Aven. The fact remains, however, that many years of research, rewarded by the discovery of much unpublished material, have inspired me with an urge to fill, or try to fill, the gaps in the existing literature. That material consists, in the first place, of some two hundred canvases by painters who at one time or another belonged to the group; these canvases have been run to earth in private collections in France (Paris and Brittany) and in Britain, America and Poland. Other sources are unpublished letters between various members of the group, and other hitherto unutilized manuscript material; photographs from family records; and lastly, detailed notes from personal interviews and correspondence with the families and friends of artists now dead.

The material thus gathered has enabled me to sketch a more complete collective portrait of the Pont-Aven group, to achieve greater accuracy in certain particulars – biographical dates, anecdotes, and the authenticity of paintings not previously identified – and finally, on the theoretical plane, to draw certain conclusions from the study as a whole. These, viewed in the light of the currents of European intellectual life in the last quarter of the nineteenth century and the early years of the twentieth, have illuminated the ideological affinities between painting and what was simultaneously going on

in philosophy, literature, music and the theatre, and have made it possible to arrive at a definition of what may justifiably be termed the aesthetics of Syntheticism. In sum, I think I may claim to have made the first attempt towards a comprehensive portrayal of the school of Pont-Aven.

The method adopted was dictated in the first place by the state of affairs indicated above, but also, and even more compellingly, by the necessity of including in this study more than one artist previously consigned to almost total oblivion. The origins of the group and the principal theoretical problems involved will therefore be analysed through the lens, as it were, of individual studies of the various artists to whom the ensuing chapters are devoted. Characters will be presented in the order, and to the extent, in which they became adherents of the group, and I shall aim by this means to lay bare the dynamics of its development and to show how various were the individuals composing it; I shall do my best to throw into relief whatever it was that attracted a given artist towards it, what he was able to contribute to it and what he received in return. It need hardly be said that every case is different, and that each personality considered demands different treatment in order to place him correctly in relation to the collective whole. Ignoring certain satellite figures whose links with the group were never more than slight, one may say that there were twenty artists in Brittany working in Gauguin's orbit. These twenty are the ones whose silhouettes, as it were, are drawn in this book.

The conception is novel in the sense that, whereas other works have treated Gauguin as the central figure and all else as a backcloth, this one illuminates what has been habitually regarded as constituting merely his human environment. Of course Gauguin will be the focal point and presiding presence, since every artist and every problem will be considered in relation to him; nevertheless his *œuvre* is not the only, or even the main, subject of these pages. The principle I have adopted makes it possible to present the other painters not just as bit-players round a star but as genuine *dramatis personae*, each with an active contribution to make, and his own way of making it, to the creation of a new style.

Another fact reflected here is that, however fluid it may have been, the group was a truly living organism; while affected by Gauguin's influence, it also affected him. The approach used here – individual studies of the artists concerned – makes it possible to observe individual affinities and aesthetic ties being contracted independently of Gauguin, and to note the reciprocal influences at work within the group. The point here is the diversity of the ways in which his message was interpreted, and the reservations expressed by one painter or another while still on the way towards final adherence.

Finally, the form chosen for this work was dictated by two characteristic features of the Pont-Aven school. On the one hand, the school represents a spontaneous association of artists eager to realize an ideological and aesthetic programme – Syntheticism – which would find expression in a novel pictorial formula and an equally novel vision of the world; an

association similar, in fact, to those later formed by the Nabis, the Brücke and the Blauer Reiter group. On the other hand, the group in Brittany was something more: a way of life, a modern community with its own life-style. Seen from this angle it interests us not only through its works, its achievements, but because all these men had rebelled against the bourgeois life of their time, the *mores* of the Philistines, and deliberately went into exile in rustic simplicity to live and work for the realization of advanced ideas.

The birth of the group can reasonably be dated 1886, the year when Gauguin and Bernard met for the first time; its dissolution can be placed in 1896, an arbitrary limit corresponding, within a few months, to Gauguin's final departure for the South Seas: in all, a decade. Both dates are of course only a conventional device, an approximation rather than an exact estimate of the life-span of the school of Pont-Aven.

A word here about groups and schools in general. An artistic association, taking shape spontaneously, is a different thing from an academy. An academy is a teaching institution based on certain educational principles and subsidized by the State; a fact which continues to insulate it against explosive change even after it – the institution, or rather its guiding programme – has exhausted its role. A group or 'school', on the contrary, emerges at a precise moment in history and tends to fill a gap which has manifested itself at that moment. As soon as the gap has been filled, or, as more often happens, when a new historical development arises and creates a new vacuum, the group dissolves of its own accord, and, like any other organism deprived of the means of life, simply dies.

This was what happened to the school of Pont-Aven. Once the respective programmes of Naturalism and Impressionism were exhausted – both movements having in their own way carried the visual analysis of reality as far as it would go – an imperious need made itself felt for the diametrical opposite of analysis: a craving for synthesis. The aesthetic pleasure obtainable from a skin-deep Impressionism, whose aim was 'to caress the eye', was no longer adequate to satisfy the new generation, bent on exploring 'the inherent mystery of the object itself'. It was believed that the key to the mystery would be found in 'synthesis', the interpretation of the object as an artistic whole in such a way as to reflect the artist's 'psychic state': a subjective form of art in opposition to the objective aspirations of Impressionism (with which, because of a shared visual unorthodoxy, it was initially confused).

This thirst for magic, for the mysteries of the imagination, for the ineffable, for implicit artistic meaning – the hint as against the overt gesture – was perfectly in line with the general crisis then taking place, the reaction against the attitudes of positivism. Naturally, there was no instantaneous widespread challenge to the sovereignty of pure science, and the rejection of empirical knowledge was hardly an overnight phenomenon. The last ten years of the nineteenth century nevertheless provided the climax of what we may describe as the rebellion against the supremacy of reason over emotion and of knowledge over imagination. The Romantic writers, the poets

especially, had long been proclaiming the rights of imagination; Delacroix and Baudelaire had denounced the impoverishment inflicted on art by the reign of positivistic naturalism. 'To us', wrote Baudelaire, 'the natural painter, like the natural poet, is almost a monster. In our context, the exclusive pursuit of the True, so noble when restricted to its proper applications, oppresses and stifles the pursuit of the Beautiful.' If we recall that the *Curiosités esthétiques* had already been known for many years, and that 1885 saw the publication of Dargenty's *Eugène Delacroix par lui-même*, it becomes transparently clear that the profession of faith of the great Romantics had heralded the arrival of a new trend which was to break definitively with Naturalism and even Impressionism.

The invading force was Syntheticism, and its pioneers were Gauguin and the group in Brittany. The aim of this book will be to treat the problem from three different angles. First, the essence of Syntheticism – also known as 'the Pont-Aven style' – and its successive mutations, from *cloisonnisme* to pictorial Symbolism; next, the motive forces, both ideological and visual, that contributed to the formation of that style; and finally the *milieu* and atmosphere surrounding the birth of this ephemeral movement which, after breaking with the tradition of the nineteenth century, revolutionized art and gave birth to modern painting, including abstract art.

ACKNOWLEDGMENTS

I would like to express my sincere gratitude to all those who have been kind enough to make available to me their collections of paintings and drawings, their archives and their manuscript and photographic records. Their help alone has made this book possible.

M. Jean Adhémar, Paris; Mr Arthur G. Altschul, New York; M. Michel-Ange Bernard-Fort, Paris; Mrs Merete Bodelsen, Charlottenlund; Mlle Henriette Boutaric, Paris; Mr Jan Bredholt, Charlottenlund; Mme Jeanne Buffeteaud, Paris; Mlle Françoise Cadic, Quimperlé; Mme Clotilde Cariou, Quimper; M. Jean Cassou, Paris; The late M. Charles Chassé, Paris; M. Jean Chauvelin, Paris; Mme Marie-Ida Cochennec, Rosporden; M. Raymond Cogniat, Paris; The late Mme Julia Correlleau, Pont-Aven; The late M. Jean Corronc, Lorient; The late M. Toré Dahlström, Porsac'h; Mr Bengt Danielsson, Stockholm; M. Yves Dautier, Rennes; The late M. Delestre, Chemillé; M. Dominique Denis, Saint-Germain-en-Laye; M. Bernard Dorival, Paris; M. Charles Durand-Ruel, Paris; M. Julien Favennec, Doëlan; M. Jacques Fouquet, Paris; M. Georges Gorecki, Paris; M. Alexandre Goulven, Bas Pouldu; M. Claude Le Grand, Paris; Dr René Guyot, Mme Jeanine Guyot, Clohars-Carnoët; M. Mieczyslaw Fijalkowski, Gliwice; Herr Fritz Hermann, Zurich; Herr Hans Helmut Hofstätter, Baden-Baden; M. Emile Jacob, Bas Pouldu; Mme Mira Jacob, Galerie Le Bateau-Lavoir, Paris; Mlle Dominique Jobert, Paris; M. Samuel Josefowitz, Lausanne; M. Guy Jourdan, Paris; M. Zdzislaw Kepinski, Poznan; Mme Marie-Louise Lagrange, Tours; M. Bronislaw Lubieniecki, Cracow; M. Maurice Malingue, Paris; M. Victor Andronikowitsch Manuilow, Leningrad; Mlle Georgette Maréchal, Pont-Aven; M. Mirabele, Paris; The late Mme Simone Morvan, Paris; M. André Mussat, Rennes; Mme J. Le Naour, Pont-Aven; The late Dr Léon Palaux, Clohars-Carnoët; The late M. H. de Parcevaux, Vannes; Mlle Andrée Parent, Paris; Mr Ronald Pickvance, London; M. Alexandre Pissenko, Nantes; M. Ksawery Piwocki, Warsaw; M. Joseph Portier, Clohars-Carnoët; M. Louis Prodhomme, Lorient; M. Louis Le Ray, Carnac; Dr Henry M. Roland, London; Mme Marie Rouart, Riec-sur-Belon; M. Tadeusz Rudnicki, Paris; Mme Jadwiga Rybarska, Warsaw; M. Maurice Savin, Paris; Mme Annie Joly-Segalen, Bourg-La-Reine; M. Jerzy Slewinski, Monte Estoril; M. Juliusz Starzynski, Warsaw; Mr Denys Sutton, London; Mme Wanda Szalowska, Lesna Podkowa; The late M. Georges Wildenstein, Paris.

I THE DIALECTIC OF SYNTHETICISM

Paul Gauguin 1848–1903 Emile Bernard 1868–1941

The encounter of these two intelligences was to engender light, and the creation of the Symbolist school. Armand Séguin

The collapse of the Bourse (the Paris stock exchange), with the suspension of all dealings, in 1882, which has gone down in economic history as a grave but not exceptional symptom of the general crisis sweeping through Europe, produced one rather unexpected effect in a different field, that of modern painting. In addition to ruining a large number of business houses the event was among the contributory causes that threw one of its victims – a certain Paul Gauguin – into the arms of art.

As recent researches by Charles Chassé have proved, the broker from the Maison Bertin did not decide of his own free will to throw up his lucrative profession and devote himself to art. Chassé has discovered a document establishing beyond any possibility of argument the fact that, in consequence of the crash, Gauguin was simply sacked by his employer. It is probable, however, that this merely hastened a decision which had been irrevocable for some time in the mind of the future painter; still, the undeniable fact brought to light by this document is significant, and all the more so in that it emphasizes the fortuitous character of the decisive change of direction in the life of the artist, a life which henceforward was to know no peace.

Gauguin was thirty-five years old. Ten years earlier he had married a Dane, Mette-Sophie Gad; four sons, Emile, Jean, Clovis and Pola, had been born to them, and a daughter, Aline. Behind him were five fairly adventurous years in the merchant marine, and nearly twelve of an honourable, steady career in business and banking. The fact that he spent some of his leisure 'amusing himself' by carving in marble or wood did not appear greatly to trouble the young couple's orderly bourgeois existence.

The studio where he worked was also frequented by a colleague from the office, Emile Schuffenecker, a shy, retiring, hesitant individual, who nevertheless was soon to throw up his job at the bank – deliberately, unlike Gauguin – and devote himself to painting and teaching. It was he who initiated Gauguin, every Sunday, into the rudiments of the art of painting; he was a little ahead of Gauguin, had contacts in artistic circles and was on excellent terms with the Impressionists. It was 'le pauvre Schuff' who was to put Gauguin in touch with Pissarro, a meeting which exercised a profound effect on Gauguin's life.

Still at that period a dilettante and a Sunday painter, Gauguin, in 1876, submitted a canvas to the Salon for the first time. The jury accepted it. The painter was more and more attracted by the Impressionists, Pissarro especially; he boasted of this and used to proclaim himself Pissarro's pupil. Introduced by his 'master', he exhibited again with the Impressionists in 1880, 1881 and 1882, despite protests from Monet, who is supposed to have said he 'didn't care to exhibit with the first dauber who happened to come along'. The subtle J.-K. Huysmans noticed Gauguin's pictures among those of the established Impressionists and declared that 'among contemporary painters who have studied the nude, none has yet struck so powerful a note of reality'.

Gauguin the stockbroker, being comfortably off, dabbled in collecting, as Schuffenecker also did; he bought canvases by Manet, Renoir, Cézanne, Guillaumin, Sisley, Monet and Pissarro. Though he was later unable to keep most of these, there was a still-life by Cézanne with which he never parted, even during his most harrowing bouts of poverty.

The 1882 crisis, and the loss of his job, were a bolt from the blue. Gauguin's wife was deeply upset, but the artist himself was confirmed in his resolve 'to paint every day from now on'. The year when he is reported to have said this was 1883; he died in 1903: thus he painted 'every day' for only twenty years. It was in this comparatively short space of time that Gauguin's huge output saw the light of day.

It should also be pointed out here that few painters' lives have been as rich, picturesque and exotic as that of Gauguin. It is not surprising that it has attracted and continues to attract so many authors, the writers of monographs (some of them well documented, other much less so), of *romans à clé* or of fictionalized biographies. They have surrounded Gauguin, despite the comparative definiteness of the main events in his story, with a legend to which new accretions adhere only too easily; so much so, that the harder one tries to keep track of it the further one finds oneself straying into regions totally unconnected with historical fact. But if on the other hand one

turns to the reliable sources, namely Gauguin's letters, what one sees is that the mask of the adventurer and the faithless husband and father hides the suffering of a man haunted by incessant visions, an artist devoured by anguish, a seeker launched in pursuit of the undiscoverable. He was under the curse of a great vocation, '*peintre élu, peintre maudit*', as one of his biographers has written, and to the end he remained an anarchist who heeded no laws but those he himself had made. Incapable of social adjustment, ill-equipped to bear material worries, hungry for kindness and friendship, he succeeded only in exciting the hostility of public opinion.

After abandoning his former profession Gauguin tried, without success, to settle in Rouen. He then departed for Denmark, but stayed only a short time: having quarrelled with all and sundry he left his family behind in Copenhagen and returned to Paris in 1885. Falling on hard times, he was oppressed by privation and by the illness of his son Clovis, whom he had insisted on keeping with him but whom he was soon obliged to put into a boarding school. Despite his adversities he was able to send in nineteen paintings to the eighth exhibition of the Impressionists, in 1886. Most of these were landscapes painted in Normandy and Denmark. According to John Rewald's book *Gauguin*, Félix Fénéon noted the presence of this new talent among such painters as Degas, Guillaumin, Redon, Berthe Morisot and Signac, and drew attention to the use of dense, contrasting complementary colours, greens and reds in particular. However, despite this characteristic perceived by Fénéon (who, on the other hand, failed to observe the relative flattening of the perspective), Gauguin's painting was still confined in a conventional Impressionism; Pissarro was his guiding star.

Such was Gauguin's artistic equipment when, in June 1886, he reached Pont-Aven, where he hoped life would be less difficult and conditions more favourable for work. On the advice of the painter Jobbé-Duval, he went to stay at the boarding-house kept by Marie-Jeanne Gloanec.[1]

He told his wife in a letter that being without money he was having to exist on credit, but that living was cheap and the food good. His lodging was very unsatisfactory to him, giving him none of the solitude he wanted so badly. There was a crowd of painters there, nearly all foreigners – Danes, Englishmen and Americans. But as time went on this lack of solitude seems not to have troubled him overmuch; we find him soon afterwards writing to his wife: 'I'm working a lot here, successfully too; I'm respected as the best painter in Pont-Aven, though it's true I'm not a penny the richer for it. Still, perhaps this is paving the way for the future. In any case, I'm getting a reputation, a position of respect, and all the painters here, American, English, Swedish, French, are clamouring for my advice, which I'm foolish enough to give – people are always ready to make use of you without any proper gratitude.'

This sounds a little like boasting or perhaps wishful thinking, an aspiration for something that Gauguin wanted but had not yet got, namely an audience. It is known that a few painters

who had completed a training at the Ecole des Beaux-Arts, and to whom Gauguin referred as the hacks (*les pompiers*), were in Pont-Aven at the time and emphatically disapproved of Gauguin and his familiars, whom they disdainfully labelled 'Impressionists'. This contempt on the part of the *pompiers* rose to such heights that they finally reserved a separate table in the dining room and altered their mealtimes, so as to avoid all contact with the 'Impressionists'.

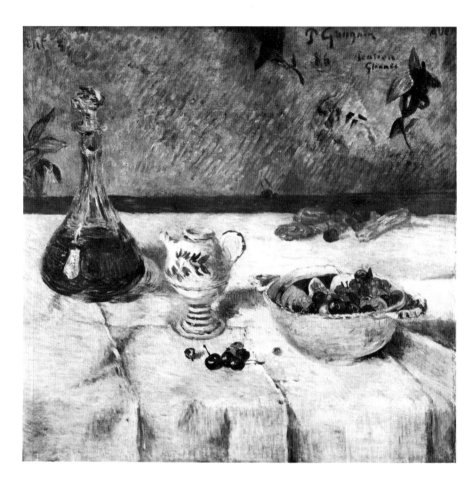

Who, apart from Gauguin himself, were these notorious 'Impressionists' of the Pension Gloanec? There is little information about Gauguin's first stay at Pont-Aven, in 1886, and even that little is vague. But it is known that during that summer, at least, Emile Schuffenecker was living in Brittany; there is no positive indication that he ever stayed at the Pension Gloanec, but there is every reason to believe that he was in daily communication with Gauguin.

In this same period, summer 1886, Gauguin met Laval for the first time.[2] Charles Laval, a talented pupil of Bonnat's studio, and fourteen years younger than Gauguin, was, with Schuffenecker, one of Gauguin's earliest friends in Brittany, and was later to be his travelling companion on his adventurous

expedition to Panama, and, later again, to Martinique. Laval was also, among the artists surrounding Gauguin, the one who was to undergo his influence to the highest degree: 'his blindly submissive pupil', as a colleague was to call him.

This description came from the mouth of a young painter, a nineteen-year-old whose identity was announced on his visiting card by the words *Emile Bernard – Impressionniste*. The

a level with Julian's. But, in spite of its independence from the Ecole des Beaux-Arts, this academy stood for the same brand of literary and sentimental classicism. 'Cormon struck me as chilly and distrustful', wrote the young artist, rather disenchanted.

But he made the acquaintance of several fellow-students who were more sympathetic to his taste than the teacher. There

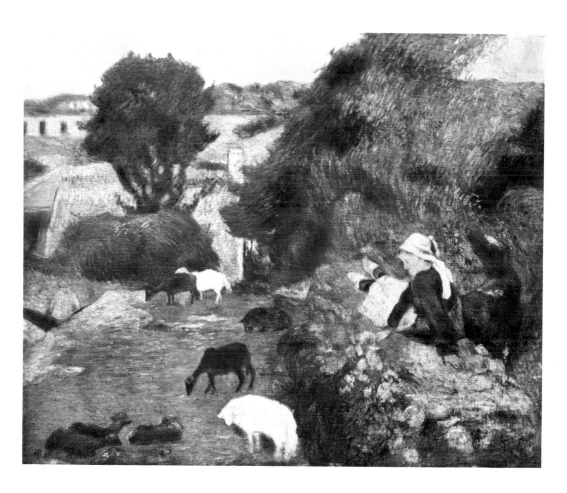

PAUL GAUGUIN *The White Tablecloth, Pension Gloanec* 1886

PAUL GAUGUIN *Breton Shepherdess* 1886

hospitable roof of the Pension Gloanec received him, tired out after a long walk, one evening in August 1886.

The artistic talent of this unusual and highly promising adolescent was combined with literary, poetic and dramatic gifts displayed almost from his earliest years. When he was a small boy, popular coloured prints from Epinal, and reproductions of scenes from his 'beloved Middle Ages', hung permanently over his bed. At the age of eight he was adding 'highly artistic' embellishments to his parents' garden furniture; at twelve, he copied Frans Hals' *The Witch* in the museum at Lille. On reaching sixteen the young prodigy was discovered by his uncle, the sixty-year-old Michel de Wylie, who took him to Paris and got him a place in Cormon's studio, at that time one of the most highly reputed private schools of painting, on

were Louis Anquetin and Henri de Toulouse-Lautrec, who in time became his firm friends, and later he got to know Vincent van Gogh.[3] Meanwhile he saw a great deal of the painter Tampier, who was older than he, and who, though he has left no mark on the history of painting, was an excellent influence on Bernard; he was eloquent, unusually erudite and irresistibly charming. He initiated Bernard into the beauties of the monuments of old Paris, and sent him off to visit not only the museums but the commercial galleries, including that of Durand-Ruel; and it was he who introduced him to the paintings of Courbet and of the Impressionists.

Bernard stayed over a year in Cormon's studio but spent most of his time in the Louvre, where he copied the great masters. Cormon did not have much opinion of Bernard's

13

studies, and finally dismissed him, an event received without joy by his parents and his patron. His father, who had never wanted him to devote his career to art, cut off his resources. But the young painter persisted in assiduously frequenting the exhibitions of the Impressionists, finding himself more and more in sympathy with that movement, which he saw as a possible escape-route from the clutches of academicism. He painted several canvases in an Impressionistic style which, however, was not to hold his allegiance for long, despite recurrent urges to return to it in later life; he was an Impressionist for only a year, during which period he also ventured a few attempts at painting with dots of pure colour (Divisionism).

What was happening was that Bernard, like Anquetin and Toulouse-Lautrec, had come to the conclusion that traditional means of expression in painting were no longer adequate; nor was the superficial, 'epidermal' aesthetic of the Impressionists. Something new had to be invented, something with which to oppose the *analysis* which was the hallmark of the Impressionists. All three were obsessed by a single, fascinating, wholly novel idea, *synthesis*. But how was the idea to be realized?

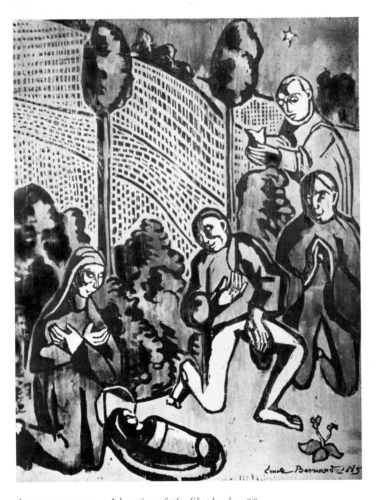

ÉMILE BERNARD *Adoration of the Shepherds* 1885

The three friends from Cormon's, who were later to exhibit at the Ecole du Petit-Boulevard, attended classes in the morning but spent their evenings trying to paint 'differently'. This they did at the apartment of Toulouse-Lautrec, the only one in the fortunate position of having a studio. They sought advice from chemists and also from the painters Georges Seurat and Paul Signac, who had studied the decomposition of the solar spectrum. An experiment by Anquetin on the effects produced by the coloured panes round his verandah gave them a partial solution to the problem: suggestive colour.

What was this experiment? 'Anquetin', wrote Bernard, 'observed the light streaming through the coloured panes of a glazed door, and noticed that yellow produced an impression of sunlight; green of dawn; blue, of night; red, of twilight. In the key of yellow he painted *The Reaper*, so often repeated by Van Gogh; and in the key of blue, *The Avenue de Clichy at Evening*. These pictures were exhibited at the Revue Indépendante, at the Salon des Indépendants, and at the headquarters of Les Vingt in Brussels.'

The coloured woodcut, *Adoration of the Shepherds*, signed by Bernard in November or December 1885, must be regarded as a first essay in Syntheticism – a conclusion also expressed, incidentally, by Hans Helmut Hofstätter in his doctoral thesis of 1954. The way in which the print is conceived differs totally from anything previously attempted. The design is distinguished by 'flattening' and foreshortening, by simplification of the vector forces. Depth, hitherto obtained by observing the laws of perspective, is eliminated, being replaced by a pyramidal accumulation of elements – in this case, human figures so arranged as to suggest the illusion of a perceptibly raised horizon.

It is true that woodcut technique lends itself naturally to simplifications of this kind; nevertheless it does seem here that, over and above the restriction imposed by the material process, a conscious will is at work in the service of some new idea. The composition has something about it of German medievalism; it also displays quite visibly the touch of folk art, almost of the grotesque. Nor is this all.

The artist represents four main figures – the Madonna and the three shepherds – and the landscape. He has therefore arranged his composition in such a way as to place the Virgin, and the recumbent Christ-child on the ground, in the left foreground, with the three kneeling shepherds on the right, one behind the other. The respective distances separating the shepherds from the infant Jesus are ignored; all three, whose figures form a pyramid, are of the same size. The first is kneeling on one knee only, and seems to be having some difficulty in holding that position.

This composition is in some sort a protest against everything represented by Impressionism – even were it only by virtue of portraying a religious scene, something quite unthinkable in the ethos of that school.

The Crucifixion, painted in oils in 1886, not long after the *Adoration of the Shepherds*, marks another step in the same

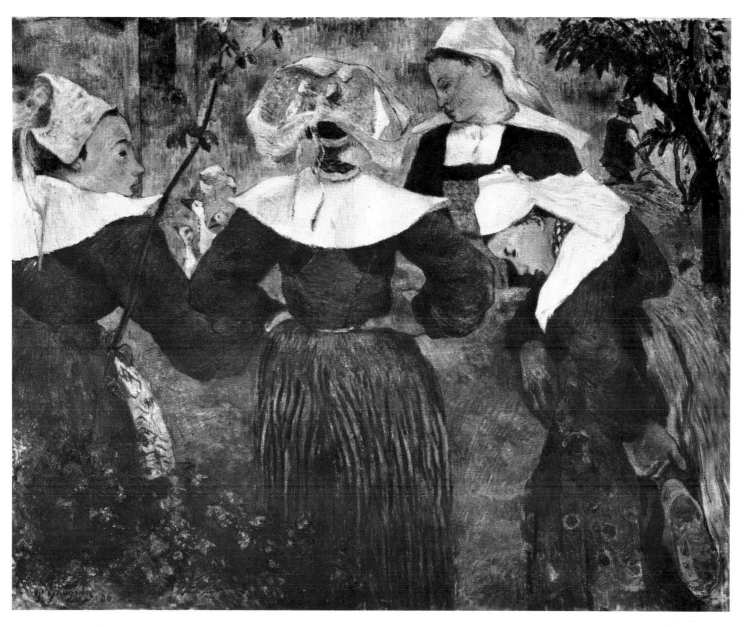

PAUL GAUGUIN *Breton Peasant Women* 1886

direction. The novelty consists in what became known as *cloisonnisme*, from a fancied resemblance to *cloisonné* enamel. This involves applying unmixed colours surrounded with a dark outline; it became inseparable from Anquetin's discovery, 'suggestive colour'. The red and blue which are traditionally reserved for St John and the Madonna, and the contrast between which is so greatly heightened here by their purity and luminosity, are the elements whose symbolic force and immanent properties enable them to express the feelings, the states of soul, intended by the artist: the Madonna's desperate grief and failing strength, and the compassionate tenderness of St John towards the suffering Virgin.

It is possible that there were other pictures by Emile Bernard, dating from this period, and that these would have signposted more thoroughly for us the way leading to Syntheticism; but unfortunately none of them has survived. He wrote in 1903 that in order to visit every part of France and acquaint himself with every aspect of the country's beauty, he went on long walking tours, 'always painting, always drawing, and, in terms of money, always poor'. This singular kind of tourism

15

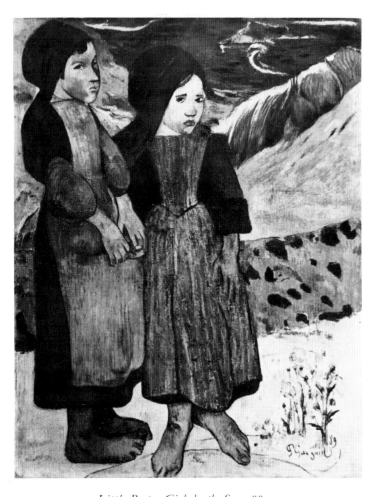

a study, an Impressionist study. Finding my presence a nuisance, he asked me if I was interested in painting; I answered "Yes, provided it's good." We chatted. He said a great deal about the Impressionists and a certain Gauguin, whom I did not know and for whom he had the greatest admiration. He asked to see my work. I took him to the inn where I had left my things. He liked my studies and sketches and complimented me on them. He gave me a card with a recommendation to "M. Gauguin", then at Pont-Aven. The next day I was in Pont-Aven and introduced myself to "M. Gauguin", who received me with a sour face and didn't appear to think as highly of his friend as his friend did of him. I moved to the Pension Gloanec at Pont-Aven. There were too many painters there for my liking, but the country was really beautiful and living was easy. I had a room in the town and used it for sleeping, reading and working, and only turned up at the Pension for meals. M. Gauguin sat opposite me at table. Beside him was one of his painter friends, Charles Laval. He took me one day to his studio where I saw pictures which reminded me strongly of Pissarro and Puvis de Chavannes. My lack of enthusiasm disposed him unfavourably towards me. By the time I had spent two months at Pont-Aven I had made a large number of studies and drawings and enjoyed the company of pleasanter painters than M. Gauguin.'

This reaction, recorded after a lapse of time, is quite unlike the way Bernard wrote to his parents on 19 August 1886, under the immediate influence of the new contact: 'There is also [at the Pension Gloanec] an Impressionist called Gauguin, a very able chap; he is thirty-six and draws and paints very well.'

The following summer, in 1887, Bernard once more left his Paris friends (Anquetin and Toulouse-Lautrec among them) and returned to Brittany. Gauguin and Laval were then in Martinique. Bernard went to Saint-Briac, where he already knew Mme Lemasson, who kept an inn; he was fond of one of her daughters.

It is not known who first had the idea of decorating the interior of the inn with murals – whether it was the artist himself, who had long been dreaming of such an opportunity, or Mme Lemasson, whose establishment would gain an added attraction in the eyes of her local customers and of tourists passing through. Whichever it was, Bernard chose for the purpose the largest of the dining-room walls – about thirteen feet by six feet six inches – and executed a monumental *Adoration of the Shepherds*, the cost of the paints being guaranteed in advance by the proprietress. Unfortunately the establishment was later burnt down, and we can form only a rough idea of what the composition was like, from Bernard's sketch, supplemented by his own description: 'It was arranged between the columns with vines climbing up them, which I used as the architectural theme of the whole. The ceiling had the appearance of being supported by these columns. In the spaces between them, which were fairly roomy, I laid out the landscape and the scenes of the *Adoration* and the *Circumcision*. These two compositions consisted of life-size figures which I did entirely

was not exactly favourable to the preservation of his canvases; he could not carry them about with him, and in any case he had to sell them to live.

Bernard's wanderings eventually brought him to Brittany, the effect of whose landscape, monuments and atmosphere on the young and sensitive artist was overwhelming: 'I thought I was living in my beloved Middle Ages, art was everywhere about me.' This record of his impressions comes from his edition of Gauguin's letters.

Passing through Concarneau, a seaport not far from Pont-Aven, he made the acquaintance of an artist who was painting a seascape from nature. This was none other than Schuffenecker. The encounter, whose outcome was destined to be so fruitful, is described by Bernard as follows: 'I had gone out walking and met a painter among the rocks. He was painting

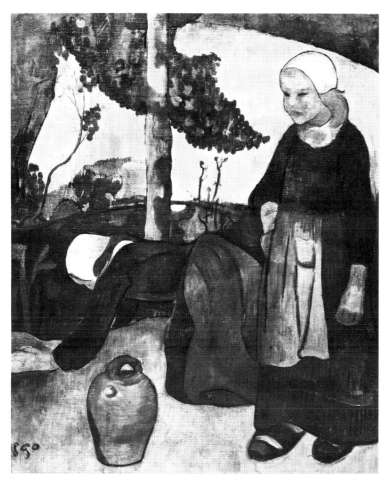

PAUL GAUGUIN *Two Breton Peasant Women*

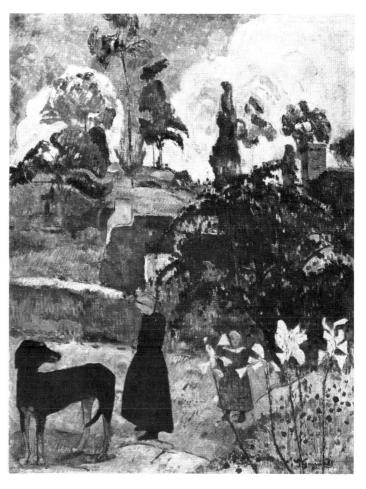

PAUL GAUGUIN *Breton Landscape with Dog* 1889

out of my head. There were twenty figures in the *Adoration* and not fewer than that in the *Circumcision*. I painted all that in oils, with colours ground by myself and paid for by Mme Lemasson.' He adds: 'I then finished my work by giving a simulated effect of stained glass to the windowpanes.'

This detailed description is quoted not so much for the subject, or for the manner in which it was executed (and which in any case we do not know), as in order to call attention to the artist's tendency at this period to abandon his easel in favour of mural painting, and to his urge to express himself through monumental forms.

Another fact worth noting in connection with this painting is that it brought him into touch with Albert Aurier. This poet and critic was staying in Brittany at the time, with his mother

and sister, at Saint-Enogat near Saint-Briac. There were rumours in the district that a painter had carried out some strange decorations in the Auberge Lemasson, and Albert Aurier came to look at them. He expressed much interest both in the work and in its creator, and later confirmed his friendly and welcoming attitude in his talk and his writings. The acquaintance begun at Saint-Briac was to ripen into firm friendship.

In the summer of 1888 Emile Bernard made yet another visit to Brittany. After a stay of three months in Saint-Briac he moved to Pont-Aven. This was because he was friendly with Van Gogh and had promised to take Van Gogh's greetings to Gauguin – since 'in art, comradeship is indispensable' – and had therefore decided to revisit 'the disagreeable Monsieur

17

Gauguin'. The meeting took place in better conditions than the last one and Bernard was able to note: 'I went to see Gauguin, who received me cordially this time.'

Gauguin, who had probably heard much favourable talk of 'little Bernard' (as the latter's older colleagues called him), examined his canvases attentively and showed him his own. Compliments were exchanged, without, however, leading to any communion of ideas. We do not know, in any case, what pictures Bernard showed him on this occasion; we do know that during this phase of his career Bernard was simultaneously pursuing several different pictorial formulae, as can be seen from his two portraits of his grandmother, which are close to each other in time but differ widely in style.

It would seem that Gauguin saw nothing to attract him in the canvases displayed by his young colleague. He had not been long back from a journey to Martinique with Laval; his eyes were full of picturesque tropical landscapes, and his mind was absorbed in dreams. This was the period in his life when Impressionism and Divisionism no longer held anything at all satisfying to him and he was feverishly searching for an outlet which would enable him to preserve intact the residue he had retained from the example and teaching of Pissarro. When we look at the pictures he painted in the spring of 1888, the *Little Breton Girls Dancing*, for instance, we can see that in some sense a break has been made with his earlier style – perspective depth has been abolished and the human form simplified; yet his vision remains traditional, and his theory of the decomposition of colours is still in line with the palette of Impressionism. But the crisis is about to break.

One July day in the same year, 1888, Bernard came back from the *kermesse* (or village fair) that was being held at Pont-Aven, and began painting, from memory, a picture which he subsequently called *Breton Women in Green Meadow*. Conceived entirely in terms of flat areas of paint, it has no background, perspective or modelling. The composition consists of a strict, geometrical division by vertical and diagonal lines; and the arrangement of the planes, as in the abstract painting of an epoch as yet unborn, is conditioned by the forms, lines and patches of colour, not by the iconographical aspect of the picture, 'what goes on'.

The canvas is divided into three levels. In the lowest compartment, two large female heads in Breton headdresses occupy one-third of the surface. They are cut off at the shoulders by the frame. At the same level, on the left and seen from behind, is a seated woman, simply imposed there in defiance of all proportion. In the centre, above the two heads, are two Breton women standing up, without any attempt by the artist to relate them spatially to the background; these two figures, with some silhouettes of children, constitute the middle compartment. The third compartment or 'top floor' of the composition consists of a decorative frieze made up of seven small figures in a rhythmical arrangement.

Every object has been flattened and crushed, reduced to a plane surface. Depth is obtained not by applying the principles of perspective but by juxtaposing excessively large figures,

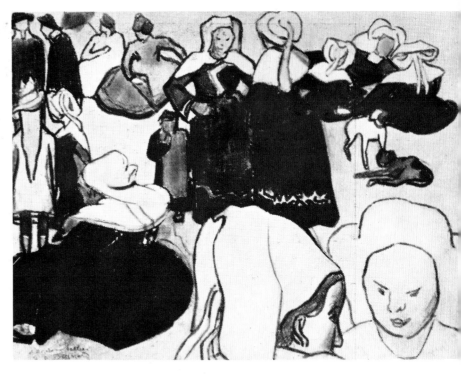

VINCENT VAN GOGH *Breton Women in Meadow* 1888

visible only from shoulder-level upwards, and other, very small ones, hardly taller than the bonnets of the women in the foreground.

The result of this construction is that the composition has been visualized simultaneously from ground level and in a bird's eye view; consequently the spectator is made to see it at once from above, from below and at his own level. The picture is not closed in on itself; on the contrary, it is open on all four sides. We are supposed to know that the setting is in the open country, the painter having entitled it *Breton Women in Green Meadow*; but there is nothing in the picture to bear witness to this, no element of vegetation to suggest it. The human beings alone constitute the whole landscape, the sky and the 'horizon'.

The colours used are: green and bright yellow for the background, which the artist designates as 'settled in advance, yellow and green' (*parti pris jaune et vert*); Prussian blue for the skirts, white for the headdresses, and black for outlines. Laid on flat, without any shading-off or gradual transitions, these colours are in every case surrounded by a black line, while the traditional composition, the 'placing' of the picture on its surface, is shattered by the linear arrangement of the whole, giving the effect of a monumental structure although the painting is in fact of modest size.

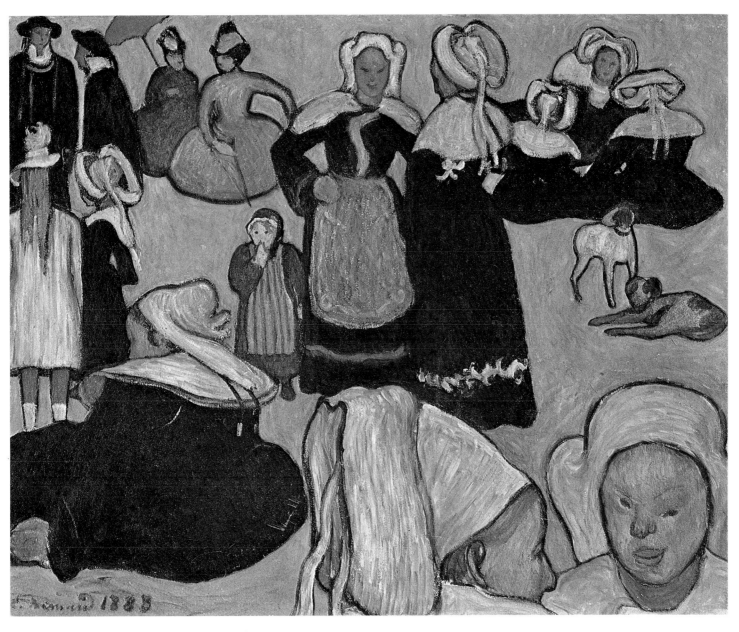

ÉMILE BERNARD *Breton Women in Green Meadow* 1888

Although all these elements had already appeared in Bernard's previous work, they blossomed out in 1885, the year of the *Adoration of the Shepherds* (the woodcut discussed above); and in this work they emerge in a complete symbiosis. On a more general plane, the work announces a definitive break with figurative vision as the basis of the art of painting. Was it a perfect picture? Far from it, but as Hofstätter justly emphasizes, 'such pictures are portents establishing a new epoch, not in proportion to their perfection but because they symbolically realize a new idea which the age is demanding'. And this idea was that of synthesis.

For Bernard, the quest for synthesis consists of reducing the three-dimensional figures existing in nature to the two dimensions of a plane surface, without, however, resorting to the

19

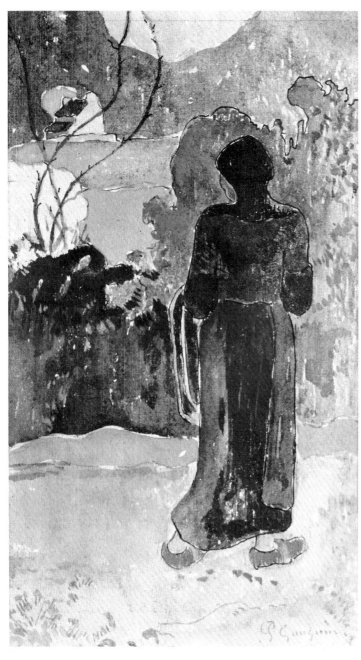

PAUL GAUGUIN *Watercolour study for 'Good Morning Monsieur Gauguin'*

elled work; on the other, from Japanese prints. In time, an added source was the fascination exercised over him by naive primitive Breton sculpture, and the thoroughly 'Syntheticist' Breton landscape.

The picture seems to have made a decided impression on Van Gogh. On 23 October 1888 he wrote to his brother: 'Gauguin has brought a magnificent canvas which he got in exchange from Bernard, some Breton women in a field, white on green, black on green with a note of red and the quiet flesh-tones.' Doubtless influenced by the *Breton Women in Green Meadow*, he immediately started painting his *Dance-hall at the Folies Arlésiennes*, and about a month later he made a copy of Bernard's picture in watercolour and gouache.[4]

We know from Bernard himself that *Breton Women in Green Meadow* strongly impressed Gauguin when the latter came to see him. It was in connection with this canvas that Bernard explained his theory of colour to Gauguin: the more colour is broken up into its component parts, the more it loses in intensity and the dirtier and greyer it becomes. If two colours are mixed the result is a third colour, with a coefficient of dirtiness thrown in. Only an unadulterated colour preserves its internal vigour, which can be made yet more vigorous by surrounding the colour with a blue-black border.

Impatient to try the method for himself, Gauguin asked Bernard (who wrote an account of the conversation) to lend him some of the colours which had been used in *Breton Women in Green Meadow* and which he himself did not possess, including Prussian blue, which he had never used before. He also demanded information about the famous *cloisonniste* contour-line, and the best way of marrying the colours so as to get the desired depth of blue-black. On leaving Bernard, Gauguin went to his studio and painted *Vision after the Sermon*, otherwise known as *Jacob Wrestling with the Angel*.

The contrast between these two pictures was the painful centre of the quarrel between the two artists, the pivot on which it turned. There was some justification on both sides, and the quarrel enables us to define more clearly the premises on which the new style was based: we must therefore examine it.[5]

There is no doubt at all that Gauguin, from the moment he finished *Vision after the Sermon*, abandoned the Divisionism that Pissarro had taught him, and also painting from nature. What happened as a result? By limiting himself to three or four colours, Gauguin succeeded in obtaining, by purely plastic, not descriptive, means, a dramatic tension and a total fusion of real with imaginative elements; in a word, he rose to the level of the symbol. He changed his vision at the same time as his palette. Gauguin's future development was determined by *Vision after the Sermon*. As Hofstätter says, 'A decisive step was implicit in this purely flat painting, a step towards absolute art and a preparation for twentieth-century abstraction'.

No doubt when we compare the *Little Breton Girls Dancing*, already mentioned, which is an earlier picture since it dates from the spring of the same year, with *Vision after the Sermon*,

artifices of illusion. The problem amounts to abolishing the third dimension. This he achieves by modifying the organization of the picture: objects are enlarged, as if seen from close to. Every form is delimited by a dark contour, and the space within the contour filled with a single homogeneous colour. Bernard borrowed this procedure on the one hand from Gothic stained glass, from medieval textiles and from enam-

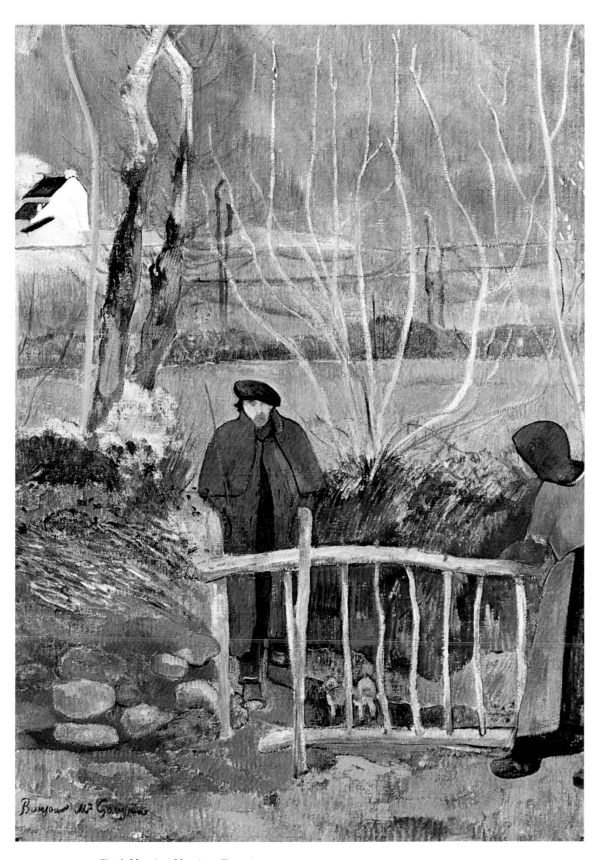

PAUL GAUGUIN *Good Morning Monsieur Gauguin* 1889

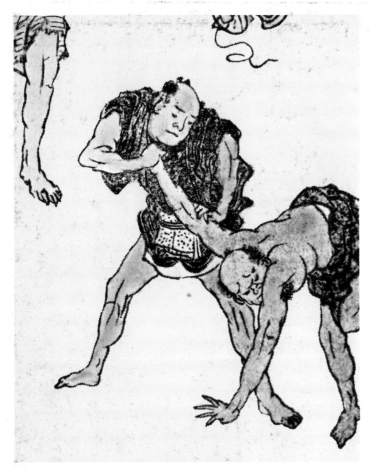

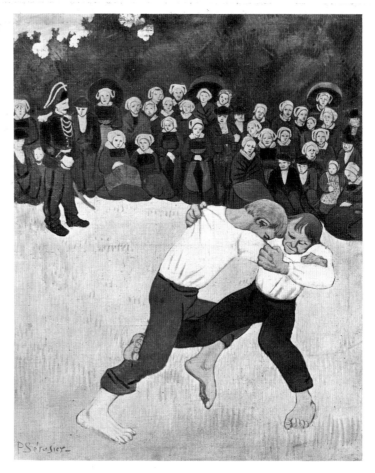

HOKUSAI *Judo*

PAUL SÉRUSIER *The Wrestlers c.* 1895

we can observe that the artist already possessed a certain desire for simplification, notably for flatness and a distorted perspective; but there is not the slightest transition between the two works. There is, in fact, a gulf between them, because of the different handling of form and colour. It seems safe to say that, ready though he was to make the crucial step, Gauguin did not know how to set about it. He had known hitherto only the aesthetic of Pissarro, from which he was on the point of liberating himself to adopt that of Cézanne. But he was still a long way from doing this: Cézanne's position was very different from his own.

Broadly speaking, Cézanne regarded the objective order of reality as being inherent in the fundamental forms of space, and his view of things was in a sense independent of the spectator. Bernard, on the contrary, felt that order more subjectively; he felt it, that is, from the point of view of the spectator and of the spectator's approach to the phenomena represented. Instead of seeking to reproduce such and such an object or scene in its real form or to display what the eye perceives, he strove to represent whatever his memory retained from the scene or object in the way of emotion, aiming by this means to foresee whether the thing represented would be welcomed by the spectator with warmth or indifference, affection or hostility. This came as a revelation to Gauguin. He felt that one day he too would express himself in this way, which, according to him, constituted the very essence of the art of picture-making. The fact remains, however, that this manner of seeing had been totally absent from all his previous work.

This same 'little Bernard', who put his theories before Gauguin with such fervour, was to write later, not without a certain bitterness: 'All he had done, in his *Vision after the Sermon,* was to put into action, not the colour-theory I had told him about but the actual style of my *Breton Women in Green Meadow,* after having first committed himself to a red background as his *parti pris,* instead of the yellow-green which I had used. In the foreground he put the same large figures with monumental bonnets like those of *châtelaines*.'

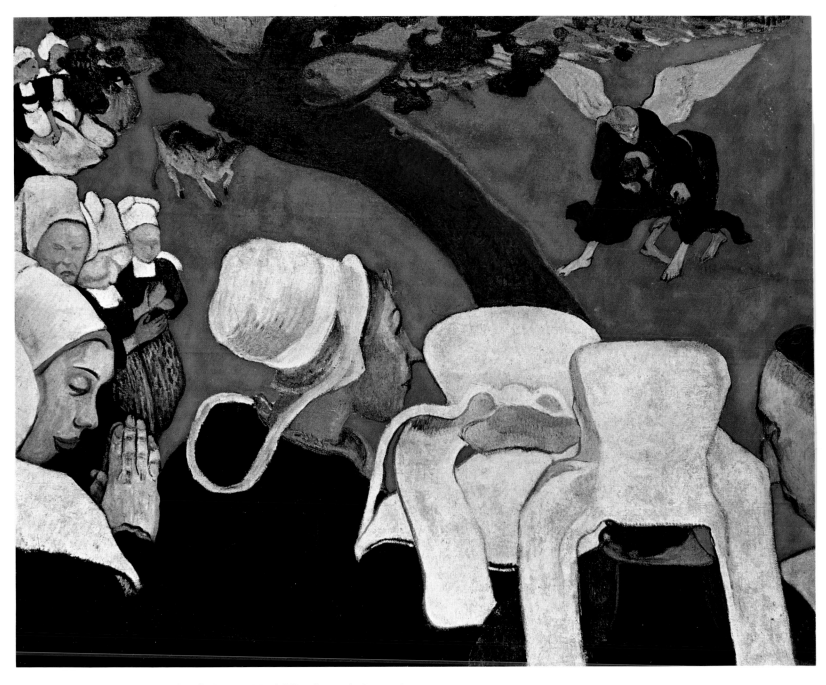

PAUL GAUGUIN *Vision after the Sermon (Jacob Wrestling with the Angel)* 1888

Bernard also made the observation, in 1903, that the attitudes of both the angel and Jacob recalled a classical judo pose; 'two wrestlers borrowed from a Japanese album have been transmogrified into a vision'. And indeed the posture of the angel may very well have been inspired by a sketch in the *Manga* albums, in which Hokusai frequently represents groups of wrestlers. But, as Yvonne Thirion has proved, none of these designs had served as a direct model for Gauguin's two combatants.

Since we are concerned just here with the question of affinities in the plastic arts, it may be not without interest to anticipate a little and recall *The Wrestlers*, a picture painted by Paul

Sérusier at Pont-Aven in 1895.[6] The identity of the subject is striking – two adversaries in attitudes strongly reminiscent of judo, and surrounded by spectators – but less striking than the differences. Sérusier has organized his composition in a natural way: the two wrestlers are placed in the foreground, whereas the spectators are relegated to the background and fulfil a secondary function, that of a decorative element. Gauguin, on the other hand, reverses the proportions. Starting from the foreground, two-thirds of his canvas are occupied by the heads of the spectators, who are seen from behind and in profile; it is above these heads that two small figures, Jacob and the angel, are fighting. The faithful have just heard a moving sermon in church; some of them are as if petrified, others are standing with eyes closed, and all are dreaming, possessed by visions despite being in the waking state.

Let us note, also, that in the hands of Bernard the subject-matter, notwithstanding the picture's monumental quality and its original composition, becomes rather uninteresting: his Breton women might be merely exchanging the latest village gossip in a lull while enjoying a local festival.[7] Similarly, the spectators in Sérusier's picture, under the watchful eye of uniformed police, are apparently riveted by the imminent outcome of the fight and the prospect of seeing the winner snatching off his opponent's shirt in the time-honoured manner.

The exact opposite is observable in Gauguin's *Vision after the Sermon*, in which a tremendous metaphysical scene is being acted. The spectator's eye does not dwell on the foreground figures, who, as we have said, occupy two-thirds of the picture-space; instead of looking *at* them he looks *with* them – upwards and to the right, where a miracle is taking place. Between the human beings and the two imaginary figures a barrier is raised, in the form of a tree-trunk which cuts the picture diagonally into two parts; but what establishes the separation of heaven from earth is not so much this barrier as the colours. In the eyes of those whom the power of the vision has touched, the ordinary, familiar, well-trodden meadow has become crimson; it matches their inward image of it, an image which the preacher's sermon has brought to a red heat.

Essentially, the subject is an old one; scenes depicting visions are a commonplace of art-history. Gustave Moreau and Eugène Carrière had used similar themes only a short time before Gauguin; but all they had evoked, in a key of half-lights and shadows, was what they themselves had experienced. Here, thanks to the new expressive means, the vision communicates the same emotion to both sets of spectators – those who are painted and those who look at the painting. The picture creates a kind of metaphysical theatre-within-a-theatre.

Is this, then, simply a story-telling picture? Perhaps; but how has the narrative been created if not by the total reversal of classical arrangement: by the rejection of perspective and the use of eccentric colours? These were not the tools of any nineteenth-century painter setting out to make an anecdotal 'picture which tells a story'.

What was Gauguin's own judgment on his canvas and the

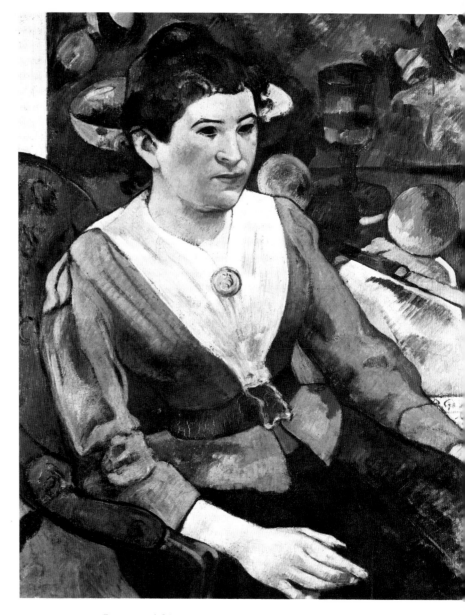

PAUL GAUGUIN *Portrait of Marie Derrien* 1890

change in his way of painting? Two of his letters tell us: one to Van Gogh in September 1888, the other to Schuffenecker in October of the same year. In the first, he writes: 'I think that in the figures I've achieved a great simplicity, at once rustic and *superstitious*. The whole very severe. For me, in this picture, the landscape and the wrestling only exist in the imagination of the people praying as an after-effect of the sermon. That is why there is a contrast between the people, who are painted naturally, and the wrestling figures in their landscape, which is non-natural and out of proportion.' And in his letter to Schuffenecker we read: 'I've painted a picture for a church; of course

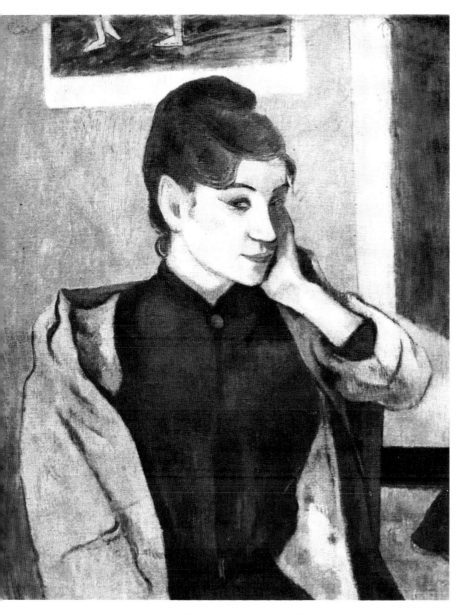

PAUL GAUGUIN *Portrait of Madeleine Bernard*

his own way, never thereafter to halt or look back. As for Bernard, he was to spend the rest of his life bowed under the weight of an understandable sense of resentment. He insisted perpetually on his claim to priority as the crucial innovator, plaguing those about him and generally making a nuisance of himself.

We may well wonder whether Bernard's sister, Madeleine, for whom Gauguin felt a lively affection, was right to address him (as she apparently did) in the following words, just before his departure for Tahiti in 1889: 'Monsieur Gauguin, you are a betrayer: you have played false and done a terrible injustice to my brother, who was the real initiator of the art through which you now claim so much on your own behalf.' Whether Madeleine only thought this or whether she actually said it is unimportant. The pertinent thing is that Bernard appropriated her supposed accusation as a vehicle for his own disillusionment.[8]

The truth is that Bernard, for all his intelligence, could not understand that the march of history is inexorable and that time flies too fast for history to record everything; only the essentials remain, the rest is lost. What is worse is that Bernard either failed to realize or refused to acknowledge that his fortunate discovery had been taken up and perfected by someone greater than himself, and that, contrary to his belief, it was not he but Gauguin who had effected the revolution in art. Bernard never accepted the role of prompter; he demanded that the world recognize him as Gauguin's master.[9] But there are good reasons for believing that, without Gauguin, the *cloisonnisme* of Bernard would have left little or no trace in the history of art and, like that of Anquetin, would have been regarded as just another studio experiment. For Bernard, however close he had come to making the breakthrough, had too little experience as an artist to be in complete control of what he set out to express.

Hofstätter rightly emphasizes that in *Vision after the Sermon* Gauguin avails himself only of Bernard's technique, and that, in any attempt to describe Gauguin's stylistic development, it would be necessary to underline that his style represented the unfolding of precisely those elements which differentiate him from Bernard. Gauguin did indeed make a real discovery, although it was based on one made by Bernard. Gauguin's style developed steadily, with no prominent deviations, right up to the period of his last Tahitian canvases. His art, based on a narrower field of experience than that of Bernard, shows a correspondingly greater homogeneity; and that quality is just what constitutes its vigour.

It is true that at no time did Bernard stand still, either, artistically speaking; but steady development in his case meant that he always set off in the same direction and continued until it was exhausted, then came round to his starting-place and began all over again. And this is what constitutes his weakness.

Directly he had finished the *Vision after the Sermon*, in summer 1888, Gauguin went with Bernard and Laval to the neighbouring village of Nizon to present it to the parish. He was

it was refused, so I'm sending it to Van Gogh. I needn't describe it to you, you'll see it. This year I've sacrificed everything – execution, colour – for style, in order to impose on myself something different from what I know how to do. I think this is a transformation which hasn't yet borne its fruit but is going to do so.'

What Bernard did was to invent a style, but it was Gauguin who breathed a soul into it, gave it wings, opened a vista towards the twentieth century and showed the way to a new vision of the world. For Gauguin, the invention was really no more than a springboard which enabled him to take flight in

Gauguin being hailed as 'the inventor of a new style' with unforeseeable potentialities. Among the picture's most enthusiastic supporters was Albert Aurier, who was later to describe Gauguin as 'a sublime seer', 'a great decorator' and 'an artist of genius'.

And so, when, in the following year, Bernard exhibited his own pictures in Paris, he found himself labelled as a pupil and imitator of Gauguin.[10]

What must his feelings have been? It appears that at first he was overjoyed to see his colleague and senior take an interest in his 'invention'. At Pont-Aven, up to the time of Gauguin's departure, the latter and Bernard, together with Laval who never left them, worked in perfect harmony. Bernard recorded that they were practically inseparable and that 'all our work was carried out so to speak in common'. And we have plenty of evidence that this was in fact so; an example is the cupboard carved by Gauguin and Bernard, with two doors representing Breton women picking apples.

It must also be remembered that Gauguin was attracted as much by Bernard's personality as by his painting. It is easy to imagine how much this youth, with his astonishingly precocious erudition, impressed the forty-year-old artist – who was certainly conscious of the sacred fire blazing in his soul, but whose infallible instinct for painting was unaccompanied by any cultural equipment, and who possessed no theoretical grounding whatever. We should not forget that certain of Gauguin's writings, such as *Avant et après*, the *Racontars de rapin*, or the *Cahier pour Aline*,[11] which are full of remarkable

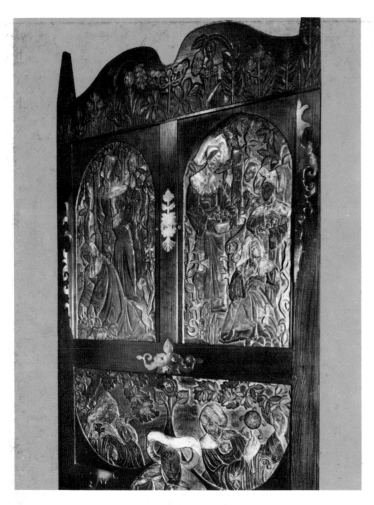

Cupboard carved and painted by Gauguin and Bernard in 1888

convinced that the canvas would harmonize perfectly with the Romanesque granite church whose interior was decorated with naive, primitive figures of saints, carved in wood and polychromed. On the picture's white frame he had written a dedication in blue: 'Presented by Tristan de Moscoso.'

The parish priest of Nizon, alarmed by the visit of these artists – whose reputation, he feared, left much to be desired – and also by the subject of the canvas, declined the gift on the grounds that the work was insufficiently religious and would be of no benefit to the faithful. His refusal, as it turned out, was a good thing.

In despair, and with his equally dejected friends at his side, Gauguin carried his picture back to Pont-Aven. On a visit to Paris, he left it behind; and through the good offices of Theo van Gogh it was exhibited at the gallery of Boussod and Valadon. It received a welcome as warm as it was unexpected,

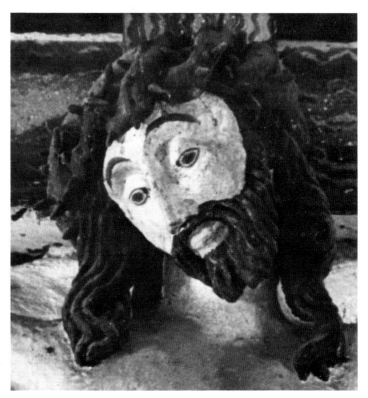

Figure of Christ in the chapel at Trémalo (detail)

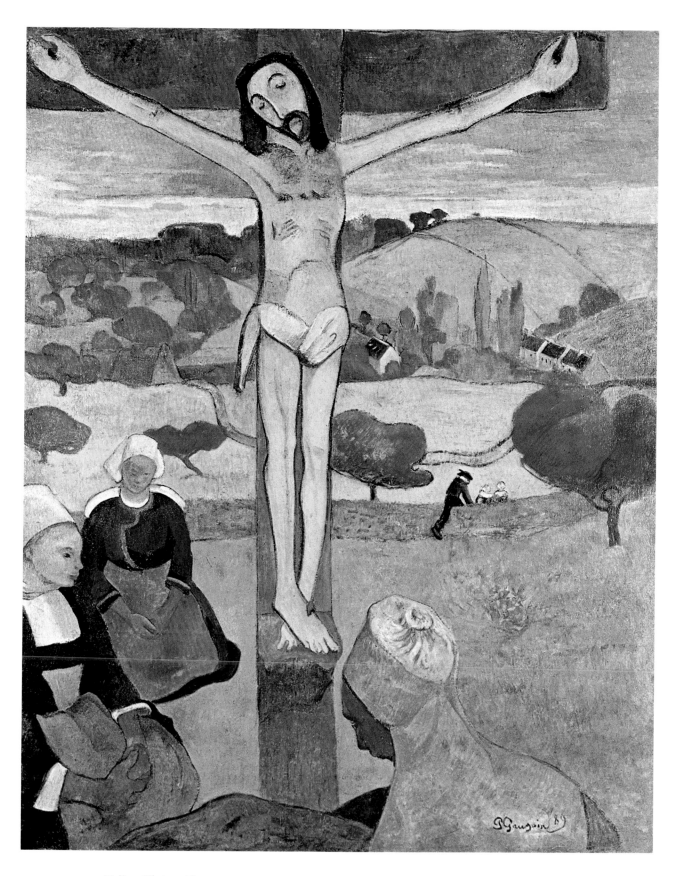

PAUL GAUGUIN *Yellow Christ* 1889

28 PAUL GAUGUIN *Breton Calvary (Green Christ)* 1889

PAUL GAUGUIN *Self-portrait with Yellow Christ c.* 1889

and unexpected theoretical formulations, belong to a later phase, when he was already canonized as 'the master of Tahiti'. As yet, at the time of his second meeting with Bernard, in 1888, Gauguin, whose mind was already in a state of permanent effervescence, had not acquired the ability to articulate his ideas with any exactness. At that period, Bernard, who was very alert to everything going on in the intellectual world of Paris – literature, music, theatre and painting – dazzled Gauguin with his aesthetic and philosophical vocabulary, which Gauguin was unable to understand. But when we read,

in chronological order, the correspondence which Gauguin kept up with his friends, we are astounded by the prodigious speed of his development.

Bernard's manner and behaviour, and his astonishing facility for expressing his thoughts, could well have caused anyone to believe that the young innovator never drew a line or laid on a colour without strong theoretical grounds for what he was doing, and that everything he composed was part of an extremely complex philosophical system of which he alone held the secret. Gauguin was to write: 'Pay attention to little Bernard, he's somebody,' while remaining convinced that he himself would eventually come out on top because he was intrinsically the better painter. We find him writing in a letter to Schuffenecker: 'What does it matter anyway, I'm telling you that eventually I shall succeed in achieving things *of the very first order*, I know I shall and we shall see. You know very well that when it comes down to it I'm always right about art.'

He expounded his 'rightness' in authoritarian fashion, excitedly pouring out his words. Curiously, his most attentive listener was Bernard, whose admiration for him was continually growing. It would appear, even, that Bernard sometimes conceived an idea without being able to see its value until Gauguin took it up, made it his own and stamped it with his genius. In a letter to Van Gogh in the autumn of 1888, Bernard spoke of Gauguin in such glowing terms that Van Gogh immediately wrote to his brother, 'Today I thought a great deal about Bernard while I was working. His letter is full of veneration for Gauguin's talent. He says he thinks Gauguin such a great artist that he's almost afraid of him, and that everything he does himself is bad compared to Gauguin's work.' A little later, Van Gogh wrote again: 'Another letter from Bernard, full of his conviction that Gauguin is a very great master and a man of absolute superiority in character and intelligence.'

As the reader can see, these letters from Bernard to Van Gogh seem to evince none of the bitterness displayed in Bernard's later statements concerning the same period. In *L'Aventure de ma vie* we read: 'I was very happy in my new friendships when I left Pont-Aven; the three of us had become close and enthusiastic comrades, all the more so in that we were fired by the same ideas – which, I must be allowed to add, had originated from myself.'[12]

Rookmaaker, in his book on Syntheticism, has some interesting things to say, notably that Bernard's ability to draw Gauguin out was in itself a fundamental contribution to the growth of the movement;[13] Bernard's questions were a stimulus forcing Gauguin to express his thoughts clearly. It would however be madness, in Rookmaaker's opinion, to consider reversing their respective roles, there being no evidence to support such a speculation; on the contrary, Rookmaaker's view is confirmed by the letter Gauguin wrote from Arles, giving Bernard and Laval his answers to their questions on the function to be allocated to the shadows in the total effect conveyed by a picture.[14]

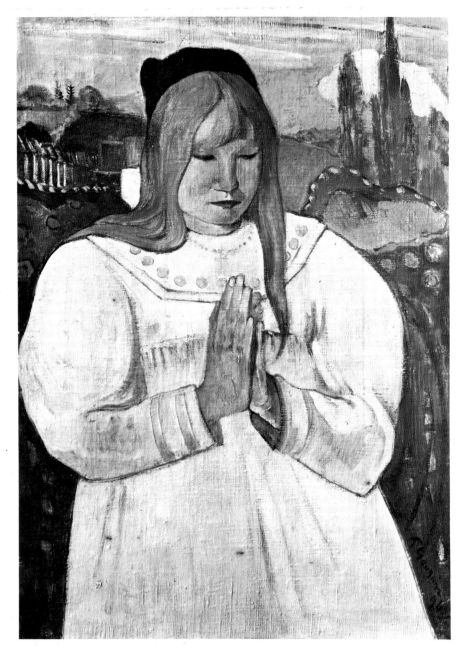

PAUL GAUGUIN *Breton Woman at Prayer* 1894

In Paris, where the two artists met again, their friendship continued intact. Bernard often went to see Schuffenecker, whose generous hospitality, incidentally, was a help to Gauguin, who was very hard up at the time. Together they executed a set of lithographs, later collected into albums. Bernard arranged with the colourman Père Tanguy to supply Gauguin with paints and canvases on credit. But this interlude in their lives was destined to be short: Gauguin, harassed by

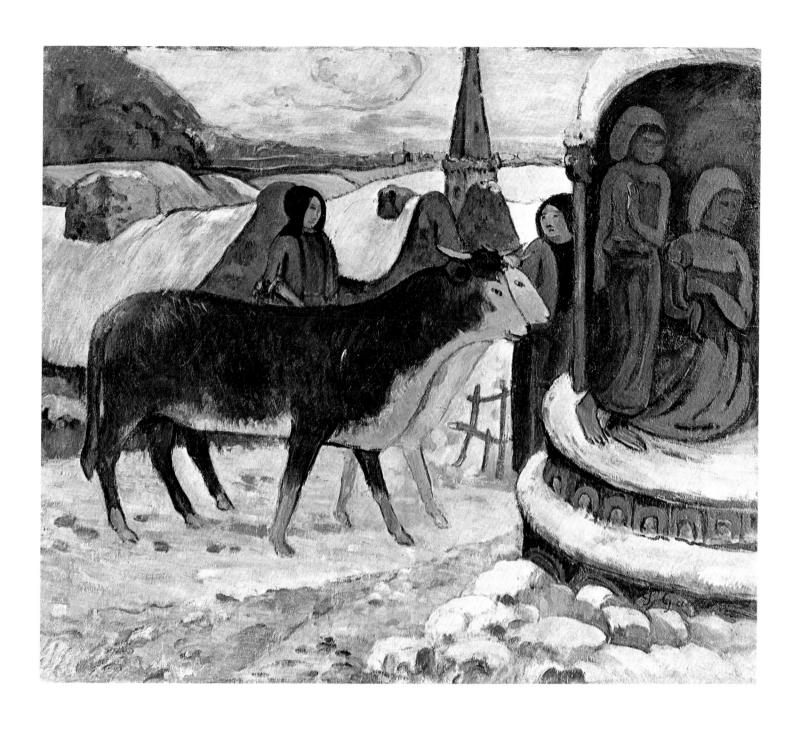

PAUL GAUGUIN *Christmas Night* 1896

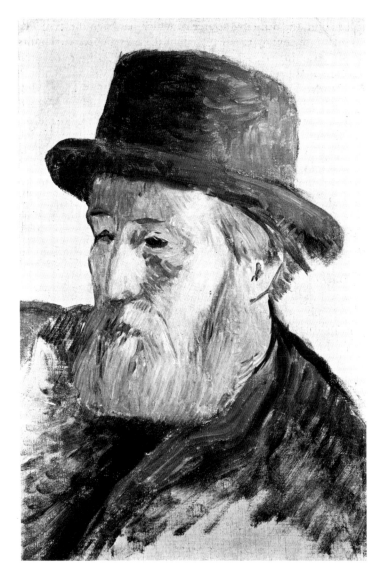

PAUL GAUGUIN *The Artist's Uncle, Henri Gauguin*

Fénéon, writing in 1889 in *La Cravache*, discerned in the canvases of Laval and Bernard 'this painter's trade-mark [i.e. Gauguin's]', and Albert Aurier, in the *Mercure de France*, proclaimed that the Symbolist poets Mallarmé and Jean Moréas had been joined by a Symbolist painter, and that 'at the banquet in honour of Paul Verlaine and Paul Fort there was a third Paul: Gauguin'.

To the ambitious Bernard, this must have been a terrible blow. His friendship with Gauguin was bound to suffer, especially as the latter did nothing to rectify the judgments expressed.

We do not know whether the two artists found occasion to thrash the matter out in talk. The fact that there is no allusion to the affair in their correspondence implies, rather, an aggravation of the conflict between them. Certainly Bernard did not go to Le Pouldu in the autumn of that year, as they had arranged, to work with Gauguin and a handful of painters who had attached themselves to him and were regarded as his pupils. Bernard was to avenge himself for his friend's 'betrayal' by giving Judas the features of Gauguin in his picture, *The Agony in the Garden*.[15] When Gauguin set out for Tahiti in 1891, relations between them came to an end.

Ever since then critics have been trying to establish which of the two was the inventor of the new style – which the master, which the pupil; an inquiry attended by a certain amount of

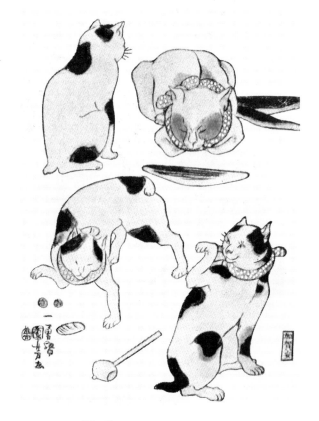

letter after letter from Van Gogh, was soon to leave for Arles. Meanwhile the two friends agreed to meet and work together again the next year, at Le Pouldu.

The Universal Exhibition of 1889 was now looming up. The indefatigable Schuffenecker, with his usual foresight, busied himself to such effect that the painters Paul Gauguin, Charles Laval, Louis Anquetin, Emile Bernard, Emile Schuffenecker, Léon Fauché, Daniel de Monfreid and Louis Roy could look forward to exhibiting their pictures at the Café Volpini, situated right next to the official art section, thereby simultaneously dissociating themselves from such institutional art and placing before the world the revelation of a new way of painting. Crowds thronged the doors of the little café to admire the works of the exhibitors, who had billed themselves as the 'Groupe Impressionniste et Synthétiste'. Félix

KUNIYOSHI *The Cats*

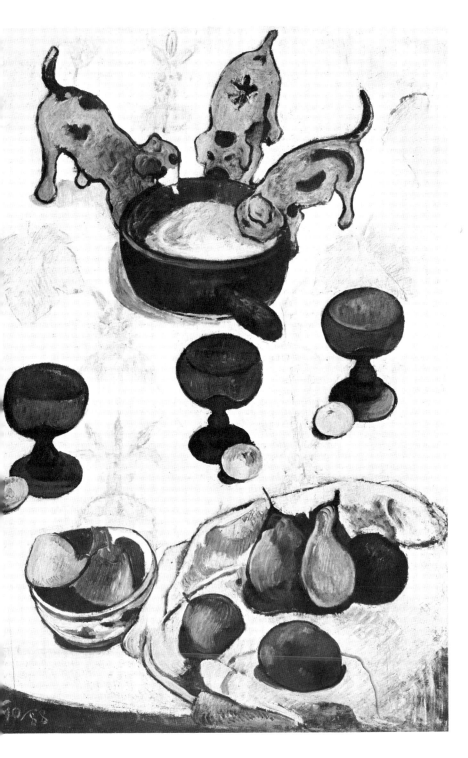

confusion, the principal source of which has been the evidence of self-styled eye-witnesses. Most of these *ex post facto* accounts are thoroughly partial and in some cases are further coloured by personal grudges.

Maurice Denis, for example, writes: 'Without taking sides, or deciding whether it was Gauguin or Bernard who invented *cloisonnisme*, Syntheticism, etc., I maintain that it was the work of Gauguin, transmitted to us by Sérusier, that was the decisive influence on Ibels, Ranson and myself at the Académie Julian. It was Gauguin who, for us, was *The Master*.'[16]

However, Denis was in no way qualified to make such a pronouncement, not having known Gauguin until 1889, at the time of the Universal Exhibition. By that time the relationship between Gauguin and Bernard had become fairly distant; moreover, as was later recognized, it was Bernard and not Gauguin who was the leading influence on the art of Denis himself.

The opinions of Denis on the subject were in any case prone to vary. On a different occasion and in a different context he delivered himself as follows: 'The one [Gauguin] was a force of nature, a born decorator, a genuine *naïf*, like a sailor or a Negro. The other [Bernard] had certain gifts as a poet and a technician, an unusual facility for execution and assimilation, a sense of composition and, even in his oddest inventions, an imperturbable logic. Putting it in a nutshell, they had developed in the same way at the same time. Pont-Aven was the point of confluence of discoveries made by the one at Saint-Briac and by the other in Martinique.'[17]

Remarks in the same strain occur in the letters of Chamaillard and Moret, published in 1906 by the *Mercure de France*. In one of them, Moret writes: 'He [Bernard] was at that time, I assure you, just a little chap without any pretensions to being Gauguin's rival, let alone his teacher. In fact, I really think he tagged along with Gauguin to profit from his knowledge and understanding and the excellent lessons lavished on us by the master.... Bernard at that period had no definite manner and produced nothing that was truly personal. It was just that, like all of us, he was in a restless state and thirsty to explore new directions.... Gauguin encouraged and guided Bernard on this new path. But, I repeat, Bernard was not and could not be anything but Gauguin's pupil, because Gauguin was already in the full possession of his talent whereas Bernard was still just a beginner.'[18]

This opinion is neither impartial nor well founded, since Moret, and later Chamaillard, were both among those painters who, although attaching themselves to Gauguin's circle, derived no particular profit from his teaching. They were latter-day Impressionists who reached a fair level of competence, stepped briefly out of line, but, as soon as Gauguin had departed, returned to a more perfect adherence to Impressionism than ever.

A sly, spiteful note was injected into the controversy by Charles Morice in the *Mercure de France* in 1904, when he mockingly garbled the terms of Bernard's statement implying that Gauguin had become an artist on the day he found himself

PAUL GAUGUIN *Still-life with Three Puppies* 1888

confronted by one of Bernard's pictures: 'M. Bernard is wrong
again. If Gauguin, visiting M. Bernard, "waxed enthusiastic",
as the latter complacently notes, the cause of his enthusiasm
was not the works of M. Bernard himself but those by Cézanne
which M. Bernard possessed and had put up on his studio
walls or transcribed into his pictures.'

Another French critic, Roger Marx, displayed greater
conscientiousness and attention to facts. As early as 1892, the
personality of the young Bernard had attracted his attention,
and he wrote in *Le Temps* that the creator of the *Calvary*, a work
on a small scale but magnificent none the less, and of the
remarkable *Agony in the Garden*, was 'the father of French
Symbolist painting'. One's only regret is that Roger Marx
confined himself to minor paintings by Bernard.

Octave Mirbeau, on the other hand, writing in *Le Journal* in
1901, rejected the possibility of any influence of Bernard on
Gauguin, and in the same year Claude Anet wrote in the *Revue
Blanche*: 'Cézanne and Maurice Denis, Van Gogh and Sérusier,
all had an undeniable influence on M. Bernard at one period in
his life. But his daring personality, eager for self-discovery,
prevented him from adapting himself to any mode of vision
which was not uniquely his own.'

The voices that render justice to 'little Bernard' are those of
Van Gogh – and Gauguin himself. Vincent wrote in November
1888 to his brother Theo: 'Mind you, in my opinion, Ber-
nard's things are very fine, and he will have deserved success
in Paris,' adding in the following June: 'Little Bernard – in my
view at least – has already painted some absolutely astonishing
things, full of a certain sweetness and something essentially
French and candid which is of quite unusual quality.'

These letters belong to the time when Van Gogh saw the
Breton Women in Green Meadow, which Gauguin had brought
down to Arles. Time adds its own perspective, and a year later
Van Gogh's feelings about Bernard were more deliberate, less
enthusiastic but still clearly favourable, as can be seen from
what he wrote in October 1889 to his sister Willemien, whom
he called affectionately Wil: 'You ask me, Who is Bernard?
He's a young painter, twenty at most, and highly original.
What he's trying to do is modern figures with the elegance of
Greek or Egyptian antiquities, gracefully expressive move-
ments, enchantment through bold colour. I've seen a picture
by him of a Sunday afternoon scene in Brittany, women and
children and men, Breton peasants all of them, and dogs stroll-
ing about in a meadow; black and red local costume, with white
headdresses. But in this crowd there are also two ladies, one in
red and the other in bottle-green, who have the effect of turn-
ing the whole thing into something really modern. Ask Theo
to show you the watercolour I did from this picture, it was so
original I just had to have a copy.'

And Gauguin wrote on 14 August 1888 to Schuffenecker,
without naming the pictures he was alluding to: 'Little
Bernard is here and has brought some interesting things over
from Saint-Briac. There's a chap who's afraid of nothing.'
Again, in another letter: 'I'm shouting this from the rooftops:
pay attention to little Bernard, he's somebody.'[19]

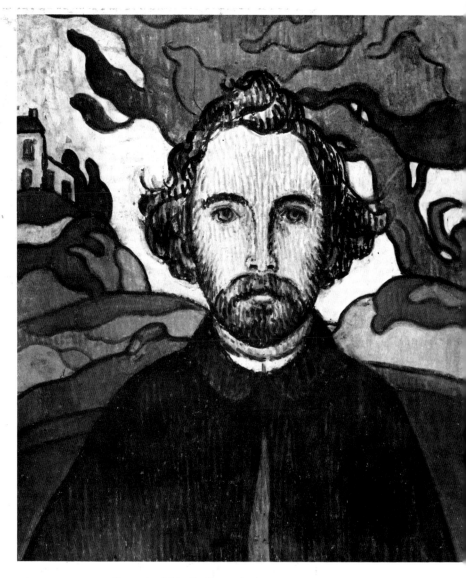

CHARLES FILIGER *Portrait of Emile Bernard* 1893

But these, though undoubtedly significant, are merely
tributes thrown out in passing. Of altogether different calibre
is the outstanding study published by Séguin in 1903, in
L'Occident; his judgment, both of the causes underlying the
split between Gauguin and Bernard, and of the general history
of the Pont-Aven group, possesses real authority. '...And into
his [Gauguin's] orbit there now came Emile Bernard, a youth
who was wonderfully well-informed and who, like Gauguin,
was a friend of Vincent; his eyes had seen the splendours of the
Louvre, and he had admired the ancient sculptures of Brittany
and understood the synthesis inherent in them.... The truth is
that Emile Bernard, who has a better right than anybody to

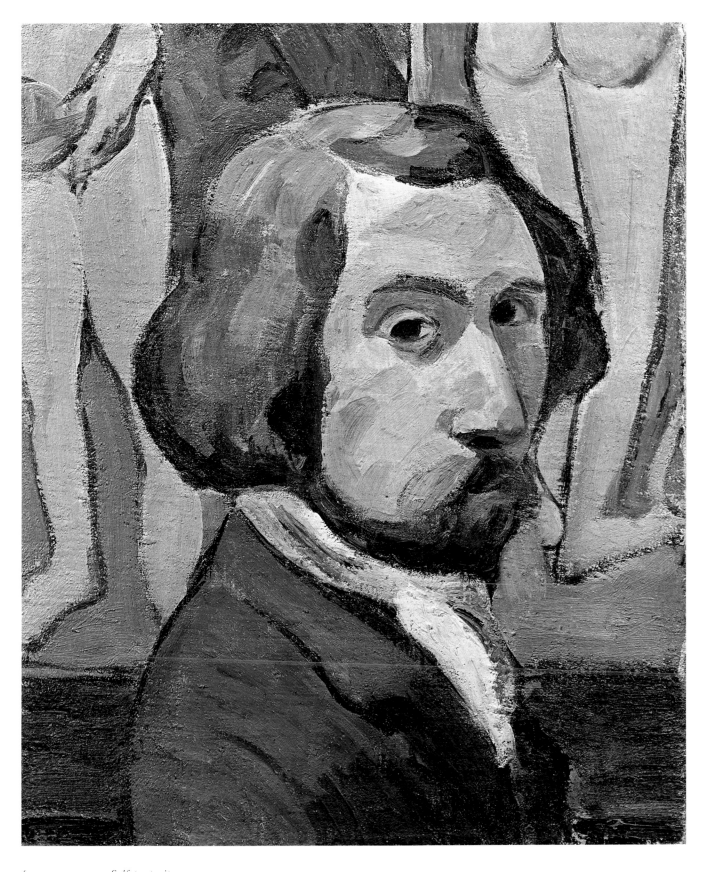

ÉMILE BERNARD *Self-portrait*

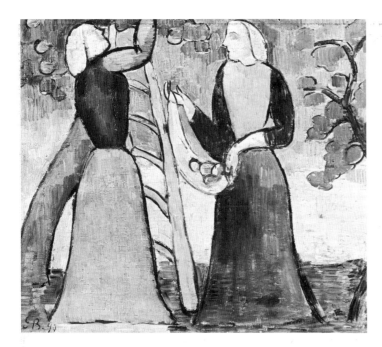

ÉMILE BERNARD *Apple-picking* 1890

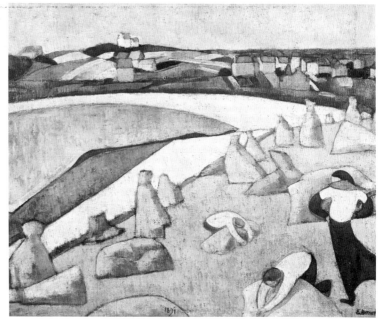

ÉMILE BERNARD *The Corn Harvest* 1891

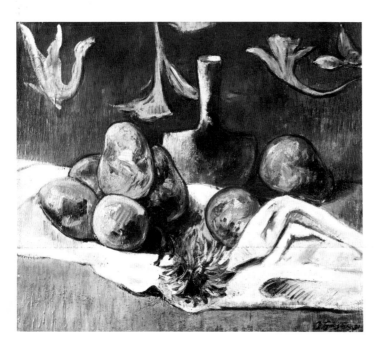

PAUL GAUGUIN *Still-life with Fruit* 1891

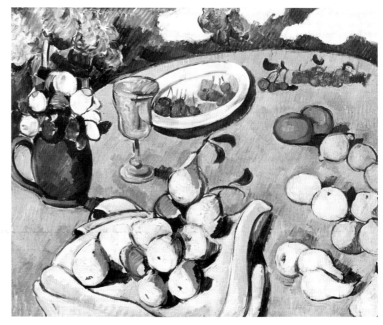

ÉMILE BERNARD *Still-life on Round Table*

write about this period in the history of our Art, of which he was one of the best representatives, maintained a powerful influence on Gauguin, and later on me. I liked the gentle, subtle flow of his conversation.... Their canvases, though based on the same principles, are in no way alike, a fact which in itself would be enough to prove that the one thing every artist needs is intuition, and that all theory is so much barren soil for whoever lacks this gift.'

The idea of comparing the two painters' pictures in chronological parallel, and of consulting reliable historical sources,

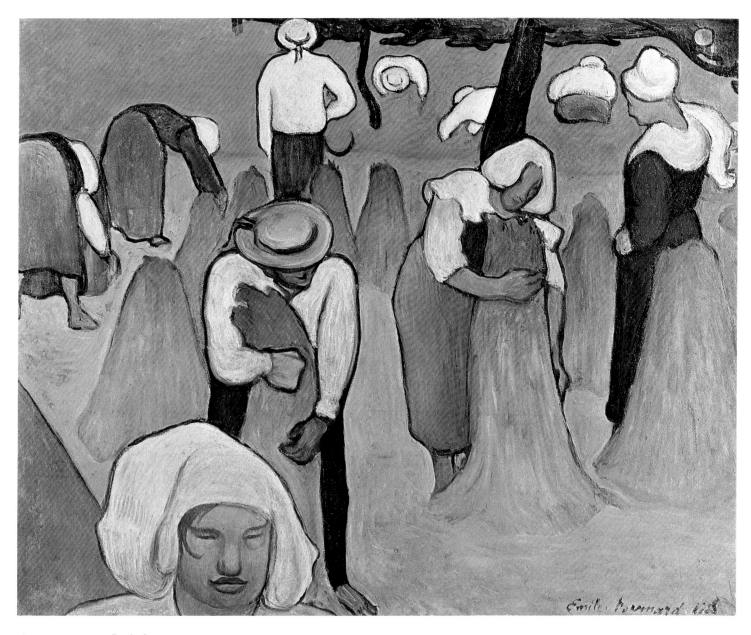

ÉMILE BERNARD *Buckwheat* 1888

was taken up and developed in painstaking detail by Hof-
stätter in his doctoral thesis 'Die Entstehung des "Neuen
Stils" in der französischen Malerei um 1890' (1954). Profiting
from the large amount of pictorial material relating to the
period, which had been preserved by a number of people
among Bernard's family and the circle of their relations, profit-
ing also from the no less abundant literature available, and,
finally, applying modern methods of investigation, Hof-
stätter obtained results not so very different from the conclu-
sion that Séguin, writing fifty years previously in *L'Occident*,

had reached by intuition alone: 'The encounter of these two intelligences was to engender light, and the creation of the Symbolist school.'

There can, however, be no doubt whatever that Gauguin was the important figure in the movement from the beginning, that his ascendancy over the others was irresistible, and that the ardour of his convictions overcame them to such an extent as to impose his frequently despotic will upon them. There was, for example, the famous scene between Gauguin and Séguin, in which the master threatened the disciple with his pistol for persisting in using his colours mixed instead of pure. According to Séguin, who told the story, the threat scared him so much that he thereupon began painting with colours straight from the tube.

Bernard was then twenty; with his weak constitution, intellectual forehead and delicate manners, and his gifts as a poet, he was also, until the arrival of the scholarly Sérusier, the most intelligent and cultivated member of the group; an artist whose exuberant imagination overflowed with ideas, all of them new – too many ideas perhaps; they came out in such profusion that he could never concentrate long on any single one of them and cultivate it until it made him certain how he wanted to paint. And indeed, if we compare his various canvases of this period we can see him continually turning from one stylistic exercise to another.

On the other hand, Gauguin, twenty years his senior, athletic in stature and possessed of unusual physical strength, was intolerant in his convictions, egocentric, fond of surrounding himself with other artists, an indefatigable educator who could not do without an audience; he was born to dominate his fellows.

Bernard's thinking certainly had a catalytic effect on others, his manners were affable and he was a charming and sweet-natured companion; but he was universally regarded as 'little Bernard', a boy of great promise – not as a man with the ability to convert others to his faith. Where Gauguin was concerned, the sight of the *Breton Women in Green Meadow*, in Bernard's studio, was the spark that lit the powder-train. Robert Goldwater describes what occurred as 'a short circuit'.[20] Gauguin, surely, was already in a state, artistically speaking, very close to that expressed by Bernard in this canvas. Untroubled by scruples, as ever, he painted a picture which appeared to be directly inspired by the one he had just seen; but in his hands, under the shaping power of his imagination, the thing acquired the breadth and scope of a force of nature. He had found what he was looking for and had perhaps already assimilated long before. Nor did he jealously hug his discovery to himself; on the contrary, he immediately provided theoretical foundations for it and strove to explain them to his entourage. Better still, he tried to convert his 'pupils' to his theory, seizing their brushes and correcting their painting. He had conceived the theory long before, but had never been able to translate it into terms of actual painting; he now applied himself to it in a frenzy of renewed energy.[21]

There was no question of either remorse or gratitude to-

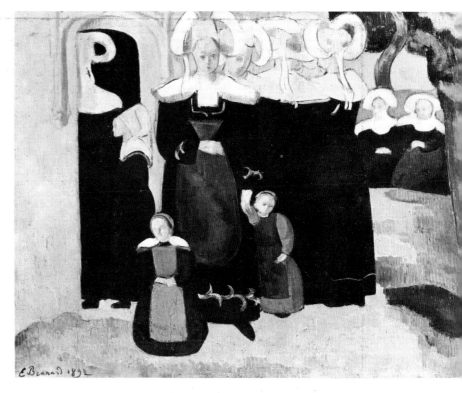

ÉMILE BERNARD *Breton Women Going to Church* 1892

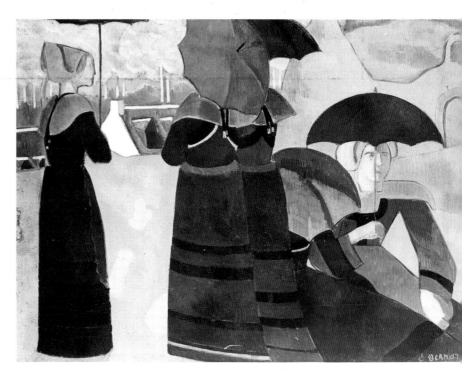

ÉMILE BERNARD *Breton Women with Umbrellas* 1892

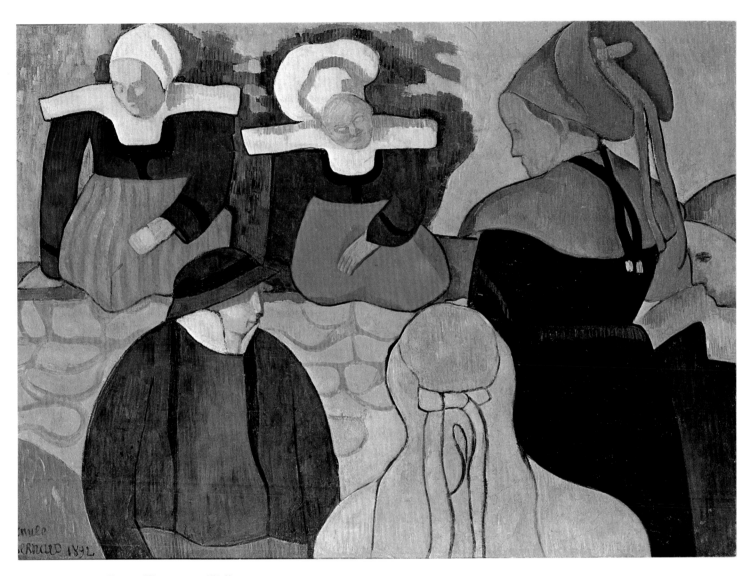

ÉMILE BERNARD *Breton Women on a Wall* 1892

wards Bernard; such emotions had no place in Gauguin's character. On Henri de Régnier, who met him at Mallarmé's house, he made an 'impression of strength and brutality'. In a different context, Charles Chassé observed in Gauguin 'a great avidity for sensations. But on the emotional side, poverty. The basis of his character was a fierce egoism, the egoism of the genius who regards the whole world as a prey dedicated to the glorification of his power, the raw material of his own creations. No charity, no pity, no affection or tenderness, no altruism.'

ÉMILE BERNARD *Landscape* 1889

ÉMILE BERNARD *Breton Women Putting out their Washing, Pont-Aven* 1888

While rendering justice to Bernard for having invented a new vision of reality and discovered the plastic forms in which to embody it, we must allot to both artists the credit for having expressed that vision in a 'style' and a specific 'manner'. But if we are to speak of the definitive formation of this revolutionary movement, and its subsequent expansion, we must attribute both of these to Gauguin; they were his achievement, and his alone. His first audience, a handful of artists, was no doubt more or less a chance assembly; still, they believed in him, were attracted by his personality and called him *maître*. As for the name 'Pont-Aven School', which was adopted later and has been the centre of so much controversy, it certainly was not stuck on from the outside, like a label. It expressed an indestructible collective solidarity; it implied membership of the group and subordination to the 'master'; and in due course it was to stand for the affection in which his memory was held after his death. His title as *chef d'école* is really beyond question. It can of course be argued that, at this rate, the grounds for promoting him to such a position are psychological only. Even so, they are not to be disdained; and the following pages will present historical arguments to reinforce them.

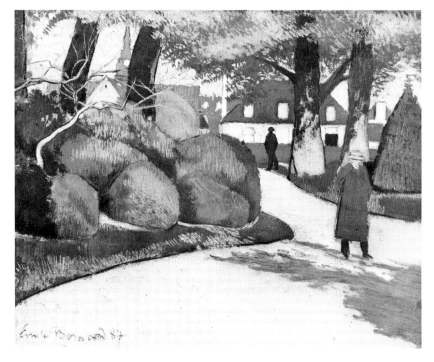

ÉMILE BERNARD *Public Square in Brittany* 1887

II THE FIRST BROTHERS-IN-ARMS

Charles Laval 1862–94

Make friends with Laval, a fine, noble nature, in spite of glaring faults.
Gauguin to Emile Bernard

It has been necessary to anticipate a little in order to place the conflict between Bernard and Gauguin in its setting, and to highlight its main incidents. I shall be returning to that conflict more than once; meanwhile, in our search for the origins of the Pont-Aven group as a whole, we must see what the Pension Gloanec was like in 1888.

Materials for the history of this period are scarce, as we saw in the Introduction; moreover, continual arrivals and departures caused the number of the Pension's guests to fluctuate, so that it is hard to be sure whether, at a given time, such and such a painter was an adherent of the group or not; opinions on the matter vary accordingly from one historian to another. Fortunately, the problem has now been simplified by unexpected help in the form of an unpublished manuscript by Dr Léon Palaux, who died a few years ago. A physician of Breton extraction, Dr Palaux maintained, alongside his professional activities, a lively interest in regional affairs. Throughout his life he devoted his leisure to writing the history of the commune of Clohars-Carnoët, in Finistère, where he lived. He collected a large quantity of information, made a detailed card-index and wrote with his own hand the first draft of a lengthy work; a serious illness, ending in his death, prevented him from completing his task.

One chapter in his projected book was to be devoted to the prominent characters, the writers, painters and poets, who at one time or another stayed in the commune of Clohars-Carnoët. He began by visiting inns, hotels and *pensions* (the three words were synonymous in his day) and combing through their registers. These yielded not only the guests' names but their regular places of residence and the dates of their arrival and departure. This information, supplemented by details from the records of the local mayor's office, where all visitors were officially required to register, enabled Dr Palaux to draw up an extremely valuable 'topography' showing that, from the mid-nineteenth century onwards, many notable people had been in the district.

Since Clohars-Carnoët is adjacent to Concarneau, Le Pouldu, Doëlan and Moëlan, Dr Palaux's manuscript also records the movements of the artists with whom we are concerned, and their changes of address. I shall refer to the manuscript from time to time to keep track of these.[22]

In his chapter on 'Some illustrious visitors to Le Pouldu', Dr Palaux writes: 'In March 1888 he [Gauguin] and his inseparable companion, Charles Laval, once more settled in Pont-Aven at the inn of Mère Gloanec. The friends he made among the men staying there included Henry Moret, Ernest de Chamaillard, Maxime Maufra, Jourdan, Loiseau, Delavallée, Granchi-Taylor, O'Conor and others, all of them revolutionaries, regarded as being beyond the pale because they represented Impressionism, the academic painters' bugbear. They therefore took their meals apart, in a small separate room, and avoided their orthodox colleagues' company.'

It is thus clear that Gauguin already had an audience; he stayed at Pont-Aven until October, and the group, which he liked to call 'the gang' (*la bande*), grew continually during that time. Meanwhile, however, the words 'we three', which were always on his lips, meant himself, with Bernard and Laval.

'His inseparable Laval' was one of the most mysterious characters in Gauguin's entourage. Laval's self-portrait, in the Musée national d'Art moderne in Paris, shows us a meditative brow over an emaciated face which is entirely surrounded with a dark beard; black protuberant eyes whose brilliance is dimmed by pince-nez, denoting short sight; and a calm expression, mingled perhaps with astonishment caused by seeing his own face in the mirror. One feels that, so far from trying to idealize himself, the painter has striven to perpetuate in this portrait the image of a man who thinks and suffers. This somewhat sickly young intellectual lacks self-confidence; he is susceptible, delicate and irritable. His lips, which are too red, and patches of red on the cheeks, indicate lung-trouble. In another picture, *Self-portrait with Landscape*, dedicated to Van Gogh, the features are yet more heavily marked by suffering and even display certain symptoms of psychopathology.

Directly he made the acquaintance of Gauguin, Laval fell deeply under his influence, both personally and artistically; they had been inseparable since their first meeting at Pont-Aven in 1886. It was during this period that Gauguin painted

the curious portrait of Laval, in which the model is gazing at a table with fruit arranged on it in the manner of a still-life. Only part of the profile is visible.

A year later, Laval was Gauguin's companion in the hardships and adventures of their journey to Panama and to Martinique, where he fell dangerously ill with yellow fever. At a crisis of his illness he tried to take his own life but was prevented by Gauguin, who was himself suffering from dysentery and malaria at the time.

What did Gauguin think of Laval as a painter? At the time of their departure for the tropics his opinion was rather a surprising one. On reaching Panama after a trying voyage the two friends found that, contrary to what they had been told in Paris, the cost of living was high and that the money they had saved would not last long. They therefore decided to take jobs, so as to earn a little money and be able to move to Martinique, where living was cheaper and the landscape more interesting. Gauguin wrote to his wife in May 1887 that on the next day he was about to start work as a navvy helping to dig the canal, for which he would be paid 150 piastres a month. The letter continues: 'It's different for Laval, he can earn plenty of money for a while by painting portraits; they fetch good prices here, 500 Frs a time and as often as you like (there's no competition), but they have to be done in a special way, they must be very *bad*, and I can't do it. Don't complain of having to work. Here, I have to dig *from 5.30 in the morning to 6 o'clock at night,* under a tropical sun, with rain every day thrown in. At night we are devoured by the mosquitoes.'

It is not clear whether Gauguin was joking at Laval's expense or whether he was jealous of him. Was Gauguin simply unwilling to paint a traditional portrait to order; or was it beyond his capacity to conform to the 'special' taste of local patrons, who preferred the brush of Laval, an experienced pupil of Bonnat, to that of an unknown Impressionist of the school of Pissarro? The riddle will doubtless remain unsolved.[23] Two facts stand out, however: the first is that Gauguin was later, on more than one occasion, to poke a little fun at his friend Laval's painting; and the second, that portraiture was always to be Laval's strong point, the form in which he would express himself with the greatest originality and freedom.

Bernard sums up Laval as a painter in the following terms: 'He had painted several portraits in a dark, gloomy style, enlightened by the delicate subtlety of his nature; after that, under the influence of Gauguin and following him blindly as his pupil, he had come back from Martinique with some sumptuous landscapes which could well have been mistaken for those of his master. In the figures he never rose to the level of Gauguin's style; studio training had left him with a narrow sincerity which chained him to a literal rendering of the model. He was tuberculous and worked little, locked in the struggle to overcome his early scruples. His technique was constrained and his colour shimmering. Less carried away than Gauguin and myself by the search for new paths, he tried to weigh up the survival-value of these, and wondered where we were going. He was paralysed by his own prudence.'[24]

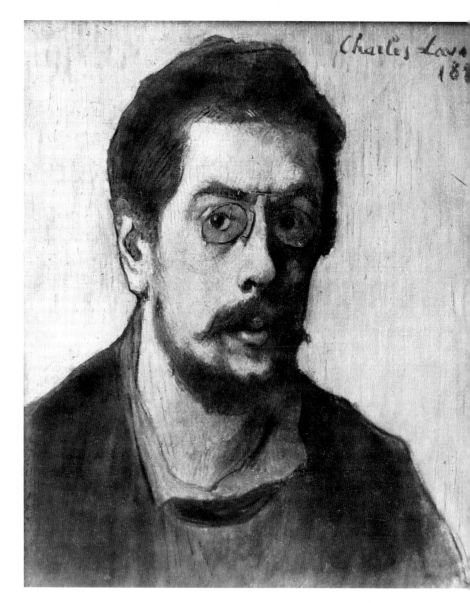

CHARLES LAVAL *Self-portrait* 1889

44

That Laval's output was small is confirmed from other sources, but it is not of great importance to decide whether the cause was laziness or ill-health. What matters is what Bernard implies, namely that Laval painted in two dissimilar *genres*: the pictures constructed in accordance with a programme which was decidedly his own, while also showing traces of the teaching of Bonnat; and those which he painted under the 'dazzling' influence, and in the presence, of Gauguin. According to Bernard, Laval painted exactly like Gauguin, who enjoined him to stop doing so and to save him from the temptation of putting his own signature on Laval's canvases.

The few pictures by Laval which have been rescued from oblivion include the two self-portraits already mentioned, a portrait of his brother and, from his New World phase, a *Landscape in Martinique* (1887), *Bathers* (1888) and another *Landscape*; the latter recalls Martinique from the point of view of style, but its subject suggests Brittany; a possible dating is 1888. Very recently I was fortunate enough to be able to complete this interesting ensemble with a previously unknown watercolour, rather larger than most pictures of its kind and definitely assignable to his Breton period. Painted in his Martinique manner, in a near-Divisionist style – the colouring and drawing are of rare beauty – it represents two *Breton Girls Lying Down*, resting on the straw at high noon in harvest-time.

Although the colour is laid on in a host of touches like commas, this picture is a perfect example of Laval's very personal interpretation of Syntheticism, and would appear to contradict the opinion of Bernard, who was to write in 1903: 'Laval produced little, and always closely followed Gauguin. His work is the least personal of anyone's.'

The *Self-portrait with Landscape*, dedicated to Van Gogh, to which reference has already been made, displays a certain pliability, as if the artist were wavering between his two manners. It is conceived in the form of a diptych; the left-hand panel contains a landscape seen through a window and painted in a style borrowed from the Gauguin of the interlude in Martinique, whereas the portrait, on the right, is in some sort an amalgam of the technical devices of the Impressionists, which were a complete novelty to Laval; it is full of bold discoveries, such as the light blue of the hair and beard contrasting with the almost vermilion tints of the face, the latter being treated traditionally, psychologically, in accordance with established practice (*les vieilles accoutumances*, as Bernard called them).

Even after allowing for Laval's poor state of health, the shortness of his life, his natural indolence, and the extent to which his painting was, so to speak, fused with that of Gauguin, we may well wonder whether the true cause of his producing so little was perhaps the internal ravages of indecision to which this sensitive, intelligent artist was prone.

Gauguin's comradeship with Laval, as with his other friends, was capricious and changeable. In his letter to Bernard from Arles, Gauguin wrote: 'Greetings to both of you, and make friends with Laval, a fine, noble nature, in spite of glaring faults – the times when the Cossack in him comes to the top.

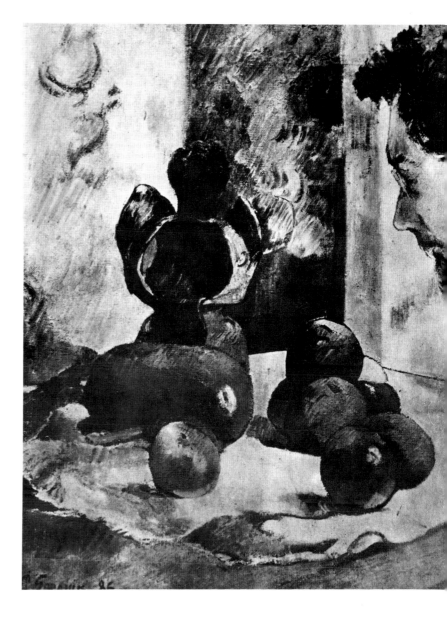

PAUL GAUGUIN *Still-life with Profile of Laval* 1886 45

You know we've all got our Cossacks, you've got some terrible ones yourself. We've all got to learn to put up with them so that we can all help each other.'

In the following year we find him writing again to Bernard to accuse Laval of being ungrateful and disloyal. Planning further travels, he refuses to go through 'the same experience' with Laval; he knows what it cost him last time. To top it all, he goes on, Laval thinks he has nothing to reproach himself for and is not far from making out that all the self-sacrifice was on his own side. But Gauguin asks Bernard not to mention it to Laval; he himself cares nothing for people's gratitude and in any case dislikes the 'tattle, uproar, etc.... which arise from misunderstandings'.[25]

It is not impossible that the cause of the breach between Gauguin and Laval was Bernard's sister Madeleine, who in the summer of 1888 came with her mother to Pont-Aven to spend the holiday period near her brother. Bernard introduced her into the circle of his painter friends. Long walks in the picturesque environs of Pont-Aven, with the added pleasure of lively conversation, were the order of the day. Madeleine was seventeen, pretty, high-spirited and highly strung, well brought up and excellently educated. Her brother had initiated her into the problems of art in which he and his friends were so passionately engrossed.

Gauguin – usually far from sinning by an excess of tact or courtesy towards the opposite sex – contracted for the girl a singular affection, which he declared was of an entirely brotherly nature. His letters to Madeleine abound with expressions of tenderness and disinterested fondness which are entirely absent from the rest of his correspondence, with the possible exception of the *Cahier pour Aline*, written for his much-loved daughter. He was full of respectful regard for Madeleine, and tried hard to convince her of it. He painted her portrait, following it with a picture which was intended to hang in the inn and which he insisted on signing with Madeleine's name instead of his own.[26]

Later, from Arles, he wrote to Bernard asking him to pick up from Theo van Gogh, at Goupil's gallery, a little vase he had made – it was decorated with a bird on a blue-green ground – and offer it to Madeleine as a present. 'I hope that from time to time, when she puts a flower in it, she will think of her big brother. It's a savage, primitive thing, that pot, but it expresses more of me than the drawing of the little girls [which he had sold to Theo]. And it's cold, too, and yet it stood up to a temperature of 1,600 degrees! A careful look at it might disclose, as in its creator, a little of that ardour.'

When, in November 1889, Madeleine sent him a note, Gauguin, writing his answer on the back of a letter to Bernard, assured her of his friendly and affectionate feelings. To seal their 'pact of fraternity' he offered her a vase representing 'a head of Gauguin the savage' and asked her to accept the gift as a modest token of his gratitude for the pleasure her letter had afforded him in the solitude of Le Pouldu.[27]

It can hardly be doubted that Gauguin was in love with Madeleine. In all likelihood it was the only time he was in love in his life, or as nearly so as was possible for a man of his nature. But what had he to offer to this ethereal creature, this seventeen-year-old *gamine*? He was forty, a married man and the father of five children; he lived from hand to mouth and was sometimes unable to pay for his meals at the inn. In compensation, he filled his head with far-fetched ideas and prospects of exotic travels which were to ensure the fulfilment of his artistic dreams.

Madeleine had made an equally strong impression on Laval, and Gauguin did not fail to notice this, knowing, as he must have done, that Laval stood a much better chance. A bachelor, gentle, appealing, and fourteen years younger than the violent, passionate Gauguin, he was better suited to please an imaginative young girl. Despairing of success, Gauguin adopted the attitude of an elder brother and, in the same letter from Arles, urged Madeleine not to lower her pride by yielding to any inclination towards earthly passions but to 'raise an altar to her dignity and intelligence and reject any other kind of feeling'. She must keep herself independent but yet not hesitate, should the need arise, to appeal to 'us' with a cry of 'Brother, let me lean on you!' – 'And we artists also need you to defend and help us.... So it would be one good deed for another, an exchange of two different kinds of strength.'

The letter was intercepted by Madeleine's father. Scandalized and wholly uncomprehending, he abruptly forebade Gauguin to correspond further with his daughter. Meanwhile Madeleine had become engaged to Laval, the very man to whom Gauguin had extended a welcome and given his teaching, and whom he had saved from death. The sequel, as is well known, was that Laval, whose pulmonary tuberculosis was steadily getting worse, set off for Egypt; Madeleine travelled out to him, looked after him and, presumably when he was dying, married him. 'From pity rather than love', was her brother's subsequent comment. A year later she was dead herself; tuberculosis was incurable at that time and she had contracted it by contact.

The whole of this sequence of events was regarded by Gauguin as so much treachery on the part of Laval, and he never forgave him. Two years after Laval's death he wrote to Monfreid: 'Well, when I examine my conscience I find nothing. I've never done wrong to anyone, even an enemy; on the contrary, at the most difficult moments in my life I have shared resources equally, and more than equally, with those in need, and never had any reward but to be dropped completely. I saved Laval from suicide and gave him more than half of what I possessed. Both with money and with introductions and recommendations I helped Bernard, Morice and Leclercq. You know what came of it.'

All the pictures left by Laval were sold at auction by his brother Nino in 1894. It is even thought that some of the canvases from Martinique and the first Pont-Aven period, in other words from the time when 'Laval painted exactly like Gauguin', have been provided with faked signatures, attributed to Gauguin and put on the market as being by him. If we

CHARLES LAVAL *Women Bathing* 1888

compare the *Bathers* painted in 1888 by Laval, and the *Woman and Haycock* by Gauguin, this possibility becomes only too plausible.

Summing up, it is fair to say that Laval's search for new paths never progressed beyond the Martinique and Brittany style of Gauguin, which can be described as a transition-stage between Impressionism and a different, decorative style which was *sui generis*.

47

Claude-Emile Schuffenecker 1851–1934

Poor devil that I am, slaving away minutely at one small canvas for months on end! Schuffenecker to Gauguin

In addition to those artists of the Pont-Aven group, such as Laval, who spent some time living in Brittany and became intimate friends of Gauguin, there were others who, although closely linked with the master and the members of the group, collaborated from a distance, for extraneous reasons of one kind or another. This category includes Claude-Emile Schuffenecker, who could not give up his job in Paris and made only sporadic appearances in Brittany, on holiday. We have no information to show that Schuffenecker ever stayed at the Pension Gloanec or at that of Marie Henry at Le Pouldu, where the group was based at one point in its history. But we do know that Schuffenecker's first stay in Brittany took place in 1886, the year when, at Pont-Aven, Bernard and Gauguin met for the first time. Schuffenecker was staying elsewhere, probably at Concarneau, which was near enough to enable him to keep in frequent and perhaps daily communication with his colleagues at Pont-Aven. This deliberate self-effacement certainly matches the psychological picture we gain of this artist from his correspondence and his portraits: a kindly, modest little man with a generous heart; 'good old Schuff', the ever-reliable.

Schuffenecker was already a friend of Gauguin's at the time when they were both working for the firm of Bertin, and it appears to have been he who, by his own example, first awakened Gauguin's interest in art, giving him his first lessons in drawing and in managing and mixing his colours, and bringing him to Pissarro's studio. At first the revelation of Gauguin's talent was something of a shock to Schuffenecker; such gifts, unfolding before his eyes, dazzled him. There was an immediate exchange of roles: Gauguin became the master and Schuffenecker his admirer, confidant and protector. The abundant correspondence between the two artists over the years, from which only the letters of Gauguin have survived, constitutes at once a chronicle of the group of Pont-Aven and an intimate journal of the life of Gauguin.

After leaving the firm of Bertin, Schuffenecker, like Gauguin, devoted himself to painting, but also became drawing master

ÉMILE BERNARD *Emile Schuffenecker* 1896

at the Lycée de Vanves, later known as the Lycée Michelet. His reputation as an 'Impressionist' and a theosophist quickly

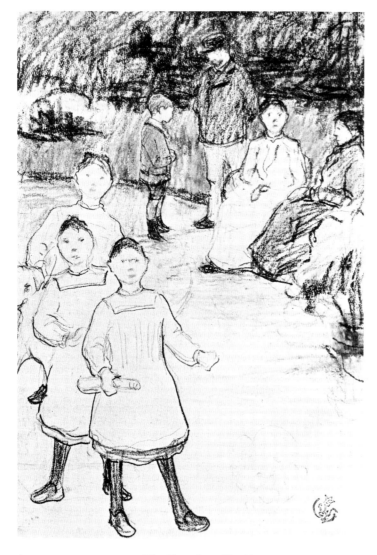

ÉMILE SCHUFFENECKER *The Fontaliran Family c.* 1890

from its owners' hospitality. He felt at home in Schuffenecker's company, to the extent of occasionally abusing his generosity both material and moral. It appears that as a painter he did not think much of Schuffenecker, a hardened Impressionist; moreover the fact that Schuffenecker, despite his admiration for Gauguin, showed little inclination to follow him in his stylistic experiments, was peculiarly exasperating to him.

Schuffenecker's painting, indeed, owed little to the new style. Prominent among his known works are portraits of women, executed with much taste and craftsmanship but conceived in a realistic, traditional manner whose appeal is heightened by a delicate harmony of colour. His *Portrait of a Woman in a Pink Dress*, in the Musée d'Art moderne, Paris, is an example. The same refined use of colour characterizes his landscapes, in which a decided tendency towards Impressionism can already be seen. Charles Morice describes Schuffenecker as a 'decorative Impressionist'. According to Edmond Campagnac, his landscapes present a silence which 'seems to sing' and the conjunction of 'the vague and the precise'. However, if one had to pick out the influences exerted on him by his contemporaries, one would think not of Gauguin but rather of Degas and Redon. Schuffenecker was moreover the first person to buy a canvas by Redon, of whom he also

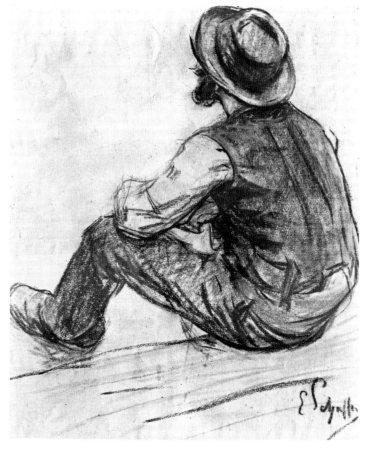

had his pupils sitting at his feet. What was more, he used to talk to them about literary things, particularly poetry, and introduce them to the complexities of Buddhist doctrine. One of them, E. Deverin, was to write: 'As for me, who knew him in days gone by at the Lycée Michelet, where he was drawing master for many years, I still have a stirring and appreciative memory of that little man with gleaming eyes, an energetic enthusiast who introduced us to the poetry of Rimbaud, Corbière and Mallarmé and revealed to our sixteen-year-old eyes those misunderstood and much criticized painters, Cézanne, Gauguin, Van Gogh and Odilon Redon.'

The Schuffeneckers' house in Paris, in the rue Boulard, though simple and modest, was always open to friends and artists in need. As time went on, it became a kind of Parisian sub-branch of the school of Pont-Aven, especially during the periods when Gauguin was particularly hard up and benefiting

ÉMILE SCHUFFENECKER *Seated Man*

the gentle modelling of the body and the hair, though without foregoing certain striking effects of chiaroscuro. The same type of interpretation is also to be found in the work of other members of the Pont-Aven group.

It could well be that this canvas was the one involved in the scene which took place between Schuffenecker and his former teacher, the painter Baudry, that 'illustrious official', on whom the young Impressionist called secretly in the hope of obtaining some enlightened expert advice. According to Campagnac, 'Schuffenecker one day put before the painter a small study of the nude. It was the bust of a young girl with red hair, seen from behind, with the head turned in profile and standing out on a dark background. This little canvas, painted in a fairly broad style, exhibited a broken tonality slightly reminiscent of Degas. Baudry, after examining it at length, said with surprise, "Did *you* paint this?" And on receiving an affirmative reply: "I can only congratulate you. But I'm astounded by one thing: how were you able, in so short a time, to transform your technical ability to such an extent and make such rapid progress?" Schuffenecker, with more sincerity than the occasion called for, answered, "Well, I took my cue from the Impressionists." Baudry turned pale, glanced at his pupil for a second, and held out the canvas: "Since the Impressionists are your masters you no longer need any advice from me." This was a full-dress dismissal. Schuffenecker left, with the comfortable certainty of having astonished the copyist of Michelangelo.'

A different tendency is manifested in Schuffenecker's *Portrait of Emile Bernard's Mother*, where the treatment is decorative and the style closer to that of the later Nabis than to that of Pont-Aven. The picture shows a woman with brown hair, the figure being integrated with the ornamental background of flowers and leaves that surrounds her.

Schuffenecker regarded Gauguin as the work of his own hand, his own achievement. He was afraid of him, he was hurt by his monstrous ingratitude, but he always forgave him and was consistently the good Samaritan, never withholding help. Although he was three years younger than Gauguin he had a truly paternal love for this ungrateful child of genius, the kind of child whom you always forgive because you know that he is fated not to be happy but to suffer.

When Gauguin sent Theo van Gogh his first canvases from Arles, Schuffenecker wrote to his friend, on 11 December 1888: 'On Saturday I went with my wife to Goupil's place to see your new pictures. I'm bowled over with enthusiasm. They're even better than the batch you sent from Brittany; more abstract and more powerful. And what leaves me flabbergasted is your fertility, the size of your output. Poor devil that I am, slaving away minutely at one small canvas for months on end! Everyone does what he can, of course; but, my dear Gauguin, I wonder just how far you will go? The more I think about it, looking at your work, the more convinced I am that you'll beat them all hollow (your comrades, I mean), with the exception of Degas. He's a colossus, but you're a giant; and you know the giants scaled the heavens. You pile Ossa on Pelion to reach the heavens of painting. You won't reach them,

ÉMILE SCHUFFENECKER *Self-portrait c.* 1890

executed a 'gentle, dreamy' portrait for the review *Hommes d'Aujourd'hui*, whereas the one he did of Gauguin was felt to show 'the artist aflame'.[28]

A further link between Schuffenecker and Redon was their love of music, or, more exactly, the question of musicality in painting; the reference is to Delacroix and to the famous *De la musique avant toute chose* of Verlaine. Nevertheless, the exhibition of paintings by Schuffenecker at the Hirschl and Adler Gallery, New York, in 1958, and, still more, of his pastels and drawings at the Galerie Les Deux-Iles, Paris, in 1963, were stamped mainly by the style of Degas, a painter he admired enormously.

One picture by Schuffenecker that stands out in the memory is an interesting oil study of a nude seen from behind (Musée national d'Art moderne, Paris). Though the background is executed in a single colour and the outline has been slightly emphasized, notably in the girl's profile, the artist has retained

PAUL GAUGUIN *Madame Schuffenecker (ceramic vase)*

ÉMILE SCHUFFENECKER *Nude Study from the Back*

because they're the Absolute, they're God; but you'll be shaking hands with the men who have come closest to it. Yes, my dear Gauguin, what is in store for you is not just success in art, but glory by the side of Rembrandt and Delacroix and the others. And you will have suffered as they did. I do hope at least that material deprivations, money-troubles, will now be removed from you.'

It is quite astonishing to see how successfully Schuffenecker, living in the shadow of this giant, kept his own originality intact. None of his pictures shows any direct influence from Gauguin. He by no means fell under his friend's sway; despite his admiration for Gauguin's work he was somewhat circumspect in his appreciation. At the time when Gauguin was abandoning Impressionism and seeking a new path in

Syntheticism, Schuffenecker wrote to tell him what he thought of his new efforts. The letter has been lost, but Gauguin's reply (16 October 1888) is a violent, prophetic outpouring devoted entirely to justifying himself: 'Why do you talk to me of my *terrible* mysticism? Be an Impressionist to the end and don't be scared of anything! Obviously this path called Syntheticism is full of pitfalls, and as yet I've only advanced an inch along it, but at bottom it's something which is in my nature and one must always follow one's temperament. I'm well aware that I shall be understood *less and less*. What does it matter if I've moved away from the others, to the general mass of people I shall be a riddle, to a few others I shall be a poet, and sooner or later good work will always find its own level.'

Schuffenecker must have warned Gauguin against Synthe-

ÉMILE SCHUFFENECKER *Emile Bernard's Mother*

ÉMILE SCHUFFENECKER *Madame Fontaliran c.* 1890

ticism more than once; he nevertheless figured, in the company of Bernard and of Gauguin himself, in a satirical drawing which one of them made and which is now in the Louvre, entitled *A Nightmare*. The three, seen from the waist upward, are standing together, turned three-quarters of the way towards the spectator. In the background a figure representing the conventional 'long-haired artist' is hunched over his palette, with his brushes sticking out of the thumb-hole. At the top, in capitals, is the word SYNTHÉTISME. Each of the three foreground figures, is labelled with his name, and the title, *Un Cauchemar*, is at the bottom. The drawing would seem to have been made at a time when neither Gauguin nor his friends were taking the term 'Syntheticism' any too seriously.

Another aspect of the worthy Schuff appears in a portrait painted by Bernard in 1888 at Pont-Aven, in which the subject is seen in profile at a window. Immersed in his own thoughts, he is contemplating a Breton landscape as visualized by Bernard (whose characteristic style is very recognizable here). It is tempting to conclude that the picture is intended to evoke the artists' work in common and the long discussions on symbolism in painting which went on among them in the summer of 1888 at Pont-Aven.

The celebrated portrait by Gauguin of the Schuffenecker family, which has been so often reproduced, was painted in the following year. On no other occasion did Gauguin paint a picture of this kind, in which he seems to show a tendency towards psychology, whereas his later compositions, those of the Tahiti period, are organized primarily from a decorative

53

ÉMILE SCHUFFENECKER
Cliffs at Etretat 1888

ÉMILE BERNARD
Mme Schuffenecker at Home 1888

PAUL GAUGUIN
The Schuffenecker Family 1889

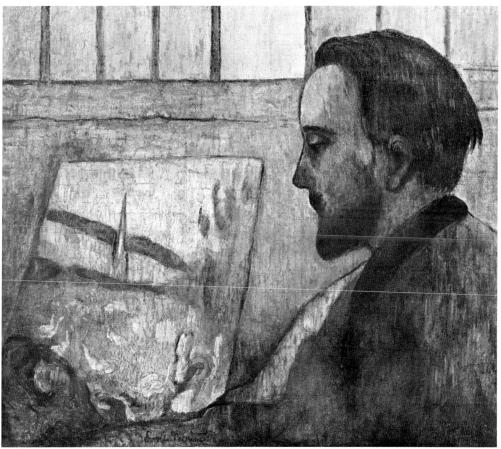

ÉMILE BERNARD
Emile Schuffenecker at Pont-Aven

55

ÉMILE SCHUFFENECKER *Small Boy c.* 1890

who not only did not return his kindness but, according to one tradition, actually destroyed the simple, peaceful happiness of his home. If we were to trust this legend we would have to re-title the picture *A Family's Happiness Destroyed*.

The fact is that, about 1889, relations between the two artists were deteriorating. In August 1890 Gauguin told Bernard that he had a boring letter from 'poor Schuff' and that, taken all round, Schuff displayed 'a fearful banality'.

John Rewald, in his book *Post-Impressionism*, prints an unpublished letter from Schuffenecker to Gauguin, written shortly before the latter's departure for Tahiti; it shows that the 'kindly and commonplace Schuff' was capable when necessary of taking a firm stand with his friend, even to the point of forbidding him the house, although at the same time he was still doing all he could to smooth his path: 'My dear Gauguin, my wife tells me you propose to call tomorrow. As I shall have to be out I am warning you now, so as to spare you a fruitless journey in the event of your having it in mind to clear matters up between us. Neither as men nor as artists are we constituted to get on with each other. I have known this for a long time and what has just happened proves me right. I have decided to stand alone; everything, my inclinations and my own best interest, urges me that way. I say this completely without animosity or combativeness – we're temperamentally incompatible, that's all – so at least we can part in a spirit of mutual respect. And now, my dear Gauguin, I must repeat the last paragraph of my previous letter, about your canvases, pottery and the other things you have left at my house. I am very anxious to avoid any of this causing you the slightest bother or inconvenience just now, when, as I imagine, you've got quite enough to worry about over your sale and your plans for departure. So I shake you cordially by the hand and remain, Your devoted E. Schuffenecker.'

Gauguin became increasingly resentful of the friendship which grew up after his departure between his own wife Mette and Schuffenecker, and also of the solicitude which the latter displayed towards the deserted family. Eventually Schuffenecker even assumed the ungrateful role of mediator between husband and wife, geography notwithstanding, and his allusions to 'poor Mme Gauguin' never failed to bring Gauguin's vituperations on his head. Gauguin even sought revenge. In his letter of October 1902, to Georges Daniel de Monfreid, he wrote, 'In this article I have mentioned a few names, but not his. You'll hear him complaining bitterly about it one of these days. The reason for my not mentioning him is that my conscience won't let me consider him as an artist of any worth at all; he's never put brush to canvas without thinking of making money and satisfying his vanity.'

As on previous occasions, the accusation was grotesquely untrue; and, as on previous occasions, Schuffenecker's reaction was to do his best to put his friend's tangled affairs in order. When, not long before Schuffenecker's death, Charles Kunstler came and interviewed him and mentioned Gauguin in passing, 'good old Schuff' had nothing worse to say of him than 'Yes, he wasn't easy to get on with.'[29]

point of view. The family is shown in the artist's studio in Paris. In the foreground is the full-length figure of Mme Schuffenecker, thoughtful and paying no attention to what is going on about her. Her two children are huddled against her; the little boy has fallen asleep with his head on his sister's knees. In the background the father, turning away from his easel and clasping his hands together helplessly, is gazing at his family with tender solicitude. Treated somewhat in the manner of the Douanier Rousseau, the man is immediately recognizable as 'good old Schuff' – nobody else could look just like that. His silhouette is so faithfully rendered that it explains at once everything we know about him: we understand why he was called 'good old Schuff' and 'poor Schuff', and why he let himself be exploited for years by his great friend

III A PROGRAMME TAKES SHAPE

Van Gogh and the School of Pont-Aven

We were two different people; he was completely volcanic and I was by nature always on the boil, and somehow, under the surface, a conflict was developing. Gauguin on Van Gogh

Van Gogh played a special part in the story of Pont-Aven. Though he never belonged to the School he was influenced by it for a time; and it was influenced by him, through his somewhat Utopian ideas for a 'Studio of the South', which he proposed setting up as a counterpart to the 'Studio of the North', the *atelier du Nord*, as he called the group in Brittany.

After settling at Arles in February 1888, Van Gogh was excited to discover the landscape of the south of France. His choice had been influenced by reading Zola and Daudet, and his hopes were not disappointed. The painter of the gloomy coalfield of Borinage, who was familiar also with England, Belgium and Paris, was literally enchanted by the south and its flood of light and warmth. He found in it a resemblance to the sunny landscapes in Japanese prints, whose charm always captivated him.

As if in a fever, he spent whole days painting in the open air. But for the overwhelming loneliness which drove him from hotel to hotel, he would have been perfectly happy. Another anxiety gnawing at him was that he could not sell his canvases and was dependent on his brother Theo, without any visible prospect of being able to manifest his gratitude.

Torn by these conflicting feelings, he conceived the curious idea of founding a guild of artists with a communal house and studio. The intention was to gather together a certain number of advanced painters and help them, mainly on the material level, but also to assist their artistic pioneering through the medium of discussion and the experience of working together. Enchanted by the landscape of the Midi, he wanted the association to have its headquarters at Arles and was prepared to take on the job of starting it up himself. He was counting on his brother, the 'merchant apostle', so devoted to the cause of the Impressionists, to look after the administrative side, such as the sale of pictures and the payment of a monthly sum to each painter in return for pictures delivered. Naturally, the first man whose support he was anxious to win was Gauguin.

The moving historical document provided by Vincent's letters to his brother and friends reflects his burning impatience to realize this plan for a collective studio. His usual nervous tension was heightened by a sense of being alone, with only himself to rely on, whereas Gauguin in Pont-Aven was surrounded by comrades, a group of painters working in concert and resisting adversity side by side. Attentively, and not without envy, he watched their activities from a distance. He kept himself constantly in touch with his friends Gauguin and Bernard, and also with painters whom he had not met, such as Laval, Moret and Chamaillard. He would have liked to join them.

In his letters to Theo, who on his side communicated his own thoughts and views, he put down all he knew of his colleagues in Brittany, telling of their work, the atmosphere among them, their plans and their disagreements; the correspondence thus became a mirror, a supplementary chronicle of the doings of the Pont-Aven group, providing many facts and details which more direct sources leave unmentioned.

Reading these letters, one gets the impression that Van Gogh's ideas about setting up an association of painters were clearer and more definite than those of Gauguin. He kept developing and adding to them, and while some of them are naive, even Utopian, we are forced to concede the reality of the artistic intentions which they reflect, and the care with which his practical suggestions had been thought out. Surprisingly, this latter aspect predominates in his expositions; the impression given is that Van Gogh was afraid lest he had not adequately conveyed to Theo the 'apostolic role' which he was to play in the association, and that he was making an ingenious attempt to get Theo interested in the business prospects. 'As you know', he wrote in 1888, 'I believe an Impressionist association would be an affair of the same kind as the association of the twelve Pre-Raphaelites in England, and I believe it really could be brought about. You also know that in my view the artists would then guarantee one another a livelihood, independently of the dealers, by agreeing that each would give a substantial number of paintings to the society and that both gains and losses would be shared by all.'

His main concern was for the spirit which would permeate the community and for the strength of the links holding it together; in spite of the differences between them, the artists

59

would remain free, united in their resolution to work out a common programme in the name of a single ideal. 'I am more and more convinced that the pictures which must be painted, if present-day painting is to be truly itself and rise to a level equivalent to that of the peaks of serenity attained by sculpture in Greece, musical composition in Germany and the novel in France, are beyond the powers of an individual working in isolation; so they will probably be created by groups of men combining to execute a shared idea.'

But he was opposed to all rigid preconceptions about the method of realizing the idea, and we find him answering Bernard's proposals as follows: 'The idea of setting up a kind of Masonic Brotherhood of Painters doesn't much appeal to me. I have a deep contempt for regulations, institutions and so on, and anyway I'm looking for something different from dogmas, which, so far from keeping things in order, merely cause endless disputes – a sign of decadence.'

Writing again to Bernard, he set out the theoretical foundations of the future association: 'By "collaboration" I didn't mean that two or more painters should work together on the same pictures. What I had in mind, rather, was divergent works, but connected and complementary. Just think! The Italian Primitives, and the German Primitives, and the Dutch school and the Italians properly so called, in fact the whole of painting! Independently of the painter's will, pictures form a "group" or "series".... In addition, the material difficulties of the painter's life make it desirable for painters to collaborate and unite (just as desirable as it was in the age of the guild of St Luke). By safeguarding the material side and treating one another as good friends instead of cutting one another's throats, painters would be happier and in any case less ridiculous, foolish and culpable' (July 1888).

Confronted by this highly ambitious project, we are better able to appreciate just how accidental were the programme and organization of the Pont-Aven group. Indeed, it can be said that many of Van Gogh's ideas – which, in the outcome, the tragic turn of events did not allow him to realize – were taken up and used by Gauguin and his group. This is not surprising; the 'Studio of the South' was conceived with Gauguin in mind, and was to be set up for his benefit.

Van Gogh had written to Gauguin on the subject for the first time on 6 May 1888, timidly as yet, with only the barest and most tentative outline of his plans. Having heard that Gauguin was living in deep poverty in Brittany and was unable to sell his pictures in Paris, Van Gogh told him that he and his brother Theo were determined to come to his assistance: 'You know my brother and I think a great deal of your painting and that our dearest wish is to see you a bit better off.' The 250 francs a month which Theo was sending Vincent would be shared equally between the two of them. Gauguin would hand over one canvas a month in exchange, and would be free to dispose of the rest of his output as he wished. They would of course set up house together. And they would begin exhibiting in Marseille at once, so as to open an outlet both for themselves and for other 'Impressionists'.

Gauguin accepted Van Gogh's invitation in principle, but persistently delayed his departure on grounds of illness; he was also nervous about the hazards of such a change; nor could he afford to pay off the arrears of his hotel bill or find the money for the train fare. But Vincent had thought of these things. He assured his colleague that he too had been seriously ill when he came to Arles, and that it was by settling there that he had regained his health. As for the hotel bill, he need only leave a certain number of canvases in pledge with the owner, with the option of redeeming them later. Simultaneously he tried to persuade his brother to advance Gauguin the cost of the journey 'at your expense and mine. *It's imperative.*' He rented a summer house in the Place Lamartine at Arles, a fine 'yellow house', a real artist's house, and furnished it as best he could with the last of his money; this was to be the premises of the 'Studio of the South'. Referring to Japanese usage in these matters, he wrote again, this time to Bernard: 'The artists often made exchanges among themselves. Which clearly shows that they got on well together and stood by one another, and that there was a certain harmony between them; that they lived a kind of fraternal, natural life, instead of intriguing against one another. The more closely we imitate their example in this respect, the better it will be for us.'

In September 1888 he wrote again to Gauguin, building up the attractions of working together into a still more seductive mirage: 'I must tell you that even while working I never stop thinking about this venture of founding a studio with you and me as its permanent occupiers, but which we would both like to make available as a refuge for our pals whenever the struggle really gets too much.... With you very much in mind, I've decorated the room which is to be yours with a mural of a poet's garden.... And if I could I'd have painted this garden in such a way as to make people think at once of the old poet of this place (or rather Avignon), Petrarch, and the new poet of this place – Paul Gauguin. However clumsy my attempt, perhaps it'll show you that while getting your studio ready I was thinking of you with a full heart. Let's be full of courage for the success of our undertaking, and mind you go on feeling really at home here, because I do feel that this is something which will go on for a long time.'

It was of course Gauguin whom he envisaged as the head of the studio. Effacing himself with truly evangelic simplicity, he yielded the leading position to the man whom he regarded as having more genius, a man with a vocation to teach and to command. He reduced his own function to that of the organizer; it was Gauguin who was to breathe life into the dwelling. It was on this supposition that he informed Theo of his most recent correspondence and communicated his opinion on the matter: 'Bernard repeats that he wants to come here and on behalf of Laval, Moret and another newcomer and himself has suggested to me that these four should make an exchange [i.e. of pictures]. He also says that Laval will come down here too and that the other two want to come. I ask for nothing better, but since this means several painters living communally there absolutely must be an abbot to keep things in order and

of course that could only be Gauguin. Which is one reason why I would like Gauguin to be here before they are (in any case Bernard and Laval won't come till February, because B. has to go round by Paris to appear before his military service tribunal).... This afternoon I've got to reply to Gauguin and Bernard, and I shall tell them that, whatever happens, we shall start off with the feeling of being completely united, and I for one am confident that this unity will give us strength against every vicissitude of money and health.... But the more Gauguin feels that by joining us he will be putting himself in the position of *chef d'atelier*, the quicker he'll get well again and the keener he'll be to work. And the more complete the studio is and the more solidly established for the good of the many painters who will pass through it, the richer will be the flow of ideas in it and the stronger the ambition to make it a really living thing. Seeing that already, at Pont-Aven, they're talking about nothing else, they'll soon be talking about it in Paris too.... I'm saying this now simply to avoid any argument in future, if things turn out so that Laval and Bernard do come it won't be me but Gauguin who will be *chef d'atelier*. As for internal arrangements, I think we shall always manage to agree.'

As Gauguin continually put off his departure, Van Gogh began to suspect that he was unwilling to leave Laval; he therefore altered his plan to the extent of decreeing that there would be two permanent residents at the studio, the rest being temporary. He let it be understood that Laval also would be welcome to come to Arles, along with Bernard, Moret and Chamaillard. But if comparison showed that living expenses were lower at Pont-Aven than in the south – or if Gauguin was particularly attached to Brittany and its landscape – Vincent would be very ready to join his colleagues at Pont-Aven. 'The very most one can do', he wrote to Theo, 'is for me to abandon the South and my plans and, if it helps him out of his difficulties, go up to him in Brittany. And of course my desire to work in the South takes second place to the interests of a man of that calibre. Still, the change is not one to be undertaken lightly. Well, if I say yet again that it's a matter of total indifference to me whether I settle at Pont-Aven or Arles, I do mean to remain adamant on the necessity of founding a permanent studio, and of sleeping there instead of at some hotel or other.'

Vincent's dream was to be realized only partially, and briefly at that; and, as we know, its end was tragic. Gauguin arrived at Arles on 20 October 1888 and stayed under one roof with him, in the 'yellow house', for two months. The two artists were inseparable, working together, trying to get to know each other better, and continually observing each other. Vincent was delighted that, as a former sailor, Gauguin was not only perfectly at home in housekeeping but was an admirable cook, an accomplishment he himself would have liked to acquire; he regarded it as one of the foundations of freedom and an indispensable protection against the cupidity of hotel keepers. He wrote to his brother on 22 October that 'the house is going fine and isn't just comfortable but an artists' house as well', that Gauguin 'is a truly great artist and a truly excellent

friend', and that it was doing him 'an enormous amount of good to have such intelligent company as Gauguin's and to watch him working'.

Van Gogh had at last found someone with whom to talk about art; Gauguin, on his side, had found a partner who, far from accepting his authority as all-sufficient, obstinately put forward his own views and compelled Gauguin to express himself less vaguely. We should remember that the Syntheticism of Gauguin was still in the first stage of its development, but also that he had never previously come up against anybody stubborn. Bernard possessed plenty of arguments with which to oppose his assertions, yet had never dared to contradict him; he was too deeply intimidated in the presence of 'the master', as he himself admitted. Years later, in *Avant et après*, Gauguin wrote: 'I owe Vincent something: namely that, in addition to the knowledge of having been of service to him, it was through him that I strengthened and consolidated my previous ideas about picture-making; moreover I learnt to remember that when things are very hard, there is always someone worse off than oneself.'

It emerges clearly from Vincent's correspondence with his brother, and from Gauguin's with Schuffenecker and Bernard, that both painters had the best intentions and were determined to make their life and work together a success; and their esteem for each other might have been expected to make the plan run smoothly. Simultaneously, however, and from the start, the correspondence holds a mirror to two explosive but differently constituted temperaments, so that their joint living and working arrangements were doomed in advance. 'We worked hard,' wrote Gauguin later, 'especially Vincent, but that's beside the point. We were two different people; he was completely volcanic and I was by nature always on the boil, and somehow, under the surface, a conflict was developing.'

Catastrophe was soon upon them. In a burst of insanity Vincent, in a café, threw his glass of absinthe in Gauguin's face, then attacked him in the street with a razor and finally, with the same weapon, mutilated himself horribly. Gauguin was shattered and immediately departed for Paris, leaving his friend to suffer alone. This black episode has been made the subject of more than one sensational novel and still remains to be investigated in the light of reliable evidence.

In 1903, the year of his death, Gauguin – to assuage his conscience and perhaps also to justify himself in the world's eyes for having deserted his friend in distress – gave his own version of what happened at Arles, in his book of reminiscences *Avant et après*. Written after a lapse of time, however, his story appears heavily slanted and by no means tallies with the spontaneous account he gave to Bernard in Paris, only four days after the drama had taken place. In his anguish on hearing the news, Bernard hurried to Schuffenecker's house, where Gauguin was staying, for further details. Deeply disquieted, he wrote at once to Albert Aurier. Passages from this hitherto unpublished letter, which was preserved by a third party, are reproduced by Rewald.[30] They contain no allusion to the razor episode, and, in general, they describe Van Gogh's supposedly

ÉMILE BERNARD *Van Gogh Painting*

aggressive attitude towards Gauguin in much more measured terms than does Gauguin himself in *Avant et après*.

What concerns us here, rather than these problems of anecdotal truth or untruth, is the question of what Gauguin had to offer on his arrival at Arles in October 1888: that is, what new picture-making concept, developed at Pont-Aven, he was able to put up against the ideas of Van Gogh, and how, and in what degree, he was able to influence such a strong personality as Van Gogh.

Gauguin had just finished the *Vision after the Sermon*. The priest at Nizon having refused the picture, as we have seen, Gauguin left it in Paris before setting out for Arles. We do not know whether he took any of his other Brittany canvases with him; what we do know is that he brought the *Breton Women in Green Meadow*, by Bernard, and that this made a deep impres-

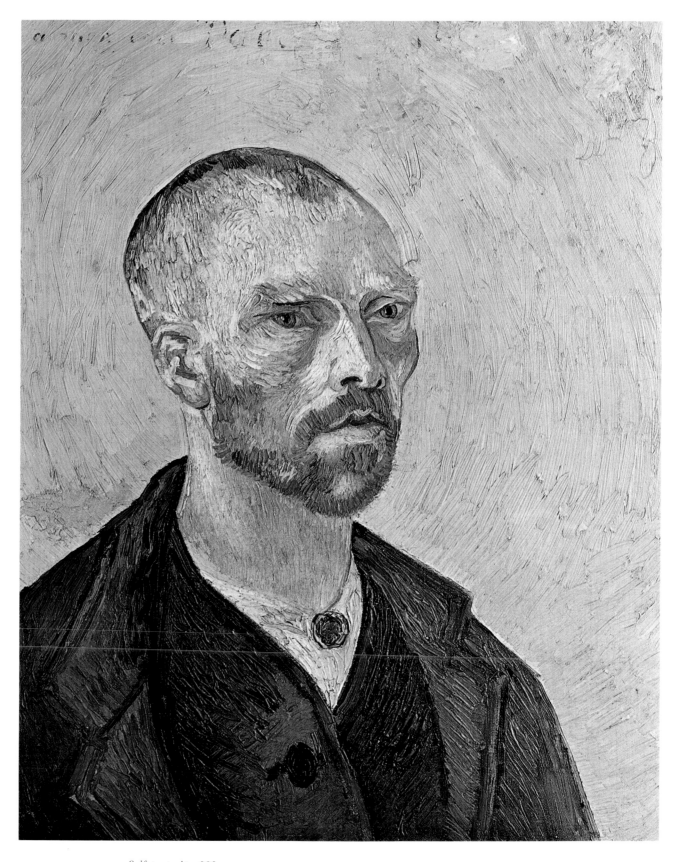

VINCENT VAN GOGH *Self-portrait* 1888

63

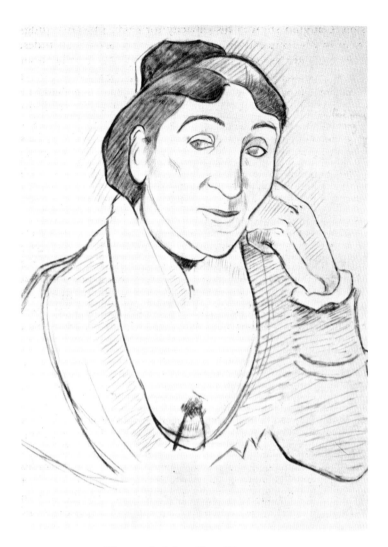

PAUL GAUGUIN *Woman of Arles: Mme Ginoux*

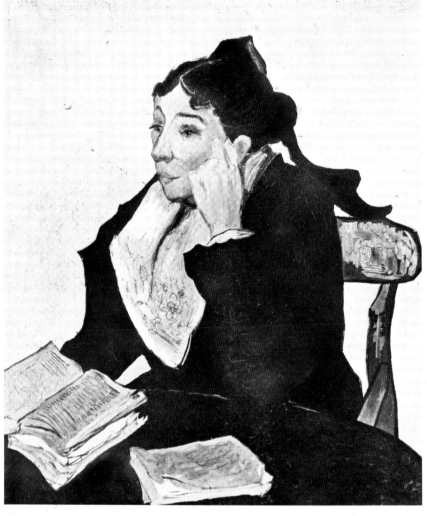

VINCENT VAN GOGH *Woman of Arles: Mme Ginoux* 1888

sion on Van Gogh, who wrote to his brother: 'Gauguin has brought down a magnificent canvas which he got in exchange from Bernard, some *Breton Women in a Green Meadow* in white, black, green and a dash of red and the matt flesh-tones.' Vincent made a copy in watercolour. It is reasonable to suppose that this picture provided the focus for the two painters' first discussion on the new style.

From the Van Gogh brothers' correspondence we learn that these discussions between the friends in Arles were endless, that it was usually Vincent who gave in, and that by evening they were worn out and felt exhausted and empty, 'like a battery of artillery after firing'. What subject was so absorbing as to inspire such talk? Gauguin at this juncture was emerging from the crisis in which he had abandoned painting 'from nature' in order to work from imagination. He presumably

criticized Van Gogh for being tied to nature and the model. He considered his palette disorderly, his line too imprecise, his forms fussy and tormented. To the dynamic romanticism of Van Gogh he opposed his own still very recent conceptions of a type of painting engendered by the imagination, which would be more intellectual and therefore colder. 'Gauguin, in spite of himself and in spite of me too, has half proved to me that it's time for me to vary my work a bit, I've begun composing out of my head, for which all my studies will continue to be useful to me by recalling things I've seen in the past.' He added (December 1888), 'Gauguin is giving me courage to work from imagination, and certainly things done this way do take on a more mysterious character.'

Gauguin soon found himself running out of arguments. As Van Gogh plunged more and more passionately into discus-

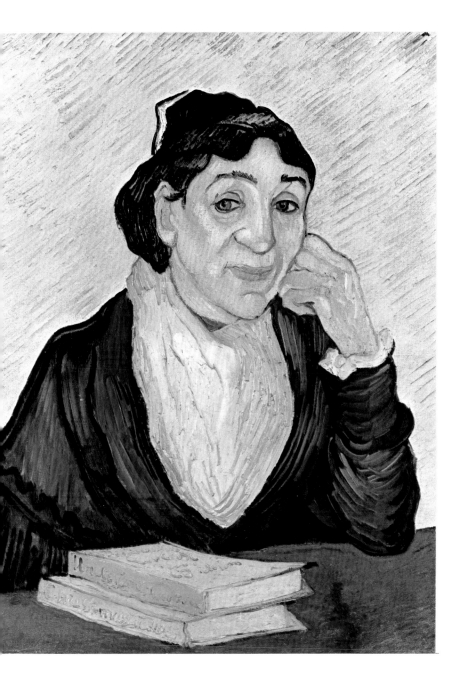

sion, Gauguin showed his capacity for calm, objective judgment in his appreciation of their respective artistic attitudes. 'Vincent and I agree very little on the whole, especially about painting. He admires Daumier, Daubigny, Ziem and the great Rousseau, all of whom leave me cold. On the other hand he hates Ingres, Raphael and Degas, all of whom I admire; I just say "aye aye, sir", for the sake of peace and quiet. He likes my pictures very much but when I'm actually doing them he's always saying this is wrong or that's wrong. He's a romantic whereas I'm really moving to the position of a primitive. Where colour is concerned he sees the dangers of *la pâte*, the sort of paint pudding you get in Monticelli, and I detest messing about and taking two bites at the cherry.'

These ardent discussions about colour were to be remembered by Gauguin when, in after-years, he wrote his reminiscences of the 'yellow house' and his life with Van Gogh. 'When we were both at Arles, both mad, continually at war for the most beautiful colours, I adored red. Where was one to find a perfect vermilion? And he, filling a brush with his brightest yellow, painted on the wall, which had suddenly turned violet, the words:

> *Je suis sain d'esprit*
> *Je suis Saint-Esprit.*'[31]

Meanwhile the two friends painted in concert, taking identical or closely related subjects: *Women of Arles, Les Alyscamps, Night Café*. Van Gogh's canvases clearly exhibit an effort to adopt the ideas of his Pont-Aven colleague. Under the combined effect of *Breton Women in Green Meadow* and of Gauguin working at his side, he painted the *Dance-hall at the Folies Arlésiennes*, the *Woman Reading a Novel* and several variants of the *Woman Rocking a Cradle*. These canvases represent Van Gogh's most determined experiments in the style of Pont-Aven.

But his fiery temperament submitted only briefly to the aesthetic, and the pictorial discipline, of Gauguin. When he started working again after a spell of illness he turned, as before, to nature and the model. Syntheticism, as a period in the work of Van Gogh, lasted exactly two months, the length of Gauguin's stay. Later, Van Gogh regarded it merely as an experiment in the direction of abstraction. Writing to Bernard in December 1889, he said: 'When Gauguin was at Arles I did try abstraction a couple of times, as you know, in the *Woman Rocking a Cradle* and a *Woman Reading a Novel*, black in a yellow library; and at the time abstraction looked a delightful path to follow. But my dear chap, that's enchanted ground: and in no time you find yourself up against a wall.'

However, this was not to be his final word on the subject. If the domain of abstraction – or, to put it more clearly, the search for a style – appeared perilous to him, like enchanted ground, he reverted to it several times in conversation. He even described to his brother an imaginary dialogue in which the speakers were Bernard, Gauguin and himself, and which was in fact an extended paraphrase of the speech delivered by Gauguin in the Bois d'Amour at Pont-Aven, for the benefit of Paul Sérusier, which led to the picture called *The Talisman*

(see p. 125).[32] Vincent, in his letter, dissatisfied with what he has produced so far, tries to console both Theo and himself by invoking the arguments of those 'men of experience' who say that a painter should be prepared to spend ten years working to 'achieve nothing'. Now, after years of turning out unsucessful studies, a better time may possibly be starting for him. He goes on: 'Bernard and Gauguin feel something of the same thing as I do: they certainly don't ask that a tree be exactly the right shape, but they do absolutely demand that it be frankly round or square – and heaven knows they're right, in their exasperation with the silly, photographic perfection of some people's work. You won't hear them demanding the exact colour of the mountains; they'll say, "Good God, shove in some blue and don't go telling me it was one of those blues with a bit of this in it and a bit of that; it was blue, wasn't it? Right – make them blue and have done with it." Gauguin really has genius sometimes when he's explaining these things, but his particular genius is something he's very shy of displaying and it's touching to see how he enjoys telling young painters something that's truly useful to them. What an odd chap he is, after all.'

When Theo apparently failed to share these views, Vincent returned to the attack with an even more explicit profession of his faith: 'Where work is concerned my ideas are, I think, gaining in firmness. Still, I'm not so sure you'd like what I'm doing now. Because in spite of your saying in your letter that the quest for a style often jeopardizes other qualities, the fact is that I feel very strongly urged to go after style, if you like to call it that, though what I mean by it myself is a more masculine, deliberate kind of design. If it makes me still more like Bernard and Gauguin I can't help it. But I think that in time you'll get on with it all right.'[33]

The permanent results of Van Gogh's contacts with Gauguin and the Pont-Aven group are the various 'portraits of friends', and, of course, Vincent's own pictures. While waiting to see whether Van Gogh would come and join the Pont-Aven group or *vice versa*, the painters sent pictures and letters to each other in a steady stream. This exchange of canvases was an advantage to all concerned, but especially to the lonely Van Gogh, for it kept him constantly in touch, more effectively than any letters, with his 'pals in the north'. For both sides it was a means of communication, of experimentation at a distance, and an uninterrupted professional dialogue. It also symbolized their community of aims and ambitions, expressed the fact that they were of one and the same species, and marked the interest and respect they felt for one another.

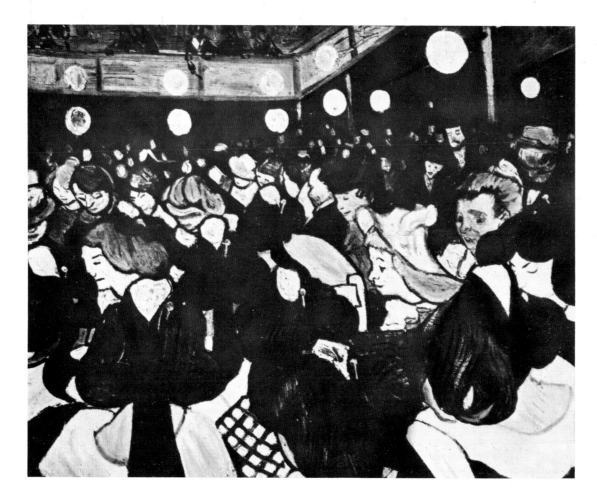

VINCENT VAN GOGH
*Dance-hall at the Folies
Arlésiennes* 1888

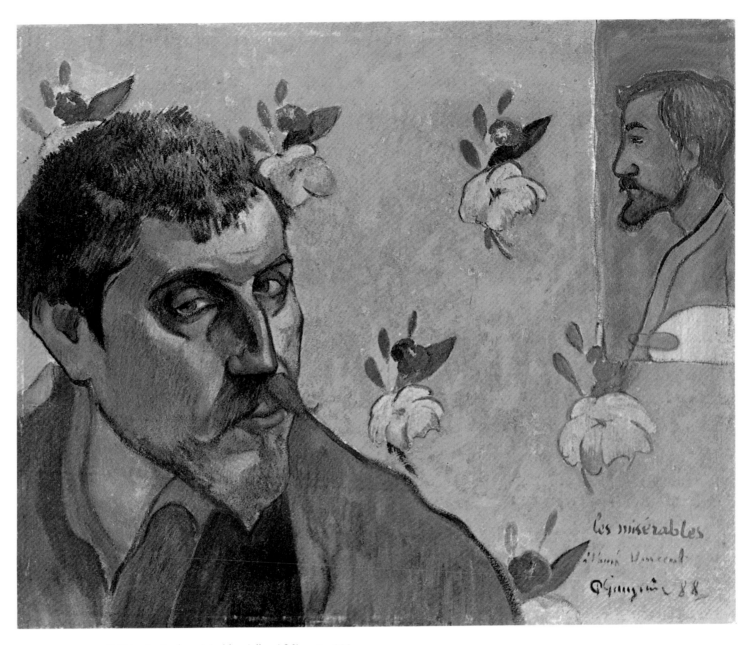

PAUL GAUGUIN *Self-portrait: les misérables, à l'ami Vincent* 1888

Van Gogh and Gauguin attached the highest importance to exchanges of portraits and self-portraits. Van Gogh wrote to Bernard: 'If Laval, Moret and the other man are willing to exchange pictures with me, I'll be delighted. But what I'd really like is if they'd do self-portraits for me.' And to his brother: 'My letter to Gauguin has gone off, I've asked them to exchange pictures with me if they're willing, I'd love to have a portrait of Bernard by Gauguin and one of G. by B.'

Van Gogh's 'order' was never executed. Neither Gauguin nor Bernard could make up his mind to paint the other's portrait. In September 1888 Gauguin defended himself in a letter written from Pont-Aven, which has been published by Rewald: 'I'm observing little Bernard and haven't quite got him yet. Perhaps I shall do him from memory, but in either case it'll be an abstraction. Perhaps tomorrow; I don't know; anyway, it'll come to me all of a sudden.'

Vincent was fearfully disappointed on hearing from Bernard that he would not be able to paint a portrait of Gauguin because he was intimidated by Gauguin's presence. Vincent flew into a temper and was almost on the point of withdrawing from the association. 'Thanks for your letter,' he wrote in reply to Bernard, 'though I'm a bit astonished to hear you say, "Oh, I can't do a portrait of Gauguin, not possibly!" Why not? What you say is all rubbish. However, I won't press the matter, and we'll say nothing more, at any time, about this exchange. And then there's Gauguin too, who hasn't even thought of doing a portrait of you, even for himself. That's portrait painters all over: they live in each other's pockets for ages yet never arrange to sit for each other, and in the end they part without having painted each other. All right then, I won't insist. And I repeat, there's no question of a swap. I certainly hope to paint both you and Gauguin myself one day, the first time chance brings us together, which it undoubtedly will sooner or later.'

The exchange question did come up again, however, to Vincent's great satisfaction. The pictures he had waited for with such impatience arrived from Pont-Aven in October 1888. He wrote in the same month to his brother: 'I've just received the portrait of Gauguin by Gauguin and the portrait of Bernard by Bernard, and the first shows the second in the background, hanging on the wall, and *vice versa*. The Gauguin is immediately striking, but I like the Bernard very much too. It's just a painter's idea, nothing more, a few summary tones, a few blackish brush-strokes, but it's *chic*, like a real bit of Manet. The Gauguin is more studied, he's taken it a long way. That's what he says himself in his letter, and the effect the picture makes on me is that above everything it represents a prisoner. No gaiety in it anywhere. It's not flesh at all, but one can put that down summarily to his intention of doing something melancholic, the flesh is all blue in the shadows. So now at last I've got a chance of comparing my work with my pals'. My self-portrait, which I'm sending to Gauguin, stands up all right beside his, I'm sure of that.... And when I put his conception alongside of mine, mine is equally grave but less despairing. What Gauguin's portrait says to me above everything is that he shouldn't go on as he is now, he should find some pleasure to console himself with, he must become once more the sumptuous Gauguin we saw in his pictures of Negresses. I'm very pleased to have these portraits, which faithfully depict our two pals as they are at this time, they won't stay like that, they'll return to a calmer kind of life. And I feel clearly that the duty laid upon me is to do everything in my power to diminish our poverty!!... Gauguin looks ill and tormented in his portrait. Wait and see, this won't last and it will be very curious to compare this portrait with the one he'll do of himself in half a year from now. One day you'll see the portrait of me, too, which I'm sending to Gauguin, because he'll keep it I hope.' In writing to thank Bernard for the pictures he added how happy he was: 'It warmed my heart like anything to see these two faces again.'

After a time, Van Gogh began wondering whether he ought to accept the Gauguin self-portrait. He felt it was too beautiful and much too valuable; he wrote several times to Gauguin and to his brother, insistently emphasizing that he really could not accept the picture, unless perhaps it could be regarded as a payment to Theo for the time spent by Gauguin at Arles. Only a letter full of compliments from Gauguin was enough to dispel his scruples.

In his self-portrait Gauguin set out to express his feelings, which were very friendly at the time, towards both Van Gogh and Bernard. He put the latter's likeness in the background, next to his own head, and signed the picture with the words '*Les Misérables/à l'ami Vincent /P. Gauguin, 88.*' This reference to Victor Hugo's novel was intended to indicate the poverty in which the two friends, Gauguin and Bernard, were living. The picture was also meant to symbolize Impressionism as Gauguin understood it, and the condemnation of Impressionism by the public. He wrote about this to Schuffenecker on 8 October: 'I have done a self-portrait for Vincent, he had asked for one. I think it's one of my best things: for example it's so abstract that it's absolutely incomprehensible. At first glance the head is that of a bandit, a Jean Valjean (*Les Misérables*), and also personifies a despised Impressionist painter who has to drag his chains with him through the world. The design is very special, completely abstract. The eyes, mouth and nose are like flowers in a Persian carpet and also personify the symbolic side. The colour is quite unlike natural colour; think of something vaguely resembling pottery under stress in the heat of the kiln! All the reds and violets are streaked with fire like a kiln radiantly blazing in front of your eyes, they are the arena in which the battles of the painter's thinking are fought out. All this on a background of chrome yellow strewn with childish bouquets of flowers. The bedroom of a pure young girl. The painter is a pure creature, not yet defiled by the putrid kiss of the Beaux-Arts.'

At the period to which this picture belongs, all three painters, Gauguin, Bernard and Van Gogh, were still calling themselves Impressionists, though their painting no longer fitted such a description. The two pictures in question are the fruit of a nascent style which is the negation of Impressionism; and while the Gauguin self-portrait, in spite of its tendency to symbolism, remains thoroughly intimate, that by Bernard displays all the stigmata of Syntheticism, and although it is a small composition its character is essentially monumental.

It is not known whether the exchanges between Van Gogh, Moret and Chamaillard, so often mentioned in their correspondence, ever took place. But we know that there was one between Van Gogh and Laval. Laval's *Self-portrait in a Landscape*, with its dedication *A l'ami Vincent. C. Laval. 1888*', greatly pleased Van Gogh. As soon as it arrived he made a sketch of it in a letter to his brother and commented as follows: 'Another thing to give you pleasure is that we have an item to add to the collection of portraits of artists. Laval's portrait is a very cool, plucky piece of work, very distinguished, and will in fact be one of those pictures you were speaking of, the ones you pick up before other people have recognized the painter's talent.[34]

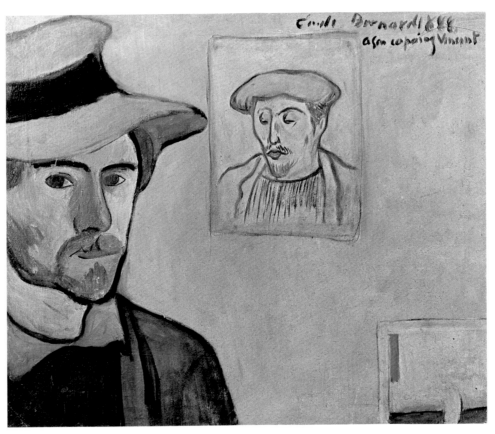

ÉMILE BERNARD *Self-portrait:
à son copaing Vincent* 1888

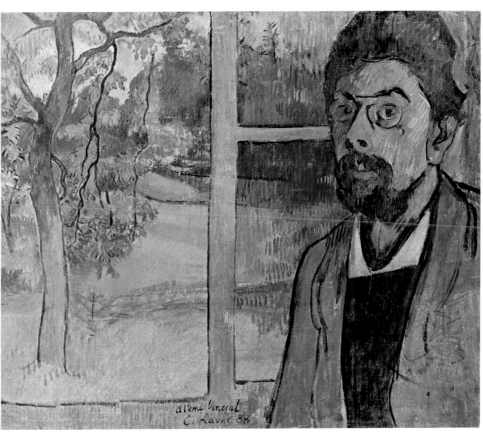

CHARLES LAVAL *Self-portrait
with Landscape: à l'ami Vincent* 1888

69

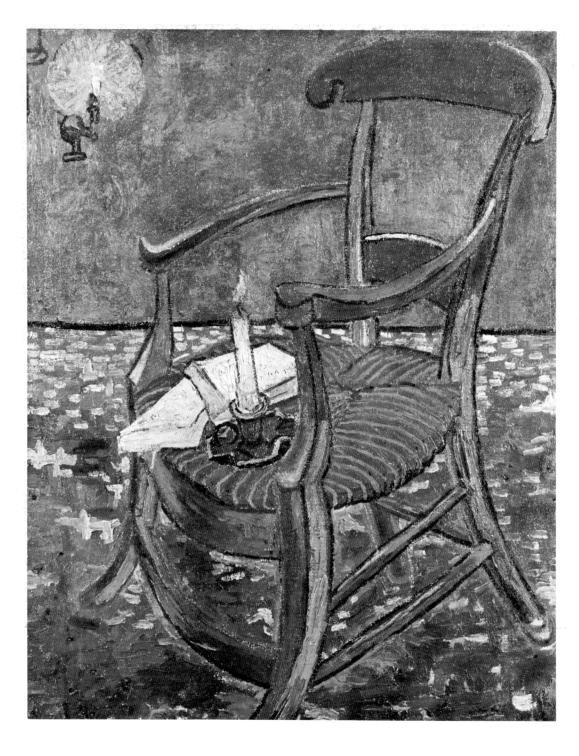

VINCENT VAN GOGH
Gauguin's Chair 1888

A year later, anxious about a frame for this canvas, he wrote to his brother from hospital: 'Have you framed the portrait of Laval? I don't think you ever told me what you thought of it, I think it's splendid the way he looks out through his pince-nez, such a frank look.'

Vincent did not forget his own self-portrait, which he had promised to Laval, and which, after some delay, did arrive.

On recovering from his illness he wrote to Theo: 'Have you got the address of Laval, Gauguin's friend, you can tell Laval I'm very surprised that his friend Gauguin didn't take with him, and hand over, the self-portrait which I had done for Laval. I'll send it to you now, and you can see that he gets it. I've also got another new one, for you.'

The most interesting work in this 'dialogue of pictures'

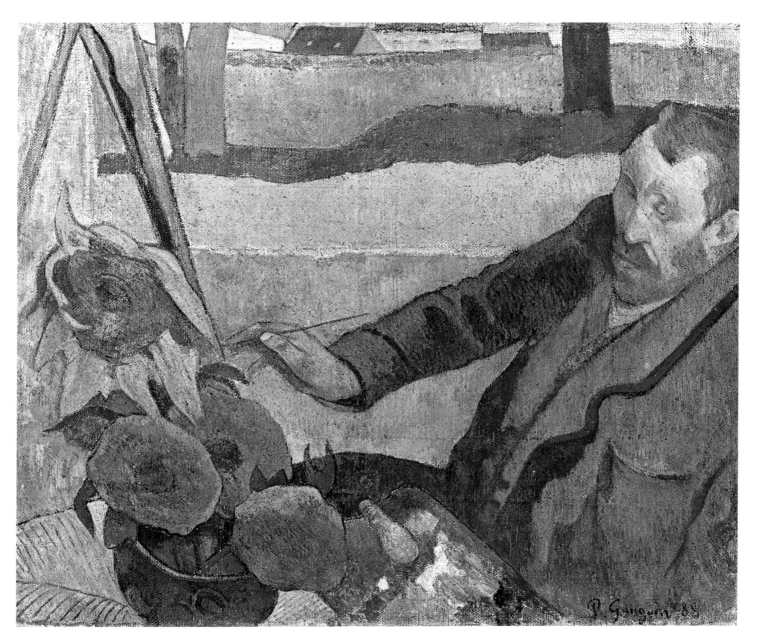

PAUL GAUGUIN *Van Gogh Painting Sunflowers* 1888

between Van Gogh and the Pont-Aven painters is surely the portrait of Van Gogh which Gauguin painted at Arles. The model is pushed over into the right-hand corner of the canvas, the main part of which is occupied by the outstretched hand holding a brush and by the palette, the easel and some sunflowers. The artist is clearly less interested in the portrait itself – presented as it is in a foreshortening which does not 'read'

very articulately – than in portraying the world, the aura, in which his friend and sitter lives and moves and has his being. Portraits of friends, in this style of presentation, were one of the genres which Gauguin specially liked; other examples are his portrait of Laval with a still-life and that of Slewinski with a bunch of flowers. The one we are concerned with here is perhaps less a portrait of Van Gogh himself than an evocation

of a painter and friend, occupied in painting his favourite subject.

According to the evidence of Gauguin himself, the completion of this portrait coincided with Van Gogh's first attack of madness. This presumably accounts for the fact that Van Gogh's letters to Theo contain no immediate allusion to the picture. He did not refer to it until a year later (30 September 1889): 'Have you see the portrait he did of me painting the sunflowers? My face has brightened a lot since that time, but it's just like me, extremely tired and charged with electricity as I was then.' This exactly corroborates what Gauguin wrote later, in *Avant et après*: 'The idea came to me to make a portrait of him painting the still-life subject he was so fond of – sunflowers. And when the portrait was finished he told me, "It's me all right, but me gone mad."'

Van Gogh's dream of painting a portrait of Gauguin was never realized. Did the sitter lack patience, one wonders; or perhaps did Van Gogh, like Bernard, feel intimidated in the presence of his senior? This is something which has never been elucidated. We have to content ourselves with a 'phantom portrait', the picture of *Gauguin's Chair*. Painted by Van Gogh after coming out of hospital, this canvas, depicting the straw-covered chair used by Gauguin, is in fact the tragic symbol of a ruined friendship and of the hope, never to be revived, that the 'Studio of the South' would eventually become a reality. The time was to come when Van Gogh would give the picture an even more eloquently symbolic title: *The Empty Place*.

Although during his illness he was forced finally to abandon his long-cherished dream of the Studio, Van Gogh never gave up the idea of close collaboration with the Pont-Aven group. In January 1890, during a temporary improvement in health, he wrote to his brother: 'I'll drop a line to Gauguin and De Haan to ask if they're planning to stay in Brittany and if they want me to send the furniture there, and if so, whether they'd like me to come up there too.' One of the last letters he wrote to Gauguin (June 1890) – an unfinished letter, never posted – announced his imminent arrival in Pont-Aven: 'Very glad to learn from your letter that you're going back to Brittany with De Haan. It's very likely that, if you'll allow me, I'll come up and join you for a month to paint a sea-picture or two, but above all to see you again and make the acquaintance of De Haan. We'll try to make something of our days together, something purposeful and full of gravity, as we probably would have done if we had been able to continue down there.'

What comes out from this brief survey of the contacts, artistic and personal, which Van Gogh succeeded in establishing with Gauguin and the Pont-Aven artists, is how strongly he was attached to both; we see that it was force of circumstance (his incurable illness and tragic death) which came between him and his ardent desire for formal adherence to the Breton group. It would seem that insufficient importance has been attached to the fact that his plan for setting up a 'Studio of the South' really consisted simply of transferring the group, with all its precious advantages, from Pont-Aven to Arles.

IV FIRST PUBLIC APPEARANCE OF THE GROUP

The Exhibition at the Café Volpini

These pictures represented the new painting, the school of Gauguin, the school of Pont-Aven, the future. M. Denis

Paris, in the spring of 1889, was tingling with excitement. The capital was preparing for the Universal Exhibition, organized under the sign of the newly-completed Eiffel Tower, the symbol of technical progress.

The fine arts, as befitted their dignity, were to be given special prominence in this ambitious display of human genius. In principle, only 'official' art – the conventional mainstream of the last hundred years' output – was to be represented, but Roger Marx, that courageous critic, succeeded in gaining the admission of a few still debatable painters such as Manet, Monet and Pissarro. Degas refused to take part, and Renoir withdrew at the last moment. No invitation was sent to Gauguin or Van Gogh.

On leaving Van Gogh so abruptly in Arles in December of the previous year, Gauguin had made for Paris and spent three months staying with Schuffenecker. He thus arrived when preparations were at their height. He was unable to resign himself to having no share in an exhibition of such scope, but he realized that his chances were of the slimmest; he was unknown and had made no attempt to build up advantageous contacts with the critics. The only answer was to do as Courbet had done in 1855: erect his own pavilion in the grounds of the Exhibition and organize a 'Salon des Refusés'. Unfortunately, however, he had not a penny to his name, and in a state of deep discouragement he left for Pont-Aven.

But events quickly took an unhoped-for turn. Schuffenecker, knowing how eager Gauguin was to display his work to the general public, conceived the idea of organizing an independent exhibition in a café on the Champ de Mars, within the boundary of the exhibition site, opposite the press pavilion and beside the plastic arts section, which was an official part of the exhibition. The owner of the café, an Italian named Volpini, was in the depths of gloom: as a shrewd man of business he had ordered a set of glass panels for the walls of his establishment, but he had just heard that they could not be delivered in time. Schuffenecker therefore had no difficulty in persuading the dejected Italian that he would make more money for a smaller outlay by lining the walls with bright red fabric, against which the painters would hang their canvases.

In March 1889, directly the happy news reached him, Gauguin wrote to Schuffenecker: 'Bravo! You've pulled it off. See Van Gogh, [35] take charge of things until the end of my stay. But remember on thing, it's not an exhibition for the *others*. So let's arrange things just for a small group of chums and I might add that I myself want to be *represented* in as big a way as possible. So do the best you can for our interests in whatever space is available.... Myself, I refuse to exhibit with the *others*, Pissarro, Seurat, etc. It's our group! I only wanted to show a few pictures, but Laval tells me it's my turn and that I would be wrong to work for other people.'

Taking the initiative, he included in his letter a list of the canvases he intended exhibiting and appended the maximum number to be allotted to the other exhibitors. It is interesting to compare this with the final list:

List initially proposed by Gauguin	Canvases	*Final list*	Canvases
Schuff	10	Schuffenecker	20
Guillaumin	10		
Gauguin	10	Gauguin	17
Bernard	10	Bernard	22
		Laval	10
		Anquetin	7
Roy	2	Roy	7
Man from Nancy (L. Fauché)	2	Fauché	5
		Daniel (Monfreid)	3
		Ludovic Nemo (E. Bernard)	2
Vincent	6		
	50		93

As can be seen, the list of 'our group', as proposed by Gauguin, underwent several modifications; but both versions, the second as much as the first, are surprising. To begin with, there is no explanation for the presence of Guillaumin, who had never been in any way connected with the Pont-Aven group. Only his unpopularity among the 'old Impressionists'

would seem to have motivated Gauguin's invitation – of which, as it turned out, Guillaumin did not avail himself. Monfreid was a friend of Schuffenecker, who was no doubt responsible for his inclusion. Louis Roy and the 'man from Nancy', Léon Fauché, had met Gauguin a short time before at Pont-Aven and had received a little practical advice from him. He must have regarded their enthusiasm for the new style, and their first essays in it, as sufficient reason for including them, however discreetly, in the list of exhibitors. Bernard was to write that 'a few retarded canvases in the Impressionist vein of Schuffenecker, Léon Fauché and Louis Roy filled the gaps.'

In the first list, a more striking feature than these new names is the omission of Laval – whose recommendations Gauguin had quoted to his own advantage when writing to Schuffenecker – and of Jacob Meyer de Haan, who had accompanied him to Pont-Aven. It is true that Laval's name was added a little later, but De Haan did not take part in the exhibition. This might conceivably be accounted for by his having belonged to the group for so short a time.

But the case of Toulouse-Lautrec defies explanation. Bernard, indeed, in the reminiscences he wrote several years later, mentions him as one of the exhibitors whom he himself introduced, a statement confirmed by many other recorders; Rewald, on the other hand, is correct in stating that Toulouse-Lautrec's name figured neither on the poster, nor in the catalogue, nor in any of the reports.[36]

Van Gogh, although invited, did not take part. It was not, however, he who had refused his collaboration but his brother, acting for him when Schuffenecker, on Gauguin's behalf, called with an invitation to Vincent to send in six canvases. 'I said at first that you would exhibit with them,' wrote Theo after his refusal. 'But they were putting on such airs, wanting to break all the windows so to speak, that it was becoming unwise to be associated with them. It was a bit like getting into the Universal Exhibition by the back stairs.'

Vincent was apparently reluctant to vex his brother, and acquiesced resignedly to his decision. But he was unconvinced by Theo's arguments, and the wording of his letter of 19 June 1889 indicates that the matter rankled somewhat: 'I consider you did well not to show any pictures by me at the exhibition of Gauguin and others, the fact that my recovery is still incomplete gives me a pretext for abstaining without offending them. To my mind there is no doubt that Gauguin and Bernard have real merit, great merit. But it is very understandable none the less that men like them, young and very much alive, men with a *duty* to live and to seek to make their way, should find it impossible to turn all their canvases against a wall until people are kind enough to admit them somewhere or other, pickled in official vinegar. By exhibiting in cafés you make a stir, which is in bad taste, I don't deny it, but I've got this crime on my own conscience, and twice over at that, having exhibited at the Tambourin and in the Avenue de Clichy, not to mention

the perturbation I inflicted on eighty-one virtuous anthropophagi of the good town of Arles, and on their excellent mayor. Finally, neither he nor Gauguin is the sort of artist who could ever look as if he was getting into the Universal Exhibition by the back stairs. Reassure yourself on that point. That they themselves *could not* keep silence is comprehensible.'

Returning to the question about a month later, he assured Theo that the initiative taken by his fellow artists was a sound one and that Theo had been wrong to consider it risky: 'I've received the catalogue of the exhibition of Gauguin, Bernard, Schuffenecker, etc., which I find interesting. Gauguin has also written me a good letter, a bit vague and obscure as usual, but, well, I feel bound to say I think they were absolutely right to hold their own exhibition.'

The catalogue, and the hastily produced poster advertising the exhibition, were superb. Gauguin and Laval, who had come to Paris shortly beforehand, stuck the posters on the walls themselves, by night, with the help of Bernard and Schuffenecker. Not having a ladder, they climbed on one another's shoulders.[37]

The poster, set in type of widely differing sizes on a background of horizontal red and white stripes, announced an exhibition which, in the expectation of Schuffenecker, would put all the other painters in Paris in the shade.[38]

The heading on the poster, 'Groupe Impressionniste et Synthétiste', requires special attention. If we are to believe Bernard, it was Aurier who thought of this wording, but there is no doubt that the group's members had discussed it at length and that the name had been accepted, if not actually devised, by Gauguin. The problem is to decide how two such contradictory terms came to be coupled in one title. At Pont-Aven,

GROUPE IMPRESSIONNISTE ET SYNTHÉTISTE

CAFÉ DES ARTS

VOLPINI, Directeur

EXPOSITION UNIVERSELLE

Champ-de-Mars, en face le Pavillon de la Presse

EXPOSITION DE PEINTURES

DE

Paul Gauguin	Émile Schuffenecker	Émile Bernard
Charles Laval	Louis Anquetin	Louis Roy
Léon Fauché	Daniel	Nemo

Paris. Imp. E. WATELET, 55, Boulevard Edgar Quinet.

Affiche pour l'intérieur

Poster of the exhibition at the Café Volpini, 1889

LES FANEUSES

RAMASSEUSES DE VARECH

PAUL GAUGUIN *Women Haymaking*
Illustration from the catalogue of the exhibition at the Café Volpini

ÉMILE SCHUFFENECKER *Women Gathering Seaweed*
Illustration from the catalogue of the exhibition at the Café Volpini

these artists were in fact quite happy to call themselves 'Impressionists', but in a completely different sense from the usual one, with the intention of differentiating between themselves and those painters whose allegiance was to the Ecole des Beaux-Arts. Obviously Gauguin was aware how far he had moved away from Pissarro and the other 'old Impressionists'; but he never made any pronouncement on the title of the exhibition, and one is therefore at liberty to venture a few conjectures.

Noting the lack of homogeneity among the exhibitors – for, according to Gauguin, only Bernard, Laval, Anquetin and himself deserved to be classed as 'Syntheticists' – he adopted the complementary term 'Impressionist' for other painters, whom he was obliged to tolerate, and in particular for Schuffenecker, the exhibition's organizer, who, with a few colleagues, represented the Impressionist style in one way or another. We can also subscribe to Rewald's hypothesis that Gauguin prudently retained the term so as not to antagonize the members of the 'old Impressionist' camp; he wanted to avoid a break with them, an added reason being that they were officially included in the Universal Exhibition and were beginning to enjoy a certain esteem.

Finally, it is perhaps relevant to quote a remark thrown out in passing by Maurice Denis, in his *Théories*, with reference to Sérusier: 'He was a bringer of order, he systematized the formulae, he deduced from them a doctrine which at first was almost indistinguishable from Impressionism but later became its antithesis.'

The fact is that the name of the Volpini exhibition was not happily chosen and that it spread confusion not only in the minds of the critics but of the painters themselves, especially as the seventeen canvases by Gauguin included those he had

CATALOGUE
DE
L'Exposition de Peintures
du Groupe Impressionniste et Synthétiste

Faite dans le local de M. VOLPINI

Café des Arts –

AU CHAMP-DE-MARS

Exposition – en face le Pavillon

* 1889 * *de la Presse*

Prix : 50 centimes

Catalogue of the exhibition at the Café Volpini, 1889

aux Roches noires 90

EXPOSANTS

Paul Gauguin	E. Schuffenecker	Emile Bernard
Charles Laval	Louis Anquetin	Louis Roy
Léon Fauché	Georges Daniel	Ludovic Nemo

Émile SCHUFFENECKER

29, Rue Boulard

55. — Danseuse. — Pastel.
56. — Nature Morte.
57. — Notre-Dame par la neige.
58. — Paysage de neige.
59. — Coin de plage à Concarneau.
 Appartient à M. Gautereau
60. — Coucher de soleil à Concarneau
61. — Ramasseuses de varech — Yport.
62. — Pivoines.
 Appartient à M. Choquart
63. — Falaises — Yport.
64. — Cirque de Fécamp.
65. — Rochers — Yport.
66. — Au parc de Montsouris.
67. — Paysage parisien.
78. — Nature morte : Oranges.
69. — Square.
70. — A Vanves.
71. — Matinée à Yport.
72. — Dans la neige.
73. — Effet de neige.
83. — Portrait de Monsieur B***
 Peinture pétrole

Émile BERNARD

5, Avenue Beaulieu. Asnières

7. — Chiffonnières — Clichy.
8. — Fleurs en pots.
9. — Paysage à Asnières.
10. — Paysage Pont-Aveniste.
11. — Paysage Saint-Briacois.
12. — Portrait de Monsieur Q***
13. — L'ami Marcel.
 Appartient à M. Hérissé
14. — Les Bretonnes.
 Appartient à Madame Berthe
15. — Château de Kerlaouen.
16. — Floréal.
17. — Paysage Asniérois.
18. — Marche au Calvaire.
19. — Moisson — Bretagne.
19bis — Paysage à Saint-Briac.
75. — Baigneuses.
 Appartient à M. Aurier Albert
76. — Château de Kerlaouen.
 Appartient à Madame La Valle
77. — Nues.
 Appartient à Monsieur de Laval
79. — Peupliers.
80. — Croquis à Pont-Aven — Aquarelle.
81. — — — —
82. — — — —
86. — Femme et oies.
 Appartient à M. Régis Delbœuf
88. — Caricatures bretonnes.
 Appartient à Mademoiselle Jeanne Simons

Louis ANQUETIN

86, Avenue de Clichy

1. — Bateau — Soleil déclinant.
2. — Effet du soir.
3. — Été.
4. — Étude de cheval.
5. — Étude de cheval.
6. — Rosée.
6bis — Éventail.

Louis ROY

Lycée Michelet. Vanves

49. — Poires.
50. — A Gif.
 Appartient à M. Filliger
51. — Paysage à Gif.
52. — Primevères.
53. — A Gif.
54. — Chemin des Glaises — Vanves.
54bis — Crépuscule.

Léon FAUCHÉ

5, Rue Boissonade

22. — Le Soir — Pastel.
23. — Femme et enfant —
25. — Paysanne cousant —
26. — La carriole —
28. — Cantonnier —

Charles LAVAL

à Pont-Aven (Finistère)

84. — Entrée de bois — Martinique.
85. — Allant au marché — Bretagne.
89. — Les Palmes.
90. — Sous les bananiers.
91. — Femmes au bord de la mer. Esquisse.
92. — Rêve Martiniquais.
93. — Le Saule — Pont-Aven.
94. — Dans la mer.
 Appartient à M. Bernard
95. — L'Aven, Ruisseau.
 *Appartient à Madame la Comtesse de Z***
96. — Course au bord de la mer.
 Aquarelle Martinique
 Appartient à M. Rippipoint

George DANIEL

55. Rue du Château

20. — Fleurs.
21. — Paysage.
21bis — Portrait du peintre.

Ludovic NÉMO

74. — Portrait d'un jeune ouvrier.
 Peinture pétrole, (1887)
 Appartient à Jacques Tasset
87. — Après-midi à Saint-Briac.
 Peinture pétrole, (1887)
 Appartient à Émile Schuffenecker

Visible sur demande

ALBUM DE LITHOGRAPHIES

Par Paul GAUGUIN et Émile BERNARD

painted in Martinique and Brittany before the summer of 1888, in other words during his pre-Syntheticist period. Still more serious was the omission from the catalogue of any mention of the most highly representative canvas of the new style, *Vision after the Sermon*.[39]

Vincent van Gogh was quite right: the exhibition at the Café Volpini (properly the Café des Arts) was an important event. Not that it produced the hoped-for results in terms of money or prestige, but because it was the first collective public appearance of the Pont-Aven group.

Bernard, always in closer touch than the others with things in Paris, looked after publicity from the time of the exhibition's opening. His first move was a passionate appeal to Aurier: an announcement of the exhibition must appear in the Symbolist reviews. He pointed out the opportunities offered to painters by the Universal Exhibition, and emphasized that it had been found possible to exhibit in a café inside the Exhibition. 'This café must now be made known, people must be told where it is and what is in it. I appeal to your friendship, and above all to your ideas in the field of the arts, and ask you to give us all the support you can.'[40] At the bottom of his letter he added a draft version of the announcement.

Aurier agreed to Bernard's request, but did not feel that a café was the most promising place for an exhibition of pictures and therefore set about wording the announcement in his own way. 'I am happy to learn that individual initiative has undertaken something which administrative idiocy – chronic and incurable – would never have consented to bring about. A small group of independent artists has succeeded in forcing open the doors, not of the Palais des Beaux-Arts, but of the Exhibition, and in creating, in miniature, something to compete with the official display. Oh, I grant you the setting is a trifle primitive, decidedly peculiar indeed and, as people will doubtless say, "bohemian"!... But what do you expect? If these worthy spirits had had a palace at their disposal they would not have hung their pictures on the walls of a café.'

Attendances were considerable, and the press was not indifferent. Surprisingly, the critics paid as much attention to the presumed merit of the pictures as to the setting in which they were shown. Gustave Kahn wrote: 'M. Gauguin is exhibiting, in a café, under the most unfavourable conditions, his painting – which is interesting but as it were hoarse, hammered-out; it is surrounded by pictures of no interest, with extravagant colour laid on in sheets, and unattractive modelling which lacks the quality of inevitability.'

Félix Fénéon, who had already taken an interest in Gauguin, did not fail to visit the 'exhibition of the refused'. His account, though favourable on the whole, produced a somewhat painful impression on the artists concerned. Here are a few excerpts: 'M. Louis Anquetin has been speculating about Humboldt's hypothesis concerning a gentleman suddenly transported from Senegal to Siberia. He reconstitutes, for example, the visual sensations of a spectator emerging abruptly from a cellar to find himself confronted by a field of wheat under an August sun.... It is probable that the manner of M. Anquetin, with its

implacably closed outlines and flat, intense colours, has in some slight degree influenced M. Paul Gauguin: a purely formal influence, since no trace of feeling circulates in these decorative, highly studied works. M. Emile Bernard exhibits Breton landscapes and scenes; M. Charles Laval, landscapes and scenes in Brittany and Martinique, the favourite surroundings of M. Gauguin. Both these painters will liberate themselves from the imprint of the latter, whose work is too arbitrary, or at least issues from too special a state of mind, to offer beginners a useful point of departure. The broad outlines in which M. Bernard encloses both figures and landscape features is derived from the network of lead in stained glass windows. His figures, arranged with extreme simplicity, would in some instances remind us of traditional poses were it not for some barbarian gesture which disconcerts memory.... Access to the canvases is barred by buffets, beer engines, tables, the corsage of M. Volpini's cashier, and an orchestra of young Muscovites whose bows unleash in the vast hall a music totally unrelated to these many-coloured compositions.'

Art et Critique printed an article, signed Jules Antoine, which brought out even more sharply the illogical, distracting character of the exhibition's name. Antoine tried to determine which of the exhibitors were Impressionists and which were Syntheticists; he concluded that the only *synthétisants* (painters with a deliberate tendency towards 'synthesis') were Anquetin and Bernard, whereas Gauguin found himself classed as an Impressionist (which seems to confirm my own conviction that the *Vision after the Sermon* was not included, even as an

ÉMILE BERNARD *Reverie*
Illustration from the catalogue of the exhibition at the Café Volpini

Emile Bernard

RÊVERIE

Léon Fauché.

PAYSAN

Georges Daniel.

FEMME LISANT

LÉON FAUCHÉ *Peasant*
Illustration from the catalogue of the exhibition at the Café Volpini

GEORGES DANIEL DE MONFREID *Woman Reading*
Illustration from the catalogue of the exhibition at the Café Volpini

uncatalogued item); he went further, regarding Gauguin as an Impressionist of only medium rank and placing Schuffenecker above him; and at the same time he endeavoured to prove that Laval, and the Syntheticist Bernard, had imitated Gauguin![41]

Aurier was always fascinated by problems connected with Pont-Aven; he regarded the work of the group as a parallel to Symbolism in literature. But it was not until two years later that he wrote his famous study of 'Symbolism in Painting', in which, taking as his point of departure the *Vision after the Sermon* of Gauguin, he succeeded in establishing firmly the ideas on which the movement was based. Only then was he able to see things clearly enough to put Impressionism and Syntheticism side by side and show that their programmes were diametrically opposed, corresponding to realism and idealism in philosophy.

But when Aurier came to write about the Volpini exhibition, the affair was too recent, and the impression made by it too much of a shock, for any such precise and mature assessment to be possible; Aurier therefore confined himself, in the review *Le Moderniste* which he had just started, to encouraging his readers to visit it themselves, and making a summary analysis of the tendencies represented in it. 'I thought I detected in most of the works exhibited, and particularly in those of P. Gauguin, Emile Bernard, Anquetin, etc., a marked tendency in favour of Syntheticism in drawing, composition and colour, and a quest for technical simplification which I found highly interesting in these days of excessive adroitness and illusionism.'

The exhibitors at the Café Volpini, especially Bernard and Gauguin, had every reason to feel disappointed. They had sold not a single canvas or lithograph;[42] even worse, they had

ÉMILE BERNARD (LUDOVIC NEMO)
Illustration (untitled) from the catalogue of the exhibition
at the Café Volpini, 1889

protested vehemently, claiming that he had never so much as
seen a picture by Anquetin, whose acquaintance he had made
during the Universal Exhibition.

Gauguin's anger was only partially justified: though it may
have been true that at the time he was acquainted neither with
Anquetin nor with his work, he had nevertheless heard, from
Bernard, about a good many of his experiments. Of these,
we may recall the one made by Anquetin with the coloured
panes on his verandah, a piece of observation which he incor-
porated in some of his canvases painted in 1887. These trials
provided the point of departure for the studies later under-
taken by Toulouse-Lautrec, Bernard and Anquetin, studies in
the use of suggestive colour and of an outline emphasizing
each area of colour.

However, we must let Gauguin have the benefit of the
doubt. During the memorable summer of 1888 at Pont-Aven,
Bernard may well have told Gauguin nothing about the
specific contribution of Anquetin to the invention of the new
formula. Moreover – and this reinforces the doubt – Bernard
himself, referring in his book of reminiscences, *Souvenirs*, to
the exhibition and those taking part in it, admitted to the
ranks of the Syntheticists only himself, Gauguin and Laval,
labelling everyone else, including Anquetin, as Impressionists.
On this question he wrote: 'This exhibition was unpremedi-
tated, and because of its impromptu nature it was fairly dis-
parate. Looking at it as a whole, the only Syntheticists were
Gauguin, Laval and myself; the others – Anquetin, Lautrec [?],
Roy, Schuffenecker, Fauché, Daniel de Monfreid – were still
Impressionists.'

Although he had invited Anquetin to exhibit at the Café
Volpini, Bernard may have felt a certain bitterness at the
memory of another exhibition, which had taken place in
Brussels the previous year, and at which he and Anquetin had
shown their first essays in Syntheticism. On that occasion the
critic Edouard Dujardin had pointed to Anquetin as the leader
of the 'Ecole du Petit-Boulevard' and the creator of the move-
ment, to which he (Dujardin) also applied the name *cloison-
nisme* for the first time.[43]

The disappointment of the exhibitors at the Café Volpini
was further increased by the fact that they had attracted the
wrath of the 'old Impressionists', who could justly accuse
them of having stolen their name and, by so doing, of preju-
dicing their reputation under the very aegis of the official
exhibition. Gauguin gave full rein to his irritation in his letter
to Theo van Gogh: 'Pissarro and *some others* are displeased by
my exhibition, *therefore* in my eyes it's good.'

We should recall here that Degas, who was very favourably
disposed towards Gauguin and had not taken part in the
Universal Exhibition, nevertheless figured as one of the
declared adversaries of the group who exhibited at Volpini's.

Gauguin left Paris in very low spirits and sought refuge in
Brittany, to which he was so much attached. But even there,
disquieting news found its way to him and gave him no
respite. It came from Guillaumin, informing him that 'no one
is taking any notice of the exhibition', and from Bernard, who

been rewarded with no moral satisfaction either. Apart from
Aurier, the critics were unanimous in insisting on the recip-
rocal influences of the exhibitors on one another, which was
of course thoroughly exasperating to all of them. Gauguin,
infuriated by the critics' speculations on the question which of
the two, Bernard or Gauguin, had influenced the other, wrote
to Theo van Gogh in November 1889: 'I'm no more like him
than he is like me, it was simply that we were both making
different researches with the same goal in view, a goal I've been
thinking about for a long time but have only lately begun to
formulate.' Gauguin never forgave Fénéon for insinuating
that he had borrowed his *cloisonnisme* from Anquetin. He

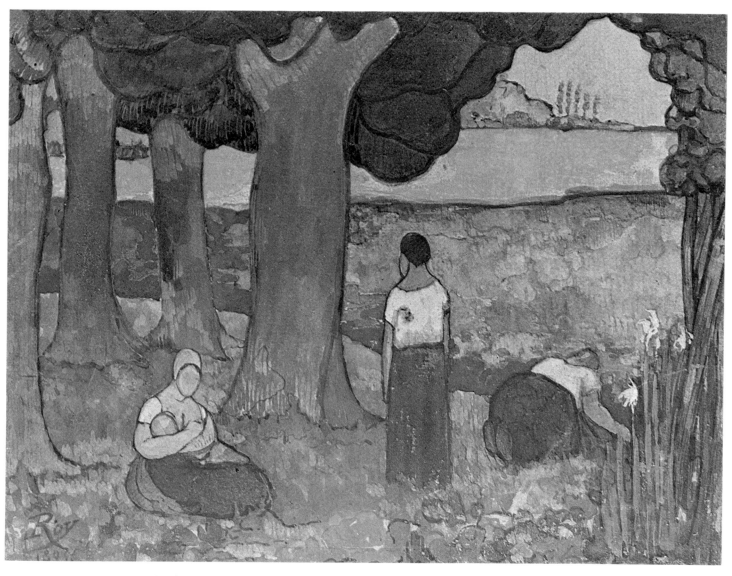

LOUIS ROY *Peasant Women under the Tree* 1895

described for him the storm the exhibition had aroused among the Impressionist old guard. Gauguin wrote to Bernard: 'Your gloomy letter reaches me in a countryside which is at present equally mournful. I well understand the bitterness overwhelming you in the face of the absurdity which greets both you and your work.... As for myself, the only result of my efforts this year is yells from Paris which reach me here, discouraging me so much that I no longer dare to paint at all but take my old body out walking along the shore at Le Pouldu.... I'm strengthened in my opinions and shan't let go of them (I'll go on looking forward, and searching), in spite of Degas who, with Van Gogh,[44] is responsible for causing

the whole disaster.... He senses in us a movement contrary to his own.... Let them look carefully at my latest pictures (if by any chance they've got hearts left to feel with), and they'll see how much resignation and suffering there is in them. Does a human cry mean nothing at all?'

The pessimistic conclusions drawn by Gauguin and Bernard from the undertaking as a whole had the effect of hiding its most important aspect from them: the impression it had made on the young generation of painters.

Aristide Maillol, according to Rewald, had found the exhibition fascinating. He had just left Cabanel's studio and was throwing all his energy into making tapestries designed in the

LOUIS ROY *Breton Landscape* 1891 GEORGES DANIEL DE MONFREID *Landscape in Roussillon* 1889

spirit of Puvis de Chavannes. The exhibition at the Café Volpini came at the right moment for him, confirming that he had chosen rightly, and showing him the path to follow. 'Gauguin's painting was a revelation to me. Confronted by these pictures from Pont-Aven I felt I could work in the same spirit. I told myself that what I was going to do would be good as soon as it received the approval of Gauguin.'

Suzanne Valadon, recalling in old age the outstanding events in her life as a painter, declared that in 1889, when she was twenty-three, she had been intrigued by the Pont-Aven style; she had promised herself there and then 'to apply it to more naturalistic subjects, avoiding everything aesthetic or arty'.

Names to be noted among the artists who first saw canvases by Gauguin at the Café Volpini are the young painters from the Académie Julian, the future Nabis: Paul Ranson, Henri Ibels, K.-X. Roussel, Edouard Vuillard, Pierre Bonnard and Maurice Denis.[45] Sérusier had already won them to the cause of the master of Pont-Aven a year previously by indoctrinating them with the theories of which Gauguin had given an exposition on a memorable day at the Bois d'Amour. But that was only theory. They could now see its realization in

plastic terms; the result was that the young painters acknowledged Gauguin as their master and 'undisputed leader' (Maurice Denis). The exhibition was a shock to them, but a creative shock. To their eyes, the paintings in the exhibition combined naivety with intellectual sublimation, brutal colour with fine line, simple subject-matter with refined vision. In short, they found themselves confronted by a completely new aesthetic which was to guide them towards unknown regions, and enable them to escape from the impasse into which their generation had allowed itself to be forced by the precepts of academicism and Impressionism alike. This revelation of a new style convinced them then and there. One of the new converts, Denis, was to write in 1938: 'These pictures represented the new painting, the school of Gauguin, the school of Pont-Aven, the future.'

Finally, Sérusier himself, who had experienced intervals of doubt after his first meeting with Gauguin, and the latter's speech at the Bois d'Amour which had made such an impression on him, expressed his faith and enthusiasm by telling Gauguin, after visiting the Volpini exhibition: 'I had imbibed the poison. I'm with you from now on.'[46]

V LE POULDU, THE NEW HEADQUARTERS

The Inn of Marie Poupée

Through the arts of the master and his disciples, a commonplace inn was swiftly transformed into a temple of Apollo. Séguin

Paris, during the latter part of the nineteenth century, was prey to an endemic and widespread lassitude. Large numbers of painters escaped from the exhausting atmosphere of the capital and sought refuge in the provinces. The exodus took place in all directions, but Brittany was the most popular choice. The shores of that picturesque granite peninsula are washed by the stormy Atlantic, but the kindly blessings of the Gulf Stream endow it with luxuriant vegetation and a pleasant climate. Not for nothing has it been called *la douce Bretagne*.[47] It goes without saying that the painters were not the only ones to discover the region. Exploratory tours had been carried out by Michelet, Balzac, Stendhal, Victor Hugo, Maxime du Camp, Flaubert and Aurier. But these were fairly short stays, to be classed as 'journeys in search of the picturesque'; whereas for the painters Brittany was to become more like an adopted home.[48]

No other part of France was so fitted to the needs of artists who yearned for romantic scenery and dreamed of a primitive life, in close touch with nature and the lives of the inhabitants. The latter were few, in relation to the size of the region. Occasional clusters of small houses with bright red roofs, the picturesque Breton costumes, particularly the women's, the quasi-patriarchal way of life, the peculiar sonority and tang of the Celtic language, the fact that horse and cart were the only means of communication between the villages, known proudly as *bourgs* – all these offered an irresistible charm: they were primitive and exotic, two qualities ardently coveted, even at this period, by Parisians harassed by the civilization of steam and electricity. Tourists and holidaymakers were still few, and the hotel industry had not yet expanded, so that food and lodging could be found at some small, unpretentious inn for next to nothing.

Gauguin, writing to his wife in 1889, described his life as follows: 'I am at the seaside in a fisherman's inn near a village of 150 inhabitants, living like a peasant and regarded as a savage. And I've been working day in, day out, in a pair of canvas trousers.... I don't talk to anyone and I haven't had any news from the children. I'm completely alone.' He added his address at the bottom of his letter: 'Paul Gauguin, Pouldu, near Quimperlé (Finistère).' This is the earliest mention of the Pont-Aven group's new headquarters, at Le Pouldu. It is unfortunate that the letter is undated and that the lack of information from other sources makes it impossible to discover exactly when the move took place. It is thought that it must have been towards the end of summer, 1889, or in the autumn, and that Gauguin stayed in Le Pouldu for about a year and a half. This period is customarily referred to as Gauguin's third stay in Brittany.

Anticipating events, let us state here an apparently surprising hypothesis, namely that the existence and development of the 'Pont-Aven School' did not really begin until Pont-Aven was abandoned in favour of Le Pouldu. Everything achieved before that should be regarded as a preparatory phase. It was only after settling at Le Pouldu that the School became a living, independent organism, one which not only continued developing internally but also spread an influence externally and attracted new adherents.

This fact can be attributed to several causes. The experience acquired by Gauguin in his contacts with Bernard – experience consolidated by his intense conversations with Van Gogh at Arles and placed before the eyes of the public and the critics at the Café Volpini – was about to prove highly fruitful. Strengthened in his determination to go his own way, both by his successes and, even more so, by his setbacks and disappointments, Gauguin now advanced with giant strides. It was at Le Pouldu that his impetuous drive towards Syntheticism was finally unleashed. Whereas *La belle Angèle*, painted at Pont-Aven a few weeks earlier, is still in a rather mixed style, wavering between Impressionist tendencies and the strongly-marked influence of Japanese prints, the canvases created at Le Pouldu (the *Yellow Christ*,[49] the *Green Christ* or *Breton Calvary*, and the *Agony in the Garden*) are all examples of an unmistakable 'synthesis'. The forms in them appear to be influenced by the traditional Breton crucifixes or Calvaries and also, notably in the case of the *Yellow Christ*, by the polychromed wood sculptures in the chapel at Trémalo.

Despite moments of despondency and indeed of acute depression, the 'master' was in a state of creative euphoria

which communicated itself to the small but continuously growing group of painters surrounding him. The first to join him at Le Pouldu were Jacob Meyer de Haan and Charles Filiger; Sérusier also put in a number of appearances. But the group was weakened by the loss of Bernard, whose relations with Gauguin had become perceptibly cooler since their experiences at the Café Volpini, though they continued to write to each other.

At Le Pouldu the group changed in character. In their correspondence and their many talks on the subject, Van Gogh had taught Gauguin a great deal about organizing an association of painters, and he now saw clearly how to set about it. The immediate result was that the former 'gang of painters' began turning into something more definite, a 'group'. Vincent's faith in him as a leader and teacher fortified Gauguin's conviction that his vocation was to gather others about him and to guide and teach them, and this made him happier than before. Instead of being obliged to share his position with Bernard, as at Pont-Aven, even if only in matters of theory and the 'government of souls', he was now in absolute command.

The group also began gaining in unity; the rural isolation of Le Pouldu[50] made the artists feel more at home and heightened their inclination to work in a communal spirit. Two principal aims were clearly stated: to oppose the official art emanating from the Ecole des Beaux-Arts, a line already initiated at Pont-Aven; and, even more strongly, to oppose the danger represented by Impressionism, something about which, at Pont-Aven, the painters had never troubled their heads. At Le Pouldu, neither Gauguin nor any other member of the group ever called himself an Impressionist, even as a joke.

Like many other young French intellectuals at the time, André Gide was wandering about France on foot. He gives a picturesque account of his fortuitous meeting with the Breton painters.

'I was following the coast, coming up in short stages from Quiberon to Quimper, when one evening I reached a little village; Le Pouldu, if I am not mistaken. It consisted of only four houses, two of which were inns; the smaller of these seemed the pleasanter; being very thirsty, I entered. A servant girl showed me into a whitewashed room and left me there with a glass of cider. Of furniture there was little and of hangings none, which gave prominence to the abundance of painters' canvases and stretchers standing against the wall. Directly I was by myself I darted over to them; I turned them round one after another and gazed at them with increasing astonishment; to me they looked like children's daubs, but the colours were so bright, so unusual and full of zest that I lost all thought of resuming my journey. I wanted to meet the artists who were capable of these amusing follies; I abandoned my intention of reaching Pont-Aven that night, booked a room at the inn and found out when dinner was.

'"Would you like to be served alone, or will you dine in the same room as the other gentlemen?" asked the girl.

'"The other gentlemen" were the painters of these canvases; there were three of them, and they soon came in, bringing their easels and boxes of paints with them. I had of course asked to dine in their company, if they wouldn't mind. They showed they didn't mind at all – they took precious little notice of me. All three of them were barefooted, wonderfully unkempt, and loud and enthusiastic talkers. Throughout dinner I was breathless, devouring their talk, tortured by my longing to talk to them, introduce myself, get to know them, and to tell the tall one with the clear eyes that the tune he was singing at the top of his voice, and which the others took up in chorus, was not by Massenet, as he supposed, but Bizet.... Later I came across one of them again, at Mallarmé's house; it was Gauguin. Another was Sérusier. I have never been able to identify the third (Filiger, I believe).'[51]

The little inn that Gide had found attractive was at one end of the village, by the sea, in which remote setting it provided rest and refreshment for men collecting cartloads of sand from the shore, fishermen at the end of their day's work, and the occasional tourist. It was run by a young woman, Marie Henry, whose beauty caused her to be known as Marie Poupée, 'Marie the Doll'.[52]

The inn became the group's headquarters in the autumn of 1889, and the modest establishment ruled by Marie Poupée entered history; it was part and parcel of the life of the School. Today, modernized and transformed without any thought of preserving the original fabric as one of the high places of painting, her inn is simply one of the many buildings along the main street of the sizable watering-place that Le Pouldu has become. It belongs to Mme Rouzet; she bought it in 1921, rebuilt it in 1934, and still runs the *hôtel-pension*, whose ground floor is a café.

An idea of what the place used to be like is conveyed by Dr Palaux, who describes it in some detail in his reminiscences: 'The inn of Mme Henry, demolished between the wars and replaced by the Hôtel de la Plage, consisted of a large room on the ground floor, separated by a passage from the bar where transient customers, such as fishermen and sand-carters, were served. On the garden side, a lean-to converted into a kitchen was joined on to the bar. On the first floor there were three bedrooms and a little room occupied by the landlady herself. The attics, which could not be lived in, were unsuitable as a studio, so Meyer de Haan rented from M. Mauduit, the stationer in Quimperlé, the second floor, with its verandah, of the latter's isolated villa, the only dwelling-house built on the dunes, looking out over the Grands Sables beach, a hundred yards from the *pension*. The villa's present name is Castel Teeaz.' So much for the topography.

Gide's description of the relatively unfurnished interior gives one to suppose that he visited Le Pouldu at the very beginning of the period spent there by Gauguin and his friends. As the months passed, the walls of the dining-room, from wainscot to ceiling, were covered with a multitude of paintings, and the window-panes were adorned with imitations of stained glass.

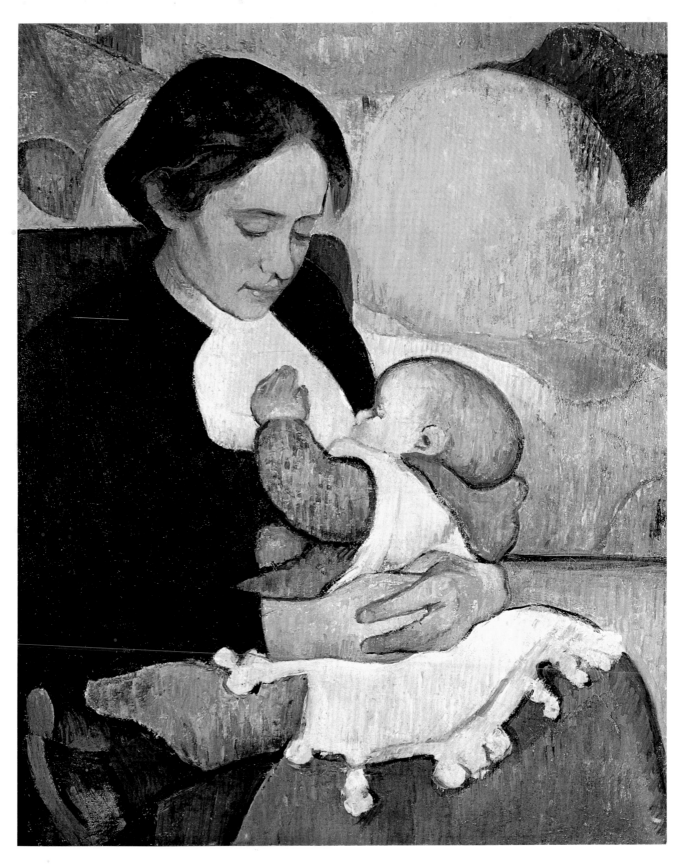

JACOB MEYER DE HAAN *Motherhood : Marie Henry Suckling her Child*

Several descriptions of this attractive interior have been preserved. The most minute is that of Marie Henry herself, in the form of memories taken down at her dictation by her friend of many years, Henri Mothéré. The small, delicate handwriting fills the whole of an oblong notebook which is among the family archives in the keeping of Marie Henry's youngest daughter, Mme Cochennec, at Rosporden. This is what the inn looked like at the time when it was sheltering *messieurs les peintres*:

'On the back (western) wall, opposite the entrance: to the right, a landscape on a square canvas, *Haymaking*, with the artist's dog in the foreground. Distributed over the wall were pictures painted on cardboard, two lithographs on yellow paper, and a small canvas of two or three green apples in a blue bowl. The place of honour, in the middle, being occupied by the large portrait of the owner painted by Meyer de Haan. Finally, a drawing in Indian ink by Gauguin. On the right-hand wall, which contained the fireplace and faced south: on the chimney-breast, the large bust of Meyer de Haan, bigger than life-size, carved and painted by Gauguin in a massive block of oak. On the mantelpiece: *Breton Dance*. On each side of the bust, earthenware pots, decorated with little humorous motifs. On brackets fixed to the wall, one each side of the fireplace, a plaster Negress and a small Javanese figure. On the upper panels of the doors of the cupboards, a self-portrait by Gauguin on the right, a portrait of Meyer de Haan on the left, both painted directly on the wood.[53] The window, giving on to the road: the panes were decorated with a composition in several parts illustrating the life of the fields, painted in oil. The weather destroyed this in four or five years. On the partition near the entrance: the upper part was decorated by the canvas *Bonjour Monsieur Gauguin*,[54] stuck on to the wall with white-lead; in the lower part, *The Carib Woman*, painted directly on the wood. Finally, outside the dining-room, over the door giving access to the bar, was *The Earthly Paradise*.'[55]

There is no description of the fourth wall, but the gap is filled by a precious photograph which has fortunately been preserved. Taken in 1924, it shows us the paintings with which this wall was decorated and which were discovered under six layers of wallpaper. The photograph was taken before the murals were bought and removed by an American collector (probably Abraham Rattner).[56] It represents part of the dining-room, whose table and chairs can be seen in front of a wall on which hangs a large picture, *Women Stripping Flax*, by Meyer de Haan, accompanied by a long panel, *Joan of Arc as a Breton Woman*, and a section of wall on which is represented *The Swan*, both painted by Gauguin.[57]

Marie Henry's careful inventory is rounded off by reminiscences in a more poetic vein from the pen of one of Gauguin's closest friends, Séguin. Although it was not until a little later that he met Gauguin, after the latter's return to Le Pouldu from Pont-Aven, Séguin was a constant visitor to the inn. 'Those days', he wrote in 1903, 'were not like our own; talent was respected then, and the village of Le Pouldu was like the garden of Plato. Through the arts of the master

and his disciples, the commonplace inn was swiftly transformed into a temple of Apollo: the walls were covered with decorations which astonished the occasional visitor, not a surface was spared, noble maxims encircled fine drawings, the windows in the bar were converted into dazzling stained glass.... But if perchance, after reading these lines, any poet or artist who was there should wish to live his time at Le Pouldu over again and re-acquaint himself with the surroundings I have tried to describe, let him not return to Brittany and visit our canny men of business. Nothing is left of the past except our own memories of the painters; the interior they decorated, for fun and for the repose and delectation of the eye, has been carried off piece by piece, the door-panels have been sawn out, the canvases cut away, the chimney-piece they carved has been taken; so have the rectangles of cardboard they decorated, and the drawings and watercolours which showed up gaily on the walls. Where are that lovely painting, *Bonjour Monsieur Gauguin*, the peasant girl painted by Sérusier, the *St John* by Filiger, and the farmyard signed by De Haan?... Never again shall be seen the cradle of Symbolist painting, and if for our greater happiness the gentle master were to return from exile, he would weep before the modern tavern which has replaced his goodly inn of times gone by, where we spent such happy hours and which I have endeavoured to evoke for the greater glory of his name and of his kind, a beloved and fatherly image, the memory of which is always in my mind.'

Marie Poupée, whose account was taken down by Henri Mothéré and repeated by Chassé, describes how the artists spent their time at Le Pouldu: 'They got up very early and came down from their rooms at about seven. After breakfasting on *café au lait* and bread and butter they went out to work in the countryside, in the open air, taking with them their easels, brushes and paints, or sketchbooks, according to the light. They came in at half-past eleven and lunched at noon. At half-past one, or two, they resumed work and went on until five, except on the rare occasions when they had visitors to receive. Dinner was at seven. The interval before it was spent in talk or studio visiting. They went to bed very early, about half-past nine, after a game of lotto or draughts. Gauguin's draughts board, marked out on an old advertisement placard, with a little decoration round the edge, is still at the house. In addition, they often used to draw by lamplight. They didn't read at all, either books or newspapers. It is true that De Haan's enormous ancient Dutch Bible is still stored in our attic. But it is doubtful whether he ever actually handled such a cumbrous volume. It weighs at least ten kilos. It would have required a block and tackle, and its owner was a little, rickety, dolled-up, sickly person, almost an invalid. But music was an entertainment they were very fond of. Meyer de Haan loved listening to it but never played, though he said he could. Gauguin, on the other hand, played the mandoline and the piano. He had learnt the latter instrument late in life, as a grown man, and could only play fairly slow pieces. His repertory included the *Cradle Song* and *Träumerei* of Schumann, and some Handel.'

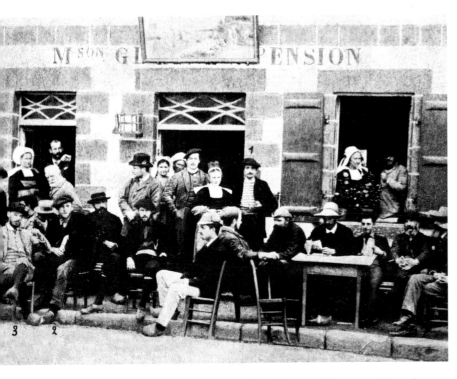

Group of painters in front of the Pension Gloanec at Pont-Aven.
1 Puigaudeau, 2 Gauguin, 3 Laval.

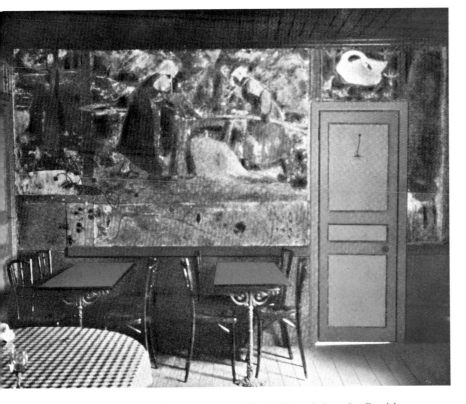

Part of the dining-room at Marie Henry's inn, Le Pouldu

Paul-Emile Colin, according to Chassé, confirms the painters' fondness for hearing and playing music: 'In their spare time the four busied themselves with music. Gauguin would take his guitar and Filiger his mandoline, and they would go down on to the sands and settle in a corner of the rocks; a melody by Schumann would rise softly from the mandoline, which Filiger played with much feeling, but almost inaudibly; he played for himself.'[58]

When, in September 1914, the Polish painter Tadé Makowski caught the last train carrying refugees from Paris and returned to Brittany at the invitation of his friend and senior, Wladyslaw Slewinski, the latter took the opportunity of their long walks together to tell him all about the life of this strange brotherhood which had existed when Gauguin was there. Speaking as one painter to another, he gave a summary exposition of the aesthetic which had governed the work of all of them. After making a visit to Le Pouldu, Makowski committed his friend's memories to paper the same day. They later appeared in print in Poland; they include the following:

'It was spring – about twenty years ago.... Two windows lit the interior of a Breton room, a few benches and wooden tables with bottles and glasses; strange faces, some gay, others sad; resolute attitudes, nervous gestures, sparkling eyes. Figures more or less familiar, dressed simply but a bit oddly, with Breton caps, pipes, and wooden sabots painted vermilion and cobalt, ornamented with carvings and dark lines. Sitting in the centre, draped in a cloak, was a man with a proud, noble face, brilliant eyes and an aquiline nose. With his elbows on the table and his long hair thrown back, he was expounding something and drawing imaginary lines in the air. The others were listening to him and watching his gestures. It was a mild, still night. The men were all painters who, after the day's work, liked to relax in good company. The dark smoky room, whose ceiling and walls were enlivened by sketches and by patches of colour, was the scene of a lively argument about the ideals and principles of the beautiful. Gauguin was surrounded by his colleagues: Filiger, Sérusier, Bernard, O'Conor the Englishman [*sic*], De Haan the Dutchman, Slewinski the Pole, and others. They used to gather every day, and they all thought along the same lines. Gauguin came from his studio, which was situated apart, by the sea, and overhung by a fig-tree growing in the middle of a little garden; Filiger, from a small stone-built house at the far end of the village; the others, from inns scattered here and there; this room was their habitual meeting-place. The little village of Le Pouldu, to which G. had moved after a short stay at Pont-Aven, was a welcoming place to the colony of painters, offering them its wonders, its colours and its life. It was a difficult period, the initial stage in the struggle to create a new aesthetic. Gauguin's *Yellow Christ*, of which Octave Mirbeau has written so enthusiastically, had just been finished. New conceptions of form, flat areas of colour bounded by dark lines, the decorative interpretation of subjects, pure tones, brilliant and full of vigour, the bold juxtaposition of elements in a harmonious unity, the struggle against Impressionism – that imitation of nature and fugitive

light – all these thoughts and aspirations were discussed on that memorable spring evening. What pictures were created in those days, pictures now so keenly sought after, pictures beyond price! What excitement, what soaring emotions! At the very time when the final blaze of Impressionism was burning itself out on the banks of the Seine and in the vicinity of the forest of Fontainebleau, these hotheads were hurling a challenge in the face of the world, as other Argonauts of painting had done before them, Poussin, Ingres, Delacroix, Manet. People who like everything to be neatly pigeonholed have called this "the School of Pont-Aven".'

Without wishing to throw doubt on the accuracy of the reminiscences – some of which are quoted in this book – of Séguin, Verkade, Delavallée, Colin or Slewinski, each of whom conveys in his own way exactly what we need to know, namely the atmosphere in this colony of painters, we must point out that for the most part these memories reflect only the successive periods spent in Brittany by Gauguin himself. Hence much vagueness about dates and other factual details, so that the historian is greatly hindered in his attempt to trace the chronology of the group's development, and to show who joined it when.[59]

After taking into account the variations caused by continual arrivals and departures, we find that the list of those present in Brittany in the period 1889–90 comprises Moret, Maufra, Chamaillard and Jourdan, joined by Slewinski in 1890; although some of these lived at Pont-Aven they frequently came over to Le Pouldu and joined in walks and discussions. Of the painters who joined Gauguin and De Haan only at Le Pouldu, Marie Poupée names Laval as the first to arrive, for a short stay only on this occasion, and, according to a letter from Gauguin to Bernard, 'after not having touched a brush for six months'. Sérusier arrived from Paris and stayed until the autumn of 1890. In the summer of the same year Jules le Ray, who had brought his family from Nantes to spend the holidays at Les Grands-Sables, attached himself to the group. Gauguin visited him frequently, gave him drawing lessons and painted his little son Louis; the portrait is the one known as *Monsieur Loulou*.[60] In July the small group gained a new member in Filiger, who took up his quarters in a studio rented from M. Mauduit before settling in the countryside in the 'little white stone house'.

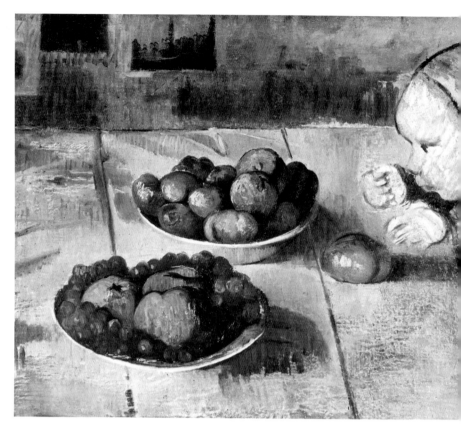

JACOB MEYER DE HAAN *Still-life with Marie Henry's Daughter Mimi*

'The result', as Marie Henry summed it up through her amanuensis, Mothéré, 'was that by the middle of summer, 1890, the poor little house at Le Pouldu was sheltering beneath its roof Meyer de Haan in the big bedroom, Gauguin in the room over the yard, Sérusier in the room overlooking the road, Filiger in the studio, the proprietress in the lavatory and the maid in the bar.'

VI SYNTHETICISM AND EXPRESSION

Jacob Meyer de Haan 1852–1895

De Haan's making wonderful progress here.

Gauguin to Emile Bernard

In a letter to Schuffenecker, probably written in October 1889, Gauguin said: 'I'm by the sea, in a big house with a view straight down on to the water. It's superb when there are storms, and I'm working with a Dutchman who is my pupil and a very good chap.' This 'very good chap' was none other than the Dutch painter Jacob Meyer de Haan, whose acquaintance Gauguin had made in Paris a short time before.

It is worth noting that De Haan was the first painter to whom Gauguin explicitly referred as 'my pupil'. And De Haan's behaviour towards Gauguin was in fact quite different from that of the other painters in the group: it was not a case of two painters meeting by chance in Brittany and one succumbing to the charm or influence of the other, as happened with Laval, Chamaillard and, indeed, Bernard and Sérusier; on the contrary, De Haan, by a deliberate act of choice, had placed himself under a master with a view to benefiting from his instruction.

What might this painter, who had arrived from Holland at the age of nearly forty, reasonably expect to receive from his French mentor?

Born in 1852, of a Jewish family of biscuit manufacturers in Amsterdam, De Haan was interested in art and had already started painting while still working in the family business. After surrendering his share in the firm to his brothers in return for a monthly pension, he devoted himself entirely to an artist's career. The lessons in drawing and painting which he took in Amsterdam revealed a by no means negligible skill and talent, manifested particularly in his portraits and in popular scenes in the style of the two Teniers. Discouraged by the cool reception given to his picture *Uriel Acosta*, which he exhibited in his native city in 1887, Meyer de Haan left in the following year for Paris, accompanied by a friend called Isaacson.

The accounts of his life which have appeared hitherto are as casual and summary as may be. Hastily compiled notes inform us that, dazzled by the Impressionist paintings in the Universal Exhibition, De Haan was introduced not long afterwards by Pissarro to Gauguin, whom he followed to Brittany, there to subject himself completely to the 'master's' influence. The rich, open-handed Dutchman supported both of them. Later, De Haan's family are said to have opposed both his marriage and his projected voyage to the South Seas with Gauguin.

Detailed examination of the correspondence between Vincent and Theo van Gogh, over the period from October 1888 to January 1890, yields a few unexpected additions to this somewhat sketchy biography and enables us to make certain vital corrections. The letters show that De Haan and Isaacson set out for Paris in autumn 1888. Feeling rather lost, they sought the support of their compatriot Theo van Gogh, who was quite at home in the artistic life of Paris. He helped them in every way he could, and even put up De Haan under his own roof. It was also at Theo's apartment that the two Dutch painters made the acquaintance of Pissarro. The meeting is easy to date: in a letter written to Theo in October 1888, Vincent asks him for a detailed account of his conversation with De Haan, Isaacson and Pissarro. In the same month we find him writing delightedly to Theo: 'I'm very pleased to hear that one of the Dutchmen is staying with you, so that you won't be alone, this is a very, very good thing, especially as winter will soon by on us.'[61]

Theo took charge of the work of his new friend to some extent, and sent Vincent his drawings and sketches to elicit the latter's comments and guidance. Vincent thought highly of De Haan's talent and progress, and was anxious to meet both the Dutchmen. He particularly liked De Haan's drawings, which showed a fondness for the finest works of Rembrandt: 'The trouble they have with colour – Heavens, don't I understand that! As for the careful study of Rembrandt which shows up in the two drawings by De Haan now in front of me, he must stick to this.' (October 1888.)

The Van Gogh brothers' correspondence about De Haan belongs to the period when Gauguin was staying with Vincent. Despite being distracted by the presence of this somewhat difficult guest, Vincent found time to dispense useful advice for De Haan in his letters to Theo. What he most admired

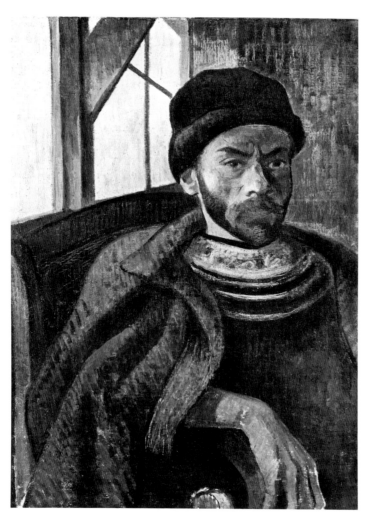

JACOB MEYER DE HAAN *Self-portrait in Breton Costume*　　　　PAUL GAUGUIN *Bust of Meyer De Haan*

about De Haan, apart from his love of Rembrandt, was his skill in depicting the human face. This was a prophetic piece of appreciation, as we shall see.

After having watched his development for a few weeks, Vincent recommended him to abandon chiaroscuro in favour of colour. He approved his intention of temporarily schooling himself in the methods of the Impressionists. 'I'm very glad to know that you're not alone in the apartment', he wrote to Theo in November. 'De Haan's drawings are very fine, I like them very much. Now he must do the same thing with colour, achieve the same degree of expressiveness without the help of chiaroscuro in black and white, and hang it, that's not easy. And he'll even find himself drawing in a new way if he carries out his plan to put himself through Impressionism *as a training*, regarding his new essays in colour as studies and nothing more. But in my opinion he's right several times over to go in for all this. Only there are several self-styled Impressionists who haven't got his knowledge of the figure, which

is going to pay good dividends later and will always stand him in good stead. I'm very keen to meet De Haan and Isaacson one of these days. If they ever come down here Gauguin is sure to tell them, "Go to Java and do Impressionist paintings". Because Gauguin, though working hard here, is always filled with nostalgia for hot countries. And there's no doubt that if one did go to Java, for example, with colour as one's objective, one would see a whole heap of new things. Another thing is that in those more luminous countries, under a more powerful sun, the shadows, both direct and indirect, of objects and figures become quite different and are so highly coloured that the temptation is simply to cut them out altogether. That happens even here. Well, I won't insist on the importance of the problem of tropical painting, I'm sure De Haan and Isaacson themselves will feel its importance in advance. In any case coming down here, at any time, will do them no harm at all, they are bound to find some interesting things.'

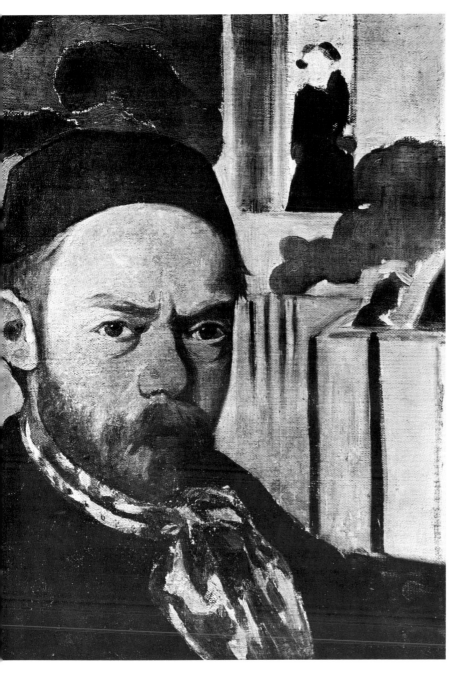

JACOB MEYER DE HAAN *Self-portrait on a Background in the 'Japanese' Style*

can be no doubt that Gauguin, who was living with Vincent at Arles at the time, had many opportunities for looking at De Haan's drawings, and it may be assumed that he took some part in these long-range discussions. It can also be inferred that it was at Theo's apartment that Gauguin first met De Haan, on his return to Paris after the tragic events at Arles.

The deductions expressed here contradict the often repeated statement that De Haan met Gauguin in consequence of being recommended to him by Pissarro. This is in any case improbable in view of the considerable coolness which had developed by now between Pissarro and Gauguin, and which degenerated into open conflict at the time of the exhibition at the Café Volpini.[62]

The same letter from Vincent reveals the meaning of a somewhat puzzling sentence in a letter written in 1890 by Gauguin to Schuffenecker, in which, overwhelmed by his total poverty, he cries in an access of despair: 'Do you think the Dutchman is supporting me here? He asked me to leave Pont-Aven and come to Le Pouldu to teach him Impressionism, and, as I hadn't as much credit as he had, he is paying for my board here, against the expectation of my selling something to Goupil.'

Although Gauguin was here indulging in one of those fits of spite which made him so unfair to other people – the truth being that De Haan financed him at Le Pouldu for whole periods at a time, including the rent of his studio from Mauduit – it must be pointed out that Gauguin regarded the bargain as a fair one: he was teaching De Haan the art of painting and was being paid for it.

Gauguin was pleased with his pupil. He wrote to Bernard in October 1889: 'De Haan's making wonderful progress here. He sends you his best wishes.' And in Marie Henry's manuscript we read: 'The place of honour, in the centre, was occupied by the large portrait of the proprietress by Meyer de Haan. This canvas had elicited the highest degree of admiration from Gauguin, not usually lavish with his praise. While it was being painted he kept asking De Haan how it was coming on, but the latter refused to show it to him until it was completely finished. When the moment came the master was markedly impressed by his pupil's work. He stationed himself in front of it and contemplated it at length. He then made a frame for it, which he decorated himself. Finally, he hung it in the most prominent position in the room.'

If the academic studies executed by De Haan in Holland[63] are disregarded, his painting career, properly speaking, covers a period of two years. All, or nearly all, the pictures he painted at Le Pouldu while working with Gauguin he bequeathed to Marie Henry. She in turn left them to her two daughters, Ida Cochennec, whose father was presumed to be De Haan, and the elder daughter, Marie Ollichon. When she moved to Toulon in 1924 to live with Marie Ollichon, she took with her, among other canvases, the portrait of herself entitled *Motherhood: Marie Henry Suckling her Child*. The collection, after being kept intact for years by the Cochennec and Ollichon families,

This lengthy extract from Vincent's letter shows that the idea of an apprenticeship in Impressionism, as an intermediate stage between Rembrandt and Syntheticism, had been conceived and seriously discussed by the triumvirate of De Haan, Theo and Vincent, and that the choice of Gauguin as director of the experiment had been made virtually at the outset. There

97

JACOB MEYER DE HAAN *Farm with Well, Le Pouldu* 1889

was sold at auction in three instalments at the Hôtel Drouot in 1959, the buyers being museums and private individuals.

Earlier, in 1952, Fernand Dauchot had compiled a catalogue, with a short preface, of fifteen canvases by Meyer de Haan which were in the keeping of Ida Cochennec at Rosporden, and published it in the *Gazette des Beaux-Arts*. Among other things, he wrote that 'The Cochennec collection shows the prodigious development made by De Haan under the stimulus of contact with Gauguin. Already equipped with a sound classical technique, he now purified his vision and discovered the enchantment of the colours with which we are always surrounded, but which it is given only to a chosen few to perceive. He made the Master's methods his own without abandoning his personal gifts: his full, juicy touch with a well-loaded brush, and his deep colour. In his painting the dramatic feeling of Rembrandt and Van Gogh is allied to something subtly and indefinably Jewish.'

It was at Le Pouldu that De Haan produced the works that place him among the school's most eminent representatives. He remained within the conventions of Pont-Aven but interpreted them in his own way, and it is this which constitutes his contribution to the message of the Breton group. Séguin records in his memoirs that De Haan was by no means a proponent of Symbolism in painting, and that he often joked about the subject, preventing others from discussing it seriously and even caricaturing the word '*symbole*' by pronouncing it '*cimebolle*'.

What are we to make of this? Was he opposed to the magic of synthesis? Undoubtedly not; its ingredients are plain to see in his compositions: surfaces flattened by the elimination of perspective, backgrounds reduced to the bare minimum, and outlines boldly emphasized, as in his *Cottages on the Edge of a Wood*, so close to typical *cloisonnisme*. But the eternal Dutchman in De Haan declined absolutely to abandon the pictorial inter-

PAUL GAUGUIN *Farm at Le Pouldu* 1890

pretation of appearances. His atavistic attitude to the visible world prevented him from renouncing it in favour of pure decoration; he refused to imprison a smooth, homogeneous surface in a dark outline in the manner of Bernard, who, in alliance with Anquetin, had made this principle the foundation of the theory of suggestive colour. Though he remained close to Syntheticist painting, De Haan did not deprive it of its realistic content; far from it. His expressive power enabled him, in fact, to elevate synthesis to its apogee, and to attain Symbolism through pure painting.

In his *Still-life with Carrots* (Musée national d'Art moderne, Paris), in which the pewter vessel gleams so lustrously, the construction of the woven basket is conveyed with astonishing mastery and a concern to render faithfully for us the surface of the object observed. De Haan's still-lifes are painted wholly in his own way; he differs from the painters of the Dutch tradition as clearly as from those of the Pont-Aven group: the plane in which his objects are placed is very close to the spectator's eye, so that they look enormous although they are in fact painted on a small scale. The bunch of garlic, in the

still-life of that name (Musée des Beaux-Arts, Rennes), takes up three-quarters of the canvas and slants part of the way round the pewter pot, which is likewise very large. The same principle is applied in the *Still-life with Onions* (Musée des Beaux-Arts, Rennes). The strength of these canvases resides in their sturdy, static construction, which has the added attraction of emphasizing a bold juxtaposition of cool and warm zones of colour.

There is in his pictures a kind of fixity which is all the more curious in that he makes it a principle always to avoid axial divisions. The majority of his compositions, analysed from this point of view, yield the following schema: an imaginary diagonal divides the canvas into two parts; all the 'gigantic' elements of the composition are massed in one of these, in the other the painter places some object which is insignificant in itself, but whose situation and lighting cause it to stand in perfect equilibrium with the opposing masses. In some of his pictures, equilibrium is achieved by means of a single touch of brightness counterpoising a group of several solid objects painted in dark shades.[64]

A painting which falls outside this analysis is the *Cottage on the Edge of a Wood*, also known as *Landscape at Le Pouldu*, in which De Haan comes closest to the style of Pont-Aven, even if not, as Hofstätter maintains, to that of Gauguin; indeed, the outlining of adjacent surfaces engenders a flattening which is far more pronounced than in the work of Gauguin, where a certain interpenetration of forms is always maintained. In De Haan's paintings the forms never cut across one another, never encroach on one another; 'each one finishes exactly where the next begins'. This was the procedure adopted by Bernard at one point, and Filiger later had recourse to it in his landscapes composed in sheets or zones.

On the other hand, a close pictorial kinship between De Haan and Gauguin becomes evident if we compare two of their canvases depicting the same subject: *The Blue Roof* or *Farm at Le Pouldu* by Gauguin, and *Breton Farm with a Well, at Le Pouldu* by De Haan. Although the canvas by De Haan (Rijksmuseum Kröller-Müller, Otterlo) is dated 1889 and that by Gauguin (Emery Reves collection) 1890, it seems certain that the painters were working on them simultaneously, with their easels side by side; the landscape framing the farm is the same in both cases, and both include a Breton woman drawing water. Moreover, both pictures are of almost exactly the same size. In view of the fact that Gauguin's landscape – painted at a time when he had already carried Syntheticism to an advanced stage – constitutes in a sense a retrograde step towards that surface lightness and freshness which he had abandoned, it becomes practically certain that this was one of those famous 'lessons in Impressionism' which Gauguin enjoyed giving to De Haan. Nor is the possibility to be excluded that De Haan's canvas was corrected here and there by Gauguin.[65]

As Van Gogh had so accurately divined, De Haan's understanding of portraiture was to prove very serviceable to him. We know of three studies in this genre which were painted during this period: *Motherhood*, already mentioned, which was

JACOB MEYER DE HAAN *Flowers in a Glass*

to impress the master so strongly, and two self-portraits. The draughtsmanship in the first of these is masterly; the composition, as well as using the diagonal scheme of which De Haan was so fond, is based on supple circular lines in conjunction with a continuous linear arabesque which maps out large flat surfaces. The head, tenderly inclined towards the baby, the serenely-placed hands, and the use of blue – the traditional Madonna colour – combine to create the ambiance of maternity without recourse either to light and shade or to literal realism in the treatment of the face. The result is that while the picture obeys the new conventions it also constitutes a subtle psychological study. It is in fact an excellent example of 'expressive Syntheticism'.

The two self-portraits are at the opposite pole to psychological interpretation. One, doubtless the earlier, suggests a conscious submission to Japanese influence; its title, indeed, is *Self-portrait on a Background in the Japanese Style*.[66] Flat patches of colour, a deliberate absence of shadows, a yellow background (with a Japanese print, as in some pictures by

JACOB MEYER DE HAAN *Bunch of Garlic with Pewter Pot*

Van Gogh and Gauguin), are contained in an unusual frame, painted red. But concessions to the programme go no further than this. The painter's face, though surrounded by the novel dark outline, is devoid neither of light nor of traditional modelling; these two conventional elements have enabled the artist both to see and to show himself more effectively. Hofstätter draws attention to the intense psychological concentration visible in the model's eyes: 'The gaze is sharp and firm; the impression it makes is one of objectivity, clarity and calm, a light shining from the furthest depths of the sitter's being. The eyes are the spiritual centre of the painting but at the same time its most realistic element; the forms radiating from it are progressively more abstract, culminating in the schematic interpretation of the background.'

In the other self-portrait, which has been more frequently reproduced, the *Self-portrait in Breton Costume*, the artist is wearing a blue smock embroidered in yellow, a cloak thrown round his shoulders, and a Breton cap: these accessories give the picture a monumental quality, reminiscent of the type of

setting used in portraits of noblemen. In view of the various written descriptions, including oral accounts committed to paper, of De Haan's physique, one is inclined to think that this personal conception of himself was intended by the artist to compensate his feelings of inferiority as a shy, puny little hunchback, feelings intensified by prolonged companionship with Gauguin, the superb giant with the figure of an athlete and the profile of an Aztec. Dauchot remarks wittily of this incongruous pair that they remind one of Cain and Artem in the tale by Gorky. The sickly Jew supported the giant who proclaimed himself invincible, and who in the end cast his ally off without compunction.

The question arises whether Gauguin really did cast De Haan off, or whether it was the sensitive De Haan, wounded by his friend's heartlessness, who foresaw the outcome and withdrew before it could happen. Probably we shall never know the answer. Relations between master and pupil had at first been very promising. De Haan appealed to Gauguin as strongly as did Bernard, as a prospective companion on his

JACOB MEYER DE HAAN *Landscape, Le Pouldu*

Tahitian venture. The matter appeared to be settled, and Gauguin frequently referred to it in his letters to Schuffenecker and Bernard. But something went wrong at the last moment, and Gauguin sailed without De Haan. Finding no explanation in Gauguin's subsequent correspondence with either Monfreid or Molard,[67] or any sort of allusion to the affair in *Avant et après*, we are thrown back on the remaining sources, for whatever they may be worth: namely the legend maintained in the family of Marie Henry and that current locally, as reported by Dr Palaux.

When Gauguin and De Haan began lodging at the Auberge des Grands-Sables, Marie Henry had reached the age of thirty. Her fresh, sparkling complexion was what had earned her her affectionate nickname; accounts by those who knew her make it clear that there was nothing doll-like about her in

other respects. 'When I alighted at the inn', wrote Jan Verkade in *Le Tourment de Dieu*, 'a woman of about thirty came forward to meet me; tall, strongly built, carelessly dressed. Her black hair was like a helmet, her black eyes lit up a face full of rude energy.... The landlady by no means shared the Dutch passion for cleanliness, but she had a kind heart and was an excellent cook.'

Marie Henry was an unmarried mother, living alone, and the morals of the painters she received at her inn were reputedly lax; far from disapproving, moreover, she seems to have joined in their nocturnal escapades in the surrounding country, and it is to be inferred that 'a person of that description' enjoyed no very good name in the austerely virtuous atmosphere of Breton society.[68] 'My mother had a very pretty voice; she was young and good-natured; and she was alone and poor,

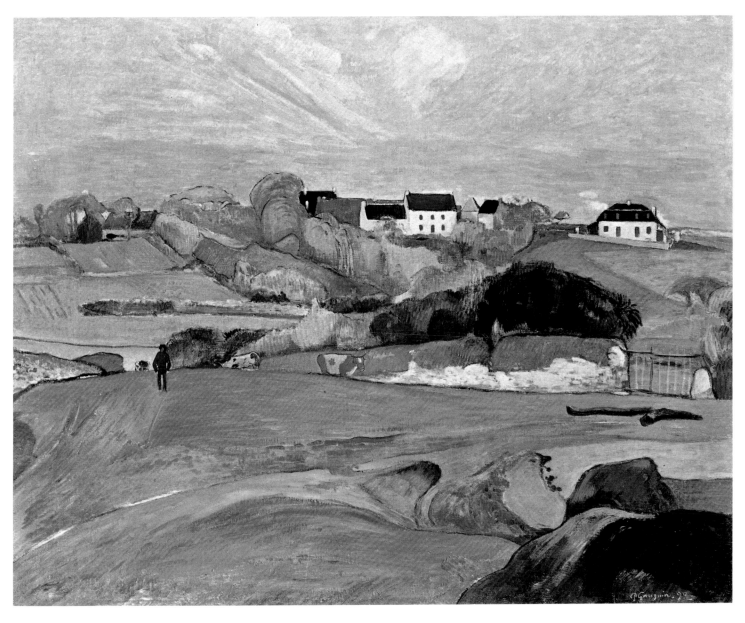

PAUL GAUGUIN *The Fields, Landscape at Le Pouldu* 1890

with no one to defend her; bad characters took advantage of her inexperience', said Ida Cochennec,[69] one of Marie Poupée's two daughters. The principal target of the words 'bad characters' is Gauguin.

It is clear that the version of peasant morality followed by Marie Poupée was all her own. Of the two suitors who paid court to her from the day they arrived, the pretty landlady had no hesitation in rebuffing the too-aggressive Gauguin, 'that husband and father', whose advances she regarded as 'shameless'. It was not the irresistibly handsome leader of the group

who was to win her heart but little De Haan, who was so ugly, calm and unobtrusive but who 'painted such pretty flowers on her sabots'.[70]

That winter, after Gauguin had left for Paris, De Haan became almost a member of the household. When Mauduit terminated the tenancy of the building which had served the two painters as a studio, Marie Henry arranged one in an outhouse close to the inn.

Inevitably, De Haan's privileged position was exasperating to Gauguin, the rejected suitor. He wrote to Bernard in

103

November 1889 that his luck was out, that everything went wrong for him, that his life was empty of all joy and that he was tormented by loneliness. It seems that in an attempt to get rid of his rival he induced him to go to Paris on some pretext or other. It can even be conjectured that it was he who warned De Haan's respectable family in Holland of an impending misalliance. However that may be, several things happened almost at once: De Haan was summoned to Paris, his family threatened to stop his income, Gauguin dropped the idea of taking him to the tropics, Marie Henry gave birth to her child, and De Haan left suddenly for Amsterdam. In 1891 he was in Paris again but returned to Amsterdam, this time for good, and died there in 1895, willing all his property, pictures and effects – his palette and the enormous Bible among them – to Marie Henry. She thereupon informed her daughter that she (the daughter) was the natural child of the Dutch painter, and brought her up to revere her father's memory.

'Gauguin shattered our mother's life,' Ida Cochennec declared to the author; 'she loathed him; the news of his death was a real relief to her. He did her a great wrong because of his jealousy.' It seems to have become a tradition in the family to accuse Gauguin of having prevented Marie and De Haan from becoming husband and wife.[71] The rift was intensified when Gauguin subsequently tried to remove the canvases he had left behind at the inn. Marie Henry refused to hand them over, maintaining that they had become her property in return for giving him free board and lodging for so long.[72]

What impression did De Haan make on his contemporaries? 'Deformed, rufous, with a shrewd and penetrating eye, he nevertheless radiated conviction to an exceptional degree' is the description of him which Chassé attributed to Paul Colin, a colleague in his Breton period. When the Dutch painter Verkade arrived in Paris with a letter of recommendation addressed to De Haan, he found, in a scantily furnished room

PAUL GAUGUIN *Nirvâna, Portrait of Jacob Meyer de Haan*

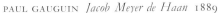
PAUL GAUGUIN *Jacob Meyer de Haan* 1889

PAUL GAUGUIN *Barbaric Tales* 1902

in Montparnasse, 'a little hunchback' who 'was very pleasant and at once began talking about his friend, the painter Gauguin, with whom he had lived and worked for some time in Brittany.'

With his stunted figure and strange expression, De Haan inevitably fascinated Gauguin by his possibilities as a model. One of the first things Gauguin did when they settled together at Le Pouldu was a portrait of him, over life-size, carved in a block of oak and polychromed. It was set up in Marie Poupée's establishment, over the dining-room fireplace. The bulging forehead and half-closed eyelids, the fragmentary hand supporting the chin, the fantastic headgear and the bizarre and sinuous forms in which the head was wreathed were intended to bring out the Oriental characteristics of the sitter.[73]

The same kind of analytical and philosophical interpretation of the face is evident in the portrait painted at Le Pouldu in 1889, in which deformation is carried over into caricature. Leaning on his right hand and gazing into the distance, the subject is sitting at a table on which are a lamp, a plate of apples and two books, *Sartor Resartus* by Carlyle and Milton's *Paradise Lost*. Quite independently of any symbolic intention, and of literary allusions to pessimism and to fantasy, it is all too clear that the peculiar presentation of the sly, slanting, wide-open eyes, the excessively bulging brow and the no less

105

excessive broadening and thickening of the nose are hardly intended to flatter the sitter; he seems to incarnate a hybrid between a philosopher and a demon.

More extraordinary still is the resemblance to a malevolent sorcerer which Gauguin imposed on De Haan in the gouache entitled *Nirvana*. The background is almost indentical with that in the lithograph, *At the Black Rocks*,[74] which was used as the frontispiece of the catalogue of the Volpini exhibition, and which represents three women in attitudes of grief and resignation. The subject of the gouache is an Oriental magus with his black hair pushed back, and a cabbalistic emblem, a golden snake, between his hands. The raised shoulders, indicating the hunchback's abnormal spinal curvature, are covered with a cloak of strident ultramarine which on one side merges into the highly decorative gold and blue background. The face recalls a fox's mask and is lit by a dazzling light that floods it with orange and violet reflections. And the centre and focus, not only of the head but of the whole picture, are the two enormous slanting eyes, the eyes at once of a fox and of a hypnotist.

Jean Leymarie maintains that Gauguin's *Nirvana* was born of the 'Oriental shock' he experienced when visiting the Asian pavilions at the Universal Exhibition of 1889. Although it is just possible to believe in this cause-and-effect relationship, to which however we should probably add the influence, direct or indirect, of Schopenhauer's ideas on the subject of *nirvana*, it is difficult to ignore the psychological element in a creation born of Gauguin's steadily increasing animosity towards De Haan and his urge to revenge himself by making a massacre of his rival's features and attributing to him the possession of demoniacal instincts. To be convinced of this, it is enough to compare these portraits of the Dutchman by Gauguin with the fox's head in a canvas painted the following year, *Lost Virginity*.[75] Writing to Bernard, Gauguin said that the fox was the 'Indian symbol for perversity'.

Gauguin remained obsessed by the deformed body and expressive face of De Haan after their friendship had broken down, and even after the death of his friend and successful rival. The *Souvenir de Meyer de Haan* can still be seen haunting him in a woodcut he made during his second period of residence in Tahiti. Like a persistent hallucination, the image reappears in the figure of the crouching, sharp-clawed demon gazing at the two Maori girls in *Barbaric Tales* (1902). And finally, De Haan's features, though distorted, are easily identified in – of all places! – the face of the dog which figures in a picture dating from the same year, *Two Women* or *Flowers in her Hair*.[76]

Was the motive simply an obsession which the artist strove to interpret in his painting? Or should we regard it as a kind of vengeance inflicted on his former friend and disciple in

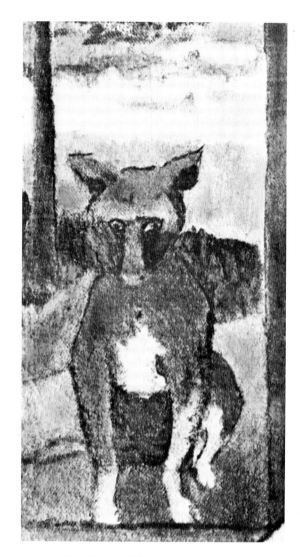

PAUL GAUGUIN *Two Women (Flowers in her Hair)* 1902 (detail)

compensation for a humiliating defeat? The question is not an easy one. As for the conjectures in which, on a merely anecdotal level, one might be tempted to indulge concerning this tormented friendship, they are best left to more expert pens, such as that of Somerset Maugham in his celebrated *roman à clé, The Moon and Sixpence*.[77]

Wladyslaw Slewinski 1854–1918

At a pinch write to Slewinski, who is a perfect gentleman.

Gauguin to William Molard

The Polish painter Wladyslaw Slewinski occupies a special place in the Pont-Aven group: his painting developed almost exclusively under the combined influence of Gauguin, the Breton group and Brittany itself, where, with occasional interruptions, he lived for some twenty years. Unlike the other members of the group, who had all in varying degrees asserted their artistic individuality before entering Gauguin's orbit, Slewinski was starting from scratch. It is probably a reliable conjecture that the irresistible fascination exerted on him by Gauguin, at the time of their first meeting in Paris, was what made him become a painter.

Slewinski arrived in Paris in 1888, after leaving Poland in somewhat dramatic circumstances. He had broken with his family and was fleeing from his creditors, and his possessions had been seized under a court order; the cause being the rather too lighthearted way in which he had administered his father's estate. In itself, his predicament was merely a typical episode in the life of a once wealthy landowner who, whenever he had a lively company to entertain, made it his pride and pleasure to receive them with lavish eccentricity. But in this particular instance the fates decreed that the remainder of the adventure be played out in solitude. The victim's finances were extremely shaky: the small sum he had saved from the bailiffs' clutches was just enough for his journey and the first instalment of the rent for his far from brilliant lodgings in Paris.

At thirty-four, with his dubious gifts as an estate manager, and his passion for hunting and the social entertainments for which his talent was more pronounced, Slewinski was a man without a profession or any special qualifications. But his abilities did include a natural disposition for drawing. During hunting parties in Poland, and on pleasure-trips of any kind, he would sketch anything which specially caught his eye. At one point he even had thoughts of devoting himself more seriously to art and enrolled at the School of Drawing in Warsaw, whose principal was Adalbert Gerson. This was a short-lived phase and does not appear to have influenced his development as a painter. His name is not even recorded among those of Gerson's pupils.[78]

None of the work he did before leaving for Paris has survived. A drawing on paper, preserved by his family in Poland, of a fat, jovial Capuchin holding a glass of wine or mead, is dedicated to the artist's father and is dated 1889, Paris; it measures 41×30 cm. It is possible that Slewinski made this drawing shortly after arriving in Paris, or that he began it in Poland and finished it later, with the intention in either case of sending it to his father as a placatory gift after his sudden and irresponsible departure. The drawing is less like a free composition than a portrait of a real person done from memory; perhaps the subject was a familiar figure in the Slewinski household. The technique is correct and careful but on the whole rather hackneyed, despite an obvious effort to make the pose look natural. It is worth mentioning that this is the only known drawing by Slewinski. Examination of his work as a whole shows that he never made preliminary sketches; when starting a picture he always drew directly with the brush, on the canvas.

Slewinski's first period of residence in Paris is still wrapped in a certain amount of mystery, which even his family have never succeeded in penetrating. It may be imagined that, as an extremely ambitious man temporarily hard up, he did not care to ask his family for help and was thus reduced to earning his living as a labourer, and disliked referring to the fact afterwards. In spite of his precarious circumstances he managed to enrol at two schools simultaneously: Julian's and Colarossi's, in the rue de la Grande-Chaumière.

Possibly it was at Colarossi's, or more probably at the restaurant opposite, Chez Madame Charlotte, that Slewinski first met Gauguin. This was a place where Gauguin liked having lunch or dinner with his fellow-painters and others who were interested, and holding forth to them. At different times between 1889 and 1894 those who met there included August Strindberg, Edvard Munch, Stanislaw Przybyszewski, Paco Durrio, Zenon Przesmyski (*alias* Miriam), Alfons Mucha and Stanislaw Wyspianski.

Gauguin and Slewinski took to each other at once, perhaps

because of their similarity in destiny and temperament. The Frenchman not only won the Pole's respect with his impetuosity and subversive romanticism but dazzled him with his revolutionary ideas on art, the factor to which he considered everything else in life should be subordinated. The aesthetic theories of Gauguin, bold, independent and quite unlike anything Slewinski had ever come across, stirred him profoundly and dissolved the inhibitions which had prevented him from recognizing his real vocation. He saw that Gauguin and his companions took life flippantly and art very seriously. For the first time he wondered whether he should not devote himself, as they did, entirely to painting.

Gauguin, for his part, found in Slewinski a character quite unlike the common run. His appetite for risks, his overflowing fantasy, which was in the best tradition of the Bohemian life of Montparnasse but also in perfect harmony with the courtesy of a Polish gentleman, and the famous 'Slav charm', visible in everything he did, combined to exert a continuous attraction over the French painter – who himself, in *Avant et après*, was to boast of his aristocratic origins and trace them to 'Borgia d'Aragon', viceroy of Peru. A similar touch of snobbery on the part of Gauguin also emerged in his relations with Monfreid; these two, Slewinski and Monfreid, were the only friends towards whom he preserved an unfailing deference, and he never missed a chance of referring to their aristocratic origins.

So at the time of their first meeting, it was purely on the social and friendly plane that Slewinski appeared to Gauguin as a man out of the ordinary. Artistically, the two men were obviously on different levels. Slewinski, who was making his first steps in painting, could not meet Gauguin on equal terms and had to content himself with the role of a grateful listener. It may well be that in the early part of their acquaintance Gauguin was ignorant of his friend's bent for drawing. According to a belief current in the Polish painter's family, the attention of Gauguin was attracted one day, in a café, by a little sketch which Slewinski had made on a paper napkin. Intrigued, he examined it, and invited Slewinski to his studio. Making a chance arrangement of the elements of a still-life, he invited Slewinski to paint them. The result was apparently not too bad, since Gauguin said: 'You've got a lot of talent. Apply yourself to painting.'

Coming from Gauguin, who was known for his harsh judgments of people and particularly of painters, these words would have impressed Slewinski as a kind of consecration. Whatever actually happened, the upshot was that he decided that he would not go home but would devote himself to painting. He continued to work at Colarossi's because of the life-drawing, and he observed the artistic life of Paris, but his faculties of mind and spirit were focused on everything Gauguin said and did.

In 1889 Slewinski visited the Universal Exhibition. In the 'Salon de peinture', academic art could be seen side by side with Impressionist pictures; he had never encountered Impressionism before, and it was a revelation. At the Café Vol-

pini another revelation awaited him: among the works of the 'Impressionists and Syntheticists' were the very latest creations of Gauguin, Anquetin and Bernard. His mind was soon made up: these were the painters for him to follow. In the literal as well as the artistic sense, he attached himself to Gauguin, both in Paris and later, in 1890, in Brittany. Relations between the two artists became closer and closer, as is shown in particular by the portrait by Gauguin in which Slewinski is seen as a flower-painter.[79]

Coming just when Impressionism, after being unfashionable for years, was rising to the zenith of its popularity with the public, Slewinski's allegiance to the new ideas of Gauguin (who had converted no one hitherto) appears somewhat surprising. It is difficult to understand how he resisted the attraction of Impressionism: as a man he was mature but as a painter still a tyro, and his experience in matters of art was almost non-existent; thus in making his choice he had nothing to abjure, no reason for preferring one tendency to another; on the contrary, all paths were open to him because none had any pre-emptive claim. Syntheticism was what he chose, however, and it was through the door of Syntheticism that he entered painting. And when, in time, he turned more towards nature, breaking out of the *cloisonniste* method, emphasizing light and shade and heightening his modelling, the aesthetic of Syntheticism remained on all occasions his point of departure, though it was enriched later by an entirely personal vision with a strong infusion of realism.

His development thus moved in the opposite direction from that of Henry Moret, for example, or Maxime Maufra, who started by adopting the principles of Impressionism after undergoing a normal academic training, and reached the point at which they not only abandoned 'local colour' as taught by the Ecole des Beaux-Arts but also fused the tiny, polychromatic 'commas' of paint favoured by the Impressionists into single compact patches each of a single colour; by enclosing these patches in dark outlines and keeping within the general pictorial climate of the Breton group they appeared to approximate to the style of Bernard and Gauguin.

The Syntheticism of Slewinski eludes any purely formal analysis, and it would be useless to seek in it the orthodox schema of Bernard, consisting entirely of distinct silhouettes with bold and unequivocal boundaries. His Syntheticism is based, rather, on artistic and expressive values derived from an ascetic feeling for design and a static quality of calm reflection; in short it is (to quote the term already coined) the Syntheticism of expression. This is what brings Slewinski closest to Gauguin, as is also the case with De Haan and, to some extent, with Sérusier.

These fundamental characteristics of Slewinski's painting were, from the start, accurately perceived by critics both French and Polish. After seeing his exhibition at the Galerie Georges Thomas in 1897, the critic of *Le Temps* was to write: 'M. Slewinski possesses qualities of the first order. As an honest and faithful draughtsman he registers form candidly, with a virile energy in his emphasis on relief; but because he sees the

PAUL GAUGUIN *Slewinski with Bunch of Flowers*

model as a whole and aims above all at unity of effect he omits superfluous detail; he knows how to stop in time and retain the virtue of breadth.'

At the same period, Janina Krakow, in a Polish weekly review, was already writing of a 'material and psychic synthesis' in connection with the painting of Slewinski: 'Synthesis is the fundamental feature of Slewinski's *œuvre*; hence the great simplicity emanating from all his canvases, a simplicity which is due to this painter's gift of detecting the material and psychic synthesis of his chosen theme and of finding the lines and colours which harmonize fully with his subject. The more one looks at Slewinski's canvases the more one sees of their transcendent beauty. They breathe and expand – they are alive.'

In the following year a friend of Slewinski's, Przesmycki ('Miriam'), introduced his painting to the Parisian public in a study which formed the preface to the catalogue of his second exhibition at the Galerie Georges Thomas. Here again the critical eye noted 'a marked preference for calm, tranquillity, repose, silence.' But 'calm and repose' in relation to what? Surely to Impressionism and its fluttering tension, its effort to 'flatter the eye'; an Impressionism which was still alive and active. But Miriam, carrying his scrutiny further, observes: 'There is also a marked, though somewhat diffident, inclination towards mystery, towards silences that speak, towards the breath that comes from one knows not where, towards those half-expressed, half-expressible things which communicate just enough to liberate thought and set the mind wondering.'

109

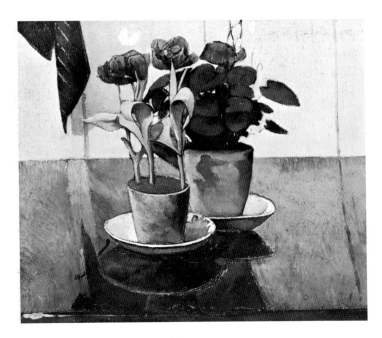

ÉMILE BERNARD *Still-life with Begonias*

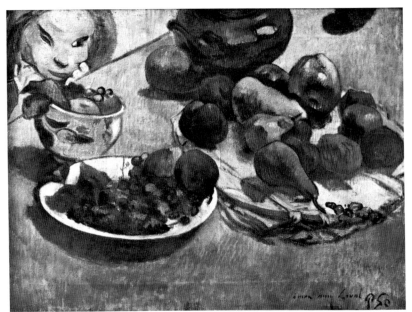

PAUL GAUGUIN *Still-life with Little Girl's Head* 1889

Similarly, the Polish poet Jan Kasprowicz, though disclaiming any intention of 'enlisting in the guild of art critics', paid homage to Slewinski when his paintings were exhibited in Lwow in 1907. He emphasized Slewinski's great skill and subtlety in playing with line and colour, a skill attributed 'to his eye which feels and his soul which sees.' And the poet concludes: 'You are neither a realist, nor a naturalist, nor a copyist. Your portraits, though they reflect an external reality, do not resemble an external reality.'

Though the judgments of Miriam and Kasprowicz are separated by ten years, both of them appear to be based on Swedenborg's theory of the 'inner eye' and to continue the line of thought expressed by Aurier. As we know, Aurier, speaking of an 'inner, hidden life' in pictures, was the first, in

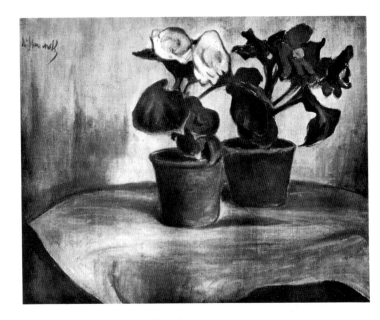

WLADYSLAW SLEWINSKI *Begonias*

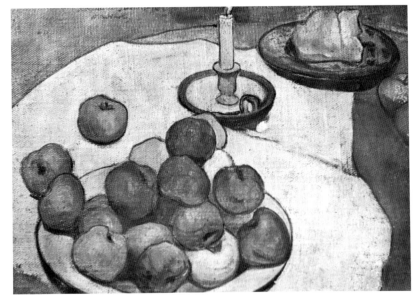

WLADYSLAW SLEWINSKI *Still-life with Apples and Candlestick*

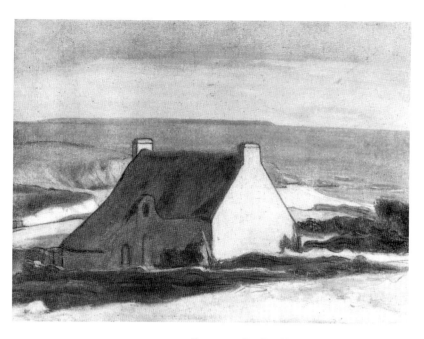

WLADYSLAW SLEWINSKI *Cottage at Le Pouldu*

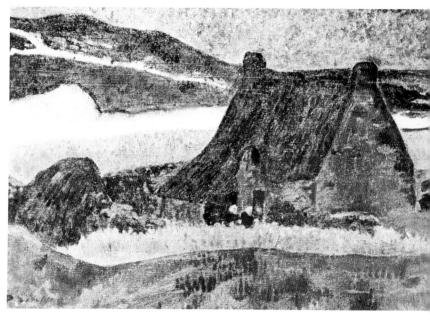

PAUL SÉRUSIER *Cottage at Le Pouldu* 1892

WLADYSLAW SLEWINSKI *Cliffs in Brittany*

1891, to describe Gauguin as a Symbolist and to apply the term 'Symbolism in painting' to the movement he had initiated.

Slewinski's art corresponds to the concept of Symbolism in the sense given to it by Aurier, and in that sense only. Slewinski is as far removed as it is possible to be from 'literature' and any sort of metaphorical or allegorical accessories, from which

Gauguin himself is not exempt; he seems deliberately to have restricted his field of experience to still-lifes, flowers, landscapes and, for a short time only, portraits. And these last are never portrait groups, or genre scenes, or historical or allegorical subjects. If he seeks confirmation for his picture-making concepts in the work of the great Symbolist Odilon Redon, he does not turn to the latter's vampire-spiders with human faces, or his anthropomorphic plants rising from the surface of a marsh, or his feminine forms emerging from half-opened shells; he turns to those simple bouquets of flowers which Redon succeeds in endowing with a mysteriously indefinable quality, a tranquil, intimate life, the essence of all vegetation. The Symbolism of Slewinski is in no way literary; it is a Symbolism in terms of purely pictorial expression.

Was his painting 'intelligible'? Yes, if we are to believe the opinions of Miriam and Kasprowicz, quoted above, and those of the painter Tytus Czyzewski, which will be noted in due course. Perhaps, though, his language was accessible only to writers and painters? Maximilian Voloshin, the Russian poet and critic, who was also a painter, after visiting the Salon d'Automne and following it up with a visit to the artist in his studio, wrote in the St Petersburg review *Viessy*: 'Whatever meaning can be expressed by two apples, a flowering plant, a Breton pot, a small yellow book and a plaster mask?... And yet, in Slewinski's still-lifes, each of these objects speaks to us with its own penetrating, mysterious voice, as moving as a song at nightfall and as sad as the homesickness of exile. This artist has the gift of making everything he treats send forth its own melancholy cry.... The secret of this gift lies in his use of tones sombre yet luminous, dense and profound, like the hues of dusk, when the light of day no longer vitiates the

peculiar luminosity of each individual thing and darkness has not yet plunged all forms into nothingness. His favourite colours are dark violet and night-blue, the world of secret, mystical states of soul.'[80]

In whatever genre he is working, Slewinski limits the subject as far as possible, throwing only one detail into relief and reducing the rest to mere allusions. He even had his own theory about this, and would explain it to anyone willing to listen. Wyspianski, a Polish poet and painter, who met Slewinski fairly often in Paris and used to ask his advice on painting, wrote to his friend Karol Maszkowski, another painter: 'One of my friends here, a certain M. Slewinski from Warsaw, who is already fairly old and a veteran painter, keeps telling me that a study should never be completely finished. Just one part of it should be carried right through to the end, the rest is a waste of time. Pictures are another matter, of course, but I must keep off pictures for the time being, I must first learn to look and to make my hand follow the idea.'[81]

Now what Slewinski said to Wyspianski also partially applies to his own pictures, since although he brings out one or several elements in the composition he leaves all the rest in shadow or in a state of 'inessential generality'. In his portraits he concentrates particularly on the eyes and their expression; the further he gets from the face the more abstract the treatment becomes, arriving at a background which is neutral and, as it were, extra-territorial. In this again he resembles De Haan. In his still-lifes, even the simplest of them, Slewinski, exactly like De Haan, does not give the same value to every element. His seas do not regale us with the spectacle of boats tossed on mountainous waves, or fishermen hauling on their nets in a waste of stormy waters; the leading actor in the picture is the mass of water itself, as an element and an eternal reality. The shore, whether verdant, sandy or rocky, is only a frame, a form whose function is to provide a boundary for the vast expanse of blue or grey. Voloshin said that Slewinski's sea was completely unromantic, that it did not 'declaim, with rhetorical gestures, the hexameters and iambics of its waves. It knows how to be stormy without being terrible, and sublime without being pathetic.'

Without any intention of prejudging the place to be assigned to Slewinski's marine paintings in relation to his work as a whole, one is overcome with admiration for the artistic discipline of this painter who, for years on end, repeatedly put the same subject on the stocks, approaching it differently every time, in a way which is always new and never infected by academicism. This is particularly visible in the sea-pictures painted at Doëlan between 1910 and 1918. To visit those Atlantic shores and compare them with reproductions of Slewinski's marine paintings leads one into an absorbing analysis which reveals how the painter, while remaining faithful to nature, achieves, through elimination and through the foreshortening of perspective and panorama, that transposition of values which a Polish critic, J. Krakow, described as a 'material and psychic synthesis'.

For many years, Slewinski cherished the dream of settling

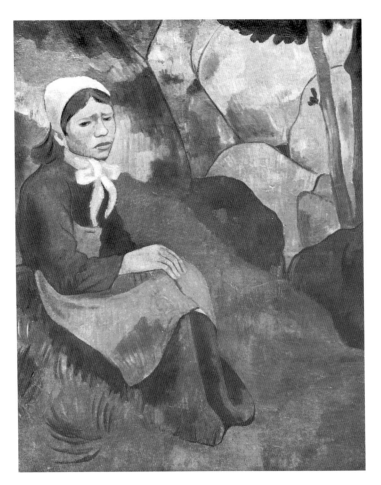

PAUL SÉRUSIER *Loneliness*

for a considerable period by the sea and devoting himself to marine studies. In 1897 he wrote from Le Pouldu to Przesmycki: 'You just can't imagine the splendour of this sea, and how many sketches and pictures one would turn out if one could stay here for a year or two. For lack of time I have merely snatched one or two on the wing, to sum it up in a general impression. Well, you'll see what I mean.'[82]

Casting one's mind back to the Polish landowner he had originally been, capricious, thoughtless and a *bon vivant*, it is hard to identify him with the artist whose iron discipline we perceive in his work. One is reminded of the fact that Gauguin, whose character and temperament left much to be desired, humanly speaking, exerted through his attitude to art an elevating and ennobling ascendancy over his followers – to mention only Chamaillard, Maufra or Verkade. He probably had the same effect on Slewinski. The latter's meeting with Gauguin was a turning-point in his life. The frivolous provincial squire, who was the protector of little ballet dancers in Warsaw, was transformed into the thoughtful, fervent artist. In going to Brittany he was withdrawing from worldly life, like a hermit. He immediately evinced an intense spiritual

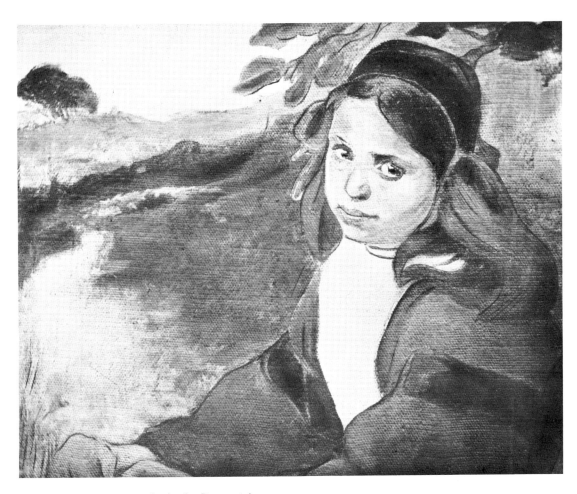

WLADYSLAW SLEWINSKI *Study of a Breton girl*

and moral concentration which hastened his artistic development and helped him to make up for lost time. In six years – the interval separating his first drawings at Colarossi's and his first exhibition in Paris – Slewinski advanced an impressive distance. After this he consolidated; his development proceeded in depth.

We have no evidence to show what Gauguin thought of Slewinski's painting. This is not surprising. Gauguin left Europe for good in 1895; Slewinski exhibited for the first time in 1896, at the Salon des Indépendants, and then on his own, at the gallery of Georges Thomas, in 1897 and 1898. The letters Gauguin wrote to Slewinski from Tahiti have disappeared.

It is a reasonable assumption that before he went away Gauguin saw some of Slewinski's paintings, at least during the period when he was staying with Slewinski at Le Pouldu (spring 1894). He is reported to have said to him: 'You, Slewinski, must always stick to that dark key of yours.'[83] This raises two possibilities: either Slewinski had taught himself too little about colour at this stage; or else dark tones were more native to his talent. The second supposition is the more likely; when we recall the speech Gauguin made not long

before to Sérusier at the Bois d'Amour, on the bold use of pure colours straight from the tube, his recommendation to use only 'a dark key' seems surprising; it must have been given for the benefit of the Polish painter alone.

Slewinski evidently took deeply to heart the advice of his 'mentor', as he called him. His earliest canvases, painted in Paris and Brittany, alternate between a dark range and one which, though slightly lighter, is always discreetly subdued. The *Still-life with Mask* and the *Still-life with Statuette* (both in the National Museum, Warsaw), *The Sea Before a Storm, The Sea at Night* and the *Self-portrait in a Straw Hat* represent the first period of his output; the *Self-portrait in an Easy Chair* shows that even after he adopted a perceptibly brighter palette the series of 'dark' canvases continued concurrently, until 1902–03 and perhaps longer.

In the pictures mentioned so far, the painter did not hesitate even to use black. His wife's family possess the *Maréchal Niel Roses*, one of the earliest paintings of his that we have seen. Three-quarters of the canvas is black, on which emerges dimly the outline of a vase and a few faded yellow roses with a waxen sheen. With true professional understanding, the

113

painter and poet Czyzewski emphasizes the importance of this black and explains its function: 'Black enabled him to bring out the construction of his picture, and to endow it with weight and density.... His fruits and flowers and pots are identified with nature not by slavish imitation but by conferring on objects the physical properties of matter, weight and density.... Often, indeed, the areas of matt black in his pictures achieve more brilliance than would a juxtaposition of brighter colours. It is in fact this fashion of creating light – with the aid of matter, not by light and shade, or exaggeratedly bright colours – which brings Slewinski so close to the "youngest" painters.' In addition to relating Slewinski's painting to the art of the young generation in Poland, Czyzewski's words also relate it to a remoter tradition, one of the highest prestige – the tradition of the Dutch masters and the great French virtuoso of the still-life, Chardin.

A key of quiet, dark colours; the weight and density of material things; static portraits, in which gestures are absent, the expression is intensified and accessories are severely subordinated, while decoration tends to be eliminated altogether; painting prudent, profound, thoughtful – these are the main characteristics of Slewinski, revealed to the French public by a few exhibitions at long intervals, and to the Polish public by displays in Warsaw, Lwow and Cracow. And they are undoubtedly the characteristics by which he wished to be known and to leave his name to history; the only paintings he finished completely, and signed and exhibited, are those which possess them.

After his death the painter's wife, perhaps in deference to his own wishes, removed for his posthumous exhibition in Warsaw only such of his pictures as were a repetition of his early manner. His studio, and the immense amount of material necessary to his work, remained unknown both to the public and the critics; this did not exactly make it easy to analyse his painting, a body of work which is luxurious in its very homogeneity. We must record, not without bitterness, that his widow, Eugénie Slewinska, denied access to this precious inheritance both to Antony Potocki, who organized a Slewinski exhibition in Paris in 1918 and wrote a detailed study of the artist's work, and to Czyzewski, who in 1928 wrote a monograph on Slewinski, with an appendix consisting of a catalogue of his most important pictures.

A happy combination of circumstances enabled me to discover in 1961 – and to report in print in 1962 – a collection of some one hundred and fifty canvases by Slewinski which had been piously preserved after the death of Eugénie by the Primel family, of whom she was a very close friend. The present owners of the collection are Mme Jeanne Buffeteaud, in Paris, and Mme Marie-Louise Lagrange, in Tours. As well as making a larger addition to the *œuvre* than one might have dared to hope, it shows the artist in a new light and helps us towards a more thorough analysis of his output as a whole. What is revealed to us is a painter who was often unsure of his drawing, an artist who sometimes strayed from his path, a seeker who had to struggle and who sometimes abandoned a picture when it was only half finished, but who never gave up trying new methods.

114

WLADYSLAW SLEWINSKI
Woman Combing her Hair

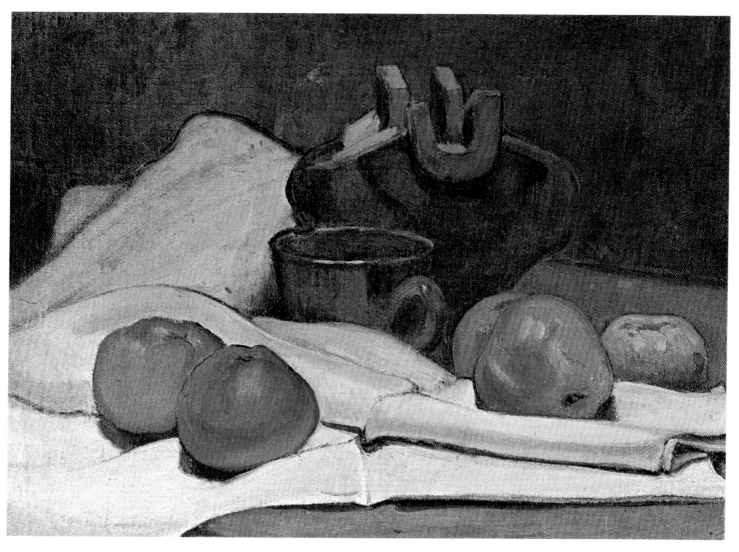

WLADYSLAW SLEWINSKI *Still-life with a Green Cup*

mood is quietness and calm, notwithstanding the energy of its lines, the violence of its colours, its incrustations of rubies and emeralds'. Subsequently the Japanese element was blunted, softened, refined away until it survived only in the form of discreet patterns in the fabrics decorating the background of a picture, a device also used, but more obtrusively, by Gauguin, Bernard and, even more frequently, Van Gogh.[85]

In 1905 Slewinski suddenly decided to return to Poland. Financial considerations had nothing to do with this. He was married to a Russian, Eugénie Schevzoff, who was a painter too; and he was comfortably settled in France, with a flat and a studio in Paris and a villa in Brittany. The income from his wife's property in St Petersburg assured the couple of a comfortable life, with freedom to paint and, when they felt like it, to travel. At one time, Slewinski was even in a position to contribute substantially to Gauguin's needs, by buying his pictures at auction[86] and by inviting him for a long stay in his house at Le Pouldu. The chief cause of his resolve to go back to Poland was homesickness; but he was also eager to put to the test the skill and knowledge he had acquired in France, and to see what was happening in the artistic world in his own country. His journey, undertaken with divided feelings, was to give

him little satisfaction and much disappointment. The disappointments included an unsuccessful attempt at teaching in the School of Fine Arts, Warsaw, disputes in connection with his plans for exhibitions, and wrangles with the tax department. In the other half of the scales were his reconciliation with his family, and the intense intellectual and artistic life at Zakopane (a celebrated winter resort in the Tatra Mountains), where he became friendly with a large number of poets and other writers, notably Jan Kasprowicz, Stanislaw Witkiewicz, Leopold Staff and Edward Porebowicz. He also had a few notable successes as a recognized master in painting, and under his leadership a group was founded whose activities were rewarded by an exhibition patronized by the Warsaw Society of Fine Arts.[87] We shall see, however, in which direction his development as a painter was to tip the balance at the end of five years' residence in Poland.

He had been out of his native country for seventeen years; his artistic equilibrium was perceptibly upset for a time by his renewing his acquaintance with the Polish countryside, particularly that round Zakopane. The snow, the mountains and their lakes made up a far more varied, dramatic landscape than that of Brittany, which was a ready-made synthesis in itself, and they so fascinated him that he felt irresistibly driven to fix the enchanting spectacle on canvas exactly as it was, altering nothing. Accustomed to a marine landscape, in which the foreground organically related itself to the middle distance – the sea – Slewinski now had to tackle a phenomenon which was completely new to him: the monumental mountain range seen across a foreground which was more or less fortuitous, isolated from the rest, and not particularly inspiring. The result was that his first Polish landscapes were incoherent and over-detailed, and that this artist who was normally so close to nature was now further from her than at any previous time.

We may assume that Slewinski, the bearer of 'the good tidings from Pont-Aven' (as Husarski put it) and the herald of a revolution in painting, was momentarily unable to resist the traditional trends dominant at that time in Polish art. His compatriot, the art historian Kepinski, wrote: 'Having returned to Poland, Slewinski is moving further and further away from the bright colour-schemes whose secrets he has learned at Pont-Aven, and is lapsing into the smoky *grisaille* so dear to the colourists of our own country. He is deeply attached to nature and will no doubt content himself with a naive and light-hearted stylization of her.'

Among the pictures Slewinski painted during his Polish period is one of his best, *The Orphan of the Village of Poronin*. But this is an exception, for while this canvas – which belongs to a series of portraits of mountain-dwellers – is remarkable in more than one respect, most of his work at this time lingers too attentively on minor details, so that his pictures fail to achieve the purity characteristic of the work he had done in Brittany.

In due course Slewinski became aware that he was undergoing an acute crisis, against which his will was powerless. In imagination he returned to Brittany, the country in which

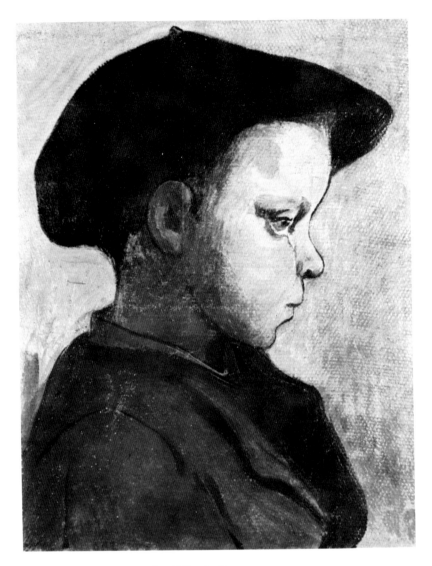

WLADYSLAW SLEWINSKI *Small Boy in Beret* 1902

he had matured as a painter. In 1907 he executed the strangest of his pictures, a Breton seascape, as it were a 'memento of Pont-Aven', a confession of nostalgia. Painted in the heart of the Tatra range, it is signed '*W. Slewinski / Poronin / 1907*'.

The 'smoky *grisaille*' mentioned by Kepinski, the cause of which was probably an over-minute division of tones, even irritated the artist himself. We know now, since the rediscovery of his studio, that Slewinski struggled desperately to free himself from it and to take refuge in stronger colours. This was the origin of various landscapes, in most cases embellished with ruins, painted in the country round Cracow and Kazimierz, landscapes in which brilliant greens are set against bright pink backgrounds and chrome yellows are juxtaposed with contrasting blues. None of these attempts satisfied him, and they remained unsigned and unshown; some were not even finished. It was two long years before he had worked his

LOUIS ANQUETIN *Boy and Still-life (Study)*

WLADYSLAW SLEWINSKI *The Orphan of the Village of Poronin* 1902

way through the impasse and dared to launch into Synthecism once more with his *View of the Black Tarn in the Tatra Mountains* (Bibliothèque Polonaise, Paris), where his mastery is apparent in the exploitation of innumberable shades of dark indigo, the tonality which plays the dominant role in the composition. This picture opened the way to a set of mountain landscapes conceived in the same spirit.

While he was living in Brittany, Slewinski had been homesick for Poland. But once the initial intoxication of homecoming had subsided, he realized how deeply his roots were laid in his second country, France. In fact, an expression often on his lips was 'at home in Brittany'. Disenchanted by his stay in Poland and the setbacks he had endured (which, however, existed only in his imagination), he set out in 1908, accompanied by his wife, for Munich, in the hope of being able to 'relax'. He wrote from there to his Irish friend, Roderic

O'Conor: 'We have often thought of you, and of the peaceful life we led in Paris and Brittany, especially in comparison with the devilish events we have endured in our own charming country. If you only knew what a life we've been having, these last two years! The best bit was last winter, the few months we spent buried in the mountains under several feet of snow, without seeing a soul. What fabulous snow-effects! Enough to drive one crazy. Almost impossible to take advantage of such beauty for painting; too cold. I did have a shot several times, I'm not too displeased with the results, but every canvas cost me a bad cold in the head and a terrific toothache. At present we are in Munich and intending to stay some time. The atmosphere isn't very pleasant here, nothing but bad pictures and beer. The pictures are awful but the beer is good. The artistic level is so low that one doesn't even want to exhibit.'

WLADYSLAW SLEWINSKI *Portrait of the Artist in a Breton Hat*

Munich failed to afford the expected relief from tension; nor did prospects in his home country show any signs of improvement. He therefore abruptly decided, in 1910, to return to France. He bought a small house at Pont-Aven and then one at Doëlan, and settled down to pass the rest of his days in Brittany. His final eight years, spent in solitude, yielded a rich harvest of noteworthy paintings. But he was old now, and in poor health, and had lost the spirit of adventure. He took stock of his experiments in picture-making, developed them in depth, and eventually returned to his discreet, low keys, the density of matter, and an austere economy of means. He remained loyal to the aesthetic of Pont-Aven, to which he owed everything, but enriched it with his own interpretation of colour and expression; his best achievement during this phase was his last canvas, painted shortly before his death,

the *Self-portrait in a Breton Hat* (National Museum, Warsaw).

Slewinski still, as always, regarded Gauguin as his true master and greatest friend, and expressed his attitude both in his work and in his writings. A short time after Gauguin's death Slewinski expressed his whole-hearted homage in an open letter to Potocki, the editor of *Sztuka*, a Polish art review published in Paris, and at the same time uttered his own profession of faith: 'Finally, I must say that Gauguin and his work are proof against all criticism or quibbling. He is too fundamentally an artist for either of these to touch him: he must be accepted *en bloc*, or rejected. For my own part I feel and accept his achievement in its totality; it is in complete accord with my conception of art and the beautiful.'

The conception possessed by Gauguin was what Slewinski had endeavoured to transplant to Poland, during the five years he spent there. And the closing period of his life, in Brittany, proves that Slewinski, like Sérusier, was among the artists of the Pont-Aven group who contributed most to the permanence of its aesthetic and of its message to future generations.

It is a baffling fact that Slewinski, whose connection with Gauguin and his immediate entourage was so close, was relegated to total oblivion for more than fifty years, whereas the master of Tahiti was rewarded with a dazzling posthumous career and attracted disciples in droves. Until the Centenary Exhibition in 1949 the portrait of Slewinski by Gauguin remained unmentioned, and it was only in consequence of the political and diplomatic affair of the collections of the Japanese Prince Matsukata and the Japanese government's claim to their possession, that the existence of such a picture became known.[88] Previously, Slewinski's name had been mentioned only by Chassé in his book *Gauguin et le groupe de Pont-Aven* (1921), and even then merely in a note informing the reader that 'Gauguin, in 1894, had received the hospitality of M. Slewinski, a Polish painter, now dead, about whom nobody knew much and the address of whose wife has not been traced either'. At the time of the Gauguin exhibition in the Orangerie, Paris, in 1949, in which the portrait in question was included, there was a hail of notes – but only notes – whose sole object was to identify the sitter. Moreover, at none of the exhibitions devoted to Gauguin and the Breton group – whether before 1914, between the wars or after the Second World War – was there any mention of Slewinski and his work.

It was only in 1961, at the exhibition held at the Mairie of Pont-Aven with the title 'Gauguin et ses amis', that the public discovered this 'new' member of the group, six of whose canvases were on view. This exhibition was followed by others the most important of which, the 1966 Pont-Aven show at the Tate Gallery, included fourteen of the works of Slewinski. In addition to these temporary exhibitions, the permanent inclusion of two of his canvases in the Musée national d'Art moderne in Paris, and of one in the Musée de Quimper, has enabled the French public and French art historians to become better acquainted with Slewinski, a Polish artist who had made hospitable France his second country.[89]

VII THE THEORISTS OF THE GROUP

Paul Sérusier 1864–1927

Sérusier's keen philosophical mind soon transformed Gauguin's slightest words into a philosophical doctrine, which made a decisive impression on us. M. Denis

Paul Sérusier is invariably mentioned as being one of the cluster of painters grouped about Gauguin at Pont-Aven in 1888. The first contact between him and Gauguin, which occurred in that year, was very brief, but was to prove highly significant for the future. At this period in his career, Sérusier, who was a pupil of the Académie Julian and had recently drawn attention to himself by his *Breton Weaver*, exhibited at the Salon in 1887, is described by Denis as exercising the office of *massier* (student treasurer), 'with an extraordinary degree of fantasy', in the little studios in the Faubourg Saint-Denis which were branches of the Académie Julian.[90]

He was born in 1864, of a prosperous, cultivated, bourgeois family. His father, the director of the Houbigant perfumery firm, expected his son to succeed him in that position. But Paul's inclinations ran neither to perfumery nor to any other form of business. His family's incautious idea, partly motivated by snobbery, of entering him at the then highly fashionable Lycée Condorcet,[91] was duly followed by 'most provoking' results. The exceptionally gifted boy plunged eagerly into the intellectual and artistic atmosphere pervading the school, and, on leaving, headed straight for the Académie Julian.

As well as being evidently gifted in art and music (he had a fine tenor voice),[92] young Sérusier showed unusual aptitude both in pure science and in the humanities, especially philosophy and Oriental studies; he learnt Arabic and Hebrew. As for Latin, he could speak it fluently. His intellect, thirsty for knowledge, always held his over-flowing imagination in control.

In the summer of 1888 Sérusier went to Pont-Aven, like many of his fellow-students from the Académie Julian, and took a room at the Pension Gloanec. Gauguin and his group, Laval, Bernard, Schuffenecker, Chamaillard and Moret, were already there. He heard them singing and joking and, even more often, fervently arguing. He caught only snatches of their conversation, but could tell that it was always about art, and that the jokes and shouts of laughter were no obstacle to

PAUL SÉRUSIER *Breton girl*

Paul Sérusier, *c.* 1890

promised to explain, in the very presence of nature, the subject-matter, his ideas about painting.

And meet they did, in the Bois d'Amour, where Sérusier, under Gauguin's direction, made a small painting of the autumn landscape on a piece of plywood (the lid of a cigar-box). According to one account, by Maurice Denis, what Gauguin said to Sérusier was as follows: 'What do those trees look like? You see them as yellow: very well, put on some yellow; and as for that shadow, which looks blue if anything, paint it pure ultramarine! Those red leaves? Take some vermilion!'[93]

Sérusier carried the picture back to Paris, showed it to his fellow-students at Julian's, and did his best to convey to them the theory sketched out for him by Gauguin. The young painters were fascinated by his words. The picture was christened *The Talisman*, and the story of its origin was accepted as holy writ.

Denis gives the following account of Sérusier's return (with a version of Gauguin's words that differs in detail but not in essence from that given above): 'It was at the beginning of the autumn term in 1888 that Gauguin's name was first revealed to us by Sérusier, who had just returned from Pont-Aven. He showed us – not without making a certain mystery of it – a cigar-box lid on which we could make out a landscape that was all out of shape and had been built up in the Syntheticist manner with patches of violet, vermilion, Veronese green and other colours, all put on straight from the tube and with almost no admixture of white. "How does that tree look to you?" Gauguin had asked him, looking at a corner of the Bois d'Amour. "It's a vivid green, isn't it? So take some green, the best green you've got on your palette. And that shadow's blue, really, isn't it? So don't be afraid – make it as blue as you can." In this paradoxical and unforgettable form we were presented for the first time with the fertile concept of 'a plane surface covered with colours assembled in a certain order'. Thus we learned that every work of art was a transposition, a caricature, the passionate equivalent of a sensation experienced. This was the beginning of a movement in which H. G. Ibels, Pierre Bonnard, Paul Ranson and Maurice Denis promptly participated.... Sérusier's keen philosophical mind soon transformed Gauguin's slightest words into a scientific doctrine, which made a decisive impression on us.'[94]

As time went on, these initiates of the gospel of Pont-Aven were joined by several neophytes: Vuillard, Roussel, the Dutchman Verkade and the Hungarian Rippl-Ronai. Sérusier remained their spiritual leader; the mystical and philosophical minority was presided over by Denis. The group came together frequently, either at Ranson's apartment or at a little restaurant in the Passage Brady; eventually they adopted a special mode of dress and a secret ritual for their meetings and called themselves the Nabis, a name derived from the Hebrew word for prophet. Although they were affiliated to the Pont-Aven group, it was under their own title that they entered history.

Sérusier, some time after converting his Nabi friends to his newly discovered faith, underwent a severe crisis of conscience.

a free-flowing exchange of views on significant problems of theory. Deeply intrigued by this strange fraternity, Sérusier, as a loyal pupil of the Académie Julian, sat at the table of the *pompiers* and was thoroughly bored, but lacked the courage to approach the 'Impressionists'.

It was not until the day before he was due to leave that Sérusier, encouraged by Bernard, the youngest member of the group, summoned sufficient nerve to speak to Gauguin. The moment was awkwardly chosen; Gauguin was unwell and received him from his bed. After a few words of conversation Sérusier produced one of his canvases. Something about the newcomer's personality seems to have made an impression on Gauguin, for he invited Sérusier to meet him the next day and

PAUL SÉRUSIER *Landscape : the Bois d'Amour (The Talisman)* 1888

PAUL SÉRUSIER *Breton Panel with Children*

PAUL SÉRUSIER *Breton Panel with Cows*

Once out of range of Gauguin and his compelling charm, the logical, observant mind of Sérusier detected lacunae and inconsistencies in the theories of the 'master'. Struggling under the assault of doubts which he was incapable of resolving, he experienced a fresh impact on visiting the exhibition at the Café Volpini. On coming away, as we have seen, he exclaimed enthusiastically: 'I had absorbed the poison. From now on I'm with you.' According to his own account in *ABC de la peinture*, he told Denis that he would soon have made himself happy by disburdening his conscience: he was going to 'ask pardon of the master, Gauguin, for not having understood him from the first'.

Full of good intentions, he set off for Pont-Aven but suffered a new disappointment: 'I realized as soon as I got here that Gauguin, who is with me, is not the artist of my dreams; in his reasoning I saw points about which we disagree, and in his work a lack of delicacy, a childish and illogical affectation in his drawing, a pursuit of originality to the point of charlatanism. I have therefore refrained from showing him my own work. So I'm feeling very much alone. A word or two of encouragement would do me good; it's awful, sometimes, to find myself in front of his canvases and wonder incessantly whether his work is beautiful or absurd.'

But his doubts proved to be short-lived. He was soon writing again to Denis, after moving from Pont-Aven to Le Pouldu, that his previous letter had been written in a moment of dejection and neurasthenia. 'I repent of what I said about Gauguin, there's nothing of the charlatan about him, at least in his behaviour to those who he knows are capable of understanding him. For the past fortnight I have been seeing him on the closest possible terms, we even share a bedroom. I've discussed with him the things I disliked in his work to begin with; they should be put down to a few playful perversities which are part of the make-up of modern painting.'

This was the beginning of the two painters' friendship and close collaboration. Sérusier won a central position in the

PAUL SÉRUSIER *Breton Boy*

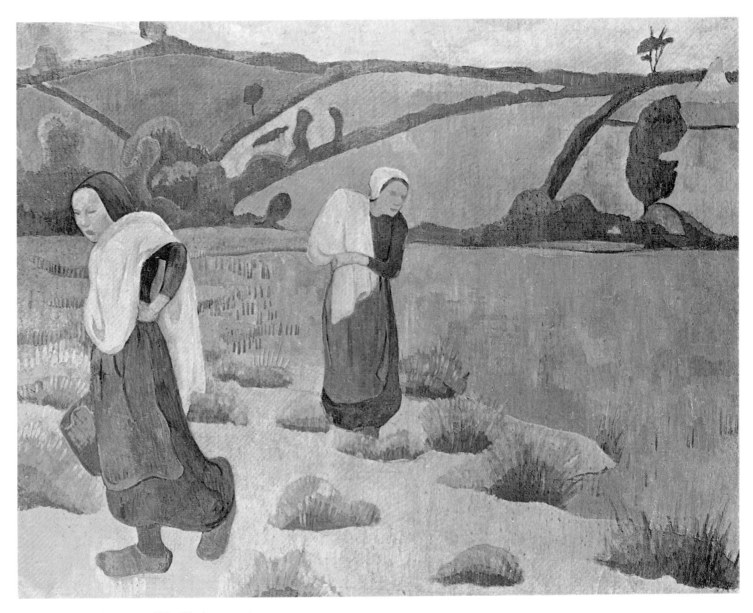

PAUL SÉRUSIER *La Laïta (The Washerwomen)*

group, as a theorist if not as a painter. Fundamentally he was simply occupying in relation to Gauguin the gap left by Bernard; and there was no longer any occasion for the painful and irritating rivalry of the early period.[95] Older than Bernard, more deliberate and thoughtful, and better educated, Sérusier possessed an inborn talent for analysis. He regarded Gauguin as an artist of exceptional qualities, and himself as one of the few people capable of understanding him. The difference between Bernard and Sérusier was that Bernard, by his skilful interpolations, induced Gauguin to state his aesthetic opinions articulately; whereas Sérusier cheerfully ignored such openings and contented himself with a few casual observations

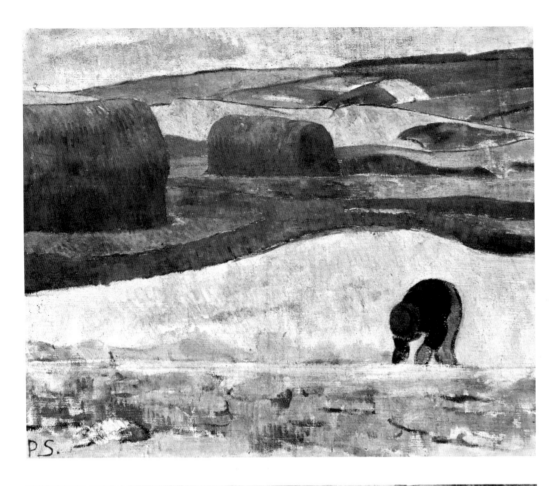

PAUL SÉRUSIER *Man Gathering Seaweed*

PAUL SÉRUSIER *Farmyard at Le Pouldu*

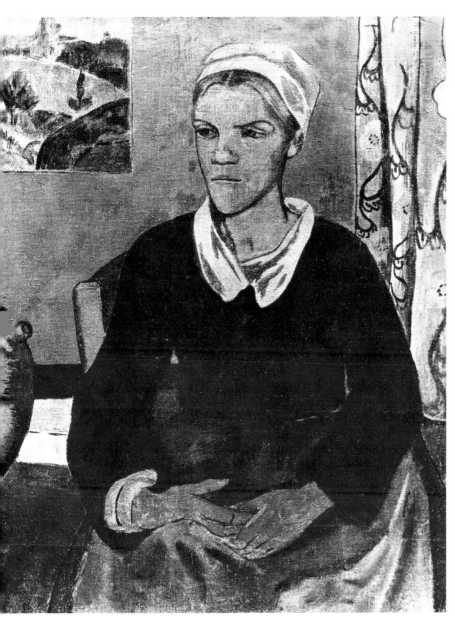

they were almost inseparable and that each hung on the words of the other. To the other artists there, the powerful personality of Gauguin acted as a judgment from which there was no appeal; powerless to argue with him, they preferred to abandon resistance and follow his lead. Sérusier, on the other hand, once he had got over his initial hesitation, knew what to take and what to leave both in Gauguin's work and in his ideas; better still, he was able to foresee what the contribution of Gauguin would be at this precise moment in the development of painting. The great merit of Sérusier is that he found an adequate form in which to clothe the prestigious opinions of the 'master' and bequeath them to posterity.

Of all the Pont-Aven painters Sérusier has been the one most frequently studied, with the exception of Gauguin and Bernard. This has been due in the first place to his talent for the written word and his large literary output. The efforts of his family and friends also had a considerable effect. His treatise *ABC de la peinture* went through three editions, of which the second includes a monograph by Denis and the third the correspondence of Sérusier. And there were the periodical exhibitions of his work. The cumulative result was that he became famous and that his pictures were much sought after by museums and collectors.

His philosophical tendencies, on which his artistic judgment was based, were as follows: before 1889 he was attracted by Plotinus and the Alexandrian philosophers; later, he discovered *Les grands initiés*, by Edouard Schuré; in 1895 he became a pupil of the Benedictines at Beuron in Germany, and finally, in 1903, as he recorded in a letter to Verkade, he began studying the *Summa Theologica* of St Thomas Aquinas. His inclinations, as can be seen, were by no means fixed and invariable, but they always fell within the bounds of the idealist school in philosophy. His interest in every subject he took up was deep and genuine, as his thinking bears witness, whether recorded in his own words or those of Denis.

Sérusier first came into touch with Gauguin and the Pont-Aven school at a time when he was reading Neoplatonist philosophy. Denis saw clearly that Sérusier's Symbolism was thoroughly Neoplatonist in origin, the product of a 'truly frenetic idealism'. Writers and painters were agreed in declaring that objects were the signs of ideas, that the visible was a manifestation of the invisible, and that sounds, colours and words possessed an absolute value independently of all interpretation and even of their literal meaning (for this assertion, see the *ABC de la peinture*). In all this there was a cross-reference to Delacroix, whose *Journal* began appearing in 1893 and who held that 'painting is a mysterious bridge between the soul of the artist and that of the spectator'.

Much study has been devoted to the question whether Gauguin influenced Sérusier, and if so in what way, both in his painting and as the figure connecting Pont-Aven and the Nabis. Little importance, however, has been conceded to the influence exerted by Sérusier on Gauguin. Detailed examination of the ideas of Gauguin, as expressed in his writings, especially in his book *Avant et après*, might reveal a number of

which enabled him, as on the initial occasion, very quickly to transform the least words of Gauguin into a philosophical doctrine.

Gauguin was without the general philosophical training, and the sense of precise formulation, which were possessed by Bernard and, in a higher degree, by Sérusier. But the latter, though aware of his superiority, avoided making too much of it and was content with his status as a pupil. His intelligence and discernment were in some sort complementary to the genius and intuition of Gauguin. It was not surprising that

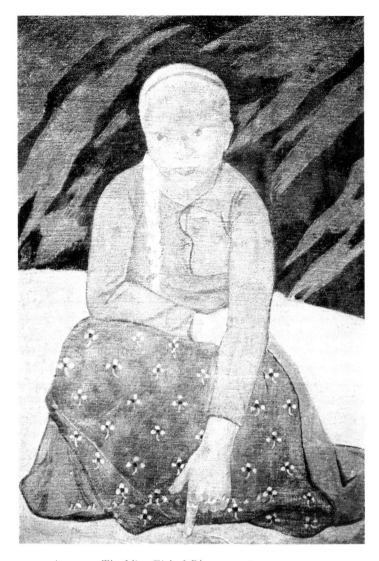

PAUL SÉRUSIER *The Idiot Girl of Plouganou* 1895

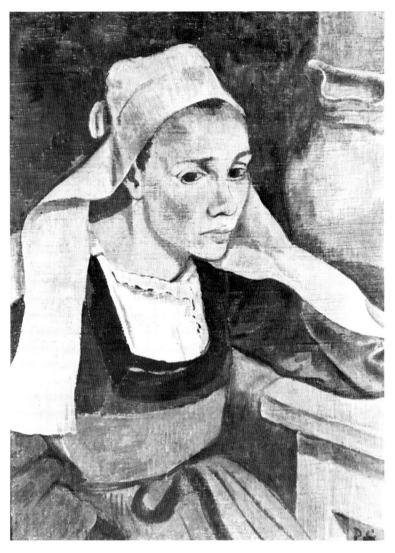

PAUL SÉRUSIER *Portrait of Marie Lagadu (Marie Derrien)*

affinities between his philosophical thinking and that of Sérusier. The latter was a born teacher, a fact noted by Denis in *Théories*: 'Sérusier is a professor now: he teaches at the Académie Ranson. But then he always was one; he taught at Julian's, in Munich, in Brittany and everywhere he went, and I remember that when he was the *massier* in the little studios which were outcrops from Julian's, he taught me, as a newly enrolled student, the philosophy of Plotinus before inducting me into the technique and aesthetic of Syntheticist painting, received by him from Paul Gauguin, whom he had met in Brittany.... That was when he found his real vocation. With his cultivated mind, aptitude for reasoning and love for both logic and paradox, he set about discovering the common factor linking together the different formulae vivifying the words and art of Gauguin. He endowed them with order and system and distilled from them a doctrine which, from being almost indistinguishable from Impressionism, developed into its antithesis; and this occurred just at the time when the painters and poets were coming together and Symbolism was being born. Since then, I have elucidated the fact that Sérusier played a large part in evolving this doctrine – Syntheticism, Symbolism or neo-traditionalism – whose paternity I had attributed to Gauguin, Van Gogh and Cézanne. It is to him that I owe the clarity with which, in my article in *Art et critique*, I established the essential points of the system: the picture as a plane surface covered with colours assembled in a certain order; art as the sanctification of nature; expression through the work itself and not through the subject repre-

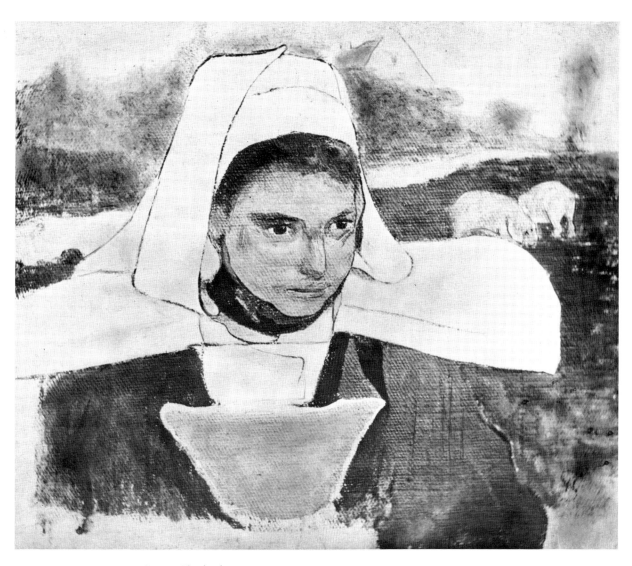

WLADYSLAW SLEWINSKI *Breton Shepherdess c.* 1893

sented.... He is, as I have said, a professor, and I repeat that I owe him much.'

Brittany, as well as Gauguin, played a preponderant part in Sérusier's development. This elegant Parisian, after conquering all the summits available to him in his *fin de siècle* environment, found his true vocation as a painter only on reaching Brittany. It was there, at Gauguin's side,[96] that his aesthetic convictions took shape and started developing, first at Pont-Aven and Le Pouldu, later at Châteauneuf-du-Faou, where he had his studio for the rest of his life. Thubert considers that Sérusier had a Celtic mentality, and the artist himself declared in 1893: 'I feel myself more and more attracted to Brittany, my true homeland, since it was there that I underwent my spiritual birth.'[97]

Sérusier's painting, from 1888 onwards, was connected exclusively with Brittany, and this was the case as markedly at Pont-Aven and Le Pouldu as in his solitary existence at Châteauneuf. Even the canvases painted during his few visits to Paris were transpositions of Breton legends. He had a lively affection for Breton costume and had recourse to it in his 'supra-temporal' allegories. 'Deductive reasoning', he wrote in a passage quoted by Chassé, 'led me to demand allegory, and Greek allegory I rejected; I was in Celtic territory; I imagined fairies. Modern dress changes too often; for the figures in my pictures I adopted Breton costume, which belongs to no one age.'

The iconographical continuity of Sérusier's painting did not at all preclude transmutation in the realm of form. The

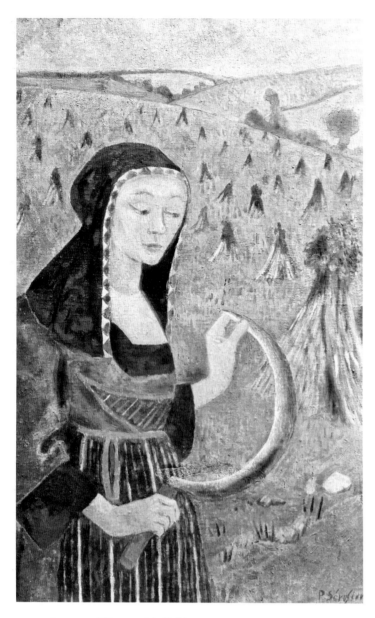

PAUL SÉRUSIER *Woman with Sickle*

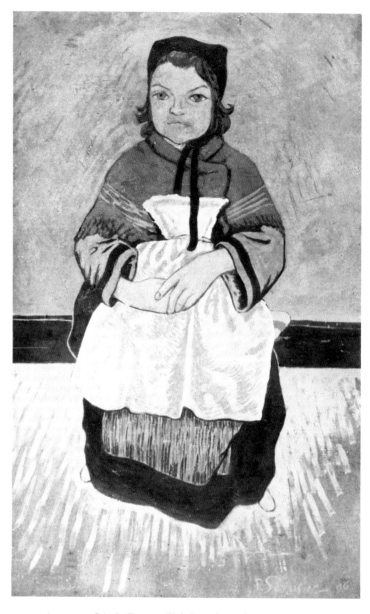

PAUL SÉRUSIER *Little Breton Girl Seated* 1896

pictures painted in the years 1889–95 are the very quintessence of the Pont-Aven style. Four of these are in the National Museum, Warsaw, and two more in private ownership, also in Poland; of the four in the National Museum, two, the *Breton Panel with Children* and *Breton Panel with Cows*, are in a style which goes back to the beginnings of Syntheticism, to the *Breton Women in Green Meadow* by Bernard and the *Vision after the Sermon* by Gauguin.

The Sérusier of this period is characterized by elimination of perspective, absence of a horizon, and completely flat areas of homogeneous colour separated by emphatic boundaries. Later, he admitted a certain amount of gradation into his work, but the principle of construction in terms of flat areas of colour he never abandoned. Later again, the figures in his pictures became more static and hieratic. He pronounced ever more categorically his antagonism to movement as an element of composition, condemning it in his *ABC de la peinture* as 'a destruction of equilibrium; to represent a movement is absurd. A work of plastic art representing movement is intolerable to contemplate for any length of time'.

PAUL SÉRUSIER *Landscape at Châteauneuf* 1906

PAUL SÉRUSIER *Ogival Landscape* 1920

In his later pictures we find ourselves watching a kind of collusion between his theoretical researches and his awareness of nature; the result being that he transposes nature on to the canvas with such sensitivity and delicacy that the painting seems to contradict the a-prioristic discipline imposed on himself by the artist. An example is the *Ogival Landscape* in the museum at Quimper. This is an essentially intellectual composition, born, however, of an acute observation of nature. The artist has found and established a formal equivalence between the fragments of woodland, the meadows and poplars of Châteauneuf on the one hand, and the ogive on the other, a feature borrowed from Gothic architecture and applied as a frame to the landscape. The pronounced axial arrangement of the elements, and the conscious distribution of warm and cool tones in a pattern of interlacing spheres, conform at once to the principle of 'sacred proportions' dear to the artist (see p. 166), and to his own theory of warm and cool colours. Nevertheless the apparently doctrinaire procedures to which the artist has submitted do not prevent the spectator from reacting naturally and directly to the beauties of the landscape.

ODILON REDON *Paul Sérusier* 1903

Looking at the work of Sérusier today, we feel that he was at his best in pure landscape, landscape with one or two figures, indoor portraits, and, sometimes, still-life. He is less convincing in his compositions with many figures, conceived like early French tapestries or depicting Breton legends, as in *The Snake-eaters* and *Naïk-la-fiancée*; the same applies to his allegorical canvases representing the old Breton way of life, such as *The Bathers* (Musée national d'Art moderne) and *Betrothed Couple* (private collection, Paris). But these reservations, it must be said, are pertinent only if his works are regarded as easel-paintings; their effect on us might be very different if we visualized them as components in a scheme of interior decoration, which is how the artist himself conceived them.[98] Séguin wrote in 1903: 'Sérusier was fond of saying, with evident conviction, shaking his shaggy head, "Don't talk to me of pictures, there are only decorations."'

134

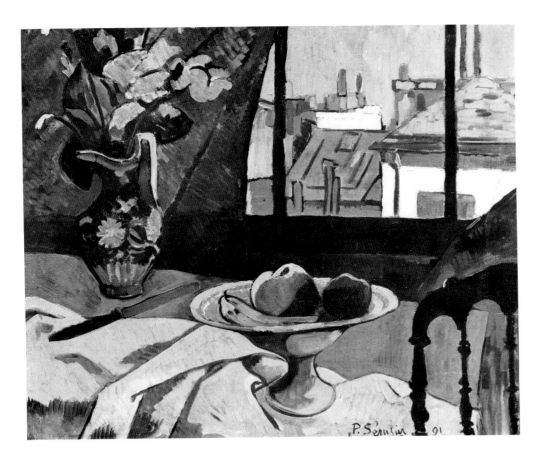

PAUL SÉRUSIER *Still-life at a Window* 1891

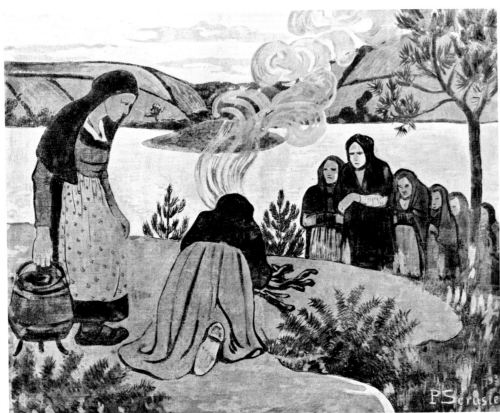

PAUL SÉRUSIER *Fire in the Open* 1893

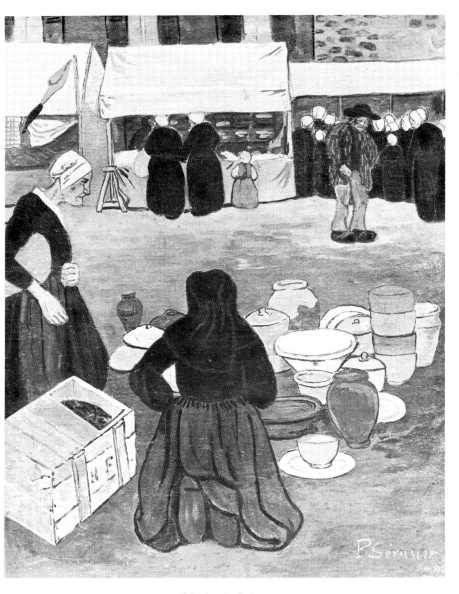

PAUL SÉRUSIER *Market in Brittany* 1892

In fact, Sérusier had never completely departed from the Pont-Aven style. His Nabi period, and the theoretical studies of 'secret geometry' and the 'chromatic circle' which were complementary to his painting, were, at bottom, developments from the very foundations of Syntheticism and remained closely related to it. We may regard Sérusier as the mouthpiece of that aesthetic and its most consistent representative, in the sense that he was more conscious then either Bernard or Gauguin in his attitude to pictorial structure. This is what constitutes his strength; and his weakness.

The reason why Sérusier's attachment to the conventions of Pont-Aven lasted longer than anyone else's is that he practically never left Brittany. It should be remembered that Bernard, repelled by the behaviour of Gauguin, spent several years travelling in Italy and Egypt, forcibly abandoning his experiments in Syntheticism, surrendering himself to the attractions of traditional painting and the imitation of the Italian primitives.[100] Similarly, Gauguin in the South Seas underwent the powerful visual stimulus of the tropics. But Sérusier had sunk his roots in Brittany, and his field of experience, though he never ceased broadening it, was unalterably fixed there. The 'Breton episode' absorbed him to such an extent as to fill the whole of his life as a painter.

His painting was very variously received by his contemporaries. The first and most ardent of his defenders, as we have already indicated, was Denis – who, however, regarded him primarily as a theorist, philosopher and teacher and spoke of his painting in rather more moderate terms. He particularly prized Sérusier's low key – his quiet colour – and the veiled expressiveness of his pictures. Quoting the brothers Leblond, who in 1919 described Sérusier's painting as 'a tapestry of silence', Denis adds: 'It is indeed a silent art; its tones are muted, its eloquence is always within.' In Sérusier's landscapes Denis detects an incomparable feeling for nature, and especially for nature in Brittany, to whose charm Sérusier was highly sensitive. 'It is impossible not to see in them a fervent testimony of his love for the land of Arvor, his real fatherland.'

A similar view was expressed by Louis-Léon Martin, reported by Chassé in his book on the Nabis: 'His painting is that of a sage and an apostle; it has a persuasive power and, as it were, compels us to silence and reflection; moreover it has a radiance of its own; light does not fall on objects themselves – it lends them its own miraculous power.'

Some other contemporaries, however, expressed reservations. Louis Vauxcelles reproached Sérusier for 'pedantry', and Arsène Alexandre did not shrink from declaring that 'his work, when all is said, lies just outside the realm of painting'. And Thadée Natanson, in 1893, asked rhetorically: 'But having acknowledged the nobility of his aims, have we not therefore the right to add that perhaps, and in spite of first appearances, his preoccupations give his work a quality not exactly literary but theoretical, which takes precedence even over its directly pictorial value?'

This view was reiterated by Bernard Dorival in 1943: 'His

The detachment from Brittany and everything going on there, which Sérusier showed while working with the Benedictines in their school at Beuron, in order to devote himself, as he said, to 'problems of a higher nature', was of short duration. It ended with his returning to Brittany and applying his ideas concerning geometry as the source from which pictorial creation was generated; at Châteauneuf-du-Faou he used them in his study of the local landscape; and in the evening of his life he embodied them on the walls of a Breton church.[99]

art is in no way spontaneous; where Gauguin relied on instinct, he relies on will and conscious choice. An excess of philosophical reflections prevents the art of Sérusier from pouring out with that violence which astonishes us in Gauguin. Like so many other intellectuals, the painter of the *Pardon* was too refined to be a creator.'

Some highly interesting judgments of Sérusier were made by the Polish novelist Gabriela Zapolska. She lived in Paris from 1889 to 1895; her association with the Théâtre Antoine, where she was acting, resulted in her becoming friendly with the Nabi group and particularly with Sérusier, who was trying his hand at stage design. The artist fell deeply in love with her, so much so that when she finally returned to Poland he tried to kill himself. It was only in the beneficial atmosphere of the Benedictine monasteries at Beuron, Prague and Monte Cassino that he was able to recover his appetite for knowledge, art and life. His *rapprochement* with Catholicism on the mystical level proved unexpectedly to be his salvation after this agonizing crisis.

It was mainly to Stefan Laurysiewicz,[101] but also to Sérusier, under whom her initiation began, that Zapolska owed her interest in the plastic arts and her first steps as a critic. Her articles in the *Kurier Warszawki* and elsewhere are full of the knowledge she acquired from Sérusier. Our debt to her includes the very sympathetic accounts she wrote of his exhibitions, which make it possible to date a considerable number of his pictures; she also gives us some of his theories, particularly on Syntheticism and Symbolism, recorded direct from his conversation.

On a visit to Brittany in 1893, in the company of Antoine (director of the Théâtre Libre), Gabriel Fabre and the painters Ranson and Sérusier, Zapolska described Sérusier and his painting in these terms: 'Ranson and Paul Sérusier, celebrated Symbolist painters, stand in silence, with folded arms, on the hillside. Ranson is smiling, revelling in the decorative charms of the scene. Paul Sérusier sweeps the horizon with his sad, cloudy gaze. His fine head and reddish-golden mane of hair stand out boldly against the limpid expanse of sky. He is one of those who believe deeply in what they are doing. His state of soul confers on his pictures that symbolism, that expressiveness, which ravish us and which tell us more than any amount of comment or anecdote. Sérusier is *a primitive, a harmonist,* who, continuing the trend of Puvis de Chavannes, creates masterpieces, as in his Breton canvases which are as sad, as simple and as beautiful as the soul of their creator.'

In a report on the Salon des Indépendants Zapolska once again gives the most prominent place to four canvases by

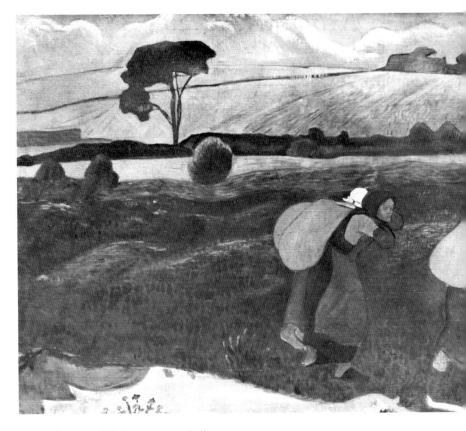

PAUL SÉRUSIER *Washerwomen at Bellangenet*

Sérusier: 'His works, though rugged and unfinished in appearance, are poems of harmony, line and colour. In most of them a single tone predominates, the other colours being woven into an astonishingly harmonious concord. These paintings are veritable "decorations" for walls, adapted in most cases to the surrounding colours and to the furniture. Their subjects are simple, borrowed as a rule from Breton folklore.'

Some readers will no doubt feel these appreciations to be a little simplistic, or overdone, or literary; the fact remains, however, that Zapolska's interpretation of both the art and the theoretical views of Sérusier is one of the most authentic we possess.[102]

Armand Séguin 1869–1903

*Every day and every night, I dream of pictures which I have no chance
of painting.* Séguin to O'Conor

Armand Séguin is generally regarded as the chronicler of the
Pont-Aven group. But his important study, which came out
in *L'Occident* in 1903, unfortunately represents only a frag-
ment of the essay he intended publishing on the school of
Pont-Aven. The work was almost completed, but for lack of
a publisher it never appeared, and the manuscript – in two
parts, one on Pont-Aven and one on Le Pouldu – was lost.[103]
The published fragment, however, is a significant and valuable
document in itself, an objective, authentic summary of the
Breton period as a whole by one of the group's most active
members. Where authenticity is concerned the comparison is
with Denis, to whom we owe much valuable information both
historical and theoretical, but who was a latecomer to Brittany
and wrote at second hand, obtaining his material from Sérusier.
As for objectivity, Séguin has the advantage over Bernard,
who was prejudiced by past injustices and could no longer see
with an impartial eye.

Séguin was twenty-two when he arrived at Le Pouldu in
1891. According to his friends he was shy, gentle and discreet.
He was particularly overawed by Gauguin, whose favourite
and constant companion he nevertheless quickly became. It
seems that on none of his friends did the master lavish his
aesthetic teaching so freely as on Séguin, whom Chassé,
writing in 1947, even describes as having been chosen as 'the
victim of his theories'. There are strong grounds for supposing
that Séguin's first exhibition in Paris in 1895 was made possible
by Gauguin, who approached Arsène Alexandre on his behalf.
Gauguin himself wrote the preface for the catalogue, and, the
day after a laudatory notice by Denis had appeared in *La
Plume*, hastened to send his written congratulations to the
author on an 'excellent article'. He believed that in Séguin he
had at last found the ideal companion for his second journey
to the islands, which was to be his 'departure for ever'; and,
after setting out alone because Séguin lacked the funds to go
with him, he continued urging Séguin, in his letters from far-
away Tahiti, to join him there.[104]

Of the life, education and painting of Séguin before his
coming to Brittany, little is known except that he is said to

Paul Sérusier (at his easel) and Armand Séguin at Châteauneuf-du-
Faou, *c.* 1903

have attended the Académie Julian.[105] The only fact of note
is that in 1889 he saw the Café Volpini exhibition; it influenced
him powerfully, and from then onwards he tried to make his
way to Gauguin and his group. A few years later he wrote:
'When the Exhibition was on in 1889, [I was captivated by]
the paintings of Gauguin, Bernard, Filiger and Laval, so

clear-cut, affirmative and beautiful; I still feel joy at the memory of them.'

It is sufficient to recall the scene in which Gauguin threatened him with a pistol and forbade him the use of complementary colours to infer that Séguin was an Impressionist. Unfortunately, the pictures painted by him at a later period are few, and they vary so much in style that it is difficult to form any idea of his work as a whole. His contemporaries, whether colleagues or critics, were somewhat reserved in their comments. He was regarded as a better draughtsman and engraver than painter; as we shall see, this fact eventually emerged as the great tragedy of his life.

Séguin died at the age of thirty-seven. He was frail, tuberculous and always poor; his life was a continual struggle with adversity.[106] Despite his exceptional gifts and his eagerness to learn he was unable to expand and flourish in the singular atmosphere of Pont-Aven, where he worked side by side with Gauguin. He had no sooner shown his work for the first time – at the gallery of Le Barc de Boutteville, in 1895 – than Gauguin set out for Tahiti, never to return. Though the master was now far away, the myth surrounding him became not weaker, but stronger. The distance involved and the separation it entailed seemed, at that period in history, no less than cosmic in scale; the hero who had withdrawn into oblivion survived only as a sublime vision, an incomparable artist, a master pouring out his precepts and his passionate ideas concerning art – that element without which life was no life at all. This dithyrambic view of Gauguin was shared by all who had been close to him in Brittany. Yielding to the obsessive resolve to paint at all costs, Séguin now embarked upon a life devoted absolutely to art.

To be able to paint he had to earn a living. But this was the genesis of a truly vicious circle: he lived by drawing and engraving and above all by illustrating; by this means he acquired a certain reputation, but never had any leisure in which to paint. And this pattern persisted until his death.

The result was that his output in graphic work was very much larger than in painting. Some of his first known plates, dated 1893, can be seen at the Musée national d'Art moderne, Paris. These engravings, eight in all, are a curious reflection of his contacts with the Breton group and his personal interpretation of the Pont-Aven style. 'The truth is', Séguin wrote in 1903, 'that Emile Bernard, who has a better claim than anybody to write about this period of our Art, of which he was one of the best representatives, retained a powerful influence on Paul Gauguin, as also, later, on myself.'

In spite of deriving from the style of Bernard, Séguin fashions his lines in an entirely personal way, uniting them in a cloud of whirling curves as fine as hairs, which fill his deliberately imprecise outlines; he uses them like colour, so that his engravings have a gently modulated character which brings them close to painting; a network of thread-like strokes fills the background and gives them an internal life which is unique of its kind. Hofstätter sees in this a likeness to the drawings of some of the Impressionists (notably Monet), but

says the parallel is merely technical, though the architectonic intensity displayed by Séguin achieves a greater simplicity than is found in the Impressionists. In my opinion a more convincing analogy, also due to Hofstätter, is that between the technique of Séguin and the so-called *style nouille* of Art Nouveau. Similar effects appear in Munch, in English etchings and in Jan Toorop. Séguin, for his part, did not use this stylistic device for long.

The engraving *Two Little Girls in Front of the Chapel* (1895) testifies to the friendly feelings which held the Pont-Aven group together, although the symbolic dedication it bears is more reminiscent of the ritual of the Nabis. In the bottom right-hand corner, outside the composition, is a monogram consisting of two hands holding an initial and a vignette with a date. Two S's are inscribed in a capital A, in the manner of Dürer, flanked by a two-fold dedication, '*à Filiger, à Gauguin*'.[107] This reminds one strongly of the formula the Nabis always used in their correspondence: '*En vos paumes mon verbe et ma pensée*' ('In your palms, my word and my thought').[108] For although Séguin was not one of the Nabis himself he always kept in touch with them, particularly with Sérusier, Verkade and Denis.

The *Two Little Girls in Front of the Chapel*, like the zinc-engraving *Breton Woman on the Shore*, show that Séguin, turning aside from constructions derived from Bernard, was seeking different formal solutions. The first of these two engravings reveals a certain kinship with the English style, and especially with the French representative of that style, Lucien Pissarro;[109] the second, the *Breton Woman on the Shore*, still shows, in addition to touches of English influence, an inheritance from Japanese prints, not only in the way the woman lying on the shore is drawn, her relation to the landscape and the flowers on her dress but extending even to the way she herself is conceived: a Mongoloid type whose mournful, pensive face seems to dissociate her from her surroundings. Sérusier, in his role of theorist, would have said that instead of presenting the figure in a realistic, concrete pose the artist had been content to express a 'psychic state'.

This was also the way in which Gauguin, in his preface to the catalogue in 1895, interpreted the art of Séguin: 'Let it suffice me to warn the visitor that Séguin is, above all, cerebral – by which I certainly do not mean "literary" – and that he expresses not what he sees but what he thinks, by means of an original harmony of lines, a manner of drawing curiously contained and limited by arabesque.' Even when he reproaches his pupil with a certain carelessness and lack of technique, Gauguin has no hesitation in emphasizing, particularly in Séguin's etchings, an exaggerated degree of technical refinement, with a consequent loss of sincerity; despite which shortcomings he regards Séguin, with his highly personal approach to draughtsmanship, as an outstanding artist.

The word 'arabesque' is generally understood to mean a capricious, sinuous use of line derived from the stylized plant-form motifs of Greek, Byzantine, Arabic or Persian ornamentation. In the nineteenth century there was a revival of

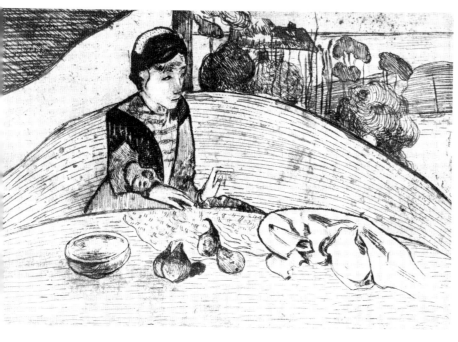

ARMAND SÉGUIN *Woman with Figs*

arabesque, which was regarded as a mystical component of artistic creation. Baudelaire, in *Fusées*, said that arabesque was 'the most spiritual form of drawing' ('*Le dessin arabesque est le plus spiritualiste des dessins*'). It was doubtless regarded in the same light by the second Pre-Raphaelite generation in England (Morris, Crane, Burne-Jones), who contributed to its widespread use in the prints and decorative arts of the *fin de siècle*. And it was one of the essential ingredients of Art Nouveau, that much-heralded movement which, about 1900, attempted to give free rein to aspirations towards universality and spiritual freedom. Oswald Spengler had already credited arabesque with magical properties inimical to the image and everything tangible, and with the power of liberating the artist's dreams from the oppressive weight of matter.

The fascination exerted by line and form was reiterated by Séguin in a letter to his friend O'Conor, dated 12 March 1903: 'I think that what you see first of all is the colours round about you; whereas what charms and takes hold of me is, above all else, beautiful lines. And the loveliest colour-harmony in the world would leave me comparatively indifferent unless it was bounded by noble forms. Oh my friend, it's the *build* of a picture which shows me what it really looks like, and so to speak its *penetration* in relation to the public.'

Line in the work of Séguin, as compared with other artists in the Breton group, is more cultivated, supple and flamboyant, and his virtuosity in handling it constitutes his distinction and originality in relation to them. The linear character of his work is no doubt the reason for his being increasingly often included in exhibitions of Art Nouveau, of which he is considered to be one of the best representatives.

But we should not lose sight of the fact that when Séguin speaks of lines 'through which he perceives the world', he is not thinking of engraving at all, but of painting: 'As for me,' he wrote to O'Conor in May 1898, 'you know that my sole object in life is to paint.' Meanwhile the agonizing pull between what he longed to do and what he was obliged to do showed no sign of ending. In 1897 he succeeded in putting on, in Paris, an exhibition of fans. But this gave him no satisfaction as an artist; and, what was worse, although the exhibition was frankly commercial in intention it made no money.

In 1889 Séguin went to Saint-Gervais, having been taken on by the lithographer Feuerstein, and began learning the technique of lithography. Hours were long and conditions bad, and his companions on the job were working men among whom he felt like a stranger. He found himself obliged to turn out labels for toilet soap and other articles; he drew flowers to order, naturalistically – even the curve of the stem had to conform to specification. He bore it all heroically. He was very keen to qualify himself as a *chromiste* (hand lithographer), a specialized, well-paid craft which would enable him to get work anywhere if he was hard up, leaving him free to paint in the intervals. But alas, after two months the workshop was moved to new premises and his job came to an end. Though he was sorry not to have completed his apprenticeship, he felt free and very happy.

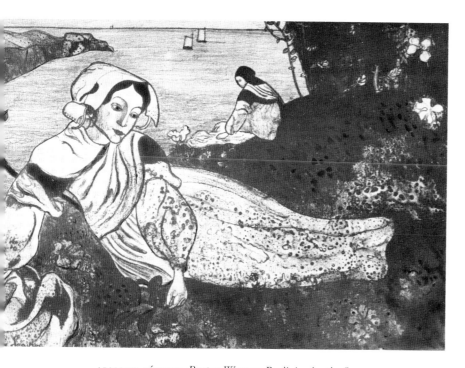

ARMAND SÉGUIN *Breton Woman Reclining by the Sea*

In the same year a recommendation from Arsène Alexandre secured a place for him as a draughtsman on the humorous weekly, *Le Rire*. But his heart was not in caricature, and his satire lacked spontaneity. The solution, he wrote to O'Conor, was suggested to him by a painter friend, Gary: 'Sentiment is what you like; so make caricatures of sentiment.'

In 1900 he was commissioned by Vollard to illustrate *Gaspard de la nuit*, by Aloysius Bertrand. This book of prose-poems, which had been praised by Théophile Gautier and to which Baudelaire turned for inspiration, made a considerable impression on Séguin; he carried out the commission at Châteaulin, in Brittany. At first sight, the engravings for *Gaspard de la nuit* appear to indicate a complete change of style, or at least an abandonment of the linear technique. Some of them are descended directly from the woodcuts of Dürer; others from Rembrandt's drawings; others, again, from Persian miniatures or even from Egyptian mural painting. Only a few, among them the title-page, belong to *cloisonnisme*. However, the departure from that style is only apparent; the continually changing manner is a stratagem, a visual ruse by which Séguin enables the reader to follow Gaspard in his progress from century to century.

The success earned by Séguin with this book was considerable; he was hailed as something very like a great illustrator. Later chroniclers of the period never refer to any other work in connection with his name. But, apart from 'a few moments of tranquillity', success brought no satisfaction; on the contrary, its effect was to magnify his bitterness. To be described as 'an illustrator' always made him angry. Shortly before his death he wrote to O'Conor: 'It's charming, and it may go on for a long time yet; then one fine day I shall be dropped and find myself more alone and poorer than ever, after wasting valuable years in ruining my powers and turning out shit; in a year from now, if they haven't done it already, they'll be sticking a ticket on me: 'illustrator – *illustrator at cut prices*'. *Gaspard* can please the public and call the attention of publishers to my name without my ever hearing of it.'

Séguin wanted to be a painter, and he had the most eminent support for his aspirations. It is true that Gauguin, in his preface to the catalogue of Séguin's exhibition, assumed a protective, master-to-pupil attitude; but his praise was none the less filled throughout with meaning and authority: 'I am making the gesture of writing this preface because Séguin, in my opinion, is an artist. This word dispenses me from all the customary superlatives, for I use it in its higher and well-nigh sacred sense.'

Regrettably, it is not known to what picture Séguin was referring when he wrote to O'Conor, in June 1896: 'I've signed the picture, so I suppose it's finished. But there are so many other things to be done; Renoir came to see it and liked it very much, which gave me more pleasure than all the theories poured out upon me by friends. He advised me to paint a lot.'

But Séguin, so far from painting a lot, was in no condition to paint at all. His health was steadily deteriorating, he was

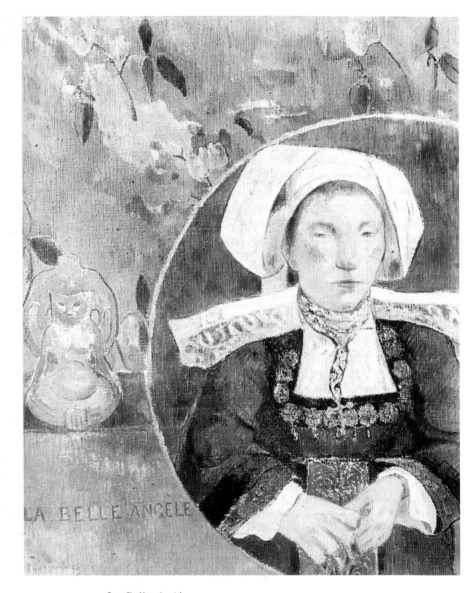

PAUL GAUGUIN *La Belle Angèle*

afraid he had not long to live, and he could see the tragedy of his life in all its cruelty. He was bitterly aware that, given more favourable circumstances, he could have done good work and become a good painter.

In 1898 he made this harrowing confession to O'Conor: 'It is a year since I worked from nature, in good conditions, with sufficient peace of mind; I can't be an illustrator, I was born for better things than that, and I'm merely repeating myself when I tell you that this is the only thing that really makes me suffer. Every day and every night, I dream of pictures which I have no chance of painting, all my powers are ready and waiting, I weep over my past and the situation it has led up to. I have never felt surer of myself, more certain of doing good

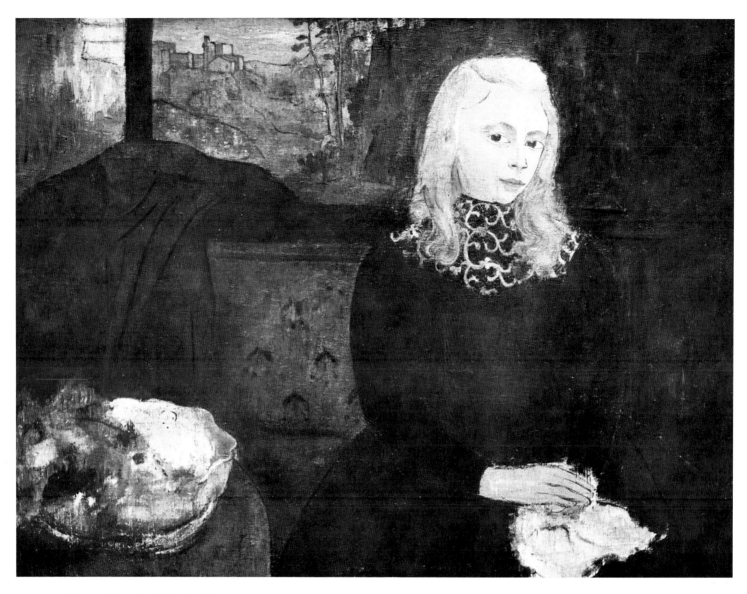

ARMAND SÉGUIN *Portrait of Marie Jade*

things, and you'll probably tell me, my dear friend, that I'm simply suffering from a swollen head, and yet in reality I'm making as big an understatement as possible. Good God, how ridiculous it would be, after a lifetime of worshipping art on an empty belly, to find oneself on the brink of the grave without having achieved anything at all or even having had a chance of achieving anything. Never mind about fame and money, I can do without those, but what satisfaction and joy there would be in thinking, as one laid oneself down for the last time, of some canvas of one's own hanging somewhere or other, which one was quite certain was talented. The opposite would be frightful. From morning to evening I stay fettered to my work-table for the sake of this one idea; no use hoping for some provi-

dential collector to turn up, after all. I'm sick of it all, sick to death, I've got every kind of trouble to contend with, but I live for this one object: to paint.'

His two best-known canvases are the *Portrait of Marie Jade* (Musée national d'Art moderne), and the *Nude in a Landscape* (Denis family collection) which has been reproduced a number of times and frequently exhibited.[110] The former is an attractive composition, careful and thorough in structure, representing a girl sitting on a couch; the background, a landscape with buildings, is seen through a broad window behind her. A large, dark drape lies over the back of the couch. On the left is a small table with a tray; the contents of the tray form an indeterminate still-life, not clearly defined. The sitter

143

ARMAND SÉGUIN *The Delights of Life*

is off-centre, in the right-hand half of the canvas. The left-hand half, thanks to its three main components, the landscape, a section of the room, and the still-life, has the greater vitality; the other half is completely neutral and comes alive only through the strong contrast between the dark tones of the background and the girl's bright, pale complexion, shining hair and white lace collar.

The picture seems to be a compound of two means of expression. The sitter herself, in particular her graceful head, strikes one as being a variation, in terms of painting, on

Séguin's most successful graphic achievements in the Syntheticist convention; the rest of the picture belongs to the Post-Impressionist tradition. Stylistically, one might perhaps relate it to the head in *La belle Angèle*, by Gauguin, and, for the remainder, to Jongkind or, at a later date, to the intimate interiors of Vuillard.

The *Nude in a Landscape*, not on quite the same level of quality, shows a similar ambiguity in plastic conception.[111] Against a landscape background, reminiscent of *Le déjeuner sur l'herbe* by Manet, a female nude sits on a blanket spread on

144

ARMAND SÉGUIN *Two Cottages in a Red Landscape*

the grass. There are errors of drawing (realism is attempted but not attained, the hands and feet are wooden, and the flexion of the torso is unnatural); in addition the picture lacks harmony, the sense of composition is unsure. There seems to be a hesitation between two different approaches: in the landscape nature is accepted and allowed to call the tune, whereas in the figure the painter partially abandons literal modelling to adopt a frankly Syntheticist mode of construction.

The Two Cottages (1894), with its beautiful reds, is a more closely-knit composition, but here again the simplified archi-

tectonic rendering of the cottages themselves is strangely at odds with the supple spirals of the decorative background, which is more reminiscent of late Nabi landscapes, particularly those of Lacombe, than of the *cloisonnisme* of Bernard and Gauguin in the Pont-Aven period.[112]

After the pictures cited so far, it is a pleasant surprise to turn to the *Three Breton Women* (Raymond Le Glouannec collection, Pont-Aven). In addition to being the most coherent and consistent of Séguin's compositions, it is the closest in spirit to the faith which drew him to Brittany; yet at the same

145

ARMAND SÉGUIN *Les Fleurs du Mal*

and vaguely joined hands give the picture the half-real, half-visionary quality so much desired by the many Symbolist poets whose watchword had been formulated by Mallarmé, '*Suggérer au lieu de dire*' ('Suggest instead of saying').[113]

Did Séguin paint any other canvases like this one? Was it an isolated experiment, leading nowhere, or did it open the way to greater fruitfulness? In *Les Fleurs du mal*, and in *The Delights of Life*, four panels for a screen, Séguin applies the suppleness and virtuosity of his graphic work to the technique of oil painting, thereby bringing himself into the company of the Nabis and Art Nouveau rather than of Syntheticism and Pont-Aven.

Among all the complexes and contradictions one finds in Séguin one thing stands out: there was a fault in his nature, some kind of internal fracture or split which prevented him from releasing his very great abilities. Analysis of his pictures and of his declarations will perhaps enable us to determine its origin.

Séguin, as we have said, was Gauguin's favourite pupil, a receptive, grateful pupil, so much so that, after the opening of his first exhibition in 1895, Denis could write: 'Go, then, to the Séguin exhibition if you want to find out what the Syntheticists and Symbolists have been trying to achieve.' We know, from Séguin's article in *L'Occident* (1903), that he regarded Gauguin as an artist of genius and the creator of modern decorative painting; he was also devotedly fond of him as a man. But what were the implications for himself? He was too intelligent not to sense, from the very outset, that the powerful influence of Gauguin might engulf and annihilate him. Unlike Van Gogh at Arles, he did not feel capable of arguing with the 'master'; it was his destiny to carry on a patient but unequal struggle in his own mind, a struggle exacerbated by his inborn tendency to bitterness. Besides, argument would have been irrelevant. He accepted Gauguin as a phenomenon, an unsurpassable artistic force; at the same time he foresaw no future for himself: 'As I am in a position to know, the master's authority was so patent that to resist it by running away would have been perfectly comprehensible. That was the real reason why I refrained from following him to Tahiti; a decision which I have since regretted.' Séguin omits to mention the chief obstacle to his leaving for the tropics, which was lack of money; there is none the less a certain truth in what he says.

The tragedy his case presents is twofold. He wanted to paint, but had neither the money nor the time; and when he eventually did have them he could not decide in what manner to paint. He was passionately devoted to nature and the profound study of the model; on the other hand he was thrown off balance by the doctrine he attempted to impose on himself, and which was expected of him, yet against which he also fiercely defended himself. He accepted it as long as his development was confined to the field of drawing and engraving, though even there his line evaded the discipline of *cloisonnisme*. In painting, he shrank from committing himself, and this led him into the most damaging of all possible paths: he married

time it bears the stamp of his own individual interpretation. The reason for this is the presence of emotional elements which in turn owe their being to his having refined and attenuated the prescriptions of *cloisonnisme*. Half hidden by the setting, the women with their Breton headdresses – figures familiar to us from the canvases of Bernard – are not differentiated from the background by means of colour or bold outlines; on the contrary, they merge into it perfectly, an effect enhanced by the dark colours used throughout. But the elimination of perspective and the use of areas of flat, uniform colour have been faithfully observed; counterbalanced, however, by the sensibility evident in the choice of subject-matter and the delicate placing of reddish-browns, sapphire blues and dark greens, against which the beeswax yellow of the head-dresses stands out, while the women's gently inclined heads

his innate freshness of vision to an arduous, methodical attitude derived from intellect and imagination. His continual wavering was stigmatized by Gauguin in 1895 as *je-m'en-foutisme* ('don't-care-ishness'), with the additional comment that 'his faults are not yet definite enough to earn him the title of master'.

Dorival, writing of Séguin's condition of inner warfare, considers that 'his forms seem to regret their inability to dissolve into thin air' and that their creator was 'a stranger to the synthesis to which he had declared his allegiance'. And Hofstätter's opinion is that Séguin 'gave up his former style without having found a new one'.

Séguin did not believe in theories – possibly because he was bad at coping with them. What he did believe in was talent, intuition and vocation, and he put his trust entirely in the study of nature. His published opinions tally completely with his confidences in letters to friends. A touch of irony lurked in his talk, as we have already seen in his account of a compliment from Renoir, 'which gave me more pleasure than all the theories poured out upon me by friends'. A more pointed instance of his scepticism was noted by Pissarro, who wrote to his son Lucien in 1895: 'The curious thing is that his [Gauguin's] own pupils are beginning to drop him and are coming back to kindly, straightforward nature. One of them, Séguin, who has just had a show at the gallery of Le Barc de Boutteville, admitted to me that he secretly didn't believe a word of it and that I was absolutely in the right. He was extremely complimentary about my etchings and my figures.'

Although this occurred after his quarrel with Gauguin, Pissarro does not appear to have misreported Séguin, who was to write in the same strain three years later to O'Conor: 'So for the last two months I've been living in utter simplicity and painting all day. This has enabled me to do two pictures; some women on the shore – it may surprise you to hear I'm not too displeased, but good Lord, how I hate not being able to refresh my knowledge by studying from nature. Because I have no money and too little room I waste hours looking for the truth, gazing at myself in the glass, delving into textbooks of anatomy... seeking, hesitating and finally making things fit.'

His distrust of intellectual painting and of theories and doctrines was so deep-rooted that he did not hesitate, although Gauguin was still alive, to express it in his study of the Pont-Aven school in *L'Occident*. This passage perhaps refers also to Sérusier and his ideas on 'sacred proportions' (*les saintes mesures*) and the colour-circle: 'Their canvases, though based on the same principles, are completely dissimilar, which is enough in itself to prove that what every artist needs is intuition, and that theory is merely barren soil for anyone not born with this gift. No colour clashes with any other colour; talent is capable of harmonizing the most disparate tonalities and will unite them in a happy embrace. This brings all the laws of complementary colours, derived colours or related colours tumbling down. Their correctness is mathematical; they turn out to be completely false in the hands of any painter in whom the divine vocation is missing.'[114]

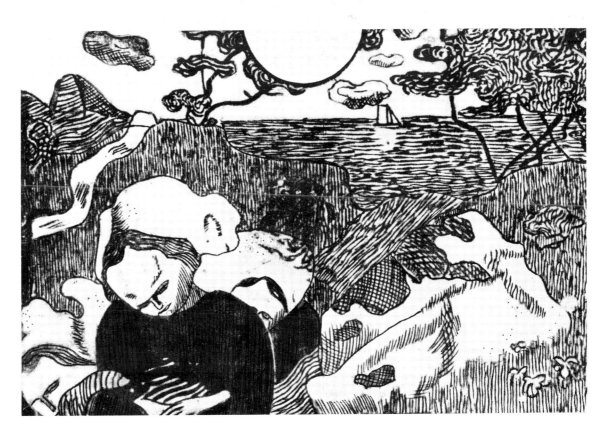

ARMAND SÉGUIN
A Summer's Day 1894

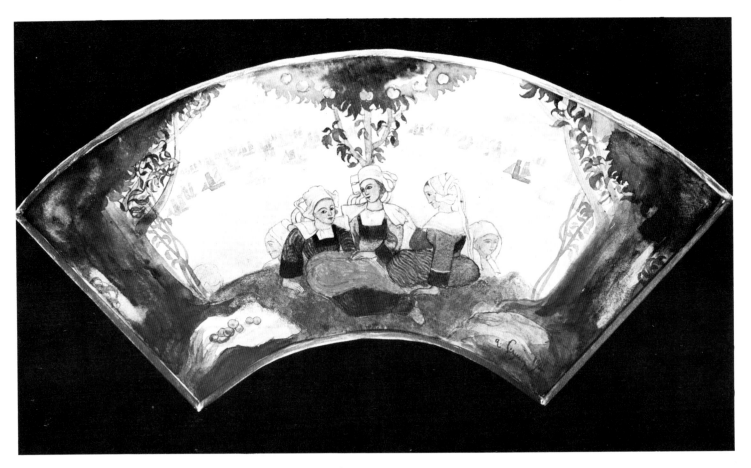

ARMAND SÉGUIN *Breton Women Seated* 1901

Séguin remained in Brittany until his death. He was the youngest member of the group, and made friends with the others, who treated him as a member of their large family. From 1900 he lived at Châteaulin, where he experienced 'the most terrible nightmares' of his life and wounded himself severely in a suicide-attempt with a razor. Knowing that he would have to spend several months in bed, Sérusier took him to his own house in Châteauneuf-du-Faou, looked after him and in due course vacated his own studio in the garden for the use of the convalescent.[115] Séguin benefited greatly both by this stay at Châteauneuf and by the long conversations about art he was able to have with Sérusier; his host, too, from being overwhelmed by his misfortunes, was now able to start painting again, after two years of complete inactivity.[116]

Séguin was also a friend of O'Conor, who helped him financially when he was very hard up, and with whom he corresponded during the last eight years of his life. Séguin's letters to O'Conor constitute an intimate journal; he himself admitted the 'pleasure of analysis and confession' which he got from writing them. He also kept steadily in touch with Filiger, Denis, Chamaillard and Slewinski. As for Verkade, who by this time had become a monk at Beuron, he took Séguin under his moral protection, steered him away from drink and urged

him, not altogether without success, to seek the consolations of religion.[117]

The death of Gauguin affected Séguin deeply. He himself died three months after his master, to whom he owed so much and who had unintentionally been the cause of the major crisis of his life. In September 1903, Séguin had written to O'Conor: 'The news of Gauguin's death came as a grievous surprise, it was Charles Guérin who told me of this sad event, a trader from the Marquesas had given the news to Molard. Gauguin died peacefully, with his women about him, in his hut.' And in early January 1904, O'Conor received, instead of the usual letter from Séguin, this message from Jahier: 'Poor Séguin, as you might have expected from what you saw, has died without suffering and without regaining consciousness, he went out like a lamp.'

Séguin had waged a ceaseless and heroic fight for the right to paint, but was fated to lose; death came for him too soon. His greatest fear was realized: he passed into history as an illustrator, and – what he himself would have least expected – as an historian and theorist of a group of artists by whom he had been welcomed and indeed cherished, but to whose doctrines he had never consented to subscribe.

Maurice Denis 1870–1943

Our wisdom will be found in your tender and noble compositions, but our torments in your writings. Paul Valéry to Maurice Denis

Maurice Denis had not started visiting Brittany at the time when the Pont-Aven School was making its heroic start in the world. He took no part in the lively discussions between Gauguin and his disciples, either at the Pension Gloanec at Pont-Aven or at the friendly inn of Marie Poupée at Le Pouldu. Nor did his name figure among those of the participants in the Café Volpini exhibition, the group's first formal appearance. But, distance notwithstanding, he contrived to keep in close and constant contact with the community in Brittany, with their thoughts and opinions and continual flow of unconventional conclusions, to such effect that it was he, in his writings, who was to take these passionate discussions and clothe them in the form of a definite theory. Generally regarded as the mouthpiece of the Nabi movement, as the regenerator of modern religious art, and as the first champion of Italianate neo-classicism in painting, Denis was, above all, the man who constructed an articulate, reasoned system from the aesthetic of Pont-Aven; and this task was what first kindled his ambition and provided him with the start of his life's work.

He was still under twenty when his friend the actor and stage-director Lugné-Poë spotted his talent and encouraged him to write an article, his first and perhaps most important essay on painting. It appeared in 1890 in the review *Art et Critique*, under the pen-name Pierre-Louis; its title was 'Définition du néo-traditionnisme'.

On leaving the famous Lycée Condorcet with the first prize for Greek and philosophy, he entered the Académie Julian and met Sérusier, who was seven years his senior and was working there as *massier*. Relations between them were soon close. The intelligent Denis, with a mind remarkably well prepared considering his youth, drank in everything Sérusier said about philosophy, and was equally eager to absorb his opinions on the art of painting as practised at Pont-Aven and Le Pouldu. Ranson, Ibels, Roussel and Bonnard, who were also students at Julian's and were soon to set up the Nabi group under the leadership of Denis and Sérusier, were no less enthusiastic. A sound philosophical training and his natural

MAURICE DENIS *Self-portrait* April 1889

perspicacity enabled Denis to co-ordinate the various opinions professed within the group, and his very real literary talent qualified him to work up into their appropriate form the ideas of those whose intention it was to shake the established order.

149

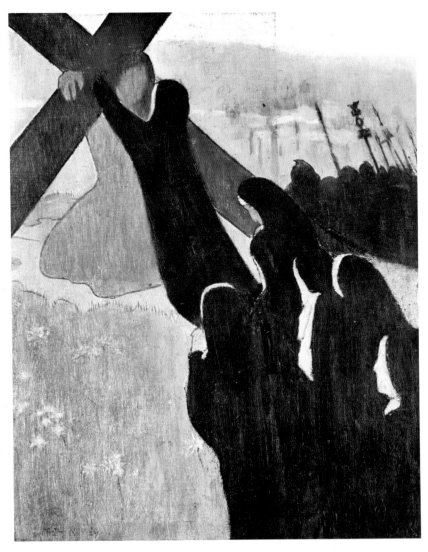

When, in 1912, Denis collected some of his writings into book form, under the title *Théories*, he had no hesitation in declaring in his preface that the first article in the collection, the one reprinted from *Art et Critique*, was 'a manifesto of Symbolism'. The word need not surprise us; manifestos were much in fashion at the time, and the very form of the piece, with its division into twenty-five numbered 'chapter-paragraphs', implies the author's intention of giving his work the character of a proclamation. Nevertheless, and in spite of the confidence he felt as a result of appearing under the aegis of both Gauguin and Sérusier, it is doubtful whether Denis could foresee just how great an impact was to be made on the world of the arts by these few pages from a youthful pen.

The most significant passage in his essay of 1890 was the first paragraph, containing the famous lines: 'Remember that before it is a war-horse, a naked woman or a trumpery anecdote, a painting is essentially a flat surface covered with colours assembled in a certain order.'

This highly concise enunciation, which recognizes the whole intrinsic autonomy of the picture, is a succinct confirmation of Gauguin's conception of the freedom of the creative artist and the attitude he should maintain towards nature and the work of art. It became the watchword of the new age, with its urge to break with nineteenth-century Naturalism once and for all. Olivier Renault d'Allonnes, commenting in 1964 on Denis's 'Définition', observes: 'In it, at the age of barely

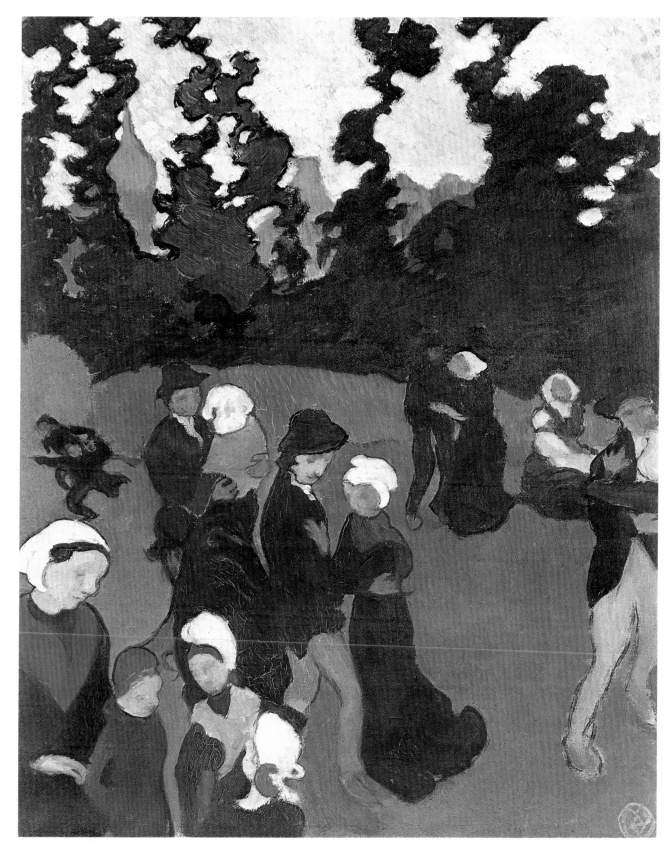

MAURICE DENIS *Breton Dance*

MAURICE DENIS *Procession under the Trees* 1892

MAURICE DENIS *First Communion*

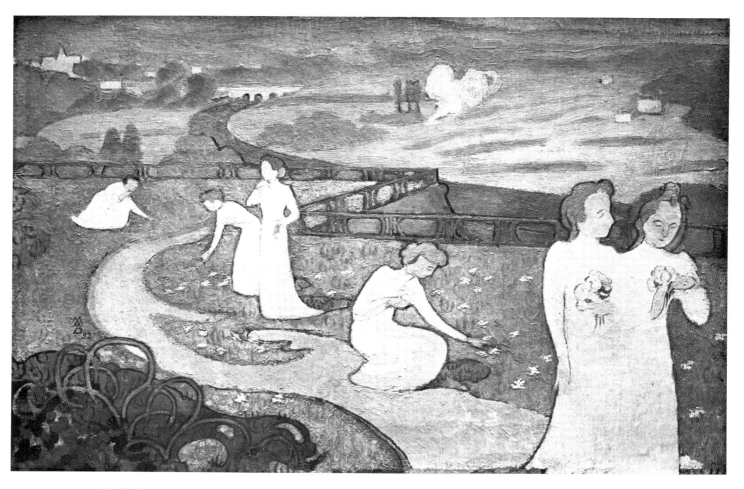

MAURICE DENIS *April* 1892

twenty, he succeeded in formulating a handful of axioms which were to be obeyed not only by Symbolism but by the whole of painting for three-quarters of a century.'

Critics have asked more than once whether young Denis was conscious or even vaguely aware, when formulating his theories, that the world might one day see the emergence of 'non-formal', abstract art which would conform to his conceptions. But the problem is perhaps not particularly important, since Denis's primary objective is to attack academic painting, the spoilt darling of society drawing-rooms; to this end he needs to establish a new code of law, so to speak, in order to validate anti-Naturalist painting: a picture is not a repetition of nature, or a copy of it, or a photograph; a picture is an absolutely independent artistic fact. If the artist has recourse to nature he does so only in order to express nature in accordance with his own vision and imagination – in other words, to translate nature into 'iconic' language.

This interpretation of the celebrated opening paragraph of his manifesto was continued by him in an article on 'L'Influence de Paul Gauguin', published in *L'Occident* in 1903 and reprinted in *Théories* (translated, also, in John Russell's *Vuillard*, 1971). Referring to Sérusier, he declared: 'Thus we learned that every work of art was a transposition, a caricature, the passionate equivalent of a sensation experienced.' In an interview given in 1891 he had stated his position even more clearly: 'I believe that above everything a picture is a decorative object. The choice of subjects and scenes is of no account. It is by means of the coloured surface, the tone-values, the harmony of lines, that I seek to arouse the mind and excite emotion.'

153

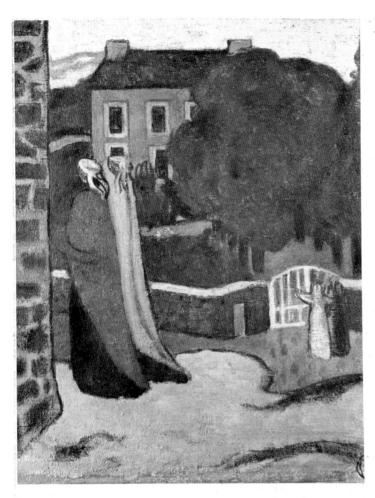

MAURICE DENIS *Breton Women with Long Shawls* 1895 MAURICE DENIS *The Barrel of Cider* 1894

There is, consequently, nothing surprising in the fact that the generations who have practised an art liberated from the object should have adopted the definition enunciated by Maurice Denis as their own watchword – which Rookmaaker says is better adapted, whatever uses and abuses may have been made of it, to the nature of free abstraction (*art informel*) than it was to Symbolism.

This assertion in no way diminishes the important part played by Denis in the relationship between Gauguin and the Breton group; and, although he never joined the group him-

self, it is quite certain that he is an essential figure, inseparable from the historical context of the Pont-Aven school. His function has been aptly defined by Revault d'Allonnes: 'Perhaps nothing would have happened without Gauguin the master, who however was not a teacher, and Sérusier the apostle, with his "highly philosophical intelligence". But the whole activity had to be unified, deepened and articulately expressed by a writer who was at once an artist and a thinker; and this was the part played by Maurice Denis.'

Since Denis constantly refers to Sérusier in framing his

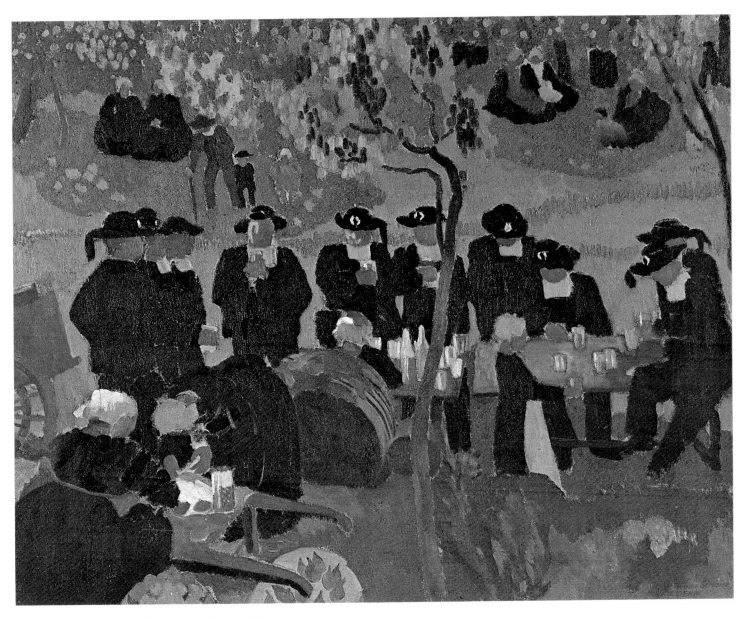

MAURICE DENIS *The Pardon at Le Guidel (Cider)*

judgments, we can justifiably regard them as faithfully reflecting the problems that were preoccupying the Pont-Aven painters about 1890; and the ideas held by Denis at a later period, which from the philosophical and conceptual point of view were very different, must not be allowed to mislead us. For, as it happened, after having been a follower for some time of the ideas of Gauguin – according to which the new painting was to contradict Naturalism by concentrating on the expression of spiritual reality – Denis changed his position. As a practising Catholic with a pronounced mystical tendency, he came to feel that he had been called to serve his faith by assisting the regeneration and revival of religious art. It was in this direction that his activity, both practical and theoretical, was later to turn.[118]

It is rather interesting to compare these two aspects of Denis. Today, the painter seems less violent to us than the theorist, especially if we compare the ideas he entertained as a young man with his later works, such as the ceiling of the Petit-Palais, or the *Eros and Psyche* series commissioned by Shchukin, the eminent Russian collector of the French Impres-

MAURICE DENIS *Self-portrait* 1896

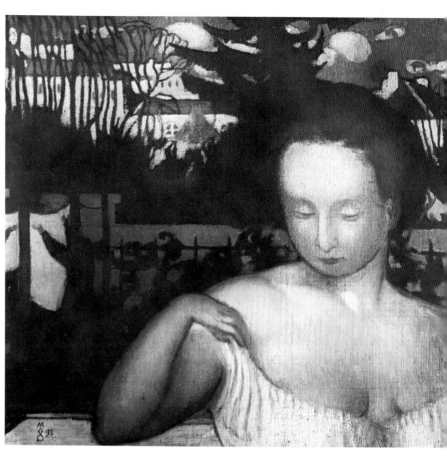

MAURICE DENIS *The Painter's Wife, Marthe Denis* 1893

sionists, for his house in Moscow. The contrast becomes even more striking when one reads his proclamations, which were prophetic in his own day and were adopted later by the abstractionists. It is always dangerous for a creative personality to combine these two activities; but Denis always remained true to himself, and his steady development as a painter did in fact move forward in harmony with his theoretical precepts.

A few canvases have been preserved from the period when he was in touch with Gauguin and the group in Brittany. Examples are the *Breton Dance*, a composition with something somnambulistic about it; the hieratic Breton church fair scene, *Pardon at Le Guidel*, and a landscape, *Rocks at Le Pouldu*. His other paintings belong rather to the aesthetic of the Nabis and of Art Nouveau, enriched however with a climate of idealism and contemplation in a spirit like that of Puvis de Chavannes, to whom he stands very close.

He was an intimate friend of many famous personalities of his period, including Lugné-Poë, Gide and Verlaine, and played a leading part, not yet fully appreciated, in the life of the various artistic *milieux* of Paris in the closing years of the nineteenth century. Books and articles about this period are constantly bringing forward fresh evidence to show how much he was liked and respected by his contemporaries. Revault d'Allonnes has published a letter which Paul Valéry wrote to Denis after reading *Théories*: 'One day when we are no longer here, people will be astonished that in one man such intelligence was combined with such grace. Our wisdom will be found in your tender and noble compositions, but our torments in your writings: and all the factions of those incompatible ghosts who are ourselves, their formal dissensions, their colourful cruelties, will be kept vividly alive in them, as in the pages of Guicciardini and Machiavelli the agitations of Florence.'

VIII THE MYSTICS

Charles Filiger 1863-1928

The perturbation or passion I undergo in front of my work frequently paralyses my mind and my limbs, so much so that I remain idle for several days; it is as if my hands were afraid to touch the Dream.

Filiger to Rémy de Gourmont

The name of Filiger appears in the register of the Pension Gloanec alongside the date of his arrival, 13 July 1889. We are forced to regard this date, which was also that of his joining Gauguin's group, as the only certain fact in the biography of this mysterious and enigmatic individual.

Of Alsatian or, as some say, Swiss origin, his very name, Filiger, is open to controversy. Some authors, according to Agnès Humbert, persist in spelling it Filliger; the 'error', they assert, lies with those who accept the signature of the painter himself and content themselves with a single L.[119] Similarly, there were at least three versions of his dates of birth and death until Hofstätter discovered the correct one and supplied evidence to prove it: the certified duplicate of an official document, in the possession of Mme Cochennec at Rosporden, which states that Charles Filiger was born on 28 November 1863 at Thann (Haut-Rhin) and died on 11 January 1928 in the civil hospital at Brest.

Filiger is still, even today, an unknown painter. The studies which have been devoted to him since 1894 are all very short; they merely say that materials for his life appear to be non-existent and that his pictures were dispersed after his death and must be regarded as lost.[120]

Filiger came to Brittany from Paris. It is not known what he had been doing before, or how he earned his living. It has not been confirmed that he met Gauguin at Colarossi's, or that he followed his example by going to sea. All we know is that the Café Volpini exhibition in 1889 made a powerful impression, and that he even bought an album of lithographs by Gauguin and Bernard and thereafter always had it with him. Paul Colin, who is quoted by Chassé, wrote: 'I had made the acquaintance of Filiger at Colarossi's; his painting attracted me at once; at that time we used to have lunch at a little restaurant in the rue Serpente. Later, he lived in Colarossi's own house. It was there that he showed me the album of lithographs by Gauguin, before we set out for Brittany.'

One episode in his life is known: the police found him one night unconscious, with blood on his hands and a knife stuck in his thigh. He spent some time in hospital and left Paris in a hurry as soon as he was better, as if running away. He never told his friends at Pont-Aven and Le Pouldu anything about his former life; and made out that he had not wanted to come to Brittany but had found it impossible to live in the capital because he 'hadn't the cash'.

Despite Filiger's lack of enthusiasm for Brittany he never left again, except for a few short trips to Paris. His painting was born of Brittany and steeped in Brittany, and portrays Brittany in the full bloom of its charms. Like Sérusier, he might have declared that Breton costume was timeless and appropriate to all ages. But his approval did not extend to costume alone.

One might describe his work as an amalgam of Byzantine art, the *Quattrocento* and the *cloisonnisme* initiated by Anquetin and Bernard, the whole being immersed in the naivety of Epinal prints and Breton popular mysticism. It is worth remembering that Thann, Filiger's birthplace, is not far from Epinal, the capital of the popular print making industry. This unexpected graft on the tree of Pont-Aven did not fail to produce equally unexpected fruit.

Of all the Pont-Aven painters, Filiger was probably the most successful in discovering adequate means of expression for his own particular version of Syntheticism. He had in any case fully acquired those means long before joining the Breton group. Filiger was also, in his time, by a long way the most *avant-garde* of them all as a decorative painter: he had an incomparable inborn instinct for ornament and embellishment. Although he expressed himself almost exclusively in small gouaches or watercolours, they are so monumental in design that they are more like projects for gigantic mosaics, murals or stained glass windows. One might say that while he was painting, Filiger never stopped thinking of architecture – it was a real and living presence to him, and its elements were as indispensable to his working as they are inseparable from the result. Even his smallest compositions are inscribed (to borrow a geometrical term) in the ogives of a Gothic stained-glass window, or in the gentle curves of some ancient fragment of Breton architecture, or in a decorative border from a

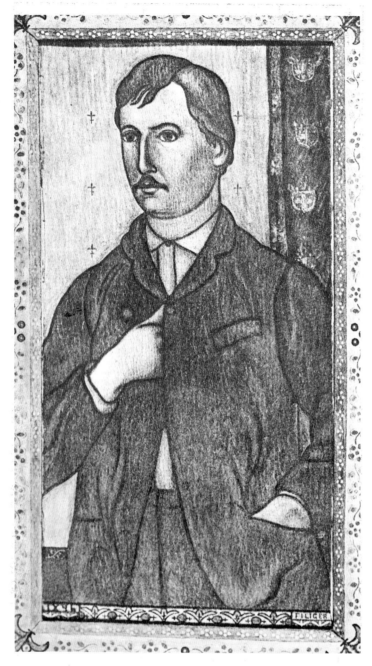

CHARLES FILIGER *Antoine de La Rochefoucauld* 1896

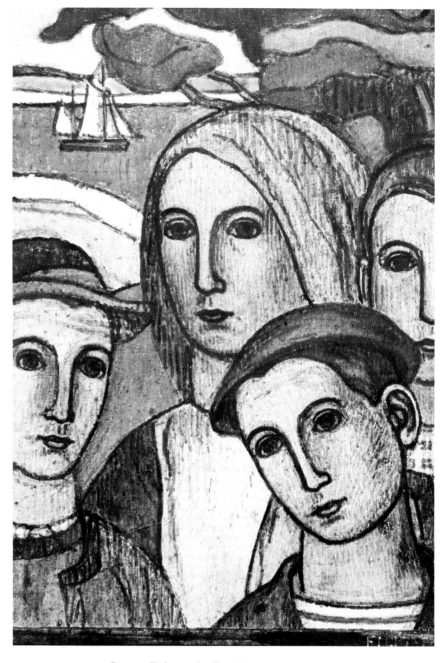

CHARLES FILIGER *Breton Fisherman's Family*

Byzantine church. In *The Martyrdom of St John the Evangelist* we can follow, empirically as it were, the painter's actual procedure: having finished his gouache he masks part of the angels' faces and bodies so as to enclose the picture on three sides in a deliberately asymmetrical border. His justification for this appears to have been the architecture of the setting in which the panel was intended to hang. The stratagem is a neat

one, but can still be detected through the delicate wash with which it was carried out.

The other characteristics of Filiger's compositions are their static, fixed quality and the absence of gesture and facial mimicry. 'Never make your figures cry or laugh', Alfred Jarry reports him as having said in front of a canvas by Forbes-Robertson, *Singing Sirens*.

And in fact none of his characters is laughing or crying: neither his sad Madonnas nor his saints, male or female, deep in meditation, nor his frail youths absorbed in prayer. His figures preserve the hieratic attitudes seen in icons; their faces, not modelled in the round but defined by outlining, are filled with a supernatural unction. It was not for nothing that their creator had been at pains, on the many harassing occasions when he moved to new lodgings, to pack among his modest possessions the reproductions of his favourite masters, Cimabue and Giotto.

Religious scenes, or rather themes, are the subjects of most of Filiger's work. Everything he did is impregnated with his own characteristic brand of mysticism, which is also present in his non-religious compositions and his portraits, such as those of Emile Bernard and Antoine de La Rochefoucauld; he is a painter who is always swinging between Catholic mysticism and a pantheism which, though pagan, is informed with spirituality.

Another distinguishing trait of Filiger is the naive rusticity of his compositions. His *Breton Fisherman's Family*, in their sailors' jerseys, are rustic; so is his *Breton Cow-herd*; but no more so than his *Christ on a Breton Common* (with a cow grazing at the foot of the cross), or *St Cecilia and the Angels*, or, for that matter, his portrait of Bernard. The faces in his pictures are all conceived according to a single unchanging formula, which so far from being tedious actually contributes to the consistency and individuality of his style. The face of the *Breton Cow-herd*, in the blue gouache of that title, is like those of the mother and children in the *Breton Fisherman's Family*, is identical with that of the angel in the *Entombment of Christ*, and bears a striking resemblance to the features of La Rochefoucauld. It was a perfectly deliberate act on the part of Filiger to paint in this way; one might almost call it a preconceived programme. Julien Leclercq, who was standing one day in the Louvre, in the company of Filiger, looking at *The Virgin with Angels* by Cimabue, recalls with what enthusiasm Filiger remarked on the fact that all the faces were alike. 'How Cimabue must have loved that head', he exclaimed, 'to paint it as often as that!'

This overmastering mystical craving of Filiger's is emphasized by Yves Dautier in the parallel he establishes between the *Breton Fisherman's Family* and Bernard's *Apple-picking*, though he is careful to point out that the resemblances are purely formal in character and that the painters' aims were completely different. Bernard, who transposes his subject into a deliberately constructed, decorative perspective, is aiming at a Japanese effect – *faire du japonais*; Filiger transforms reality in obedience to his predisposition towards mysticism.

It is hard to say how his mysticism had originated; the question is as tangled as his life-story itself. We must turn to the latter for such insight as we may be able to glean. The first thing to note is that Filiger was an inveterate alcoholic, with

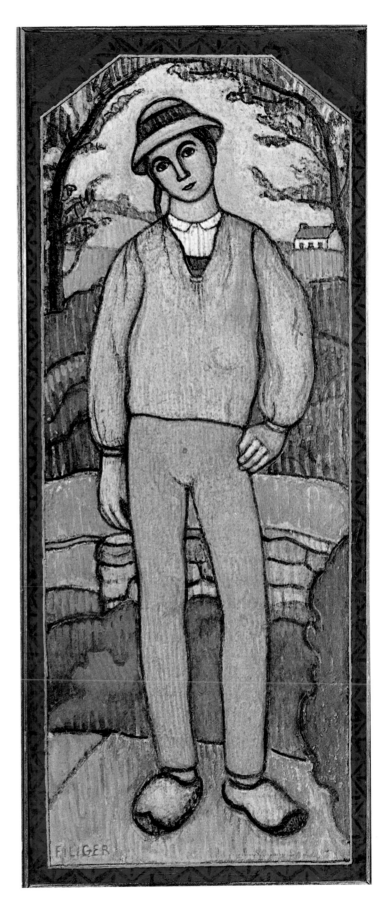

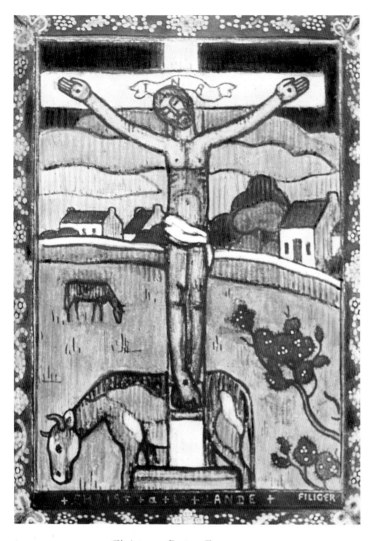

CHARLES FILIGER *Christ on a Breton Common*

short, small hooded eyes and a large, sensual mouth, was a highly complicated character. He hailed from Alsace-Lorraine and was one of those unhappy beings who, under the burden of heredity, are sometimes unable to help themselves and commit actions which they subsequently deprecate and deeply regret. Their weaknesses drive them deeper and deeper into unhappiness and rancour until eventually they seek revenge both on themselves and on society, abandoning themselves completely to excess, endeavouring to drag others with them into ruin, and all this only for their own ever-greater torment. They are people who suffer horribly, but their suffering is completely wasted because their pride and self-love remain untouched, and it is often only in their last hour that, from the depths of their distress, they turn to God with that appealing cry which, against all expectations, opens the gates of Heaven to them. Companions of this sort can be very harmful, but can also exert a very useful influence. In many cases they possess outstanding gifts of mind and heart, have much experience, have suffered and thought a great deal in their lives. Often, too, they have loved much and even squandered their love; they are usually squanderers by nature. They give much, but not well, because they often give what does not belong to them, and even deliver up their very selves in a love which is misunderstood. If men of this kind are painters they seek to compensate for their disharmony of soul through artistic creation, but, as they are not over-endowed with vital force, every work that comes from their hands leaves its maker even poorer and emptier than he was before. Because they sense their own lack of energy they have recourse to narcotics, to alcohol or morphine or opium, because, after the exaltation to which they were raised by the will to create, they cannot bear feeling so empty of life, so starved in spirit....

'Drathmann produced little, but I have seen some very fine gouaches by him; most of them are religious paintings, very reminiscent of the Byzantines and the Italian Primitives, but completely personal and modern in feeling. He was fundamentally Catholic by nature, in the sense that no other form of belief would have suited him. He had Catholicism in his blood like so many other Frenchmen, even when they claim to have their own ideas on religious matters and seldom or never go to church. He often spoke of the Catholic Church, sometimes with affection and sometimes with scorn, but he never tried to convert me. On hearing that I had become a Catholic he scolded me in a letter, telling me that my Protestant faith was worth as much as the Catholic faith. He certainly did not know that I had never been a Protestant; in reality, I belonged to no sect.

'Drathmann's ideas and emotional outpourings tossed me this way and that, but luckily drove me more often to the good side than the bad. He taught me many things about life and art which experience has so far confirmed. He regarded me as his disciple and showed me a master's love.'

The moralizing tone of this portrayal of Filiger owes its comparative mildness to the twenty years spent by the author, as Dom Willibrord Verkade, at the monastery of Beuron. The

neurotic tendencies which became acute and developed into the typical symptoms of persecution-mania towards the end of his life.[121] His condition inevitably went downhill because he took hypnotic drugs, particularly veronal, in large quantities over a period of years. He was remembered by many people in Brittany as 'a hard drinker and an idler', and it was to these two capital weaknesses that they attributed the poverty in which he lived and died.[122] Quite other is the judgment of Verkade, a Dutch Mennonite who was converted to Catholicism and became a monk, and whose reminiscences of Pont-Aven are recorded in his book *Le Tourment de Dieu*. He refers at some length, although obliquely, to Filiger's homosexuality.

Verkade writes: 'The painter Drathmann [i.e. Filiger], a plump, stocky man with full cheeks, hair and beard trimmed

CHARLES FILIGER *The Entombment*

verily a wolf in lamb's clothes. I pray for him, often, and hope indeed that God will save him after all. But for you he is dangerous. Pray for him, but keep away from him. If you are not convinced by what I say I shall say the same and more to him, but I hope this will not be necessary, as I do not like talking like this about anybody. But this time, I must." Horror and Mystery! I haven't seen Filiger for five years; what is he supposed to have done or said?'[123]

To 'place' Filiger more accurately, and in particular to describe the complex origins of the mystico-religious character of his art, it is important to remember that the epoch was that in which preoccupation with theosophy, spiritualism and occultism was particularly strong. Horoscopes, table-turning and graphology were in vogue, and such practices harmonized smoothly enough with a certain religious sublimation. Romanticism had modified the way in which Christianity was conceived; the resulting interpretation ran directly counter to orthodox theology and progressively diluted the distinction between God and the world, God and man, sentiment and faith; between nostalgia for far-away things and faith in the immortality of the soul.

Such, precisely, is the role of Christianity in the art of Filiger. He found it easy to fuse the Catholicism instilled into him by his family with the spiritualism practised in social circles connected with the Société de la Rose-Croix, under the aegis of which organization he exhibited in his capacity as a 'religious painter'.[124]

This fact was responsible for his meeting La Rochefoucauld and also Sâr Peladan, the 'prince of aesthetes', both of whom were fond of taking part in the spiritualist séances that were a feature of Parisian high society. In time, La Rochefoucauld became Filiger's protector and patron and collected his pictures. At Le Pouldu, and later at Plougastel, the artist received a supply of money from him and sent pictures in return.[125] Almost his whole output went to Paris in this way, and the discretion with which its dispatch was carried out was presumably the origin of his local reputation as an idler who did not paint much. (It is not known, incidentally, what became of this collection, except that it is supposed to have been stolen in mysterious circumstances; nor is it known what happened to the copious correspondence between the painter and his patron.)

Nevertheless, even if it be true that he got his religious inspiration from spiritualism and occultism or, as Verkade maintained, from 'Satanism', no effect from these movements is to be seen in his works. His art is pure and naïve, the art of an illuminate; and the artist himself bore a far closer resemblance to St Francis of Assisi than to Satan. Hence Alfred Jarry, in a reference to the *Chants de Maldoror* by the Comte de Lautréamont (Isidore Ducasse), wrote: 'Maldoror, too, incarnates a beautiful god under his resounding cardboard rhinoceros-hide. And perhaps a holier one.... The demons doing penance between the long ribs, like lobster-pots, of the beasts, climb heavenward on all fours, the only way of walking in

difference can be seen in a letter which Séguin addressed to O'Conor in September 1902, and in which he quotes a fragment from a letter he had just received from Verkade; the newly-converted novice, twenty years before the book was written, had reacted much more violently to the supposed 'Satanism' of Filiger. Séguin writes: 'For your entertainment, Verkade has written me a letter from Beuron, a very beautiful and kind one. Surely you remember – the painter I used to say used blue to paint things red! The Protestant who was converted to Catholicism by Filiger's eloquence, who is now a Benedictine and told me not long ago that he had said his first Mass. In answer to my congratulations I get this lengthy epistle from which I'll copy a few sentences – don't forget it's a Swede [*sic*] writing: "Avoid, also, the company and influence of Filiger. He is a terrible instrument in the hands of Satan,

163

steep places.... This is why, definitively, he is surpassed by the art of Filiger, with the candour of his chaste heads and their expiatory Giottism.' The art of Filiger is similarly interpreted by Alfred Mellerio, in his *Le Mouvement idéaliste en peinture*: 'Candour fuses into religious feeling, which is the keynote of the work of M. Filiger.'

Like some other painters in the Pont-Aven group, Filiger turned to Christianity as 'the religion of the humble', and he felt it constituted an essential element of Italian Primitive painting. But unlike Gauguin and Bernard, who regarded religious feeling simply as a possible ingredient in a painting, the mystical potential constantly at work in Filiger's personality makes his pictures seem as if they have been painted for the greater glory of God and the comfort of the human heart. And this is undoubtedly how his work was understood by the 'humble' themselves. Let Jarry be our witness again: 'No need to praise Filiger; the highest praise, in his eyes, is that of the peasants who (after duly admiring the little St Georges – or Our-Lady-of-the-Hermits in her hut, like a drawing-room, hung about with red draperies – or St Claud with his mitre and crozier, walking above the churches[126] – or Christ, like a flower among palm-trees, with the Evangelists round Him – or St Blaise and St Guérin, symmetrical defenders against cattle diseases – or all the Christs on backgrounds of dawn or twilight or air or sea or crêpe), say: *What you do is even more beautiful than these*. (And so much the worse for those who see in the Epinal prints only the superficial inanity and miss the real, Lorrainish or German, unique truth and excellence.)'

There is a fairly large number of watercolours and gouaches, called *Notations chromatiques*, which constitutes a curious cycle within the *œuvre* of Filiger. Starting from a strictly geometrical figure inscribed in an oval or a polygon, ornamental forms are developed, composed of tiny multicoloured facets executed with striking technical precision. The central element in these compositions, and the most alive, is often supplied by a human face, seen frontally or in profile, round which there is a profusion of ornament of every kind. The face is sometimes that of a Madonna, sometimes a saint of either sex, and sometimes a stylized portrait of a friend.

These *Notations chromatiques*, most of which are in the Musée national d'Art moderne or the Galerie Le Bateau-Lavoir, are generally lumped together under the classification 'projects for stained glass'; but this term, which was not applied by the artist, is fallacious. Neither the medallion-type design of these works, nor their technique, suggests stained glass; on the other hand, they do show all the characteristics of cartoons for mosaics.

What concerns us here is not the ultimate purpose for which the *Notations chromatiques* were intended, but the fact that the artist was obsessed by the search for artistic problems which could be solved, and design-structure which could be drawn, by means of pure geometry. What was the source of this obsession? Even if we assume that the *Notations* were in fact conceived as designs for mosaics, none of which were executed, it would have been enough in each case for the artist to execute

CHARLES FILIGER *Christ Surrounded by Angels* 1892

a fragment of his ornamentation, which would have been duly enlarged and reproduced the required number of times; it would then have been a simple matter to assemble the finished pieces. So far from doing this, however, Filiger, with a truly Benedictine ardour and self-abnegation, took square and compasses and marked out his 'crystal grains' one by one before colouring them with extraordinary minuteness, producing an interplay of complementary colours, sometimes superimposing one on another, sometimes progressively intensifying a single colour. We cannot help wondering what sort of satisfaction the artist and mystic was able to wring from these laborious exercises.

The *Notations chromatiques* are not the only example of Filiger's attachment to the geometrical figure and its application in painting. In the unfinished gouache *St John the Baptist* there can be seen a spider's web of delicate pencil-lines, a network within which the artist marked out his composition. Analyses carried out on other works of Filiger show that a

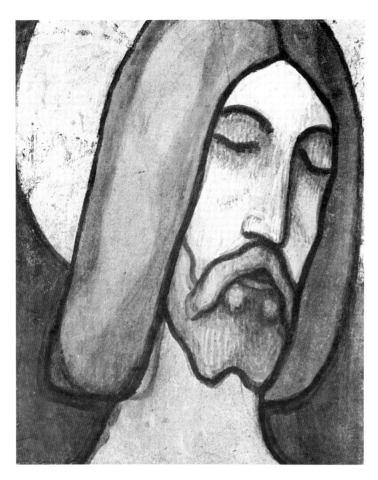

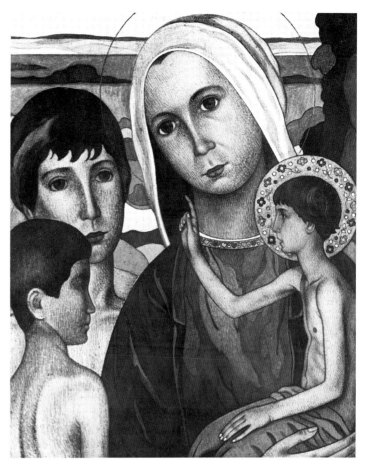

CHARLES FILIGER *Head of Christ*

CHARLES FILIGER *Virgin and Child*

geometrical framework was generally the basis of his creative activity, and that this was how the static, hieratic quality was imparted to his work.

It is obviously possible to argue that for centuries every pictorial work (and painters allow that this is so) has been constructed in accordance with the famous 'secret geometry' to which a good many scholarly investigations have been devoted, among them the fascinating study by Charles Bouleau (which includes modern and contemporary painting as well). But where Filiger is concerned one is particularly struck by his love of geometrical figures and lines, his urge to express himself through controlled forms; and we may expect that further persistent inquiry, particularly concerning his abundant correspondence, will eventually succeed in throwing new light on the origins of his aesthetic.

Several conjectures are possible with regard to his pronounced fondness for geometry. As a passionate admirer of the *Quattrocento*, he may have seen a reproduction of one of the

drawings of Paolo Uccello, for example, such as the study in the Uffizi in which the Italian painter worked out with extraordinary minuteness the perspective diagram of a chalice which, of necessity, causes straight lines, circles and semicircles to intersect in a dense mesh not altogether unlike that of Filiger's 'crystal grains'.

Nor was Pont-Aven, as a milieu, entirely alien to these tendencies of his. Verkade and Sérusier were deeply interested in geometry as a creative principle in painting. Verkade, after his ordination as a monk, went to Germany, where the monastery at Beuron had become an important centre in the movement for regenerating sacred art, a regeneration based on modern principles and led by Father Desiderius, a Bavarian whose secular name was Didier Lenz. Desiderius was a sculptor who had studied at the Munich Academy and had developed in the sphere of influence of Cornelius and Overbeck; he had entered monasticism comparatively late in life, less from a sense of vocation than because he enjoyed the

Gregorian chant and wanted to introduce a new aesthetic into ecclesiastical art, on the basis of the Egyptian canons 'vivified by Christian mysticism'. His theories concerning the 'sacred proportions' – purporting to be justified by geometrical procedures and by numbers – were brought together in his book *Zur Ästhetik der Beuroner Schule*.

As for Sérusier, he met Verkade several times at Beuron and then began working, in Prague and at Monte Cassino, with Father Desiderius (they conversed exclusively in Latin), who influenced him powerfully. In the years 1897 to 1907 Sérusier moved back and forth between Beuron, Paris and Brittany; the only subject of his thoughts, conversation and letters was mathematics, including geometry, as applied to painting; he made endless calculations; he devised the famous 'colour-circle' (*cercle chromatique*) on the basis of which he was to set up a scale of colours, somewhat similar to the musical scale. To Verkade he wrote: 'These things are too vast for treatment in a letter. I shall write volumes about them, God willing.' In 1905 he finished his translation, *L'Esthétique de Beuron*, of Lenz's book, and wrote his own treatise, *ABC de la peinture*.

After Gauguin had gone to the South Seas a few of the Breton painters – Filiger, Sérusier, Slewinski, Séguin, O'Conor, Jourdan – settled permanently in Brittany, and in spite of being dispersed they continued to see a good deal of one another. From their letters we gather that Sérusier, passionately devoted to the 'sacred proportions' that were taught at Beuron, sought to convince his Nabi friends in Paris and his old friends from Le Pouldu of the correctness of the Beuron doctrine.[127] From the way the dates fit in, it is a safe deduction that his audience included Filiger, of whom Palaux says that 'lonely and introspective, even during the fiercest discussions with Gauguin at Le Pouldu, he sat apart, listening but not speaking.' So it may be that he was converted to the theory, and that he worked in secret, away from the others, on the incorporation of iconic frameworks in his figurative pictures, and on the pure geometrical experimentation of the *Notations chromatiques*, which were produced between 1903 and 1905.

How did Filiger himself define his aesthetic? He was a copious letter-writer; 'philosophical, as usual' was how his friends and colleagues described his epistles. This written testimony makes it abundantly clear that he regarded himself as a religious painter, and artistic creation as a grace from God. A letter to Rémy de Gourmont, published by Jarry in 1894, which in this respect at least can be taken as characteristic, tells how Filiger visualized himself and his work: 'The little Virgin at the head of my letter was done specially for you, several days ago.... You notice, I hope, that I was thinking of you already before hearing from you again? She will sing again in your ears the immortal names of Duccio and Cimabue, those names which are so dear to you! I am so very far below these geniuses myself, yet perhaps God has put something of their heart into me too?... The perturbation or passion I undergo in front of my work frequently paralyses my heart and my limbs, so much so that I remain idle for several days; it is as if my hands were afraid to touch the Dream, and yet

CHARLES FILIGER *Breton Landscape*

charity demands that for the sake of our fellow-men we come down, right down, and suffer the travail of reaching the reality of Dream.'

This *Credo*, this Christian humility, is here uttered expressly for the benefit of the founder of *L'Ymagier*, to which review Filiger was one of the contributors;[128] its sincerity might therefore seem doubtful. But we find it confirmed in other letters, and while the recipients were close friends it must also be conceded that they were men whose agreement the writer could hardly hope to secure. In November 1903, Séguin wrote to O'Conor: 'I've had two letters from Filiger, philosophical and full of high morality and good advice, in which he holds forth at length about his humility. He tells me he is living at Le Pouldu like a departed spirit!!! and doing a lot of work. Here are the opening lines of the four-page letter he has just sent me, they're just like him, as you can see: "For a month and more I've been working without a let-up, putting the last touches on a contraption of a composition which is giving me more trouble than *the devil himself, a Christ* on the cross, comparatively large, flanked by a *tiny* Virgin, all on a black background ornamented with red roses, and Heaven knows *the good Lord is putting me through the mill*", etc. Then he goes off on one of his flights into art-theory, you'll read it some time, they're interesting though I don't always agree with him.'

CHARLES FILIGER *Tree on the Shore, Le Pouldu*

PAUL SÉRUSIER *Breton Women Sitting by the Sea*

Is this the wolf in sheep's clothing abominated by the Savonarola of Beuron, or, on the contrary, a humble brother of the poor? Which of these two masks conceals the man and artist as he really was? Or was it, perhaps, precisely this moral and intellectual dualism which forced Filiger to seek refuge in his characteristic form of art as an escape from himself? Whatever the answer, the fact remains that he succeeded in awakening strong interest in himself and his works, both among the mystical Catholic circles associated with the Rose-Croix and among the most eminent *avant-garde* Symbolist writers of the time. The names already quoted (Jarry, Leclercq, Gourmont, Alexis, Mellerio, Peladan, La Rochefoucauld) establish it beyond doubt that the man whom the Breton fisher-folk viewed as a drunken down-and-out,[129] and the local doctors as a psychiatric case, was continuously in the closest possible touch with the intellectual and artistic *élite* of the Paris of his day.

Jarry, the author of *Ubu roi*, was much interested in Gauguin and the other painters in Brittany. While staying at Pont-Aven in July 1894 he wrote, in the visitors' book at the Pension Gloanec, three poems in honour of pictures painted by Gauguin in Tahiti: *Manao Tupapau, Man with an Axe* and *Ia Orana Maria*. He was equally interested in other members of the group, such as Séguin and O'Conor, but it was to Filiger alone that he devoted a substantial critical and theoretical study which was published in the *Mercure de France*, and which, though ostensibly a notice of the painter's two exhibitions (in 1893 and 1894) at the gallery of Le Barc de Boutteville, was in fact a solemn homage, in poetic prose, from a Symbolist writer to a Symbolist painter.

'And we shall unfold these notes on Filiger', wrote Jarry, 'because, after so many "Parisian" painters, it is pleasing to see one who has isolated himself at Le Pouldu; and because at this present time he is exhibiting a St Cecilia with her viol and three angels, and because this is very beautiful; because, by so doing and living, he *pleases* us; and because, finally, he is a *deformer*,[130] if this be the conventional term for the painter who paints what is and (divesting himself of outworn forms) not what is conventional.... Saying that everything in nature is beautiful, he forgets that everything is beautiful for the few who are capable of seeing; and that each of us elects his own kind of beauty, a special kind, the one that is closest to himself; and amid the nature he finds at Pont-Aven and Le Pouldu he sets about distilling his own version of beauty like a bee in the funnel of a lily with its swarming pollen. Thus Séguin, who chooses the peasant women of Trégunc, the silhouettes of the dancers in the gavotte with the bagpipe players standing by, and the tall trees, like spindles and earthworms, on the road to Clohars; thus O'Conor, the models suggested at siesta-time by local people passing across the triangular public "square" – in his case there is a slight disdain towards making a choice at all, his belief being that the painter is outside time and is therefore not concerned with place or space either; and thus Filiger, those Bretons with their air of resignation, their figures oval or almost lozenge-shaped, whom one sees framed

167

in gateways of verdure at farms or weddings and who are clearly predestined for the immobility and torment which await them in his pictures, a torment which will preserve them, like beetles in a collection, unfaded (they would look much more beautiful, to me, if they were crucified – and who knows? perhaps crucifixion is at the heart of the eternally immobilized face of every one of them). It is true, exceedingly so, that the eternal is enclosed in every individual, that every individual is the eternal, epidermally masked, and that I prefer the artist who, instead of the abstract eternity offered to him, accentuates – just so much, no more – the eternal soul which heaven and memory have infused in these transparent and contingent bodies.'

The *St Cecilia* was the work by Filiger which most affected Jarry, though he had already been impressed by 'the profile of the mystical and sensual adolescent' in an earlier exhibition and by the *Breton Fisherman's Family*, which was finished but had not been exhibited when Jarry wrote about it, and which the artist spoke of not as a picture or a composition but a *vision*. 'St Cecilia and her viol' (to quote Jarry again) 'against the blue sky and golden ornamental crosses, the Saint's arm, whose sex is ambiguous, a hand, perhaps the angel's, mingling with hers, union or communion. The incense of her head burns on the wrought gold paten of her halo.'

Switching abruptly from his metaphors and symbols to the incongruity of his own role as arbiter and critic, Jarry ends his study with this passage: 'It is thoroughly absurd that I should seem to undertake a description or critical account of these paintings. Because (1) if they were not very beautiful I would take no pleasure in mentioning them and therefore would not mention them; (2) if it were possible for me to explain point by point why they are beautiful, they would no longer be painting but literature, and not beautiful at all; (3) if I abstain from comparisons between one picture and another as a means of making myself clear – which would have been quicker – it is because I am unwilling to do those who dip into these notes the injustice of assuming that they require elementary aids.'

Filiger appealed strongly to the imagination of poets, and has never ceased doing so. André Breton, a great admirer of his painting, said that 'from Pont-Aven there emerges above all the work of Filiger, borne up throughout on the same wings as the *Cantique à la Reine* of Germain Nouveau.'

Pierre Cabanne wrote that Filiger's painting played such a ruling part in the life of Breton that the latter 'arranged his pictures round his bed, so as to receive their beneficent protection'.

But it should be noted that, while the contemporaries of Filiger appreciated his work, seeing in it a pendant to literary Symbolism, this response extended only to his figurative and ornamental output; one whole side of him, his landscape work, was overlooked. To me that is precisely the most interesting part. When, at the beginning of this chapter, I maintained that Filiger already had *cloisonnisme* and Syntheticism in his blood, as it were, by the time he joined Gauguin and his group, I was referring both to his religious composi-

tions and to his decorative projects, which were enabled to come to realization by, and in, the Pont-Aven style. This is doubtless what Bernard was implying when he wrote in 1903: 'Filiger descends exclusively from the Byzantines and from Breton popular art.' In fact, despite working in the midst of the Pont-Aven group, Filiger, in the compositions so far mentioned, resembles nobody else and occupies a place apart.

The common ground between him and the other 'Bretons' is none other than his landscapes, which Jarry and Bernard may never have seen, and which alone reveal what he contributed to the group and what he received from it. My investigations in this direction have been rewarded by the discovery of five landscapes by Filiger which were part of the property left by Slewinski, the two painters having remained on close terms during their residence in Brittany, long after the death of Gauguin.[131]

The quasi-crystalline purity of construction of Filiger's landscapes is what constitutes their special character. Every form is flat, one-coloured, with a perfectly definite boundary; none encroaches on a neighbouring form or cuts across it. The *cloisonné* principle is so rigorously applied that one would be quite happy to see these paintings executed in enamel or stained glass. Moreover – and this is what makes him so different from the others – most of his paintings would not suffer from being either enlarged to the scale of a monumental stained-glass window, or reduced to that of a delicate miniature. Taking the comparison all the way, it can be claimed that his small gouaches (which, alas, have been somewhat damaged by mould) display the most advanced and consistent *cloisonnisme* to be found in the entire school of Pont-Aven. If his rhythms and forms are sometimes inflected – if, in his landscapes, conceived in terms of 'sheets' or 'coats' of paint, he varies the intensity and degrees of contrast of his colours, the sole cause is the highly personal, emotional interpretation with which he is capable of responding to a formal schema, which latter is for him the basis of the new aesthetic. What is more, these means permit him to obtain either an atmosphere of peace and serenity, as in the very delicate *Seascape with Shades of Mauve*, or a highly-charged dramatic intensity, as in *The Tree on the Shore*, with its greens and rust-reds.

To sum up: Filiger, painting his curious icons in the full glare of the twentieth century, constitutes in relation to Gauguin and Bernard an anachronistic phenomenon, both figuratively and decoratively; but his landscapes, on the contrary, reveal a remarkably modern artist, one who was among the creators of a new conception of picture-making. It is only natural that, his landscape work having been brought to light only recently, his undeniable affinities with the Pont-Aven school should have eluded a number of well-informed and perceptive critics. This doubtless explains the judgment of Rewald, who saw in him a painter whose small gouaches 'escaped from the influence of Gauguin'; of Chassé – 'there was much that was purely mechanical in the art of Filiger'; and, finally, of Dorival, who in 1950 expressed the view that he was 'merely a French Pre-Raphaelite'.

Jan Verkade 1868–1946

After meeting Gauguin I was impelled to consider my own mind as a principle co-ordinating all that is presented to us in nature.

Verkade

Metaphysics, one of the foundation-elements in the birth of Symbolism, also played an essential role in the development of the Breton group, where, however, it naturally underwent various mutations; in some individuals it eventually emerged as Christian mysticism. During his Breton period – and even thereafter[132] – Gauguin painted a series of pictures with mystical subjects, such as the *Yellow Christ*, the *Breton Calvary* and *The Agony in the Garden*. But this inclination towards a Christianity divorced from dogma and devotional practice was at bottom merely a device enabling the artist to study a certain kind of subject-matter. The Breton chapels, with their ancient sculptures in stone and their polychromed saints, added to his experience of primitive art and fertilized his imagination, as the ceremonies and idols of the South Sea islanders were later also to do. We can justifiably suppose that the *Self-portrait with Yellow Christ*, and the self-portrait in *The Agony in the Garden*, were a layman's and indeed a pagan's way of comparing himself with Christ, and his own suffering with that of the Son of Man.

Sérusier, coming from a Catholic background, moved away from Christian dogma and plunged into theosophy (as a result of reading *Les grands initiés*, by Schuré), but was steered back to Christianity by the Benedictines of Beuron and practised his religion with devout fervour. Filiger, who was in touch with the leaders of the Rose-Croix, Sâr Peladan and the 'archon' La Rochefoucauld, oscillated between the mysticism of *The Imitation of Jesus Christ*, spiritualism and occultism. He regarded himself as a religious painter, just as much so as the ultra-Catholic Denis. Another member of the group, Chamaillard, used to read aloud the *Sagesse* of Verlaine (from the edition illustrated by Denis) to his colleagues of Pont-Aven; 'as a Breton, he clung with all his soul to the religion of his forebears'. Even Séguin, towards the end of his short life, practised an intense Catholic devotion.

Yet the event with the most violent impact on religious life inside the group was the sudden conversion to Catholicism of

JAN VERKADE *Breton Girl* 1892

the Dutch artist Jan Verkade. It must be made quite clear that Verkade's development, unlike that of his colleagues, and although it led to his ordination, never impressed any mystical stamp on his painting. Even when, in course of time, as a

169

monk at Beuron, he worked either by himself or with a team on mural paintings for churches and monasteries, his doing so was an expression not of an artistic impulse towards religious subject-matter but of obedience to the rule of his community. Towards the end of his life, Verkade in his monastic cell went so far as to confess that lay painting, by which he meant painting from nature, attracted him more than all the intellectual speculations of Father Desiderius. Nevertheless, the conversion and ordination of Verkade administered to some members of the group a shock which permanently affected their life and art. Only a few days after his baptism, celebrated in an atmosphere of mystical euphoria, his friend Mogens Ballin, a Danish painter of Jewish origin, also embraced the Catholic faith. Later, in spite of having left Brittany, Verkade kept in constant touch with Sérusier, Denis, Séguin and Filiger, exercising his priestly vocation towards them from a distance. His influence was considerable.

The religious tendencies of Verkade probably dated from the early days of his acquaintance with Sérusier, who prevailed on him to read *Les grands initiés*, the Bible and Balzac's *Séraphita*.[133] The latter made a deep impression on him. The final metamorphosis occurred in Brittany, following the illumination he experienced while watching a religious procession in a village, with the crowd of the attendant faithful winding their way behind it through the picturesque setting of Calvaries carved in stone, amid singing, banners and the burning of incense. He was baptized at Vannes in 1892.

Later, as Dom Willibrord, he wrote two volumes of reminiscences: *Die Unruhe zu Gott* and *Der Antrieb ins Vollkommene*, both with the sub-title *Erinnerungen eines Malermönchs*. The first volume, published in French in 1926 (*Le Tourment de Dieu – Etapes d'un moine peintre*), recalls the time he spent in Paris and Brittany in the years 1891–95. It is one of the best sources of information about both groups, Pont-Aven and the Nabis. His account of his conversion and ordination shows an extreme and sometimes naive sincerity. He lets it be inferred that the former had meant no more to him than a new way, different because outside the boundaries of art, of experiencing Breton religious folklore. But we must go back a little.

After studying at the Academy of Fine Arts in Amsterdam, where he succeeded in making certain contacts with Impressionism, Verkade arrived in Paris, the city of his dreams, in 1891. He had a letter of recommendation to his colleague and compatriot De Haan, who received him in the most cordial manner and at once started telling him about his friend and master, Gauguin, to whom he subsequently introduced him. Meanwhile he taught him the rudiments of the new style and introduced him to Sérusier, who in turn took him into the Nabi circle. Verkade wrote later that Sérusier had a great influence on him, both artistically and religiously: 'Through Sérusier, I too became a disciple of Gauguin and as such was admitted into the circle of the *Nabis*.'

This is how Verkade describes his impressions and feelings during his first experience of Paris: 'After spending about ten

JAN VERKADE *Farmhouse with Tree*

days sightseeing in Paris, I asked Sérusier to let me paint a few still-lifes in his studio. I was impatient to make some sort of use of what I had seen and heard in Paris. I painted these still-lifes in accordance with the theories and recommendations of Gauguin. People were rather surprised by the results I succeeded in getting from the very first day. When I had a chance to show my work to Gauguin he expressed his approval but put me on guard against my technical skill, which could easily degenerate into slickness.... Gauguin hated painting to be a

JAN VERKADE *Farm at Le Pouldu* 1894

slavish copy of nature, and at the time when I got to know him he was already to some extent in opposition to Impressionism. It is true that he too, like the Impressionists, talked about sense-perceptions, but he taught that the impression received from nature must join hands with aesthetic feeling, which selects, arranges, simplifies and synthesizes.'

Verkade's *Still-life with Apples* (Arthur G. Altschul collection), painted in Paris, probably in 1891, seems to confirm the

artist's description, 'in accordance with the theories and recommendations of Gauguin'. Similarly, the *Farm at Le Pouldu* of 1894 (S. Josefowitz collection), bears the characteristic mark of Syntheticism.

Verkade apparently possessed great facility in drawing, and, in order to learn what he wanted, did not hesitate to appropriate someone else's manner and incorporate it into his own work. His paintings thus display his interest not only in Gauguin

and De Haan but in Bernard and Sérusier, while his *St Sebastian* (Ballin family collection) seems to corroborate his own opinion: 'Filiger regarded me as his disciple and showed me a master's love.'[134]

But where Verkade is concerned there can be no question either of mere copying or of pastiche. His undeniable mastery of drawing and his great sensibility to colour make it clear that his borrowings were made deliberately and for definite reasons. It is interesting to note that already, at the beginning of the 1890s, other members of the group besides Gauguin and Bernard were exercising an influence on newcomers, and were seen to be well worth imitating.

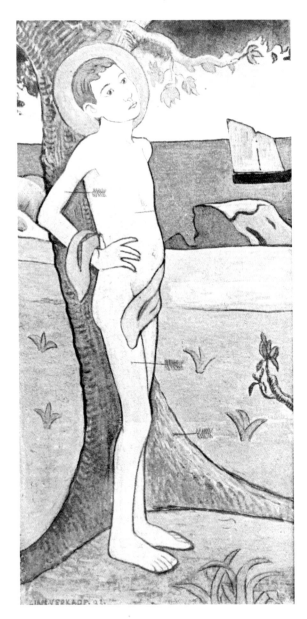

JAN VERKADE *St Sebastian* 1892

The affinities between Verkade and the Breton and Nabi groups did not last long; they extended only to the period from 1891 to 1895, in other words from his arrival in Paris to his ordination and departure for Beuron. During this period he exhibited in Paris, at the Indépendants; in 1894 his one-man show at the Bredgade in Copenhagen, organized with the help of Ballin, was a brilliant success. During his stay in Copenhagen his ties with Ballin became closer, and he also acquired a new friend, the *avant-garde* poet and writer Johannes Joergensen.[135] The latter was editor of the review *Taarnet* and invited Verkade to become its art editor; this contributed to the success of his exhibition.

It was while he was on the crest of this wave of success, pleasure and amusement that Verkade suddenly decided to become a monk. From then onwards his connection with Pont-Aven and the Nabis, though still friendly, was slighter, especially as at Beuron he came under the influence of Father Desiderius and found himself incorporated in a team for the production of large-scale religious paintings.

It can reasonably be assumed that Desiderius's cherished idea of modernizing religious art, partly by a return to Greek and Egyptian models and partly by purely geometrical calculations, had more effect on Sérusier, when he came to Beuron as a visitor, than on the newly ordained painter-monk. It may also be suspected that a purely intellectual conception of art, excluding imagination and feeling, was by no means suited to the needs of Verkade, and that the paintings he executed for various towns and cities – Aichhalden, Vienna, Prague and Jerusalem – and for Monte Cassino, were the fruit of conscious subordination to monastic rule rather than of any overwhelming creative impulse. He had several ordeals to put up with at this stage of his career. During his novitiate at Beuron, for example, he was given permission to paint, unsupervised, a Madonna for the monastery's chapel. The painting was adjudged by the community to be a bad one, on the ground that it did not conform to the spirit of dogma. The matter was referred to a kind of court, and Verkade was sentenced to destroy his work with his own hands. It is not surprising that in order to come to terms with his situation he reduced his profession of artistic faith to the minimum: his aim, he said, was 'to make a work in front of which the poor can pray, and artists will not turn and run.'[136]

Verkade was deeply attached to Desiderius, but did not allow this to blind him to his own failure as an artist. In 1907, when he had a dispensation from his superiors to visit the Bavarian capital in order to buy materials for future religious paintings, he fell to thinking of old times; and wrote, later: 'During my stay in Munich I tried to continue the sort of work of which I had been capable sixteen years earlier, in France, when I was a pupil of Gauguin and Sérusier, and to recover a capacity I had lost.... But whenever I looked at a few of the little pictures I had done in 1891 and compared them with those I painted at Munich, I was forced to admit: "That's something you can't do any more. You've widened your horizon, but at the expense of painting, properly so called."

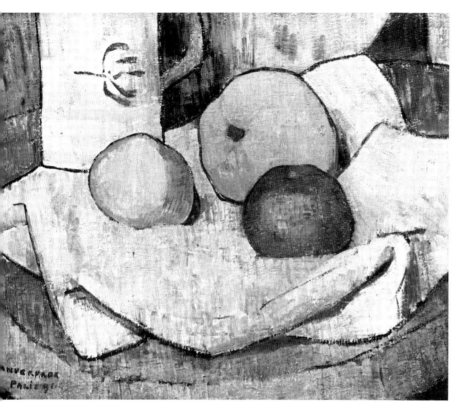

JAN VERKADE *Mug and Apples* 1891

Its representatives, the Symbolists, did not set up against the vital force of reality as it actually is, and its situations which are often so acute and poignant, the omnipotence of a higher reality. What made the painters and poets of 1890 into adversaries of realism and naturalism was, in many cases, no more than the presentiment of a higher reality, a predilection for the strange and mysterious, an inclination to reverie; a luxury of the mind, engendered in all too many instances by sensuality. The favourite expressions of its partisans, "the beyond", "the mystery", "the symbol", though vague and imprecise, corresponded to feelings innate in the human heart, which can never remain indefinitely content with the purely terrestrial.

It was very painful for me to have to accept this as a fact.'[137] During the same visit to Munich he met his old friend Alexej Jawlensky, and admired his 'sense of *joie de vivre*'.

In his autobiography Verkade also studies a certain number of theoretical problems, mostly arising out of Impressionism. In this connection it is worth noting that the sponsorship of De Haan had enabled Verkade in his early days in Paris to take part in the gatherings of Symbolist writers which occurred on Sunday evenings at the Café Voltaire (opposite the Théâtre de l'Odéon), and at which he used to meet Verlaine, Charles Morice, Adolphe Retté, Julien Leclercq, Jean Moréas and others. Provided we bear in mind that his reactions were those of a recent Catholic convert, and a monk at that, some of them may repay quotation; they have a distinct period value and refer to a larger sphere than the specialized ambiance of Beuron.

'In reality, our generation, at least in the majority of its representatives, has always remained realistic and naturalistic. To clear the way for the advance of a new tendency in art, the prerequisites are a clearly-defined objective and great plastic strength. To recognize the deficiencies of the existing school is not enough. Symbolism lacked a clear-cut objective, so the Symbolist movement petered out, losing itself in vagueness.

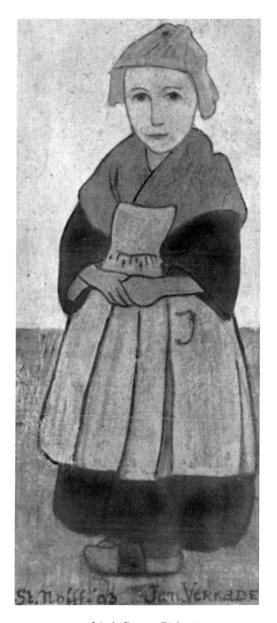

JAN VERKADE *Little Breton Girl* 1893

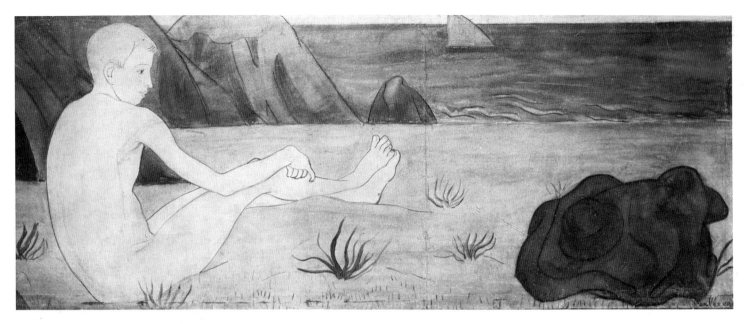

JAN VERKADE *Breton Boy on the Beach*

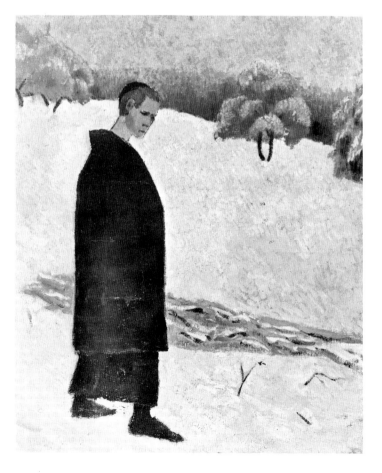

These expressions cast a faint gleam into many a "soul without God", and to such it served as a guide on the path which leads to Eternal Light.'

Dom Willibrord Verkade died at an advanced age in 1946, at Beuron. Despite his complete submission to the rule of the community, and the docile acceptance with which he carried out the orders of his superiors in matters both religious and artistic, he never broke faith with his memories of his short-lived experience in Brittany, which had caused him to 'find art and God', and to which he owed his adult formation. This 'obeliscal Nabi' in his monk's robe, meditating in his cell on the successive phases of his life in the Church, wrote: 'Before my stay in Paris, I had abandoned myself in my painting almost entirely to my own temperament, not to say my whims. The time had now come to reflect, to put my house in order. Previously I had pursued natural appearances, like a child chasing butterflies. After meeting Gauguin I was impelled to consider my own mind as a principle co-ordinating all that is presented to us in nature. And in this way the practice of my art restored me to myself. My painting was a new source of support to me. It made me fairer and more honourable, because I became calmer, more circumspect and more prudent.'

PAUL SÉRUSIER *Portrait of Jan Verkade* 1906

Francesco Mogens Ballin 1871–1914

Ballin makes us glimpse the prospect of a strange new art, grave, rich and fantastic. Sérusier

At the time when Verkade, with De Haan and Sérusier as intermediaries, was making his connections with the Pont-Aven group and the Nabis, Francesco Mogens Ballin, a young painter from Copenhagen, arrived in Paris. Armed with a letter of recommendation to the master from Mette Gauguin, who was his French teacher, he presented himself at the farewell banquet held in honour of Gauguin in March 1891. There he met Verkade, and an enduring friendship sprang up between them. Verkade introduced Ballin to the Nabi circle, where the young Dane found a keenly sympathetic welcome.

Ballin, the son of a wealthy family of orthodox Jews, was then nineteen. His pleasing appearance and delightful manners made him well-liked wherever he went. Verkade wrote: 'Mogens Ballin was a very handsome man; well built, of average height, with his black beard, dark eyes, full lips, and a nose which although a little thick was boldly and finely shaped, he was like a king of Chaldea from an Assyrian relief'; a description which certainly tallies with the self-portrait painted by Ballin about this time.

In the spring of 1891 Gauguin sailed for the South Seas, and Verkade and Ballin went to Brittany to work under Sérusier. Under his influence they read each other's books, delighting to study and discuss the Gospels, St Augustine and the works of Guiraud. Reading matter of this metaphysical nature, the suggestive atmosphere of the Breton chapels and Calvaries, the canticles sung by the Augustinian nuns in the church at Auray, and, above all, the sudden conversion of Verkade to Catholicism, contributed powerfully to the development in the young Dane of a mysticism which was undoubtedly already there, being innate. In January of the next year, 1893, when the two friends were travelling together in Italy, Mogens was baptized in the Franciscan monastery at Fiesole. He was admitted not long after to the Third Order of St Francis.[138]

Two years later Ballin returned to Copenhagen and exhibited his pictures, which were very favourably received by both press and public. It was at this time that he helped Verkade to

FRANCESCO MOGENS BALLIN *Breton Girl*

exhibit, and that both of them contributed illustrations to Joergensen's review, *Taarnet*.

In 1899 Ballin married a Frenchwoman, Marguerite d'Auchamp. Most of their numerous children eventually embraced

FRANCESCO MOGENS BALLIN *Breton Boy*

CHARLES FILIGER *Christ in Majesty*

the monastic life. As for Ballin himself, Denis speaks of him as of a saint, saying that he 'died in the odour of sanctity; I do not know how far the ecclesiastical commission of investigation has proceeded in its deliberations, but it could well be that "the Jew, Ballin", with his kindly, handsome face adorned with the beard of an Assyrian *keroûb*, will one day be canonized.'

Ballin is thought to have been the first Danish painter to be an adherent of the French Symbolist movement, and to have introduced the programme of the Pont-Aven school, the Nabis and Art Nouveau to Denmark. His career as a painter, however, was brief: soon after returning permanently to Denmark he opened a bronze foundry, to which, painting less and less meanwhile, he devoted the remainder of his short life.

But the relatively few canvases he bequeathed to the world merit our full attention; on examining them we find that he was influenced by both Verkade and Filiger, who for their part had used the tenets of Sérusier as the theoretical foundation for their own conceptions of painting.

176 Icon, early 12th century (detail)

FRANCESCO MOGENS BALLIN *Self-portrait* 1892

FRANCESCO MOGENS BALLIN *Breton Girl*

It was in Brittany that Ballin met Filiger. It was probably also there, under the influence of Filiger, that he composed his *Self-portrait* in a quasi-Byzantine manner, painted in gouache on a gold ground. His Oriental-looking face lent itself admirably to such an interpretation (the so-called 'Veraikon' style), and his contemporary collar and tie are the only details to match the date: '*anno 1892*'.[139]

Two landscapes by Ballin, and his *Still-life with Salad Bowl*, point to Syntheticism as his approach to painting, an approach similar to those of Sérusier, De Haan and in particular Verkade; but Ballin's is at the same time very personal and perhaps more emotional and imaginative than theirs. The refined drawing and subtle colour demonstrate the undeniable sensibility and talent of this artist, of whom Sérusier was to say that 'Ballin makes us glimpse the prospect of a strange new art, grave, rich and fantastic'.

Ballin never had the good fortune to become more closely acquainted with Gauguin, who was about to leave for the Pacific, or with Bernard, whose ties with Brittany had become

Icon, *St Dimitri Solunki*, 12th–13th century (detail)

FRANCESCO MOGENS BALLIN *Still-life*

FRANCESCO MOGENS BALLIN *Breton Landscape*

distant. So it is doubtful whether this painter ought strictly to be classified as a member of the Pont-Aven group. On the strength of his having been admitted to the company of the 'prophets' during his first visit to Paris, and of his having taken a fairly active part thereafter in the Nabis' gatherings, art-historians have regarded him as being a Nabi himself. Though this classification is by no means indefensible, it is pertinent to recall the very close links he maintained, not moreover in Paris but in Brittany itself, with Sérusier, Verkade and Filiger.

These contacts, reinforced by his experience of the Breton landscape and the primitive art of Brittany, make it possible to affirm that Ballin's painting is more directly related to the aesthetic of Pont-Aven than to that of the Nabis. He also constitutes a further example of the irresistible influence of Gauguin; of a radiation which in this case did not emanate directly from the 'master' but was communicated through the School of Pont-Aven.

FRANCESCO MOGENS BALLIN *Breton Landscape*

FRANCESCO MOGENS BALLIN *Breton Landscape*

IX · THE IMPRESSIONISTS

Henry Moret 1856–1913

Henry Moret is the whole of Brittany; and Brittany is the whole of Henry Moret. Henry Hugault

Among the painters of the Pont-Aven School there was a more or less separate group, consisting of painters who were pupils of Gauguin for a time but whose work can be regarded as a latter-day continuation of Impressionism. They had links of feeling with the master, and of topography with the Breton environment; but they succumbed to the fascination of Syntheticism only temporarily and imbibed only a limited proportion of the teaching of Gauguin and Bernard. For these men, the Breton adventure was a passing episode which, however rewarding, did not inhibit them from promptly reverting to the Impressionist pattern. The only ground, but a real one, for relating them to the Pont-Aven School is iconography, the fact that they too painted Breton subjects. The chief of them were Henry Moret, Maxime Maufra, Ernest de Chamaillard and Gustave Loiseau. All of these exhibited a number of times at the Galerie Durand-Ruel; Séguin mischievously nicknamed them the Durand-Ruel School.

One is struck by the fact that practically all the painters who became in any degree involved with the Breton group went through a phase, long or short, of submission to the personality of Gauguin, or to the collective atmosphere, or both at once. In every case we find at least one picture composed at this stage, showing very markedly the influence of the school and its fundamental aesthetic, Syntheticism. After this rapid ascent the curve usually flattens out: the artist's orientation changes, leading to his own personal variety of Syntheticism (Sérusier, De Haan, Slewinski, Séguin, Jourdan), or returning to Impressionism (Chamaillard, Loiseau), or, finally, making a blend of the two styles by combining a Syntheticist layout with the colour-dissection and vibrant touch dear to Impressionism. Moret represents this latter tendency.

In Brittany, Moret survives in memory as perhaps the best-known painter of all and a highly popular figure. After his art-student days in Paris he did not return to his birthplace, Cherbourg, but came to Brittany and made his home there. Many elderly people in the sea-ports of Finistère still remember him, and in the modest dwellings of the Breton fishermen it is

Henry Moret

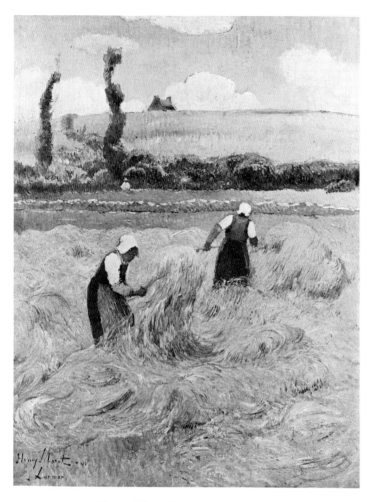

HENRY MORET *Women Haymaking at Larmor* 1891

HENRY MORET *Spring at Pont Aven*

not a rare occurrence to come unexpectedly on one of his canvases, given away by him in memory of a shooting expedition or in gratitude to a patient sitter.[140] But it is particularly the inhabitants of Doëlan, where Moret, like Slewinski, lived for a considerable length of time, who recall him vividly, even now, as the man who painted their country, their sea.

Henry Moret is one of the few painters in the Pont-Aven group the examination of whose life and work appears to offer no great difficulty. A considerable number of his pictures, mostly dated, have come down to us; they are accessible, being owned by French museums, European and American collectors specializing in Pont-Aven, and a few amateurs here and there; various summary information about him has appeared in print, and Durand-Ruel continues to show his work at intervals; all in all, every facility for the understanding and interpretation of his painting appears to be present. Yet the fact is that to make a proper appreciation of his work is by no means a simple matter.

It may be conjectured that on completing his training at the Ecole des Beaux-Arts and in the studios of Jean-Léon Gérôme and Jean-Paul Laurens, Moret, on arrival at the *pension* of Marie-Jeanne Gloanec, found himself sitting at the table of the *pompiers*, before crossing, like Sérusier, to that of the so-called Impressionists. We know for certain that Sérusier, arriving in Pont-Aven in 1888, found him settled in and working with Gauguin. The same date is given in the reminiscences of Léon Palaux.

Unlike Chamaillard, for instance – a *bon vivant*, sociable, talkative and self-assertive – Moret kept himself to himself and was gentle, industrious and thoughtful. In his *Souvenirs* devoted to Gauguin, Bernard wrote: 'I first met him at Pont-Aven in 1888 or thereabouts; he made a fairly long stay there. I used to see him working long and hard. Since arriving he had changed his manner and adopted ours. At the house of his landlord, M. Kerluen, I saw in 1892 a large bundle of the studies he had done in that earlier period; some of them were

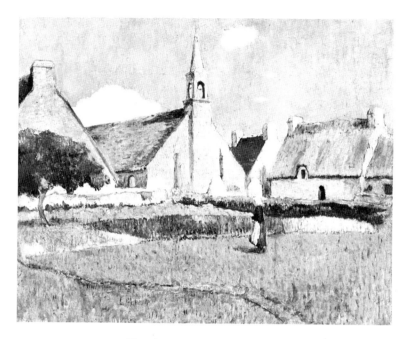

HENRY MORET *Chapel at Le Pouldu*

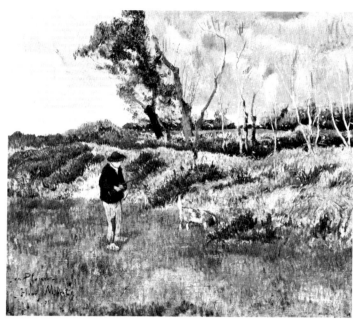

HENRY MORET *Man Shooting, at Ploemeur* 1891

very good.... I had a genuine esteem for Henry Moret and we used to go out walking together sometimes, looking for suitable *motifs*. He was a very gentle, likeable character; a peaceable, sincere revolutionary. I lost sight of him when I left Pont-Aven. He had turned away from our developments in synthesis and gone over to the *plein air* school of Monet, which surprised me. I had a high opinion of his contribution to our circle and had thought he was going to carry on in that direction. When I came back from the East after eleven years away and saw his canvases at Durand-Ruel's, I saw that he had been

HENRY MORET *Coastal Scene with Cottages* 1909

HENRY MORET *Snow at Doëlan*

quite right. So far from weakening his talent he had strengthened it, rejecting theories, keeping in touch with life itself, with nature.'

As a general description of Moret's work and development, this is correct. But it must not be overlooked that Bernard was making a judgment a good many years after his 'revolutionary' period, and basing it therefore on premises quite different from those of Syntheticism. The reservation applies particularly to his final sentence, reflecting the fact that by this time he no longer felt any urge towards Syntheticism and was seeking his inspiration 'in God, the old masters and nature'.

A few pictures have been preserved from the period when, as Bernard wrote, Moret was 'changing his manner and adopting ours', that is to say from 1888 to 1892: *Breton Land-* scape (1889), *Breton Woman Knitting* (1891), *Breton House* and *Breton Washerwomen* (1892). The last is the one which appears to come closest to the spirit of Pont-Aven. It now belongs to the heirs of Marie-Jeanne Gloanec, the former owner of the *pension*, who had it from the artist himself – presumably, as the custom was, in payment for meals and lodging.[141] It is as Gauguinesque as any painting can well be. The forms, the colours, the way the paint is laid on and the brush has been guided, all strongly recall the celebrated *Breton Farm* painted by Gauguin in 1890 at Pont-Aven.

All the known examples of the later landscape work of Moret possess a roomy, 'panoramic' character in which the foreground is uninhabited, so to speak, consisting of a sheet of water or a deserted meadow; the 'living' elements in the

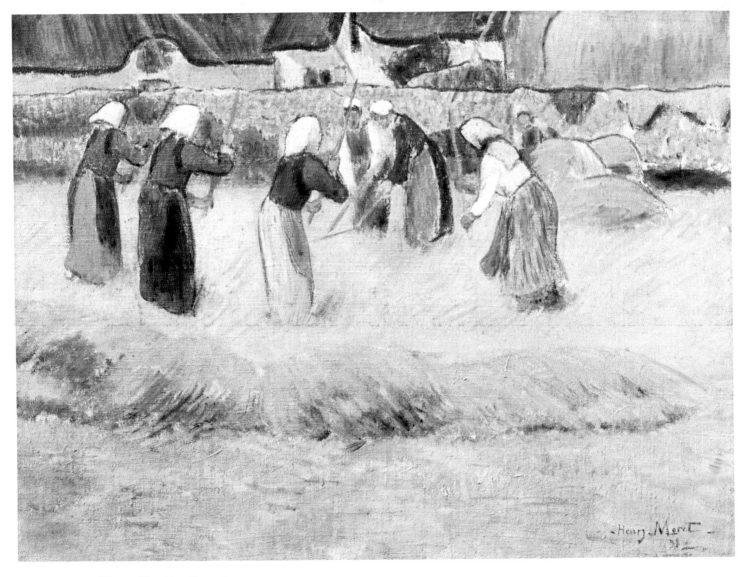

184 HENRY MORET *Women Threshing Corn* 1891

HENRY MORET *Rolling a Field at Le Pouldu* 1894

picture – buildings, trees, boats – are pushed back towards the distant horizon. (This type of landscape treatment, as we shall see, was later taken up by Jourdan.) The design of *Breton Washerwomen* is quite different. The foreground is reduced to a minimum: the silhouette of a house, a small section of stone wall, and three trees. There is no horizon, and the background is neutral and indeterminate. The arrangement of the figures is rather similar to that favoured by Gauguin; in other words, the part they play is purely decorative. The colour range extends from green to warm brownish-red, passing through chrome yellow on the way, and is thus identical with that of *The Talisman*. The design is flat and summary, the paint-handling smooth and devoid of that division into a multitude of small, simple touches found in so many others of Moret's paintings from nature.

For an example of what he ultimately achieved – a completely integrated personal style which nevertheless originated in the Pont-Aven school – we can turn to the *Ile de Houat* (Dr Guyot

HENRY MORET *The Ile de Houat* 1893

HENRY MORET *Outskirts of Lorient* 1892

collection). This is a simple composition: large, almost mono-chrome planes contained in strictly horizontal zones, with sharp contrasts between groups of cold and warm colours. The rustic atmosphere is heightened by the naive drawing with which the three grazing cows are rendered. (Cows drawn like this are a frequent *motif* in the work of the Pont-Aven painters, particularly Sérusier and Jourdan.) The almost empty fore-ground fills two-thirds of the canvas, the horizon is distant and set high, the paint-handling is not as flat as in the *Breton Washerwomen*, the brush-strokes are violent and hooked, but strong contrasts in the colour-scheme are as evident as before. The transition to a personal style consists precisely in a kind of symbiosis combining Syntheticist forms with Impressionist technique. This period, beginning in 1893, was to last until 1900, the year in which Moret was converted to pure Impres-sionism.

Most of the pictures from Moret's Breton period belong to Breton collectors, notably Dr Guyot at Clohars-Carnoët, M. Alexandre Pissenko at Nantes, M. Hernigou at Châteaulin and M. Corronc at Lorient. The collector with the largest number of late Morets is M. Durand-Ruel, in Paris.

Can it be said that Moret made any significant contribution to the development of the Pont-Aven school; and, if so, how great was it? His merits must not be overestimated by attribut-ing much importance to him where the birth of the style of the group is concerned: he followed his own path and assimilated only a fraction of the teaching of Pont-Aven. It may however be pointed out that his noble individualism in painting was not without influence on other artists in the group. Even if the analogies with the work of Chamaillard, Maufra and Loiseau are fortuitous, those with Jourdan are not.

Henri-Ernest Ponthier de Chamaillard c. 1865–1930

I understand him and praise him; it is impossible for the life of an artist to be more nobly filled than it is by him.

Apollinaire on Chamaillard

Chamaillard was the only member of the Pont-Aven group who was born of a Breton family. He lived at Quimper, practised law and was well off; for some time he divided his energies between law and painting, but eventually devoted himself entirely to the latter. Malingue, mentioning Chamaillard in his edition of Gauguin's letters, tells us that 'his pictures, most of which are owned by collectors in Brittany, are not well known'. Rewald merely notes that the friends of Gauguin at Le Pouldu 'included Henri de Chamaillard, a former lawyer, whose pictures bore a strong resemblance to those of Gauguin'. Finally, Chassé, in his book *Les Nabis et leur temps*, states that 'after having been strongly influenced by Gauguin, he gradually reverted to Impressionism'. None of these writers, however, informs us to what pictures he is referring or where they are now.

Having been privileged to visit several private collections in Brittany, I have been able to look at more than twenty canvases by Chamaillard and also to examine one of his most representative pictures, the *Breton Landscape* in the Musée de Rennes. In my view, not one of these pictures presents any particular resemblance to the work of Gauguin or shows signs of his influence. It is therefore difficult to agree with the conclusion drawn by Dautier, who, in his thesis, analyses the use of colour in the picture *Pea Harvest at Camaret* (M. Lucas collection, Châteaulin) and goes so far as to claim that this painting 'gives us an idea of the fundamental influence exerted by Gauguin on his first Impressionist disciples at Pont-Aven'. If we accept Hofstätter's statement that Chamaillard got to know Gauguin in the latter's initial period, that is to say before 1888, we have to admit that the influence in question, if there was one, was that of the Impressionism which was the style of Gauguin at the time: meaning a style dominated by Pissarro. It is a pity that most of the paintings of Chamaillard are undated.

The majority of them are landscapes from different parts of France; delicate, airy, with a harmonious balance between the silvery surface of a river or a lake, the blue of a pure sky and the green (perhaps a little over-luxuriant) of the grass, bushes and trees. The painter seems to have had a special predilection for masses of greenery. The atmosphere of these landscapes is peaceful, luminous and natural, far removed both from the 'suggestive colour' of Anquetin and from the Syntheticism of Bernard and Gauguin.

In Chassé's book on the Nabis there is a quotation from an article by Chamaillard, published in 1905 by the *Mercure de France*, in which Bernard and Gauguin are referred to as follows: 'What all these great predecessors have left us is a broad new road for those who are returning to gravity in drawing, to the search for nobler lines, in a word to simplicity. Nature is a document and no more, a document to which we must adhere as closely as possible, but still only a document. I believe that no work of art can be accomplished without transposition; but the work should be, so to speak, involuntary.'

This is in fact a very apt judgment by Chamaillard of his own painting. In his work, the transposition or transformation always takes place naturally, involuntarily, without subjecting nature to the fragmentation and inlay-work of *cloisonnisme*, with its heavy bands of outline, and with no trace of Symbolism and its cerebral speculations.

There must nevertheless have been a period in his career when he underwent the influence of Syntheticism and painted in that style. Bernard, writing in 1903, classes him with Laval, De Haan, Sérusier and Moret as being among 'the real pupils of Gauguin', one of those who 'owed themselves to Gauguin'. (In making this assertion, Bernard is careful to imply that he himself had never been a pupil of Gauguin and owed him nothing at all.)

We gather from Denis (1942 edition of Sérusier's *ABC de la peinture*) that Chamaillard's 'awkwardness' (*gaucherie*) excited the admiration of Gauguin; it must of course be understood that the word '*gaucherie*' was a term of commendation as used by Gauguin just then, when he himself was seeking the primitive and the naive, finding it even in the hobby-horse which had been his childhood toy. We unfortunately do not know what picture by Chamaillard it was whose 'awkwardness' was so much appreciated by Gauguin; if we did we should

know more about the painting of Chamaillard in the Pont-Aven period. In a letter to Bernard in October 1889, Gauguin commented on the laziness of Laval, who 'hasn't touched a brush for six months', adding: 'Chamaillard on the other hand has painted an *excellent* portrait of his wife.'

Favourable judgments on Chamaillard are also expressed by Séguin, in his study of Gauguin and the Pont-Aven school: 'What are these strange trees which look like seven-branched candlesticks, these masses of verdure like animals with gigantic tentacles, these gentle, unforeseeable blossomings of colour? Chamaillard, whose painting has become simpler today, created them under the guidance of the master, who regarded him as a gifted pupil to whom he had taught much.'

Séguin also singled out the simplicity, naivety and 'clumsiness' which were the special property of Chamaillard, and so much appreciated by his colleagues in Brittany, in a letter to O'Conor in 1902: 'I've seen his canvases, four of them are all right. He's the only painter now at Pont-Aven who has recovered the colourful, simple, naive qualities which are what we like about his work, and really two of his landscapes are ... charming, but it seems to me that they're not artistic enough,

they're superficial. I would like to see more freshness in his colour and more flexibility in his drawing. Still, it's all right and it's amusing. I can't say as much for the Durand-Ruel School.'

So much for the written evidence. As for the collections in Brittany which contain the Impressionist canvases previously mentioned, only one work stands out and, moreover, bears witness to the painter's experiments in Syntheticism: the *Seascape with Cottage*. What surprises us in this tall vertical panel is the unusual shape made by the dark rocky shore and the ocean; the entire left-hand side, from top to bottom, is filled by the towering continental mass, which reaches out gigantic fingers into the huge expanse of water. The texture of the paint, compared with that in his other pictures, is smoother, less tormented. As for the source of any possible derivative touches, we must seek it not so much in Gauguin as in Jourdan.

From the point of view of originality, Chamaillard deserves particular attention as a watercolourist. The thirty-seven watercolours owned by Dr Guyot (and a few more in private collections in Paris) reveal an artist on a substantially higher

HENRI-ERNEST PONTHIER DE CHAMAILLARD
Farm at Pont-Aven 1890

level than his work in oils would lead us to expect. Painted in a fairly bright key, they are distinguished precisely by what is missing from his oil-paintings: areas of pure colour with clear, firm boundaries, a straightforward texture without Impressionist 'vibrations', and *motifs* which are not fussy and

overdone. With their uncluttered drawing and generous colour, these miniature landscapes perfectly express the painter's poetic sensibility and refined taste.

Like his colleagues at Pont-Aven, Chamaillard could not resist the temptation of creating carved and painted furniture in the Breton style. He exhibited some of these pieces alongside his paintings, at the Galerie Vollard in the rue Laffitte, in 1910; the preface to the exhibition catalogue was written by Arsène Alexandre. Opinions varied greatly; Charles Morice wrote in the *Mercure de France*: 'As for his dresser, bureau and panels, I find nothing really original in their shapes, and the colours are unpleasant'; but Félicien Fagus declared: 'Some pictures, possibly excellent; we know nothing about them, having decided in advance merely to glance at them. And the furniture is exquisite: for example, a stocky, massive Breton chest, painted all over in the style of an illumination, with zest and tact; an appetizing, harmonious ensemble, a real piece of craftsmanship, and thus an authentic work of art.'

Chamaillard the man was a most endearing character. A good comrade, always ready to put himself out, he kept constantly in touch, personally or by letter, with other members of the group, notably Séguin, Sérusier, Slewinski and Laval.[142] He was open-handed in his help to his less fortunately situated painter-friends. His financial position remained strong even after he left the Bar; he owned a château, and the rent from it provided him with a steady income. From Châteaulin, where he spent a whole winter as Chamaillard's neighbour, Séguin wrote to O'Conor in 1901: 'I have been, and am, living under a triple aegis: that of the painter, the tippler and the lawyer. But seriously, he's been very good to me, and he works hard and drinks very little. He encourages me, gets me working, makes me drunk, lectures me and invites me to dinner every Sunday.' In another letter he said: 'Without Chamaillard it would be awful here, but we brighten up the evenings by reminiscing.'

Fortunately, this lawyer turned painter had other weaknesses besides drink; he was sensitive to poetry, and used to read and re-read Verlaine. Verkade describes in *Le Tourment de Dieu* how Chamaillard, sitting one day on a bench outside the Pension Gloanec, read or recited ecstatically, for the benefit of Séguin, Ballin and Verkade himself, fragments from *Sagesse*, emphasizing and expounding the Christian inspiration and dogmatic content of Verlaine's lyrics. Verkade adds that 'as a Breton, he clung with all his heart to the faith of his forebears'.

The Pont-Aven painters were not alone in being fond of Chamaillard; there was also a close attachment between him and Guillaume Apollinaire. Apollinaire was the spiritual leader of Cubism in its 'heroic age'; he nevertheless had a high opinion of the painting of Chamaillard, the polar opposite of Cubism. In 1914 a Chamaillard exhibition was in preparation, and the preface to the catalogue was to be contributed by Apollinaire. The catalogue was never published, the exhibition having been cancelled because of the war. But the manuscript preface, partly in a secretary's handwriting and partly in the poet's, has been preserved; one passage reads: 'The destiny

HENRI-ERNEST PONTHIER DE CHAMAILLARD
Coastal Scene with Cottage 1891

HENRI-ERNEST PONTHIER DE CHAMAILLARD
Stream at Pont-Aven 1890

of Ernest de Chamaillard is very enviable. He reveals to the French the rural charm of their beautiful provinces, the nobility of the rivers which are the veins of the gracious body of France, and the changing aspects of her manors, which have survived in spite of centuries and revolutions. One of the highest merits of Dante is to have celebrated the cities of his native country. And the political unity of Italy, not realized until so much later, had already been fashioned immortally in the *Divine Comedy*. France, on the other hand, whose political unity is already ancient, has not hitherto found a poet or a painter to undertake a similar task. It is to this that my friend Ernest de Chamaillard, that lover of the woods and fields, is devoting himself. I understand and praise him for it; it is impossible for the life of an artist to be more nobly filled.'[143]

Clearly, the apostle of Cubism had been captivated by Chamaillard's painting and the felicities of his Impressionist palette. Thus, through the mouth of a poet, France expressed yet again that aesthetic liberalism in whose eyes no manifestation of the spirit of art is obsolete, provided only that it be sincere.

Maxime Maufra 1861–1918

Gauguin to Maufra

It was in the summer of 1890, when he came to stay at the Pension Gloanec, that Maxime Maufra made the acquaintance of the group and of Gauguin. Sérusier, Filiger and De Haan were there at the time; so were a few other painters who had trained at the Académie Julian. Failing to find any common language between himself and the latter, Maufra sought contact with Gauguin; De Haan paved the way for this. Maufra soon came to consider it a great honour to have been (in the words of Arsène Alexandre) 'admitted to hear the discussions and to drink with the master and his pupils'.

However, he stayed only a few months at Pont-Aven, and his relations with the group were temporarily suspended; he went to Paris and rented a picturesque studio in Montmartre, where every Saturday he received friends from the literary and scientific worlds. In November 1893 Gauguin paid him a surprise visit, and is reported to have told him after examining his pictures: 'I know you defend my painting, and I thank you for that. We are following a completely different path; yours is a good one, you have only to go on.' It was probably after this meeting that the friendship between the two painters became closer. A letter from Gauguin to Maufra, written in Tahiti in 1896 and published for the first time in 1949, testifies to the affection and confidence which the master continued to feel towards his disciple, although the latter was 'following a completely different path'.[144] It is moreover a further proof of the complete artistic freedom prevailing in the Pont-Aven milieu.

This pronouncement by Gauguin was perhaps what made Alexandre, Maufra's biographer, go so far as to maintain that 'neither the group nor its leader influenced Maufra in the least', and that it was because of 'finding too little fair-minded appreciation at Pont-Aven' that he only remained there for a few months.

The opinion of Alexandre, like that of another biographer of Maufra, V. E. Michelet, would appear to be partial and too sweeping. In reality, Maufra most certainly was not untouched by Syntheticism; the difference was simply that the influence

Maxime Maufra

was comparatively slow to declare itself, so that Gauguin, visiting Maufra in 1893, naturally could not detect its presence. To confirm this, it is sufficient to compare the later works of Maufra with those he painted before his contacts with the Pont-Aven group.

191

MAXIME MAUFRA *The Outer Port* 1886

MAXIME MAUFRA
Boats at the Quay 1889

PAUL GAUGUIN *Heads of Breton Women, Aïta Aramoe*

Born in Nantes, Maxime Maufra began training at an early age for a business career, in conformity with his parents' wishes. To widen his experience he spent some time in Liverpool; when he went sightseeing in England and Scotland he stood out among the other tourists because he was always drawing. The long letters he wrote at frequent intervals to his father show how deeply the fledgling businessman was impressed by the landscapes of Scotland and by the Turners in the National Gallery. 'Turner's pictures dazzled me, and in my naive admiration I exclaimed, "But I can paint like that! This is bright, clear painting, like mine!"' (Quoted by Alexandre.)

Back in Nantes, Maufra met Charles Roux, a now-forgotten Impressionist, who appreciated his young friend's talent and took his side in discussing his aspirations with his parents. In 1886, at the age of twenty-five, Maufra sent a canvas to the Salon for the first time; it was accepted and won an excellent notice from Octave Mirbeau in *La France*. As a result of this success the young painter finally turned his back on business,

MAXIME MAUFRA *Cliffs and Sea* 1897

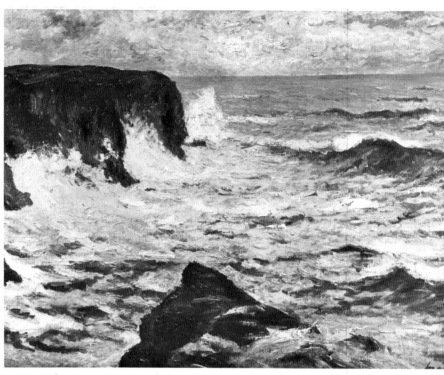

MAXIME MAUFRA *Belle-Isle-en-Mer*

MAXIME MAUFRA *Cliffs at Saint-Jean-du-Doigt* 1894

with his parents' complete assent. From now on he exhibited regularly at the Salon d'Automne, and later at the Indépendants.

Thus by 1890, when he came to Pont-Aven, Maufra was a painter with four years of exhibiting already behind him. His choice of vocation had undoubtedly been determined by the impact of Turner. This was something he never forgot, but communion with Pont-Aven was to modify his vision and his palette. He was a passionate lover of nature and sought his inspiration in it, rapidly putting Impressionism behind him and placing the emphasis on the structure of the picture, as against 'catching nature on the wing'.

Maufra had a bent for theory. Withdrawn and taciturn by nature, he liked putting his thoughts on paper in the form of memories, comments and imaginary conversations. The resulting mass of notes was eventually arranged by their author under the title *Propos de peintre* with a view to publication. For reasons unknown, the book never appeared. Much of it was used by Alexandre when writing his monograph on Maufra.

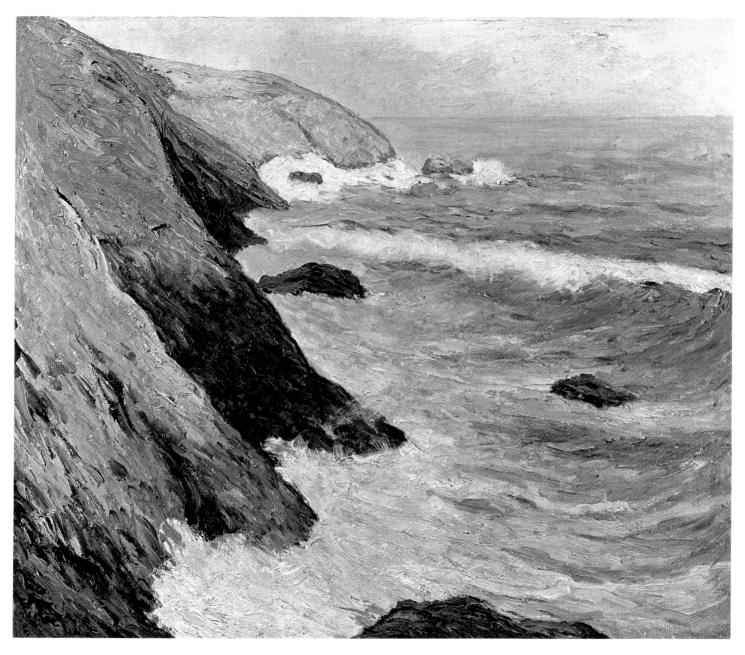

MAXIME MAUFRA *La Pointe du Raz*

Setting out his profession of faith, in which Impressionism is clearly and categorically rejected, Maufra writes: 'As early as my exhibition at the Galerie Le Barc de Boutteville, I had begun proclaiming the necessity of a return to composition, a renascence of style.[145] The works I showed then were doubtless very incomplete, yet significant in spite of their lack of mastery. So far from being literal impressions of a given time of day, they were condensations of things seen; pictorial arrangements of nature; compositions from nature, as distinct from nature cut into slices and presented direct. I work unremittingly. What I seek to express is the major sensations, the strange aspects of nature; cosmic, tempestuous, lunar

effects; storm, shipwreck, agitated landscapes, floods, water-falls; in a word, everything susceptible of being rendered not by an impression or snapshot of an effect but, on the contrary, by means of everything contained or implied by that effect, while always keeping in mind the picture and its subject.'

Alexandre comments on this, not without reason, that reflections of the same sort might well have emanated from a Pissarro, but that if the elder artist had set about formulating them he would have chosen rather to emphasize the choice of subject (and the elimination of unsuitable subjects), whereas Maufra, on theoretical grounds, 'would devote himself to any subject provided it "said" something'. It is very probable that he could not have arrived at such a standpoint without the contacts he had made with the Breton group. The passage quoted above is simply the principle of Mallarmé, 'Suggest instead of saying', transposed into pictorial terms; a principle which was also the motto of the Pont-Aven school.

Mellerio is doubtless in the right when he states, in *Le Mouvement idéaliste en peinture*, that Maufra presents 'a kind of compromise between direct observation of objective nature and purely decorative and Syntheticist vision. His works have the interest of attempting to combine two different points of departure.' The fusion of these two modes of expression was what produced the specific style of Maufra, a style in which the accent is on structure, but which nevertheless remains securely anchored to Impressionism.

If we compare his two pictures in the Musée de Nantes, *La Haute-Ile*, painted in 1884 (before he went to Brittany) and the *Dam on the Loire*, painted in 1909, when his Breton phase was some way behind him, it is easy to see what he had learnt from Pont-Aven: his colours are clearer and more radiant, anecdotal and other superfluous detail has been left out, and the picture-space is organized in large, compact areas. This has not prevented him from retaining perspective depth and that airy, volatile quality which was typical of him, and which he did not feel called upon to surrender. We are thus able to see, from the example of Maufra, that Gauguin's influence did not consist of imposing on other painters a Syntheticism reduced to a recipe, a formula for picture-making via the technique of *cloisonnisme*, but rather of inculcating a synthesizing vision which consisted of simplifying and eliminating. Whereas Mellerio sees Maufra's work as a compromise between two aesthetic viewpoints, Dorival (1943) finds in him, and also in Moret, new elements which constitute an enrichment of Impressionism: 'And so the works of these two painters are, in a higher degree than those of the Impressionists, compositions from nature and not, in Maufra's phrase, copies of pieces of nature.'

But our considerations so far, like the opinions of the critics, refer only to Maufra's paintings; and except in the case of his *Still-life with Melon* (Dr Guyot collection), we are compelled to admit that his affinities with Gauguin or Bernard are minimal. They are considerable, however, in his drawings, where the influence of Pont-Aven cannot be overlooked. His drawings in charcoal or coloured chalk, his watercolours,

MAXIME MAUFRA *Le Fondet* 1896

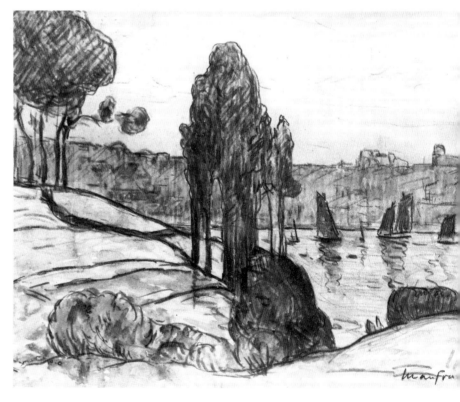

MAXIME MAUFRA *Red Sails*

196

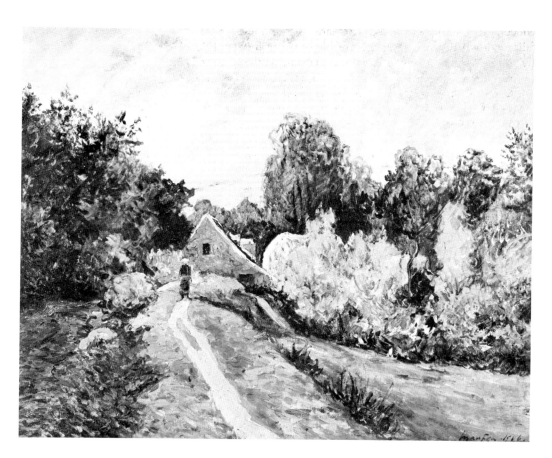

MAXIME MAUFRA
The Track to the Watermill,
Saint-Jean-du-Doigt 1906

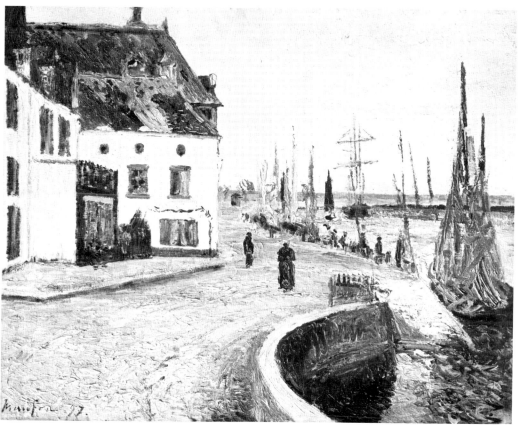

MAXIME MAUFRA
The Quay at Croisic 1897

197

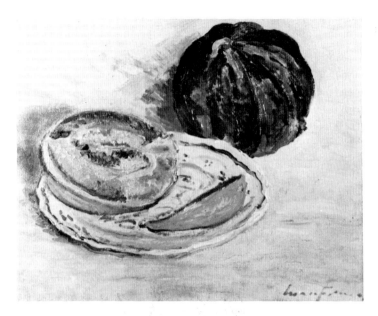

MAXIME MAUFRA *Still-life with Melon*

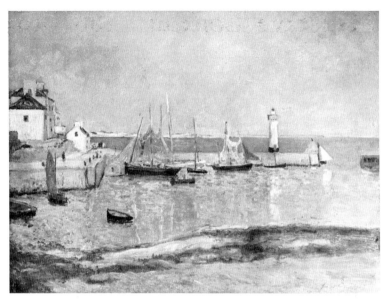

MAXIME MAUFRA *The Harbour* 1909

etchings and lithographs, show much originality and also a definite leaning towards a new style, and thus stand on a higher level than his paintings. The latter justify us in placing him in the same family as Moret, Loiseau and Chamaillard, whereas his drawings and engravings relate him rather to De Haan and Sérusier.[146]

The superiority of Maufra's drawing over his painting did not escape that classic representative of Impressionism, Camille Pissarro, who wrote to his son Lucien (18 February 1894): 'I wish you could have seen the show of a young painter called Maufra, a friend of that excellent chap Flournoy from Nantes. That boy has talent, his work is *synthétique*, observed from nature, he gets what you're after in your engravings and find so hard to pull off in paintings; only Maufra is very good in his sketches heightened with pastel (which, between ourselves, is what you ought to do as an exercise), but hasn't got there yet in his painting. But he will, his studies give one grounds for hope.'

Is it possible, in the light of the foregoing, to determine the nature of the artistic connection between Maufra and Gauguin? By vocation Maufra was a painter of landscapes, or rather seascapes, and he appears to have recognized in Gauguin only the discoverer of the primitive art of Brittany, whose fascination he also experienced himself. In the article he contributed in 1893 to *Essais d'Art libre*, he says of Gauguin: 'He was the first to discover all the charm of the primitive, naive quality which characterizes both the inhabitants and their country. He was the first to divine the simplification implied by both.'

Captivated in youth by the beauties of the Scottish coast, Maufra, by his own account, had experienced a presentiment of Brittany before he had even been there. And we may say that the Breton landscape and the vision of it he acquired from Gauguin were at once to provide the fulfilment of his artistic aspirations and to bind him to the land the master had taught him to love. Maufra, with Moret and Slewinski, will always be counted among the most fervent lovers of Brittany, and among her best interpreters.[147]

Gustave Loiseau 1865–1935

I credit myself with only one merit, sincerity. Loiseau

In the whole Breton group, the painter with the most marked
Impressionist tendencies was Gustave Loiseau. Although he
regularly spent his summer holidays at Pont-Aven, starting
in 1890, joining the group and taking part in its discussions,
the conclusions he drew from these were purely of a moral
order and seem to have affected only his theoretical activity,
not his practice. Nevertheless, in view of his connections with
the group, he has been regarded as a member of the Pont-Aven
School, one of the painters gravitating round Gauguin.[148]

Maufra, who had known Loiseau in Paris, was responsible
for his entering the Pont-Aven *milieu*, and the style which his
own came in time to resemble most closely was Maufra's. It
was not by chance that their two names were linked, in an
exhibition at the Galerie Motte, Geneva, in 1955. It should
however be noted that the affinity extends only to certain
investigations that they both made into colour and paint-
handling, and a preference for the same type of landscape; it
stops at the point where Maufra seeks to simplify his language
by effecting a marriage between the two fundamental formulae,
Impressionism and Syntheticism. Loiseau's painting, on the
contrary, is pure Impressionism straight out of Monet, the
Monet of the period of the haycocks and Rouen Cathedral.[149]
Moreover, there is in Loiseau nothing to match the Synthe-
ticism achieved by Maufra in his drawings and engravings.

Loiseau's painting is characterized by clear, delicate colour,
spatial depth and a surprising luminosity. His favourite
atmosphere is that of morning mist over the Seine, hoar-frost
whitening the trees, and the effects created by light filtering
through the branches. His painting is subtle, dreamy and
permeated by a certain nobility, but nevertheless represents
the tendency against which Syntheticism was in revolt.

Loiseau was well aware of being an alien in a group of
innovators, and made no attempt to disguise it from himself:
'I credit myself with only one merit, sincerity. I sit in my little
corner and work as best I can, trying to translate the impression
I receive from nature. I hardly ever satisfy myself, and even
when I do I don't plume myself on it. I follow nothing but
my own instinct and am proud of not being like anyone else.
Plenty of better-known people than I can't say as much for
themselves.'

Gustave Loiseau

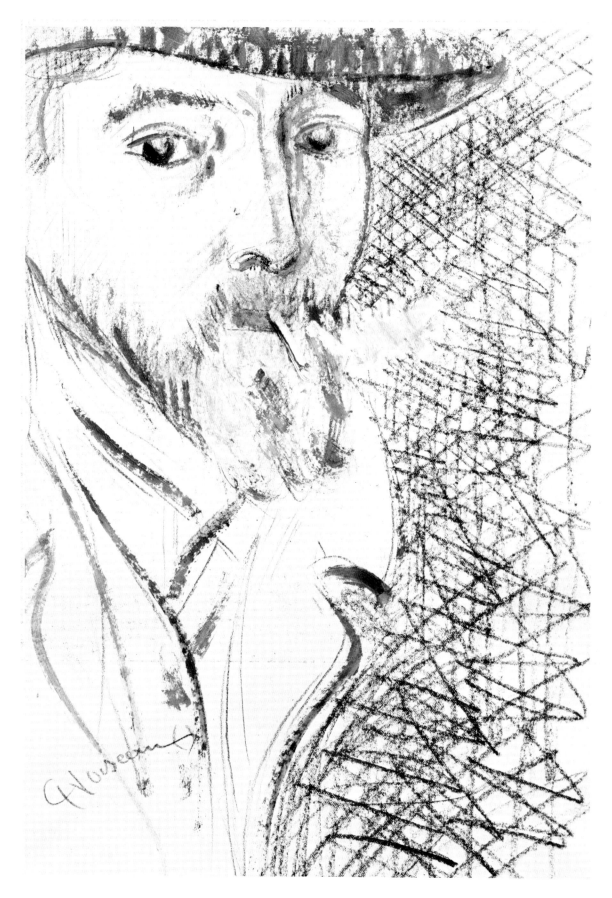

GUSTAVE LOISEAU
Self-portrait

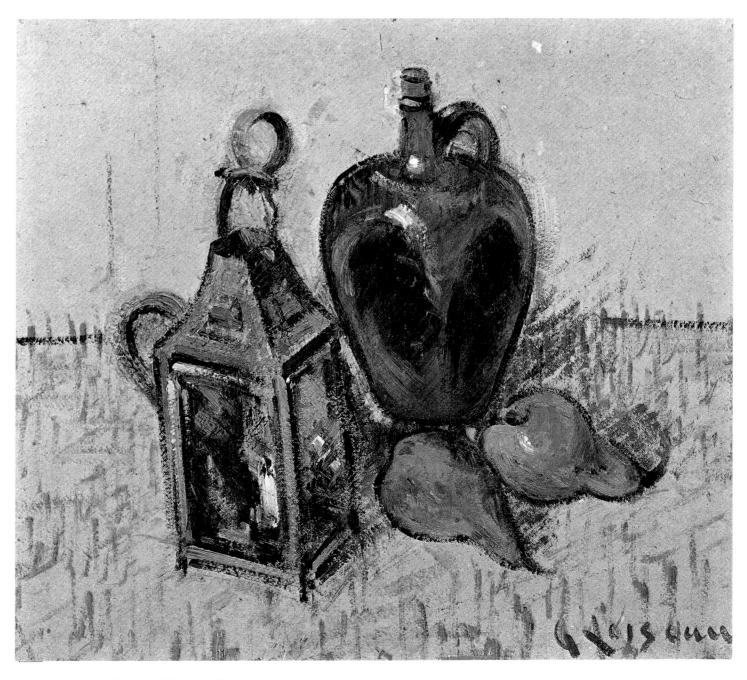

GUSTAVE LOISEAU *Lantern, Flagon and Pears*

Durand-Ruel was Loiseau's patron and dealer, and the gallery still has a considerable collection of his canvases. Loiseau had one-man shows fairly frequently in his life-time, and there have been others since his death. His visits to Pont-Aven are reflected in certain of his canvases which once adorned the walls of the Pension Gloanec and are now owned by the heirs of Marie-Jeanne, and in a collection of eighteen pictures at Lorient, the property of the family of Jean Corronc, who was an intimate friend of the painter during the Pont-Aven period.

GUSTAVE LOISEAU
The Watermill, Pont-Aven 1892

GUSTAVE LOISEAU *Farmyard*

GUSTAVE LOISEAU *Cap Fréhel*

GUSTAVE LOISEAU *Two Sailing Vessels*

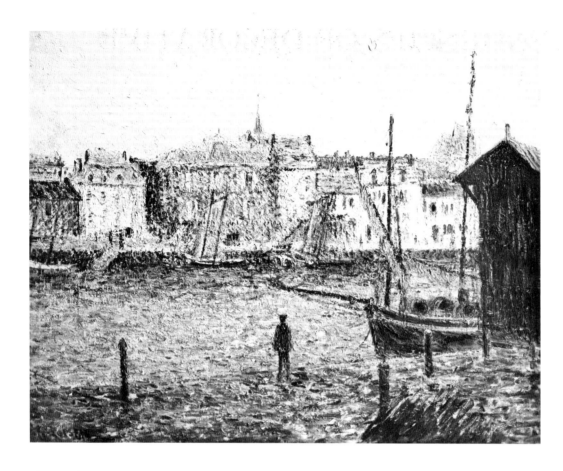

GUSTAVE LOISEAU
The Harbour, Pornic, at High Tide

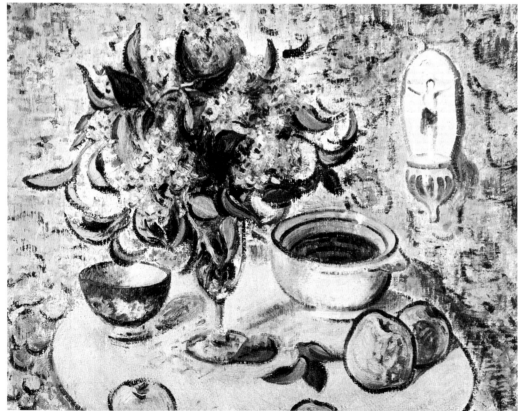

GUSTAVE LOISEAU
Still-life after Gauguin 1921

X OTHER TENDENCIES OF DECORATIVE SYNTHETICISM

Emile Jourdan 1860–1931

That's the artist's life. Others besides me have famous names and have died in poverty. Emile Jourdan to his son Guy

Jourdan was one of the handful of painters who, in 1888, joined Gauguin at Pont-Aven and remained with him throughout the time known as his second period in Brittany. He is also, like Filiger, one of those whose ties with the locality were the closest, so close, indeed, that the legends surrounding their names have remained picturesquely alive to the present day. Popularity of this kind is particularly surprising in the case of Jourdan, being inversely proportional to his impact on the history of art; in that respect he has remained completely unknown, apart from the inclusion of his name in a few catalogues and some unimportant articles in the press.[150]

I have therefore had to try to reconstruct his biography from local legend, completed and corrected in conversation by his son Guy and his daughter Marthe[151] – only partially so, however, as the children did not grow up in their father's company. Inevitably, there are a good many gaps, and we have had to turn to his pictures, scattered in Brittany and Paris, in an attempt to follow his development and analyse it in relation to the Pont-Aven group.[152]

Three portraits of him are in existence, eloquently illustrating the stages of his career. The first, painted by Louis Echenoz in 1884 (Guy Jourdan collection, Paris), shows us a dandy of commanding presence, wearing a top hat and a white silk waistcoat, and casually holding a lighted cigar. An abundant head of hair and a flowing cravat seem to hint that this member of the social élite enjoys playing the part of the great painter. The picture is dedicated 'to my good friend Jourdan'. The second portrait, drawn with charcoal on cardboard in 1904 and signed 'R. Klein', presents a handsome man in the prime of life, his slender torso enclosed in a kind of short, close-fitting shooting-jacket, wearing a broad-brimmed hat and holding a cigar, or possibly a cigarette. The drawing hangs in a little café at Pont-Aven belonging to Mlle Georgette Maréchal, whose adoptive father was a friend of Jourdan and whose mother was godmother to one of his children. The third portrait, by Ernest Correlleau, is the most interesting of the three; it shows us the artist at an advanced age, sitting, pipe in mouth, at an inn table, with a glass and a bottle of absinthe

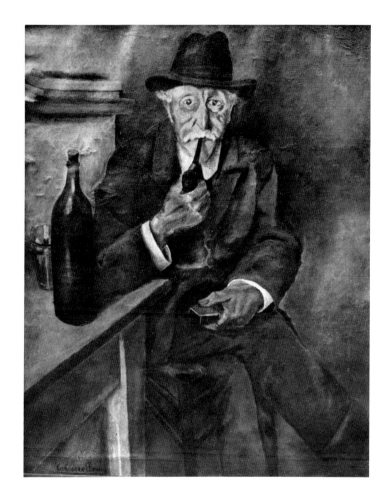

ERNEST CORRELLEAU *Emile Jourdan*

beside him. The drooping shoulders, the long white hair, and the flaccid skin of a once-handsome face, herald the approach not only of normal decrepitude but of a state of decay induced by poverty and drink. The portrait is at present hung where it

was painted, namely at the Hôtel de la Poste in Pont-Aven, which is much frequented by tourists, and which was formerly run by Julie Correlleau.[153]

The story current round Pont-Aven is that Jourdan did little work because he was lazy and always drunk; but Jean Corronc, who, as a sculptor and collector, knew about art, told me that Jourdan painted a great deal and that he was gifted, intelligent and cultivated, with interesting ideas about art, and a delightful conversationalist whose company was much sought after.[154] Chassé, in his *Les Nabis*, called him 'very much the bohemian'. And he was in fact an obsessive wanderer, always on the move – but one whose wanderings never carried him beyond the boundaries of the commune of Clohars-Carnoët. It is not known what gave him this urge for the road; poverty, perhaps, or a romantic nature; or he may have been just looking for things to paint; or perhaps it was all three at once. Whatever it was, the description of him given by Tadé Makowski in 1957, 'Jourdan, whom in their mind's eye the old farmers still see tramping along, deep in poverty and forgotten by everyone', agrees with local memory.

In the days of his splendour Jourdan had married and had begotten four children, but for most of his life he lived alone. After he had spent everything he had inherited from his father and reduced himself to poverty, his wife, accepting the fact that he could not provide even for his own needs, removed herself and her children to Brest and later to Paris, where by dint of drudgery she succeeded in supporting them. Jourdan stayed in Brittany, deeply afflicted by separation and hoping for better times, when his pictures would begin to sell and he would be able to rejoin his family. But neither he nor his wife entertained for a moment the idea of his giving up painting and earning a living by some other means. Inevitably, one compares his position with that of Gauguin. But there is really no common measure between the latter's wife, whose bourgeois mentality was incapable of appreciating the anguished crisis through which her husband was passing, and the noble and understanding Mme Jourdan. Neither she nor her children bore the painter any grudge for not supporting them; indeed, as they grew older, the children never failed to come to his help. Jourdan's letters to Guy show how strong was the affection between father and son. They also make it clear how desperate was the painter's financial plight.[155] In his pride and distress he made as if to treat his son as a collector, offering him pictures in return for his generosity.

He also received help on a similar basis from a well-to-do friend at Bélon, Fernand Jobert. As a painter himself, Jobert appreciated his talent, and they made an arrangement under which Jourdan would receive a small monthly allowance in return for canvases delivered. But his will-power was atrophying as alcoholism tightened its hold; he was working less and less, and often failed to keep the bargain. Jobert nevertheless succeeded in amassing a considerable number of paintings by Jourdan, thus saving them from dispersal and deterioration. The collection was inherited by Mlle Dominique Jobert, an antique dealer in Paris.

Numerous canvases by Jourdan are also to be found scattered round Brittany, probably left as payment for lodging or meals.

When, in 1924, there was a rush of journalists to Le Pouldu after the discovery of the murals hidden under several layers of wallpaper, a correspondent from Brest interviewed Jourdan about his relations with Gauguin. His answers constitute not only the earliest but the only authorized information we possess about him. He said: 'I arrived at Pont-Aven in 1886; the coach from Quimperlé brought me on a fine evening to this charming district which I have hardly ever left since, except to go painting in other parts of Brittany or travel to Algeria or Finland in search of fresh material. When I got out at Pont-Aven someone pointed out to me the Hôtel Gloanec, which doesn't exist any more; the landlady was a real mother to the painters and charged them very reasonable prices. And in fact, within a few minutes of my arrival that excellent lady had given me a studio-bedroom for 15 francs a month and full board for 55 francs. Yes, 55 francs a month! And how she looked after us! I introduced myself to Gauguin, he greeted me coldly; he thought I was a high society type from Paris, the kind of person he had no use for. He went on working and took no further notice of me. I must add, though, that within a few days we were good friends and that we stayed on excellent terms until he left the country. In 1886 Gauguin was back from Martinique but hadn't yet gone to Tahiti. There was a circle of young painters round him whom he was training in his own way, young men who had come under his influence or who simply had an admiration for him. At that time I met Emile Bernard in his company. It was only later, towards 1890, that we were joined by Sérusier, Maufra, Séguin and others, who are famous today.'[156]

Jourdan confided to the same journalist that he was writing his reminiscences of Gauguin with a view to publication, and that in addition to making a thorough analysis of that painter's work he was going to salt the account with some highly entertaining details about his private life: 'I shall aim at portraying Gauguin as he really was; I was more intimate with Gauguin than anybody else, and over a longer period.'

Jourdan was born of a wealthy family of lawyers, in which the profession was passed down from father to son. After a university education he studied painting at the Ecole des Beaux-Arts. He was a gifted pupil, and his early pictures, painted in Paris before 1888, which have remained in his family's keeping, reflect a wholly academic training typified by competent draughtsmanship, compliance with perspective, and the use of chiaroscuro. But it is worth mentioning his delicate seascapes inspired by the Dutch minor masters (one of them was painted when he was only sixteen), and his still-lifes of copper pots, also deriving from the Dutch. His portraits from the same period, which are absolutely in the convention of the Ecole des Beaux-Arts in the nineteenth century, are less interesting.

His meeting with Gauguin in Brittany was a turning-point; it was now that he altered course and made his first ventures

ÉMILE JOURDAN
Landscape at Pont-Aven

into Impressionism. Such a conversion was natural enough as a spontaneous reaction against academicism; in Jourdan's case the Impressionist phase lasted unusually long and developed along a somewhat confused course. The year 1888, so important for Gauguin and Bernard, aroused no immediate reaction on the part of Jourdan, though he was as close an eye-witness of the birth of Syntheticism as it was possible to be. The effect was not to emerge in his work until a few years later, after Gauguin's departure for the South Seas. So it is hardly surprising to find Gauguin reporting sardonically in 1889, in a letter to Bernard about the progress of his pupils: 'Moret not much good. Jourdan turns out sub-Morets; all the same thing.' 'The same' means 'Impressionist'.

As we shall see, Gauguin was not coupling these two names at random. With the exception of a single canvas, *Landscape at Pont-Aven* – whose construction, colour and even subject justify us in relating it directly to the style of Gauguin, notably to his *Farm at Le Pouldu* (Emery Reves collection) – there was a long period during which the painting of Jourdan was closely akin to that of Moret. The resemblance lay in their interpretation of Syntheticism. This consisted in eliminating

perspective, simplifying all form as far as possible, and concentrating colour into fundamental groups; but having toed the line to this extent both painters proceeded to use a thoroughly Impressionist technique in filling in their outlined patches, applying the paint in detached strokes like so many dashes or commas; and though they abstained from complementary colours, the final effect was one characterized by modelling and 'vibrations'. Their technique was thus the opposite of *cloisonnisme*, which makes it possible to rely solely on the intensity of colour and the effect of juxtaposing homogeneous surfaces. This is the specific difference between the style of Moret and Jourdan and that of other members of the group.

The Pont-Aven School was like a planetary system: about a central luminary – or twin luminary, perhaps – various planets moved in their respective orbits and generated forces of mutual attraction or repulsion. In other words, in addition to the influence exerted on all the group's members by the personality of Gauguin and, for a certain length of time, that of Bernard, reciprocal influences can be observed between the other painters. Hence we sometimes find painters who are

ÉMILE JOURDAN *The Storm* 1927

perpetual struggle to find the wherewithal for food and lodging, caused him to repeat his own pictures over and over, in order to sell as many as possible.[157]

The themes treated by Jourdan hardly ever come from outside Brittany. Mostly they are country scenes, or interiors of peasant homes, or landscapes round Pont-Aven, Moëlan, Doëlan or Le Pouldu, or the sea, which was his favourite subject. Stylistically, his painting from 1888 onwards maintained a certain homogeneity while continuing to develop, as we have said, towards a decorative Syntheticism. This has the advantage of making it easy to 'place' his pictures chronologically (duplicates excepted).

However, while the version of Syntheticism favoured by Jourdan remained fairly constant, the sea-pictures he painted between 1915 and 1927, which derive from the art of Japan, are a perpetual surprise. An eloquent example is the *Wreck at the Signal Station* (1915), in which, with the Pont-Aven conventions as a basis, he has proceeded, entirely on his own initiative and from his own resources, to incorporate the Breton landscape in the *style japonisant*. Bearing the Japanese print in mind as one of the ingredients of the Pont-Aven style, we can see that Jourdan made contact with the Japanese style directly, without Bernard or Gauguin as a bridge: Jourdan's originality consists precisely in his having discovered something quite different in the Far Eastern model from what they discovered.

As regards its subject-matter, the *Wreck at the Signal Station* is hardly to be linked with the *Mangwa* prints – unlike Gauguin's *Vision after the Sermon* – or with the other Japanese prints which were very popular in Paris at the time (especially those with figures in them: Utamaro, etc.). On the other hand,

called pupils of Gauguin but who bear less resemblance to him than to each other. Moret and Jourdan are a case in point.

As the years went by, their paths diverged. Moret withdrew further and further into Impressionism, both in his palette and in his conception of the visible world, while Jourdan reorientated himself in the direction of decorative painting, a development which became both his strength and his weakness. The strength was in his admirable sense of internal structure – that quality so necessary in Syntheticism, because the elimination of detail means that everything depends on the balanced integration of planes and the interplay of large areas of colour. This property, possessed by many of his landscapes, enables us to visualize them enlarged to the scale of a big mural. His weakness consists of taking some decorative form he has discovered and wearisomely repeating it; the *motif* is duplicated a number of times, always on the same scale, so that it becomes a mechanical pattern and the freshness of the initial inspiration is completely lost. Jourdan was particularly prone to this device in the 1920s; acute alcoholism, and his

ÉMILE JOURDAN *Wreck at the Signal Station* 1915

the affinity between this canvas and the famous *Deep Sea Wave* of Hokusai is much more obvious than that between the *Wave* and the imitations of it confected by Henri Rivière. Jourdan's picture is constructed on the principle of a flattened-out shell or, as some might say, a half-opened fan. Launched by the furious ocean, the waves come dashing against the olive-green hill, dominated by the celebrated custom house with its bright red roof. The edges of the hill – the handle of the fan – whose curve is cut into a zigzag by the jagged rocks, are violet, bordered with rust-red. Topped by their white, foaming crests, the waves extend in straight, almost rigid rays, corresponding to the ribs of the fan. Heeling landward before the driving wind, the sailing vessel constitutes a supplementary decorative element added to that of the furious waves. The

general tonality of indigo, progressively modulated to violet, the tropical lighting which the combination of storm and sunlight renders almost unreal, complete an ensemble whose every component is characteristic of the Japanese style.

As for the juxtaposition of colours, it seems to owe its origin to the colour-symbolism which was so much debated at Pont-Aven and which was a direct development of the standards evolved by the 'Ecole du Petit-Boulevard' from the experiments of Anquetin. Séguin, in the study published in 1903, wrote: 'Green is the friend of violet, makes an alliance with red and flatters orange; and cajoles ultramarine and yellow, from which it came into being. This colour is adored by Bernard and Sérusier, it is the image of the sun, life, gold and power.'

Absence of illusionism; graphic interpretation of agitated water; clearcut representation of the sea's various movements; crisp drawing of the foaming wave-crest – such are the characteristics of those Japanese woodcuts whose makers were specialists in studying water, and who synthesized, and indeed schematized, the diverse forms of its mobility to turn them into ornamental *motifs*. Many details of this kind are given as examples in the Japanese sketchbooks. Some of these properties had perhaps been noted by Jourdan, and he made use of them in the picture discussed here.

Japonisme had many followers among the painters in Brittany. Gauguin had succumbed to its charm, as we know from his letters as well as his paintings; he introduced Japanese prints into his pictures as interior features (as in the *Still-life with Japanese Print*, 1889), and also incorporated elements from Japanese art in a more direct sense. This was his procedure during the first period of his Syntheticism, especially after his stay with Van Gogh in Arles, at a time when Vincent was intensely receptive to the charm of Japan. And, although after his arrival in the South Seas Gauguin was to discover his own mode of interpreting the tropics, he continued to the end of his life to refer to the example of the Japanese in his theoretical expositions.

This cannot have escaped Jourdan's notice. Even if we suppose that he omitted to visit the exhibition of *Ukiyo-e* held in 1888,[158] and that of Japanese woodcuts at the Ecole des Beaux-Arts in 1890, he must certainly have seen some of the many Japanese prints which Gauguin always had in his possession. Japan was a perpetual subject of discussion at Pont-Aven. The essay by Séguin makes several mentions of the interest taken by the Breton painters in the Japanese, from whom they learnt in particular the symbolism of colour. Séguin also speaks of their admiration for the *kakemono* pictures, and notes that, in Gauguin's room at Le Pouldu, Utamaro's prints looked as if they were smiling at the solemn canvases of Puvis de Chavannes.

The style of Jourdan foreshadowed from an early period his affinities with Japanese art, as can be seen from his *View of the River Aven* or *The Chapel of Saint-Léger at Riec*.[159] The Japanese potentiality in Jourdan, like the other tendencies in his artistic make-up, required a fairly long incubation period; not

ÉMILE JOURDAN *The River Aven* 1926

until the *Wreck at the Signal Station* did it emerge boldly into the open. This picture marks the peak of his 'Japanese' adventures, which were never developed further. Indeed, his treatment of similar subjects a few years later show that he had renounced experimental daring and made a strategic withdrawal to more cautious and eclectic positions.[160]

It must nevertheless be emphasized that the *Vision after the Sermon*, by Gauguin, and the *Wreck at the Signal Station*, by Jourdan, together represent the high-water mark of the Japanese inspiration in the painting of the Pont-Aven group, and that they are also the works most powerfully rooted in Breton popular iconography. If the decorative components used by the two painters are different, the reason is that for every member of the group Syntheticism constituted a different creative stimulus, and that each conferred his own plastic formulation on its ideas. Jourdan is a highly significant example of this.

Jens Ferdinand Willumsen 1863–1958

A totally different tendency of decorative Syntheticism is that manifested by the Danish painter Jens Ferdinand Willumsen. Although his connections with the Breton group were fairly sketchy, his brief contacts with Gauguin (less brief, however, than with other members of the group) influenced him considerably. The first occurred one day at the Pension Gloanec, when Gauguin saw a stranger – Willumsen – painting a picture with a Breton theme and started a long discussion with him. As he was only passing through Pont-Aven at the time, Gauguin had not got a picture on the stocks and was contenting himself with doing a bit of drawing (later, he drew Willumsen). Needing examples with which to support his arguments, Gauguin, it seems, took Willumsen to the studio of Denis, who was living in a small house near Pont-Aven. As Denis was not at home, Gauguin, according to Rewald, showed his Danish colleague several pictures by Denis and used them to illustrate an exposition of his own theories.

Willumsen said later that Gauguin's recommendations were essentially technical – how to prepare a canvas, how to mix colours, and so on. None the less the influence of the Pont-Aven aesthetic on the Dane during his stay in Brittany is beyond question. It has been convincingly confirmed by Merete Bodelsen in her book on Willumsen, in which she maintains that the influence was greater than the artist himself believed.

A detailed comparison of Willumsen's works reveals as it were a symbiosis of influences; Gauguin is there, of course, but Sérusier and Bernard even more so. Pissarro wrote to his son Lucien, after a visit to the Salon des Indépendants in 1891: 'One M. Willumsen is terribly Bernard.' This refers particularly to his rendering of figures (usually Breton women), a wholly decorative simplification in which the figure is reduced to a silhouette, as in the *Buckwheat* or *Haymaking* of Bernard; with this difference, that Willumsen introduces a new element into his canvases: movement. There is nothing static or hieratic about his characters, they are always doing something, always busy. But their attitudes do not reproduce those of natural

JENS FERDINAND WILLUMSEN *Quarry Workers* 1891

movements; they are a foreshortened projection. One consequence is that these people are never shown in an upright position but always obliquely, so as to get as much decorative dynamism as possible. Movement was indispensable in order to make this plausible. The result, in *Women in the Street*, for example, is an impression like that of a frieze in which the principal motif is rhythmically repeated. This excessively organized, almost schematic conception constitutes the characteristic feature of Willumsen's work, and was responsible for Leclercq's remark that, of all those who had come

213

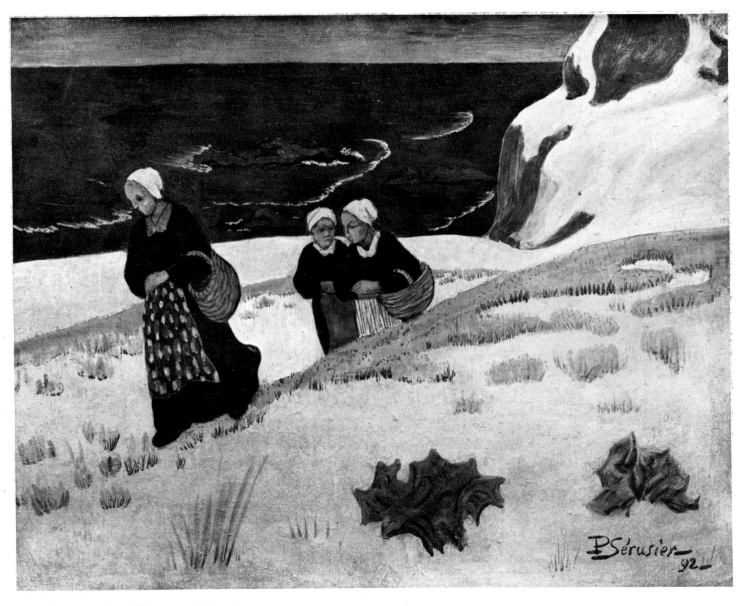

PAUL SÉRUSIER *Breton Women by the Sea* 1892

under the influence of Gauguin, Willumsen was one of the few to retain his own personality.

Another canvas by Willumsen, more personal but no less decorative in approach, *Breton Women Walking*, is clearly related to the Pont-Aven style, more particularly to Sérusier in his first manner (before he turned against the use of movement), and notably to his *Breton Panel with Children* (National Museum, Warsaw), and to *The Stoning of Three Breton Women* by Georges Lacombe, in which the influence of Sérusier, though indirect, is obvious.[161]

Rookmaaker has pointed out another way in which Wil-

lumsen was influenced by the circles he encountered in Brittany. It is known that the bedside book of Gauguin and De Haan was *Sartor Resartus*, and that Carlyle was also much read by the other Pont-Aven painters. When Willumsen left Brittany for Norway in 1892 he settled in the mountains near the North Cape, where he painted Symbolist pictures prompted by the ideas expressed in *Sartor Resartus* (as when the book's hero, Teufelsdröckh, wonders whether his esssential thoughts could be expressed in painting).

Willumsen's affinities with the Pont-Aven group are such that one composition alone, the polychromed bas-relief

JENS FERDINAND WILLUMSEN *Breton Women Walking* 1890

JENS FERDINAND WILLUMSEN *Animation on the Quays of Paris* 1890

Quarry-workers (Tilhorer Statens Museum for Kunst), would be enough to show that his meeting with Gauguin was by no means unproductive.

An interesting light is thrown on their relations by a letter written by Gauguin to Willumsen in autumn 1890, from Pont-Aven, replying to one in which the Dane had described his impressions of Holland. The letter is one that a master would write to his pupil: 'although a Dane', Willumsen can count on his entire sympathy. The purpose of his journey is study; Gauguin completes and corrects his impressions, and at the same time launches into an exposition of his own aesthetic,

using the Dutch painters, particularly Rembrandt, as a spring-board. At the time, Gauguin was about to leave for Tahiti and his thoughts were already far away; in the letter he nevertheless indulges himself by glorifying the unity existing between artists, and the principles which were the watchwords of his group: 'You are right in saying there is a certain kinship between us. With time, we shall acquire the strength to accomplish our work, provided we learn to recognize one another and to join together as the disciples of a new religion, and bear witness to our faith by mutual affection.'[162] It may be supposed that such teaching did not find Willumsen unresponsive.

XI AN IRISH EXPRESSIONIST

Roderic O'Conor 1860–1940

I suspect he was a tragic figure though he kept his tragedy to himself.
Clive Bell on O'Conor

Roderic O'Conor, the only representative of the English-speaking world in the School of Pont-Aven, had already been exhibiting in Paris for several years by the time he met Gauguin. This was either in late 1893, in Paris, or early 1894, in Brittany. His friendship with Séguin and Slewinski began at the same period.

Among the other Breton artists O'Conor makes an unusual and striking figure. Financially independent, so that he did not have to support himself by painting, he reminds one of that breed of Northerners who choose one of the Continental countries, Italy or France, as a second home, without ever shedding their insular ways and character.

Born at Roscommon, in Ireland, O'Conor was educated in England, and then spent two years, beginning in 1881, at the Académie Saint-Luc, Antwerp. In 1883 he came to Paris, but it is not known which school or *atelier* he attended; it may have been that of Carolus-Duran. His name started appearing in the catalogues of the Salon des Indépendants in 1889.[163]

As a young landowner of suitable means and background, he appeared predestined to a career in politics or diplomacy; he set out to study painting merely in order to complete his general education. But, once in Paris he quickly discovered both his vocation and his spiritual home. He devoted himself utterly to painting, leaving a modest place for his second passion, the acquisition of rare books and *objets d'art*. Except for very short periods, he never again left France.

Because O'Conor lived far from his native country and moreover disliked talking about himself, his life-story has remained shrouded in mystery. In historical accounts of the Pont-Aven school he is one of the individuals who always get summary treatment, and whose Christian names are omitted but not their nationality, as if to stress the international character of Gauguin's entourage. After the Second World War he was represented several times in exhibitions devoted to Gauguin and the group, but always in a rather come-by-chance manner.[164]

Long virtually a forgotten man, O'Conor has achieved a renewed popularity during the last few years, a revival which has been not without repercussions on the market in Paris and New York. The sequence of events was that, not long after the death of Mrs O'Conor, the artist's property and paintings were put up to auction at Nueil-sur-Layon (Maine-et-Loire) and at the Hôtel Drouot (February 1956). The pictures fetched low prices, being by an unknown painter, and mostly made their way to the other side of the Channel, where in April of the same year Rowland, Browse & Delbanco in London put on the first exhibition of the Pont-Aven group's Irish member. Further exhibitions, the last in 1971, were held at the same gallery, arousing considerable interest on the part both of private collectors and of museums in the United States, Britain, Ireland and several of the Commonwealth countries.

In 1956, Clive Bell's reminiscences were published in London under the title *Old Friends*; included in them is a verbal portrait of the Irish painter, sketched with the author's habitual humour and grace. A few years later, in 1960, Denys Sutton contributed to *The Studio* a study of O'Conor in which several dates are given and an analysis of his painting is attempted. This fortunate conjunction of circumstances has rescued both the man and the artist from the shadows and brought him to life before us.

Here is Clive Bell's description: 'O'Conor – Roderic O'Conor – was of course an Irishman. He came of a land-owning family which by his own account had done well enough out of the Land Purchase Act. He was a swarthy man, with a black moustache, greying when I met him, tallish and sturdy. He carried a stick, and there was nothing Bohemian about his appearance. In 1904 he was over forty I suppose, and had not been in the British Isles for twenty years or more, so he told me.[165] He told me that somewhere in London he had a top-hat. He was highly intelligent and well educated, had read widely in French and English and was conversant with the Latin masters.... I suspect he was a tragic figure though he kept his tragedy to himself. Conscious of gifts – perhaps great gifts – he was conscious too that he lacked power of expression. His pictures – there is one in the room next to the study in which I am writing – were full of austere intention unrealized; incidentally, they were influenced by Cézanne at a time when the influence of Cézanne was not widespread, when,

in my part of Montparnasse, his name was unknown.'

Here, it seems, Bell puts his finger on an essential component of the artist's personality and gives us one of the clues to the enigma. The tragedy to which he refers, and which was born of the disparity between O'Conor's awareness of himself as a creative intelligence and the actual results of his efforts, was probably caused in the first place by his inability to decide on the form best suited to express his artistic impulses.

When we analyse his pictures we get the impression that we are dealing with a genuine expressionist, who strives to curb his temperament, however, by applying some form of academic discipline, or by introducing a delicate touch of Impressionism or, more often, of Divisionism, or, finally, by subordinating his 'art of intensified expression' to the Syntheticism of Pont-Aven. But in his artistic subconsciousness the note which is continually sounding is expressionism, and this gives his talent an eclectic character. He is a painter who gives the best of himself only when he throws off the yoke of the stylistic formulae to which he himself has submitted. As an example we may cite three sea-pictures in which the *motifs* are almost identical – cobalt and emerald-green sea, red and black rocks – but which are fundamentally different because of the variations in the intensity with which the single theme has been expressed. In the first, the sea is calm and gently undulating, in the second it is aggressively rough – a storm seems to be on the way – and in the third the storm is at its highest pitch. The date, 1898, on the second of these pictures tells us approximately when the other two were painted.[166]

Although the officially recognized date for the meeting of Gauguin and O'Conor is 1893–94, it is not impossible that the latter had reached Pont-Aven in 1892. He seems, in fact, to have adopted certain items of a new aesthetic which is said to have been communicated to him by De Haan, Chamaillard and Moret, whom he met at Pont-Aven. Some confirmation for this may perhaps be found in certain of his canvases painted in 1892, such as the *Still-life with Bottles* (Tate Gallery) and *The Clearing* (Museum of Modern Art, New York). They indicate that concurrently with the more or less Syntheticist style in which he was painting soon after 1902, an interesting process was going on, a struggle between different aesthetic tendencies. He imposed an extreme degree of simplification on his lines and forms, and simultaneously intensified his colour in an essentially expressionistic fashion and resorted to exaggerated, strident contrasts. This can be seen in his *Still-life with Apples and Green Tray* (Delestre collection, at Chemillé), and in the sunlit orange landscape, *Sunken Road* (formerly in Jean Corronc collection, Lorient).

Nowhere among O'Conor's pictures, however, do we find an example of complete submission to the doctrine of Bernard, the *cloisonnisme* of the 1880's, or to the theories later held by Sérusier, with whom O'Conor, who settled in Brittany, was permanently in touch. It is well known that he was fiercely

RODERIC O'CONOR
The Bois d'Amour

RODERIC O'CONOR *Yellow Landscape, Pont-Aven* 1892

opposed to ready-made ideas, and that he painted in a state of perpetual revolt against all considerations of theory. On the other hand, certain references can be found in his painting to Gauguin, from whom he probably sought, as formerly from Cézanne, the confirmation he needed for constructing his own compositions; without, however, attaining the robustness and solidity of form characteristic of the master of Pont-Aven. Writing of O'Conor in connection with the Salon d'Automne of 1906, Charles Morice drew attention to these affinities, and also to the emotional filter, as it were, through which that painter had imbibed Gauguin's doctrine: 'O'Conor, who is closer to Gauguin in feeling and vision, but less didactic, less inclined to base himself on a doctrine whose inventor professed it whenever he was not painting but took liberties with it in order to create masterpieces – O'Conor recalls him to our memories, with an accent of emotion and tenderness which indicates a personal nature and gives promise of future discoveries.'

This tendency to soften everything, to melt lines into nothingness – '*accentuation sentimentale*', as Morice calls it – was regarded as a fundamental fault of O'Conor's by Séguin, who had no hesitation in taking him to task for it, notably in his letters. We do not know what arguments were put up by O'Conor, whose own letters have been lost, but we can guess at them from Séguin's answers: 'I believe that any and every *motif* can be the basis of a fine work, but you won't object to my preferring the form of a human body to that of an apple or the folds of silk to those of a dishcloth. You admit to this preference with much less conviction than I feel about it, because I think that what you see first of all is the colours round about you; whereas what charms and takes hold of me is, above all else, beautiful lines. It is perhaps because, in certain of your canvases, you haven't pursued this quality which I regard as primordial, that all the fine shades of your talent, the thoughtful search which goes into your colour, and the details which give us such pleasure, do not come across at their true value. It takes an artist's eye to perceive their beauty at a glance.'[167]

As a colourist, O'Conor was always different from the others, even at the time when he was closest to the Pont-Aven group. It is true that he uses pure, unmixed colours, but their symbolism is different from that of similar colours in the hands of a Gauguin or a Bernard. He likes oranges and yellows, but, above all, every shade of red, from the lightest, relieved and illumined – as in the practice of Seurat also – by transitions through cyclamen to the richest and most succulent. One would probably be not far out in saying that the gamut of his unmixed colours relates him more to the Fauves, who had not yet made their appearance, than to Pont-Aven.

Accepting it as an observed fact that O'Conor, while living and working at Pont-Aven, was in a state of permanent opposition to everything that those about him were doing, we may well wonder what it was that attached him so strongly to such company. Bell, with the intuition of an alert psychologist, provides an explanation: 'The great event in O'Conor's life had been, I surmise, his friendship – a close friendship so far as I could make out – with Gauguin. They met at Pont-Aven, during Gauguin's last sojourn in Brittany, or perhaps earlier; O'Conor dealt little in dates and let fall his recollections in stray sentences on alien topics. But I assume the friendship was pretty close because O'Conor possessed drawings by the master bearing affectionate and humorous inscriptions:[168] also, at some time or other he lent Gauguin his studio in the rue [du] Cherche-Midi.[169] What to me seems clear is that Gauguin's strength of character and convincing style of talk made a deep impression on the young, or youngish, Irishman, and I dare say it was the only deep impression he ever received from a fellow-creature. That Gauguin had a way of talking and moving and looking which caught his imagination I feel sure: years later, in 1919 or 1920, when I invited him to meet Derain, O'Conor told me, solemnly almost, that he had never met anyone whose manner reminded him so much of Gauguin's. Now O'Conor did not much admire Derain's painting; he

RODERIC O'CONOR *Seascape with Red Rocks*

RODERIC O'CONOR *Red Rocks* 1898

would have been at no pains to pay him a compliment, and assuredly he considered this judgment of his complimentary in the highest degree. So, if in his judgment Derain and Gauguin were in some subtle but significant way alike, I am inclined to believe that they were.'

O'Conor, with Séguin, was meant to have accompanied Gauguin on his second journey to Tahiti. The question why he did not go will always remain a riddle, even in the light of what, according to Sutton, he remarked on the matter to Alden Brooks: 'But really, can you see me setting out for the South Seas in the company of that maniac?' Who can say that the impact the journey would certainly have made on him would not have been a salutary shock, inspiring him with a higher ambition than that of becoming a modest, correct, sensitive painter in the orbit of the Pont-Aven group?

O'Conor was neither the first man nor the last whom Gauguin marked with the stamp of his personality, both in his art and in his destiny. A study of the Pont-Aven milieu from a sociological viewpoint would readily show that anyone unable to accompany Gauguin on his intrepid voyage to the Islands could compensate by expressing his solidarity with the group in other ways. One of these was to renounce the attractions of urban life in favour of provincial isolation, preferably in the countryside of Brittany; another was to abandon one's family and devote oneself exclusively to art; the first was a variant of the *vie de bohème*, the second a protest against the chains fettering the freedom of the individual artist.[170]

To settle permanently in Brittany was a deeply significant symbolic gesture, in two ways: it was an expression of personal loyalty to Gauguin, a return for past friendship; and, even more, an expression of fidelity to the master's doctrine and of a resolve to perpetuate it. There were many of these voluntary exiles, these posthumous children of the ideology of Pont-Aven; some of them were still there long after Gauguin set out, and even after his death; their number included Sérusier at Châteauneuf, Filiger at Le Pouldu, Chamaillard at Pont-Aven, Moret at Doëlan, and the eternal vagabond Jourdan, always on the move but never leaving Finistère.

O'Conor was a member of this group of the faithful. It is true that in later life he acquired a property at Nueil-sur-Layon, in Maine-et-Loire, and made it his permanent home, but for many years prior to that he had divided his life between Paris and Brittany. He too, like Sérusier, had 'absorbed the poison'.

There were three sets of people with whom O'Conor maintained close ties. The first was the international group at Pont-Aven, where, as we have seen, his roots were particularly deep. His closest friends were Séguin, Slewinski[171] and Filiger. The second was a circle in the capital, consisting mainly of the Ecole de Paris, in which his friends included Modigliani, Krémegne, Kikoïne, Ortiz de Zárate, and Dunoyer de Segonzac who, says Bell, bestowed on him the affectionate nickname 'Père O'Conor'.[172] The third set consisted of Anglo-Saxon painters and writers who came to Paris for long or short periods and found in O'Conor the perfect cicerone. There were, among others, the sculptor Paul Bartlett, the painters Alexan-

RODERIC O'CONOR *Surf and Red Rocks*

RODERIC O'CONOR *The Coast of Finistère* 1898

223

RODERIC O'CONOR Lithograph

or two persons whom he thought worth while.' His 'haggard look, the pungent humour, seemed to suggest personality.... He was constantly dissatisfied with his work as a whole: perhaps a part would please him, the forearm or the leg and foot of a figure, a glass or a cup in a still-life; and then he would cut this out and keep it, destroying the rest of the canvas; so that when people invited themselves to see his work he could truthfully answer that he had not a single picture to show.' (The same novel also contains a recognizable sketch of Gauguin, 'a queer fellow who had been a stockbroker and had taken up painting at middle age'; Clutton has met him in Brittany.)

As one puts the pieces together – these fragments from reminiscences, correspondence and fiction – what gradually emerges is an original and attractive personality: an artist, a distinguished amateur and bibliophile, a generous patron, and a discreet and faithful friend.[173]

In his work, O'Conor always remained an eclectic. It is worth noting, however, that his deep and appreciative knowledge of modern painting enabled him to choose the best guides to follow: Cézanne, Seurat, Gauguin, Bonnard. Of his inability to commit himself in any definite direction we must conclude that he wanted it that way; it was his own choice, determined by his love of change, his passion for perfection and his insistence on always being free to make a fresh start.

The work he left behind him is nevertheless very personal and always deeply felt. One can but agree with the opinion expressed by John Russell, writing of the O'Conor exhibition in 1962: 'O'Conor knew what was best in modern French

der Harrison, James Morrice and Gerald Kelly, the illustrator Penrhyn Stanlaws, and the writers Arnold Bennett, Clive Bell and Somerset Maugham. The artists from Britain were in the habit of meeting at the restaurant Le Chat Blanc, in the rue d'Odessa, which seems to have been the Parisian outpost of the intellectual life of Great Britain about 1900.

O'Conor, the leading character in these gatherings, frequently figures in the published reminiscences of the writers who took part, and who tell us much that we should not otherwise know about his life and painting. In addition to Bell, who admired his knowledge of French literature (it was O'Conor who recommended him to read Claudel, Laforgue and Jules Renard), there was Arnold Bennett, who noted in his *Journal* that, where English literature was concerned, O'Conor 'cursed, with delightful fury, the style of Conrad, but was enthusiastic about Thackeray'.

In his novel *Of Human Bondage*, Maugham borrows certain traits of O'Conor's for one of the characters, the painter Clutton. The author's minute observation enables him to illuminate the personality of the Irish artist. Here is his summary portrait of Clutton-O'Conor, whose conversation was frequently aggressive and who 'liked a butt.... He seldom talked of anything but painting, and then only with the one

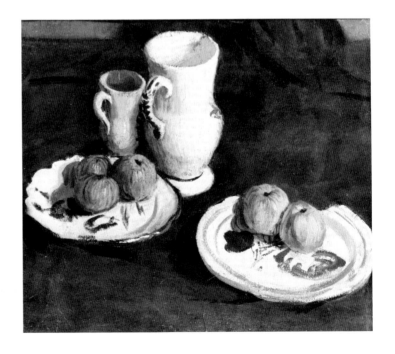

RODERIC O'CONOR *Still-life with Apples*

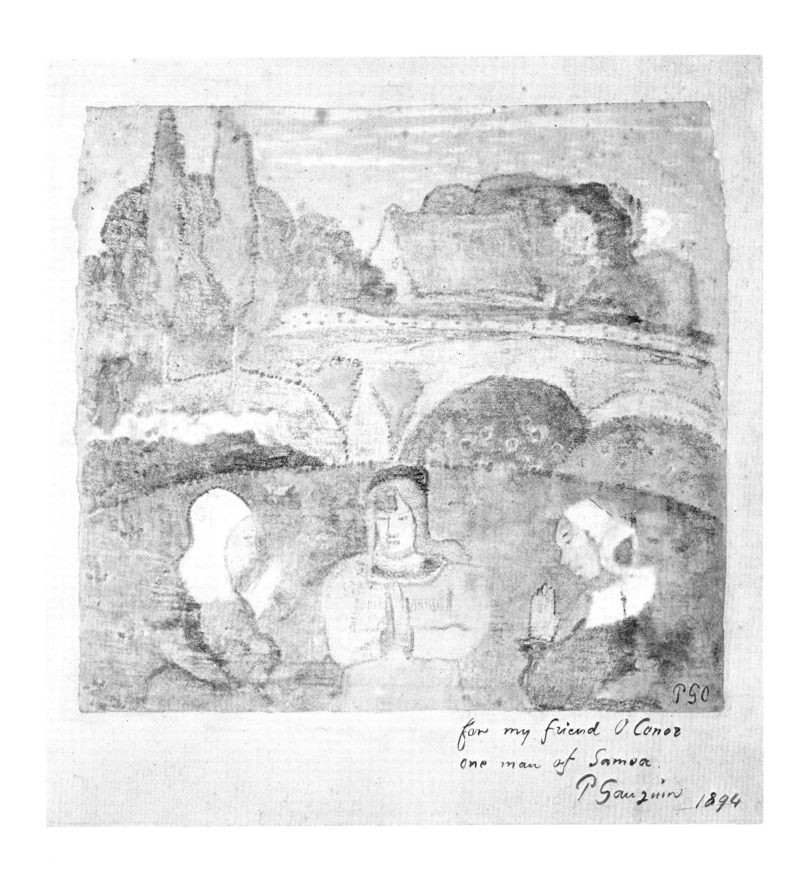

for my friend O. Conor
one man of Samoa.
P Gauguin 1894

PSO

PAUL GAUGUIN *The Angelus in Brittany* 1894

RODERIC O'CONOR *Seascape*

painting and, modestly, integrated it into his own vision of the world.'

O'Conor's artistic life can be summed up as a drama of creativity, a drama whose tragic side did not go unnoticed by Bell, and whose gravity is set forth by Maugham in these unsparing terms: 'The ruggedness of the head, which looked as though it were carved from a stone refractory to the sculptor's chisel, the rough mane of dark hair, the great nose, and the massive bones of the jaw, suggested a man of force; and yet Philip wondered whether perhaps the mask concealed a strange weakness. Clutton's refusal to show his work might be sheer vanity: he could not bear the thought of anyone's criticism, and he would not expose himself to the chance of a refusal from the Salon; he wanted to be received as a master and would not risk comparisons with other work which might force him to diminish his own opinion of himself. During the eighteen months Philip had known him Clutton had grown more harsh and bitter; though he would not come out into the open and compete with his fellows, he was indignant with the facile success of those who did. Clutton appeared destined to a life of failure. Its only justification would be the painting of imperishable masterpieces.'

XII THE AESTHETIC OF THE PONT-AVEN SCHOOL

In giving an account of the origins and life of the Pont-Aven School I have drawn certain theoretical conclusions, whether by analysing the work of individual artists, or by indicating aesthetic convergences and divergences within the group as a whole. Inevitably, the method adopted has given rise to further reflections; some relating to the group, others to a number of its members, and yet others to individuals.

The purpose common to the whole group was, of course, the shaping of the new style, Syntheticism. The study of this problem and its ramifications has involved investigations, often minute, not only into the content and form of the works themselves but their wider implications in the field of art and thought. The time has now come to draw the threads together, to sum up these rather sporadic soundings and explorations, and to take as complete a view of Syntheticism as we can: to determine its origins, its essential nature, its variant forms and the extent of its influence outside the group.

(1) *Cloisonnisme and Syntheticism*

Verkade wrote: 'Just as Barbizon was the cradle of the School of Fontainebleau, so it was from a village near the southern coast of Brittany that there arose the art-movement known as the School of Pont-Aven, or Syntheticism, whose initiators were Paul Gauguin and Emile Bernard.'

There was no special novelty about the words *synthèse* and *synthétisme*. Both had already been used in philosophy and literature and also in aesthetics. But towards the end of the 1880s they began to be used more widely, and to be defined with greater precision. What interests us here, of course, is their application to the painting of this period in general and to the painting of Gauguin and his group in particular.

Is it possible to detect the exact moment when these painters began using the word *synthèse*, in its specific sense? The task looks difficult; facts are in short supply, and such as we possess either appear to be purely random and coincidental, or are of later date. When Gauguin writes: '*Vive la syntaize!*' on a pot he has just shaped, he is indulging his own brand of humour at the expense of synthesis, and, incidentally, leaving us a proof that the word is already in vogue in the circles where he

moves. But the notion clearly lacked a precise meaning as yet; artists had not yet sensed a potential contradiction between analysis, the characteristic of Impressionism, and synthesis, that of the new painting, which some of them had in fact already begun to practise. We need only recall the exhibition at the Café Volpini in 1889, advertised as being that of a 'Groupe Impressionniste et Synthétiste', a dual title for a single movement. Not until 1891 did Aurier write that the Impressionist programme was in direct contradiction to the principles of the Gauguin group. Of what did this contradiction consist?

Briefly, the artists of the younger generation found fault with Naturalism (and therefore with Impressionism) for its *analytical* view of nature, which they intended to counter by means of a new kind of art in which reality would be interpreted through *synthesis*. In other words, truth versus illusion. According to Denis (in his *Manifesto* of 1890), art was to be the 'universal triumph of the imagination of the aesthetes over the efforts of stupid, uninformed imagination', the 'triumph of the emotion of the Beautiful over the Naturalistic lie'.

Thus this art of synthesis and deformation was considered to 'tell the truth' about *the object*. On the one hand the intention was to eliminate detail and go to the heart of things, manifesting their essence and content, instead of merely exhibiting their external appearance. And on the other hand it was the aspiration of the new art to render the state of the creative artist's soul at the moment of creation, by having recourse to what Denis defined as 'plastic equivalents': simplified form, and suggestive colour, applied in simple areas each of a single colour, surrounded by a dark outline. Thus the truth was also to be told about *man*.

'Synthesis' was a word with a future; it caught on. It implied at once a subjective vision of the world and a simplified style, and hence an artistic form in which it was possible for that vision to be perfectly expressed. Aware of this today, by hindsight, we are in a position to establish the relationship between the words '*cloisonnisme*' and 'Syntheticism', and that of 'Symbolism' with both. If we want to get at the origins of Syntheticism we must consider the artistic and visual stimuli which were the motor forces of the new style; we must also examine the movement, a purely intellectual movement, that

generated the philosophy used as a foundation by the creators of Syntheticism.

A brief review of the origin of the word 'cloisonnisme' takes us back to 1887, in which year Anquetin and Bernard sent a few canvases to the exhibition of the Groupe des Vingt in Brussels.[174] Anquetin, as we know, had made the original experiment, which for a short time appeared to solve the problem engaging the desperate efforts of the group known as the Ecole du Petit-Boulevard (Anquetin, Toulouse-Lautrec and Bernard). What he proposed was to create and suggest atmosphere by means of colour.

Now, as will be recalled, the Anquetin family house at Etrépagny (Eure) had a verandah; and this, after the fashion of the period, was glazed with small panes of different colours – yellow, red, green and blue. Anquetin noticed that the landscape took on a different mood according to which pane he looked through: regardless of the real time of day, green produced an impression of morning; blue, of moonlight; yellow, of sunlight; and red, of dusk. The parallel with painting was obvious: a predominance of cold colours yielded an effect of gloom; warm, of joy; and so on. This apparently childish, simple deduction was the origin of modern colour symbolism in painting.

The first works in which this experimenter applied his conclusions were *Reaper: Mid-day*, in different tones of orange-yellow, and *Avenue de Clichy: Evening*, in shades of blue; both were painted in 1887. Structurally, these were characterized by flattening – the absence of perspective and of light and shade; almost monochrome colouring; and areas bounded by outlines. The writer and critic Edouard Dujardin was the first to point out the resemblance of these closely packed one-colour areas to stained glass, and, more particularly, to *cloisonné* work in enamel, and to recognize Anquetin as the inventor of a new practice in painting, *cloisonnisme*.[175]

Dujardin praised the 'intellectual construction' and ' n-bolical conception' of these pictures, which he described as conveying at once 'the idea of a decorative painting; the use of outlines, and the violent, resolutely straightforward colour, inevitably recalling *japonisme* and popular prints. Then, beneath the over-all hieratic character of the drawing and colour, one becomes aware of a truth-to-sensation emerging from the romantic brio; and what one sees gradually taking command of the whole is a deliberate, reasoned quality, an intellectual construction dependent on prior analysis.... Hence the circumscription of colour by outline, as conceived by the popular print and Japanese art; in both of these... the lines are made first, by means of a master-block, and the colours are put inside them; in the same way the painter will lay out his drawing in closed lines, between which he will then lay on the various tones whose juxtaposition is to create the effect of the intended colour-scheme; the drawing reinforcing the colour, and the colour the drawing. And the painter's working procedure will be a sort of painting by compartments, like *cloisonné* enamel, and his technique will be a kind of *cloisonnisme*.'[176]

It should be remembered that there was a fashion for the simplicity of folk-art at the time. Epinal prints were collected in large quantities, and Rémy de Gourmont even founded a review, *L'Ymagier*, to encourage and protect the production of such work. One of his collaborators on *L'Ymagier*, as we have seen, was Filiger, who was not only a native of the district where the prints were manufactured, but whose work was a transposition of the Epinal prototypes into a mystical key of his own. Bernard, in his autobiography, wrote that he was a collector of Epinal prints from early childhood, and that he used to keep examples of them hung over his bed, among reproductions depicting his 'beloved Middle Ages'. It was in the naive, clumsy drawing of the Epinal prints that the most refined *fin de siècle* artists rediscovered the sincerity for which they longed so earnestly, and which they said the art of their own time had long since lost.

In the quest for synthesis, a leading part was destined to be played by Brittany and all it meant: its landscapes, architecture, folklore and traditions. Earlier chapters will have made evident the powerful effect of the region on Gauguin and his group; in the case of Filiger, Verkade and Ballin the influence was mystical, in that of Gauguin, Bernard and Sérusier it took the form of a violent love for the primitive and archaic quality of Breton life. A kind of delirium, it is perhaps not too much to say, took hold of most of these artists in Brittany. Bernard, for instance, tells us what a vivid impression, like a flash of lightning, the place made on him: 'I felt as if I was living in my beloved Middle Ages. Art was all about me.' And Gauguin wrote to Schuffenecker, in February 1888: 'I love Brittany: I find in it something savage, something primitive. When my clogs resound on this granite soil, I hear the dense, powerful tone which I am looking for in painting.' And Sérusier confessed that he felt 'more and more attracted to Brittany, my true country, since it was there that I underwent my spiritual birth'.

There was more in all this besides spiritual and emotional exaltation. The painters found their creative impulses at once confirmed and given a new stimulus by Breton Romanesque architecture, by primitive carvings in wood and stone, and by the landscape. The latter should be understood as the Breton landscape in its natural formation, whose very structure renders it *synthétique*; no landscape more so.[177] As spring comes round, the country is covered with oblong patches of yellow (gorse and broom in flower), their shape and colour standing out boldly on a background of green turf, which becomes greener still where it is met by the orange sand of the shore; and the orange in turn becomes more intense as it approaches the vast greyness of the sea. A variety of sombre maritime pine, growing in regular lines in the proximity of the gorse, makes a dark streak between the stretches of blazing yellow and the emerald green of the fields. The soil, which is interspersed with loess, bears violets and roses in profusion, while the stone-built cottages are resplendent with the white of their walls and the brilliant red of their roofs. Thus the landscape imposes its own synthesis of form and colour.

CHARLES FILIGER *Seascape with Shades of Mauve*

PAUL SÉRUSIER *The Customs Officer's House*

Morice wrote in 1903: 'Brittany reminded him [Gauguin] that the spirit of man can express itself most movingly when it deliberately forgoes the finite detail which, everywhere on earth, mankind in its innocence has spontaneously improvised.' Séguin – also in 1903 – stressed that 'the landscape they saw before them every day was a wonderful help in reaching the goal of their desires: synthesis, and the characteristic feature. Round them was the soil, with its bony structure showing; the stone walls sketched the shapes of the fields they surrounded, forming *cloisonné* patches of red, green, yellow or violet, according to season, hour and weather.'

Later, in a pastiche of Swedenborg, Séguin has recourse to a rhetorical personification: 'The whole of Nature spoke to them. She was saying to them: "See how simple are the means by which I achieve beauty and grandeur, and let your eyes, once blindfolded by the Chevreuls of this world, rest now upon the truth. Seek the origin of the sensation you feel, and do not work until you know what has caused it. My handiwork pleases you and it is immense; so find out how to express it in brief and summary form. On this soil I have set vigorous men and sturdy women, and their dress is severe, like myself. They alternate the white of their headdresses with the black of the rest; when they work, the curved outlines of their stooping forms is all the more harmonious in your eyes for being compensated by the vertical lines of my making. The blue of the skirt makes a concord with the orange apron, like the harmony of my green trees and red soil, and my golden broom in flower stretching away over my violet granite. This is the eternal book in which you must read!"'

It was in the delicate, purified art of Japan that the painters found a repetition and confirmation of what was offered to them so generously by the natural, primitive landscapes of Brittany. Louis Gonce wrote that the Japanese possessed 'a natural inclination towards synthesis, a marvellous instinct for th esources of colour, a profound knowledge of the laws of colour-harmony, and infinite delicacy in varying the uses of colour.'[178]

In his *Notes*, published in 1903, Bernard pointed to Japan as the first source of his interest in synthesis: 'The study of Japanese fabric silks (*crépons*) is leading us [himself and Anquetin] towards simplicity, we are creating *cloisonnisme* (1886).' Even if we accept the emendation proposed by some researchers, according to whom this piece was written only in 1887, after the exhibition of Japanese prints (lent by Bing) organized by Vincent van Gogh at the Café du Tambourin, the fact remains that Bernard was referring here to the first attempts in the direction of synthesis which had been made by the group consisting of himself, Toulouse-Lautrec and Anquetin.[179]

Needless to say, interest in Japanese art had not begun with these three painters. Japanese influence on Western art was perceptible as early as the middle of the nineteenth century, and the enthusiastic references to it in the *Journal* of the Goncourt brothers were only one of the many signs of its presence.[180] However, each generation took from Japan whatever it found seductive at the time. Thus the Impressionists were

attracted by the delicacy of the Japanese artists' colour, whereas the next generation was excited by their two-dimensional drawing and their elimination of perspective and the illusions of modelling. Japanese line was seen to contain a unique poetry, with the power of expressing psychological states. Bernard even considered that the formal conception employed in Japanese prints, so far from contenting itself with reproducing the external reality, was aimed at the inner spirit of things and at divining life's meaning.

Drawing their inspiration from these prints, the adherents of Syntheticism, particularly Bernard himself in the early stages, created an abridged form of the human figure by reducing it to a silhouette, removing its individual features and, so to speak, universalizing it. And – what was essential – Japanese art unveiled the secret of how to interpret, in plastic terms, dreams and visionary musings, the goal to which the arts in general were supposed to aspire.[181] Ary Renan wrote in Bing's magazine: 'Hokusai is not only a lover of visible nature but a dreamer, an imaginative painter.... Is it not remarkable to find in an artist of the Far East the plastic realization of those dreams of the beyond, those nostalgic visions, which the most advanced school of English and French writers thought they were alone in having glimpsed?'

Renan, who wrote these lines in 1888, mentioned literature only; he was unaware that at that moment, in a little village in Brittany, a painter, Gauguin, was in the act of realizing his own 'nostalgic vision' in the picture entitled *Vision after the Sermon* or *Jacob Wrestling with the Angel*. Looking at it from the formal point of view, Gauguin in a letter to Schuffenecker described this work as the 'synthesis of a form and a colour achieved by omitting everything except the keynote'. But he was aware of having initiated something more than a new graphic technique, and wrote to Van Gogh: 'For me, the landscape and wrestling figures in this picture exist only in the imagination of the people who are praying as a result of the sermon. That is why there is a contrast between the life-size people and the wrestlers in their landscape, both of which latter are non-natural and out of proportion.'[182] In other terms, the synthesis of form and colour enunciated by Gauguin amounts to simplifying and impoverishing the expressive means and consequently enriching the faculty of creative thought, which has prepared itself to express the inexpressible, the metaphysical.[183]

No such ambition had been in the mind of Anquetin, whose *cloisonnisme* had been a purely formal experiment, intended, at the most, to arouse an emotional condition in the spectator such as might equally have been expected to result from a sunset, for example, or a gathering storm.

What results from the foregoing considerations is that, formally speaking, *cloisonnisme* was the origin of Syntheticism, or more precisely that it was one kind of Syntheticist solution, consisting of interpreting all the constituent forms of a picture as plane silhouettes, with a prominent outline separating each from the next. Human figures were treated no differently from inert matter; they were impassive and cold, as if dwelling

imprisoned in the compartments of a stained-glass window. Many examples of this treatment can be found, both in the Bernard of the years 1888–89 and in Willumsen, who followed his lead. It is obvious that the formula could have led straight to a purely mechanical use of decorative elements, a dehumanized pattern-making. What made it possible to avoid this was the introduction of a subjective, emotional potential; the flat, simple forms remained intact, but their rigour was sufficiently softened for the artist to convey his message or express his psyche. Hence there was a point of departure for Syntheticism conceived not as a technological formula, but as an aesthetic and philosophical doctrine.

Syntheticism as a phenomenon in painting was brought to birth and effectively defined in two canvases painted in summer 1888: *Breton Women in Green Meadow*, by Bernard, and *Vision after the Sermon*, by Gauguin. These two pictures are essentially representative of the style, because everything which preceded them, in the work of either painter, was only a presentiment of Syntheticism, and everything which came after was only a logical development from them – developing, it should however be added, in somewhat contrary directions: in the case of Bernard, towards a concentration of form tending ultimately to a schema,[184] and in the case of Gauguin, towards an explosion of form by means of a metaphysical charge, a magical content – 'the dream', as the master was fond of calling it. Thus Bernard eventually found himself in an impasse: he was compelled either to go on virtually repeating a set of clichés or take refuge in a completely different style. He chose the second road – and was defeated. From the same starting-point Gauguin progressed after his astounding Breton cycle (the *Yellow Christ, The Agony in the Garden* and *Breton Calvary*), to the use of a synthesis both spiritual and expressive as the foundation on which to erect a modern world, his miraculous Tahitian mythology. And that is his great victory.[185]

(2) *Syntheticism and Symbolism*

The birth of Syntheticism in painting coincided with the rise of Symbolist poetry. Seeking for analogies in other arts – in music, painting and the theatre – the poets gave the name 'Symbolism' to the Syntheticism of the painters and declared Gauguin to be the leader of the new movement. It is a remarkable fact that, at the time, such illustrious artists were living and working in Paris as Redon and Moreau, whose art, full of delicate allegorical allusions and of more or less pertinent metaphors, conformed exactly to the accepted meaning of the term 'Symbolism'. It was nevertheless in the canvases of Gauguin and his group, which contained no allegorical matter, that Aurier was able to detect the Symbolist values. Which is to say that he was able to distinguish the literary Symbolism of Moreau and Redon from the purely pictorial Symbolism of Gauguin.[186]

Verkade, in an attempt to characterize the method and style of Gauguin, noted: 'The impression received from nature

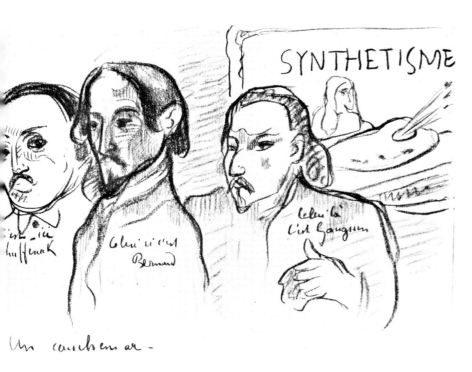

SYNTHETISME

celui-ci c'est
Bernard

celui-là
c'est Gauguin

ich-ich
Schuffenek

Un cauchemar –

ÉMILE BERNARD *A Nightmare c. 1888*

should come to an alliance with the aesthetic faculty, which selects, orders, simplifies and synthesizes. The painter shall allow himself no rest until he has brought into the world, in plastic terms and for the delectation of all who may see it, the child of his imagination, born of the union of his mind with reality.... Gauguin demanded logical construction in composition, a harmonious distribution of light and dark areas of colour, simplified forms and proportions, giving the silhouette a strong, eloquent expressiveness.' Rookmaaker rightly insists on the relationship connecting such words as 'select', 'order' and 'simplify', which according to him are all more or less synonymous with 'synthesize'.

One of Zapolska's 'Letters from Paris' (1884) contains an interesting theoretical treatment of Syntheticism, its inventors and its terminological metamorphoses. However simple and unsophisticated, this document carries unique weight: it has every appearance of being directly inspired by Sérusier, who was on terms of close friendship with the Polish novelist at the time and, according to her, was responsible for 'initiating her into the complex universe of art'. Here is what she says: 'In ordinary language, the word "symbol" is applied indifferently to any allegory and any sign; in reality, the symbol is a synthesis of the artist's soul and the soul of nature, whereas

signs and allegories are something quite different. Symbolism represents the most perfect form of individualism, and the true Symbolist, summoning to his aid the art of using and combining colours, gives us in his pictures a share in the state of his soul as it was at the moment of creation, that is to say the state of soul not of a photographer-slave but of a free, independent being who listens only to his inspiration. At the beginning, the Symbolists called themselves Syntheticists. There were only a handful of them: Gauguin, Bernard, Anquetin. In 1889 they organized an exhibition in a down-at-heel café during the Universal Exhibition, and succeeded in arousing the attention of the public and the critics. The name "Symbolists" was given to them by a group of poets with parallel aims, who thought they found, in this species of painting, resonances similar to those of their poetry.'

What, then, were the theories which had presided over the emergence of the first pictures conceived in the spirit of synthesis? The first and most important was that the artist was free and independent as regards the external, purely optical aspect of nature. What mattered was what he had spiritually received and retained from it. This conception of the model evidently implied that it was better to paint from memory than from nature, so as to sift the subject-matter and cast out the mass of superfluous detail. Gauguin advised Schuffenecker: 'Don't paint too much from nature. Art is an abstraction, let yourself dream in front of nature in order to derive this abstraction and then think rather of the creation which is to be the outcome, this is the only way of rising towards God by imitating our Divine Master, that is to say by creating.'

The imagination of Bernard, which was less intuitive but correspondingly more thoughtful and philosophical, prompted the following considerations in his *Souvenirs*: 'Simplification, or synthesis, imposed itself primarily because it was inherent in the idea: for the idea keeps only the essential part of things perceived and, in consequence, rejects detail. Memory does not retain everything but only what strikes the mind. Forms and colours therefore became simple, united in equality. By painting from memory I secured the advantage of cutting out unnecessary complications of form and colour. What remained was a *schema* of the spectacle before me. All the lines were resolved into their geometrical architecture, all the colours returned to the type-colours of the prismatic palette. Since what was required was to simplify, it was also requisite to find the origin of everything; in sunlight, the seven colours of which white light was composed (and to which the pure colours of the palette correspond); in geometry, the typical forms of all objective forms. Such was my Syntheticism in 1888.'

It is difficult, not to say impossible, to establish what – if any – were the philosophical and literary influences affecting Gauguin at the time when his artistic convictions were beginning to take shape, namely the period from summer 1888 to autumn 1889. We have no sources for this. All the evidence suggests that his personal relations with the literary *avant-garde*, of which we shall have more to say, began after he had painted the *Vision after the Sermon*, the *Yellow Christ* and the

231

Breton Calvary, and also that in literary circles much importance was attached to the opportunity of welcoming 'a representative of Symbolism in painting'.

We do know, at any rate, that discussions on art were endless, at Pont-Aven and thereafter at Le Pouldu. The participation of Bernard, and later of De Haan and Sérusier, ensured that these debates proceeded on a fairly high philosophical and literary level. Gauguin's portrait of De Haan, hunched with a meditative air over some books, gives us an idea of these painters' literary tastes. The two books lying in front of De Haan, it will be remembered, are by Carlyle (*Sartor Resartus*) and Milton (*Paradise Lost*). According to Rookmaaker, Milton's epic and *Les Fleurs du Mal*, by Baudelaire, which the painters had certainly read, provided the genesis of the self-portrait painted by Gauguin in 1889 (National Gallery of Art, Washington); in addition, Carlyle and Baudelaire played a part in revealing to them the role of music in painting. Let us also remember that De Haan brought with him to Le Pouldu a gigantic Bible, which he is said to have been in the habit of reading in his colleagues' company. And from Morice (1920) we know that Gauguin was fond of Poe, Renan and Balzac.

Gauguin's philosophical equipment was rather that of a dilettante, a mixture of Eastern philosophy, Schopenhauer and Swedenborg. But he had the creative gift of quickly drawing from these sources conclusions which were definitive both for himself, and for his art. It was enough for him to hear any philosophical system mentioned, in however superficial and fragmentary a fashion, upon which he would at once intuitively construct a theory of his own to justify what he was painting at the time, and the way in which he was painting it: 'Philosophy is a dead weight unless it is in me instinctively,' Morice reports him as saying.

This philosophical intuition possessed by Gauguin was admired by many artists and critics who knew more about philosophy than he did. Denis wrote: 'Sérusier used to prove to us by arguments drawn from Hegel, and the heavy-handed articles of Albert Aurier rammed the point home, that logically, philosophically, it was Gauguin who was right.' If we compare the dates of the paintings produced by members of the group and their writings, we find that they appeared almost simultaneously; this means that we must exclude as artificial any suggestion that the theoretical formulation came first and its realization in plastic terms second, a suggestion which, if valid, would lay the art of Pont-Aven open to a charge of 'applied theory'.

A word which was constantly associated with the notion of Syntheticism, and which was considered to denote its essence, if not its very basis, was 'imagination' – which meant the antithesis of science, observation and everything resulting from experience. Art born of imagination – Syntheticism, in the immediate context – was diametrically opposed to the art which copied nature (well or ill), and therefore to Naturalism, to academicism, and, as time went on, to Impressionism.

The word 'imagination' was used in the sense given to it by Delacroix and Baudelaire. Delacroix held that 'the true painter is the one in whom imagination speaks before all else',[187] and Baudelaire completed this thought by calling imagination 'the queen of the faculties'. 'Imagination is both analysis and synthesis. It was imagination that taught man the moral meaning of colour, contour, sound and scent. It created, at the beginning of the world, analogy and metaphor. It dismantles the whole creation, and with the materials amassed and disposed in accordance with rules whose origin is only to be discovered in the depths of the soul, it creates a new world, it produces the sensation of the new. As imagination created the world (I believe this really can be said, even in a religious sense), it is a matter of justice that it should also govern the world.'[188]

The views of Delacroix and Baudelaire on the role of imagination in the creative act were well known to the Pont-Aven artists, as is proved by the *Théories* of Denis: 'Instead of "working round about the eye, we were searching at the mysterious centre of thought", as Gauguin used to say. In this way the imagination becomes once again what Baudelaire wanted it to be, the queen of the faculties. Thus we were liberating our sensibility; and art, instead of being the *copy*, was becoming the *subjective deformation* of nature.'

Nevertheless the artist is installed inside nature and is part of it; it is nature that provides him with sensations, emotions and ideas. On the other hand he tears himself away from nature by the act of observing it; he is dreaming yet fully awake, and his dream is that of which Baudelaire says that 'it, too, is a means of knowing'. When this dreaming becomes identical with his living, its effect is simply to heighten yet further the subjectivism and individualism of the artist. The dream is the projection of the thing to be created, a vision arising from the potential of the work as yet unrealized; the dream is a sort of state of grace, in which the artist, under the influence of maximum imaginative excitement, surrenders to an act of creation, feeling himself meanwhile to be separated from the world of external reality, concentrated exclusively within his own self, and as it were 'depositing' his dream in a work of art. Bernard said the picture was 'above all, a dream written down', and Gauguin, in a letter to Monfreid in 1897, said of his picture *Te Rerioa* ('The Dream', in Maori): 'Everything in this canvas is a dream; is the child really there, or the rider on the path, or is the whole thing a dream of the painter's!!!'

The same thing was going on in poetry. In the dream-state, reverie merges with waking consciousness, and the real with the fictitious. Mallarmé, wrote Wyzewa in 1886, believed that the world really existed, including its visual enchantments and human societies, but that all of these were nothing but 'the soul's dreams'.

Were these dreams real? Of course they were – in exactly the same way as all dreams are real. In that case, by what forms in art and what language in poetry were the painters and poets to express their dreams and their emotional and psychic states? Alfred Poizat appears to be answering this question when he says: 'The Decadents, having rallied to subjectivism... from that point onward looked at reality exclusively by means of

the distorting mirror which was the dreaming soul of the poet himself. And since on the other hand they were highly rational, deliberative creatures, it was not long before they were seeing the realities thus reflected and dematerialized in their own selves as nothing but emblems and symbols!'

This takes us to the heart of the problem. The symbol is what constitutes the communication-system, the language of the poet and the artist. Aurier declared in 1893 that 'a mere imitation of material aspects, without any spiritual import, is never Art; in other words, *there is not and never has been any Art without symbolism.*' It is clear that Aurier uses the term in a very wide historical and conceptual bearing.

We must turn once more to Romanticism if we wish to locate the original sources of modern Symbolism. Very judiciously, Rookmaaker points to Heine as the spiritual link between German Romanticism and French literature, because the German poet had expressed the notion of the symbol, and its role, clearly and precisely: 'Sounds, words, colours, shapes, and in general all phenomena, are only symbols of the idea, symbols which are born in the artist's soul when he receives the impulsion of the holy spirit of the world; his works of art are symbols by means of which he communicates his own ideas to other souls.'[189]

Romanticism, however, was inadequate to the needs of the Symbolists, who criticized it for not going deep enough, not getting to the bottom of things. They were attracted, says Valin, neither by Romanticism's noble flights of sentiment nor by its impetuous manifestations of the passions. Morice declared in 1889, in describing the Romantic attitude, 'This is not the fundamental content of the passions but their outward gesticulation, their active display.'

'It was no more than natural', Morice was to write in 1920, 'that synthesis should lead the artist to the symbol. Certain sacrifices, and a certain order in composition – both meant to make the creator's thinking intelligible – and freedom from immediate subjection to observed reality, engendered in the artist a desire to retain only those aspects of nature in which he could read an allusion to that thinking, and to combine those aspects in some major image which would be at once free from all literal resemblance, and profoundly, that is to say vitally and artistically, true. That image is the symbol.'

In brief, what these artists were claiming to attempt was to use lines and colours in order to formulate a message which, subjectively, would function as something more than a picture composed of these lines and colours. They meant to use those elements in exactly the same way as a language uses sounds. 'This amounts to saying', wrote Aurier, the leader of the *avant-garde* in art at the time, 'that objects – in an abstract sense: meaning the various combinations of lines, planes, shadows and colours – constitute the vocabulary of a mysterious but marvellously expressive language, without a knowledge of which no one can be an artist. This language, like any other, has its own writing, spelling, grammar, syntax and even its rhetoric, which is style.'[190]

But a language does not consist only of onomatopoeic sounds; it is intelligible, even, and indeed especially, when it has recourse to 'organized' sounds. The same is true of art. Naturalism treats the image (the *motif*) mimetically, like the camera; this corresponds to the onomatopoeic sound, the least organized noise. An apple in a drawing remains an apple, a tree remains a tree and nothing more. A work of art, as understood by the painters of the 1890s, employs plastic signs in the same way as organized sounds are employed in language, and hence expresses values which have no visual connection with those signs. Wagner said of Beethoven's *Missa Solemnis* that the words of which it was a setting had no effect on the hearer during performance, the text being only 'material in the service of singing', but that on the other hand they produced an effect on the symbolic plane. This was how the artists we are discussing understood the relation between the visible object and the work as such. Harvest, haymaking or apple-picking were merely pretexts or 'interposed' objects; only the painter's power of expression was capable of moving the spectator.

PAUL GAUGUIN *Be a Symbolist (Caricature of Jean Moréas)* c. 1891

The painters were not actually conscious of all this; or, to put it more precisely, they did not use our modern terminology. But they did consider the work of art as a messenger conveying a thought, and their conclusions and discoveries in this realm were to open the way to future explorations in significant picture-making. Rookmaaker writes that these artists were conscious in the first place not only of the 'iconic' character of the image but also, and above all, of the necessity for the work of art, as such, to represent the meaning of the object, not to offer a narrative (still less an imitative) description, whose artistic content would have been nil.

The fact of turning aside from all 'literature' meant that the artist must present the object without a subtitle, so to speak, and translate it not as a visible thing but as a thing which had been thought and felt. Gauguin wrote, when introducing to the public his young pupil Séguin, who was exhibiting in Paris for the first time: 'Let it suffice me to warn the visitor that Séguin is, above all, cerebral – by which I certainly do not mean "literary" – and that he expresses not what he sees but what he thinks, by means of an original harmony of lines, a manner of drawing curiously contained and limited by arabesque.'

In a discussion on the way in which he had visualized the landscape of Tahiti, a critic observed to Gauguin that 'all these fabulous colours, this fiery yet subdued and silent air – all this really doesn't exist!' To which the painter replied: 'Yes, all this does exist, as the equivalent of the grandeur and profundity of the mystery of Tahiti when it's a question of representing it on a canvas one metre square.'[191]

It would be impossible to omit from these considerations the frequently quoted conclusion of Cézanne, which shows how much the minds of that generation were obsessed by the idea of representing 'something by means of something else', that is to say by a purely plastic equivalent: 'I wanted to copy nature but I never succeeded. I was pleased with myself when I discovered that sunlight for example (sunlit objects) could not be reproduced, but must be represented by something other than what I was seeing: namely, by colour.'[192]

Gauguin wrote to Bernard, in November 1888, on the subject of Japanese art: 'You are discussing shadows with Laval and asking whether I say to hell with them. As regards the explanation of light, yes I do. Examine the Japanese, they draw admirably and yet you'll see them depicting life in the open air and in sunshine without any shadows. Using colour only as a combination of tones, diverse harmonies, giving the impression of heat.... If shadow enters into your composition as a necessary form, that's quite a different matter. Thus instead of a figure you merely put someone's shadow; this is an original point of departure, whose strangeness you have deliberately calculated.'

Gauguin's disciples – Denis and Sérusier – spent much time on this problem, opposing modern art, the art of plastic equivalents, to naturalism. In the *Théories* of Denis we find the following: 'For the idea of "nature seen through the medium of a temperament" we have substituted the theory of equiva-

lence, the theory of the symbol: we affirmed that the emotions or states of soul caused in the spectator by any given spectacle implied the existence, in the artist's imagination, of signs or plastic equivalents capable of reproducing those emotions or states of soul, without his needing to supply a *copy* of the original spectacle; that to every state of our sensibility there must correspond an objective harmony capable of translating it.'

Lastly, Sérusier's view, in the *ABC*, is: 'Thoughts and moral qualities can only be represented by formal equivalents. The faculty of perceiving these correspondences is what makes the artist. Everyone possesses this faculty at birth, in a state of potentiality; his personal work develops it: a bad education is capable of destroying it.'

(3) *Musicality*

Music occupied a place of the first importance in the life of the Pont-Aven group. As we know, Gauguin played the piano and the mandoline, Filiger the guitar, Sérusier had a fine tenor voice, and Bernard notes in his reminiscences that when passing through Paris he never failed to go to the opera and to a concert of the orchestra of Charles Lamoureux, who was a friend of the Nabis. Love of music was by no means unusual in artistic and literary circles. Redon records in his journal, *A soi-même*, that 'from the cradle' he was accustomed to listen to Bach and Beethoven, and later to Berlioz, Chopin and Schumann. He never ceased extending his familiarity with music and liked people to call him a *peintre symphoniste*, a 'symphonic painter'. Stefan Jarocinski, the Polish musical scholar, observes in his notable book on Debussy: 'The pride of place given to music by the Symbolists was in some sort a reaction against the tone-deafness of the previous generation, in which Delacroix, Gautier and Baudelaire stand out as glorious exceptions. At no other period had music commanded so many followers among writers and painters as in the time of Symbolism. It was not longer merely a cult, it was a religion. People vied to surpass one another in fervour, simply in order not to seem insensible to music, and the great majority prostrated themselves before Wagner.'

Here, however, I am not concerned to illustrate the interest taken in music by the generation of the Symbolists, but rather to emphasize what part music could and did play in the creative process of the painter, and also to stress certain analogies between the painter's working activity and the composer's. The 'musicality of a picture' is an idea which comes up frequently in the talk and writings of the painters discussed in this book, and some of the musical terms to which they had recourse were 'melody', 'sound', 'harmony', 'discord' and 'counterpoint'. In his article on Gauguin and Mallarmé, Chassé points to the affinities between poetry and the plastic arts on one hand and music on the other; and Suzanne Barazetti remarks in her book that when reading the correspon-

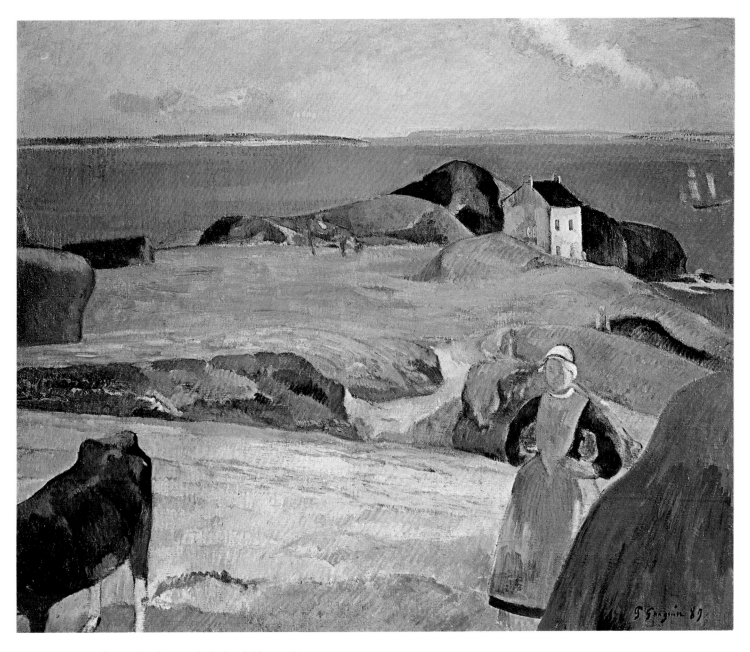

PAUL GAUGUIN *Breton Landscape, the Isolated House* 1889

dence of Sérusier and Denis, we have the impression that it is not two painters who are writing but two musicians.

Hofstätter, in his treatment of this aspect, opts for synaesthesia, accepting the philosopher Jaensch's definition of that phenomenon: 'Just as the composer composes by employing sounds and anti-sounds, rhythms and melodies, so the painter works with the colours and anti-colours, forms and anti-forms, lines and rhythms in the plane. Both renounce literary content.'

Unlike Schopenhauer, who asserted that 'music alone is the spontaneous expression of the feelings of the soul'[193] – which caused the poets to elevate music to the supreme position, above all other means of expressing the inexpressible – Gauguin had no hesitation in placing these two arts, music and painting, on the same level, and even in according a certain supremacy to painting: like music, painting 'acts on the soul through the intermediary of the senses; but in painting we achieve a unity impossible in music, where the chords come

235

one after the other (harmonious sounds corresponding to harmonious tones in painting), and the judging mind is subjected to continual fatigue if it attempts to reunite the end with the beginning. In short, hearing, as a sense, is inferior to sight. Hearing can take in only one sound at a time, whereas sight embraces everything, meanwhile simplifying if and as it wishes.'[194]

(4) *Contact with the literary avant-garde*

It was not until late 1889 and early 1890 that Gauguin made contact with literary circles in Paris (the only exception being Aurier, whom he had met during the exhibition at the Café Volpini) and was able to compare his own opinions with those held by the proponents of Symbolism in poetry. This initial contact was a surprise for both parties. Denis wrote describing it to his friend Lugné-Poë, who was doing his military service at the time, and who recorded the matter later: 'Aurier brought Gauguin along to the Café François Ier. There, Aurier revealed the painter to the admiration of Stuart Merrill and a crowd of other writers of the young generation. A great stir around Gauguin: "We know Denis and Sérusier already. Are you Gauguin? The man who painted this... and that...?" He for his part was much surprised that, in his absence, we had developed such abundant and lively good-will towards him. The thing's going well.'

In addition, Aurier introduced Gauguin to his friends who were responsible for the magazines *La Pléiade* and *Le Moderniste*, Jean Dolent and Julien Leclercq; and these in turn introduced him into the circle of Symbolist writers and poets surrounding the *Mercure de France*. Gauguin frequented the Symbolist gatherings which took place in cafés, notably La Côte-d'Or, near the Odéon; in this way he met Charles Morice, Jean Moréas, Rodolphe Darzens, Jules Renard and others. He soon made himself a familiar figure in these circles, and his personality aroused admiration.[195]

Nevertheless, his opinions on art took longer to win acceptance than did his painting itself. In Brittany he was accustomed to express his ideas in front of a small audience and to adopt an authoritative tone, tolerating not the slightest opposition; and at first he took up the same attitude towards his new friends. They listened to him with interest but disliked his manner.

'With very few exceptions', wrote Morice in 1920, 'the poets exhibited a deep spontaneous deference towards both the person and the art of Gauguin, a fact very logically to be explained by the preponderance which the painter allowed in his canvases to poetic thought, even, one may say, to "literary" thought.... In this first encounter, however, there occurred, not head-on clashes, but – what is worse – gestures of recoil, noisy objections, silences. The attitude of this painter who had come to explain to us not only the whole of art but also poetry, its laws and its obligations, gave offence to certain people. And

the man's utterly downright personality, his broad, clear-cut theories (with shoulders to match), the incisive intuition of his glance, the racy incorrectness of his diction, in which sailors' and painters' slang made an incongruous medium for expressing ideas of absolute nobility and purity – everything about him was out of tune.... Without meaning to, Gauguin overbore them, usurping the foreground. And they, also without meaning to, no doubt, tried to regain the advantage by displaying a knowledge which, at least where literature was concerned, was greater and more accurate than his.

'The result was general embarrassment, which he himself was the first to notice. He dropped the argument and asked Moréas to read one of his poems; and now that he was immobilized, listening, I studied him carefully. Power, sheer power, was everywhere apparent in him; a noble strength, justifying his visible pretention to tyrannize over others. But at the same time the short chin, the unusually delicate nostrils, continually palpitating, and the bitter expression of the mouth, seemed to me to betray the possibility of sudden collapses of the will, moments of weakness or despair, jealously concealed, and these characteristics were somewhat at variance with his general expression of calm, conscious energy. Never again, in our gatherings of artists and poets, did he assume the doctoral or professorial tone of this first day. He had understood.'

On a Gauguin who had just spent several months in Brittany, holding forth to a small group on matters largely professional in nature, this contact with Parisian literary circles had a salutary effect. Their agreement and encouragement were necessary to him, but so was their criticism, to force him to express his views with greater precision. Although Gauguin did not take the theories of the literary *avant-garde* any too seriously, he was delighted to find himself hailed as 'the leader of Symbolism in painting'.[196]

In another café, the Voltaire, in the Place de l'Odéon, Gauguin met Verlaine, now a valetudinarian, Alfred Vallette, editor of the *Mercure de France*, and his wife Rachilde, celebrated for her beauty, Henry de Régnier, Edouard Dujardin, Maurice Barrès and Louis Brouillon, who was later to write, under the pseudonym J. Rotonchamp, a well-documented study of Gauguin (1906). There, too, he met the young poet Paul Fort – the future brother-in-law of Bernard – who had just become director of the Théâtre d'Art, founded to oppose the naturalism of the Théâtre Libre of Antoine.

It was Morice who took Gauguin to meet Mallarmé at the latter's house in the rue de Rome. It would appear that the painter and the poet at once became excellent friends. Gauguin took part in the gatherings held in the rue de Rome every Tuesday evening, and did a portrait etching of Mallarmé.[197] At the time, Gauguin was concentrating hard on his project to get to the South Seas and spend a considerable time there. His friends tried to help him, and also Verlaine, by organizing a spectacle at the Théâtre d'Art for their joint benefit. Mallarmé was among those most active on his behalf. He fully understood Gauguin's decision to 'withdraw into solitude', and he persuaded Mirbeau to write an article on 'this rare artist'.[198]

The letter he wrote to Gauguin in February 1891 runs as follows: 'My dear Gauguin, an influenza on which I have just embarked, briefly and uneventfully, as I hope, deprived me of my chance to shake your hand and to look once more, with a farewell in my eyes, at beautiful things which I love.... This winter I have often been musing on the wisdom of your decision. Your hand; all this, not to exact a reply but to tell you that I am always, whether near or far, yours, Stéphane Mallarmé.'[199]

It should be noted that these numerous contacts and friendships, however warm, were to last only a short time; they were confined to the period from November or December 1889 to the end of March 1891. Gauguin set out on 4 April 1891 and was away for almost a year and a half; all his links with the world of the arts, with the exception of one or two individuals, were suspended.

Nevertheless during the ensuing years the Symbolists persistently sought a closer connection between literature (particularly poetry) and painting, as this passage, written by Morice in 1893, eloquently illustrates: 'Two artistic events of the highest significance have just occurred – simultaneously, harmonically: the presentation of Ibsen's *An Enemy of the People* took place on the same day as the opening of the exhibition of paintings and sculptures by Paul Gauguin, which the artist has brought back from Tahiti. At the Théâtre de l'Œuvre and at the Durand-Ruel gallery, it is the same drama which is being performed. In a dramatic form which is novel in its simplicity, in new territory – new to us at least – Ibsen shows us a man suffering for the truth. Gauguin is at once hero and author of an entirely similar tragedy. To express his personal artistic truth, he has elected a country, a décor and a people unknown to our Western world; and in this chosen atmosphere the artist has spoken freely, with the natural splendour of his dream of beauty.'

Contact between Bernard and the literary world of Paris went the same way: it ceased automatically in 1893, when he went to the Far East for a stay of seven years. Filiger, it is true, maintained his connections with the society of the Rose-Croix and *L'Ymagier* (La Rochefoucauld, Peladan, Gourmont), and with Jarry, but as he lived in Brittany these relations were confined to correspondence. The dialogue aiming at the integration of the arts was carried on henceforward by Denis and Sérusier, but as representatives of the Nabis rather than of Pont-Aven. Despite having at one time taken up, for its own ends, certain ideas originated by Pont-Aven, the Nabi group was to embrace a different programme and aesthetic from those occupying us here; it therefore passes out of our purview.

To return to Gauguin and his school, it is relevant to inquire what were the convergences and divergences between Symbolism in poetry and Syntheticism in painting. The common ground seems to lie mainly in their similar approach to philosophy, music, religion, the primitive and the archaic. This amounts to a common outlook: a rejection of the rational, scientific interpretation of the world, the interpretation which

Gauguin stigmatized as 'working around the eye'; other expressions of his were 'to fall into scientific reasons' and 'the abominable error of Naturalism.'[200]

But it may be observed that the painters understood this anti-rationalism in a completely different sense from the poets. It is true that Bernard and Sérusier repeatedly quoted the dictum of Mallarmé, 'suggest instead of saying', but he and they meant different things by it.[201] To the constellation of artists around Gauguin, the meaning was: do not describe the object but, rather, interpret its spirit and essence so clearly that the picture will act on the spectator even more strongly than does the object itself: 'In order to discover the thought inherent in the thing seen, and extract it, they demolish, simplify, synthesize, they remove everything which might come between themselves and a clear view of the object, they deform, that is to say they correct, everything tending to deceive them about the reality of the object.'[202]

Similar references to the 'essence' and 'spirit' of the object are not found among the Symbolist poets. The painters' intention is to explain natural realities; the poets', to envelop them in mystery. To the painters, form is a servant; to the poets, it is a queen, and the function of the Word is to convey sounds, not to convey sense.

In this context, Hofstätter propounds an interesting thesis according to which pictorial Syntheticism finds its counterpart in the poem 'L'Albatros', by Baudelaire, whereas the visual parallel to poetic Symbolism is abstract painting, in which form and colour play the same liberating role as language does in poetry. 'No colour, only the nuance', Verlaine used to say. The only colour admitted by Mallarmé is white; he speaks of snow, lilies, frozen lakes, mysterious white leaves. The painters, on the other hand, admit only strong, frank, intransigent colours, and utterly reject nuances.[203] Séguin wrote that the symbolism of colours was a frequent subject of discussion at Pont-Aven; and Gauguin, that fanatical champion of pure, bold colour – whose virtues he extolled in his famous discourse in the Bois d'Amour – wrote to Schuffenecker in 1885 that in painting there was not only a graphology of lines but a symbolism of colours: 'There are tones which are noble and others which are common, harmonies which are tranquil and consoling and others whose boldness excites you.'

It would be impossible to deal exhaustively here with all the aspects of the mutual affinities and influences between Symbolist poetry and the painting of the Pont-Aven group. It seems, however, that in the existing literature there has been a tendency to overestimate the part played by writers and poets in the development of Symbolism in painting. Commentators have been over-zealous, transferring to the part certain doctrinal exchanges which in fact occurred later. In other words, what the poets identified, *ex post facto*, as Symbolist painting was the creation of Pont-Aven and had, moreover, emerged well before the two groups – painters and poets – came together in Paris. The encounter, in fact, surprised both parties by disclosing that their aesthetic views were similar.

It is even permissible to go further, and assert that the

mission of inspiring the other side with a new creative impetus and poetic vision fell to the painters, without their undergoing any corresponding 'literary' influence in exchange. As we have seen, Jarry, in 1894, wrote three Symbolist poems inspired by Gauguin's pictures and dedicated them '*D'après et pour Paul Gauguin, Souvenir de novembre 93*'.[204] Some outstandingly beautiful pages of poetic prose were to link for ever the name of Jarry to that of Filiger; Mirbeau and Morice to Gauguin; Apollinaire to Chamaillard; and Przesmycki and Kasprowicz to Slewinski. In all these cases, writing was born of painting, not painting of writing.

In this whole connection, it is worth while to recall yet again the personality of the most eminent representative of all the literary critics and art critics involved. This was Albert Aurier,[205] who, with Morice, was the first to lay the theoretical foundations of Gauguin's style and of Syntheticism itself, or (as Aurier called it) Symbolism, in painting.

Aurier sets out from the principle that the beauty of a work of art cannot be reduced to abstract aesthetic norms, but is determined by the psychic and affective state which the work in question is capable of arousing in the spectator. A work is beautiful to the extent that it reflects a spiritual truth, not by virtue of being correct or accurate. This essentially subjectivist view bears some relation to the theory of Plotinus, according to whom beauty is not an attribute of the object, considered as an external element, but, on the contrary, constitutes the essence of the object and is at the same time the reflection of an idea.[206]

Aurier had doubtless recognized Gauguin as the spiritual (and pictorial) heir to the philosophy of Plotinus – and also to the doctrines of Swedenborg. His long exposition takes as its point of departure Gauguin's picture *Vision after the Sermon*; one might even conclude, indeed, that Aurier's theory was created solely with this composition in mind. To demonstrate that Gauguin really is 'the initiator of a new art' and 'a sublime seer', Aurier, in 1891, analyses this art from the point of view of a general aesthetic.

The essentials of this aesthetic, and this art, are as follows. In the history of art there are two opposite tendencies: the realistic and the 'ideistic'. The former springs from blindness, the latter from clairvoyant lucidity, the faculty peculiar to the 'inner eye' described by Swedenborg. 'Therefore', Aurier goes on to say, 'to sum up and come at last to a conclusion, logically the work of art, as I elect to conceive it, will be:

'1. *Ideistic,* because its only ideal will be to express the Idea;
'2. *Symbolist,* because it will express this Idea through forms;
'3. *Synthetic,* because its mode of understanding is general, and these forms, these signs, will be inscribed in accordance with that mode;
'4. *Subjective,* because it will never consider the object as an object but always as the sign of an idea, perceived by the subject (the artist);
'5. (This is a consequence from the foregoing): *Decorative,*

because decorative painting properly so called, as it was understood by the Egyptians, and very probably the Greeks and the Primitives, was nothing if not the manifestation of an art at once subjective, synthetic, symbolical and ideistic.'

According to this *summa aesthetica*, the only true painting is decorative, because it 'was created, and could have been so, only in order to decorate with thoughts, dreams and ideas the commonplace walls of human buildings'. An easel-painting is nothing but a perfidious, illogical invention whose purpose is to satisfy the whims and commercial instincts of decadent civilizations. The first ventures in the plastic realm in primitive societies were, of necessity, decorative.

Aurier regards Gauguin as an essentially decorative painter who cannot confine himself to the cramped limits of the easel-picture and whose indomitable, soaring imagination breaks them apart. And he brings his absorbing study of Gauguin to a close with an oratorical passage at arms in which he invites the Establishment – '*ces messieurs de l'Institut*', the dispensers of official patronage – to entrust that painter with commissions for large mural decorations: 'Ah, gentlemen, how posterity will curse you, deride you, spit on you, if ever the day dawns when artistic perception shall have woken from its sleep in the mind of humanity! Come now, show just a little sense, you have a decorator of genius among you: walls, walls – give him walls!'

Aurier, at this point, has brought up a problem of essential significance for the aesthetic not only of Gauguin himself but of the Breton group as such. What is at issue is the form to be taken by monumental painting in a modern context. 'Decorate', 'decoration', 'co-operating with architecture' – discussions involving such words as these occurred frequently at Pont-Aven, and the aim cherished by all was to raise the useful, applied arts to the dignity of great art. And in fact, though '*ces messieurs de l'Institut*' failed to respond to Aurier's clarion call, Gauguin and the others in Brittany succeeded in finding other walls, if less imposing ones, as vehicles for monumental composition. As early as 1887, Bernard executed murals at the inn in Saint-Briac; the frescoes in the dining-room at Marie Poupée's inn were the result of a collective effort, like that of which Van Gogh had hopefully dreamed when preparing his 'Studio of the South' for his colleagues from Pont-Aven. Most of Filiger's works are projects for murals, mosaics or stained glass. Verkade painted frescoes at Prague, Jerusalem, Monte Cassino and Vienna; Sérusier painted one in the church at Châteauneuf and another in his own house, and was always saying 'Don't talk to me of pictures, there are only decorations.'[207]

The Nabis did not fail to appropriate these ambitious ideas for their own purposes. The work of Sérusier, Denis, Vuillard, Bonnard and Ranson, in the Théâtre d'Art of Paul Fort, the Théâtre de l'Œuvre of Lugné-Poë, and the Comédie des Champs-Elysées, springs directly, though with slight modifications, from the principles proclaimed with such sonorous vehemence by the artists of Pont-Aven.

Conclusion

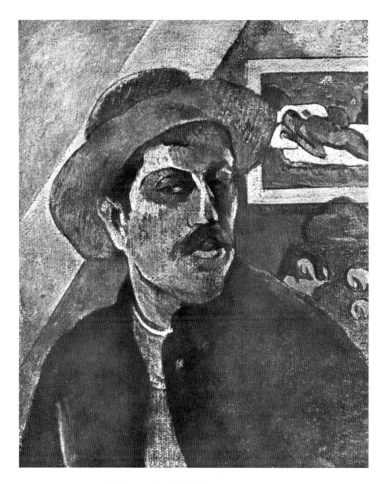

PAUL GAUGUIN *Self-portrait with Hat*

To determine the place occupied by the Pont-Aven School in the history of art, let us begin by glancing at the attitude adopted by Gauguin and his group towards the situation they found confronting them at the outset of their period of activity. Their collective intention was to break with everything then in force: academicism, official art, on the one hand; Impressionism on the other. This did not, however, mean a break with tradition. Gauguin never ceased declaring his admiration for the Egyptians, the Japanese, Raphael, Ingres and Puvis de Chavannes; and Bernard, when his Breton phase ended, turned for inspiration to the Italian Primitives. They all admired Delacroix and regarded Cézanne as their precursor. The name chosen by Denis for the movement as a whole was *Néo-Traditionnisme*.

Their graphic conceptions were based on conscious thought; there were theoretical foundations for everything they did in practice. It may be assumed that their determination to work in a group was due in particular to their desire to discuss work in progress, and to collaborate on a jointly accepted programme. On this point, Rookmaaker asserts that the Pont-Aven painters, despite their passionate keenness for discussion, were not in the least concerned to work out an aesthetic system, something they regarded as having no importance. They were mainly interested in the usual problems of the working painter: the preparation of canvases, nicety in the selection of which brush to use for what, and, on a slightly less homely level, how to mix a certain tint and what juxtapositions were most harmonious. This assertion gains a good deal of plausibility from the fact that the Pont-Aven painters often made fun of 'Symbolism', 'Syntheticism' and other words of the kind.

While conceding that Rookmaaker is right in saying that the Breton artists had no desire to create an aesthetic system, we can equally well assert that they did create one, and a fairly definite one at that. Surely a technical programme, which includes a definition of one's artistic aims, comes to the same thing as an aesthetic system?

The question arises whether the Breton painters succeeded in realizing, with synthesis as their guide and instrument, their ambition to express 'the truth about oneself', and to lead the spectator's glance 'through the object', to make the object proclaim an 'eternal idea'? Certainly they did. But they were wrong in claiming any exclusive merit for having done so, since these are simply the aims of art: all art.

The Pont-Aven School occupies a special place in the history of art. It is not enough to say that it set up a new idea in opposition to the existing situation, and that that idea was based on synthesis, or was intended to replace painting from nature with painting from imagination. The revolutionary activity of Pont-Aven consisted of abolishing the whole set of existing artistic conventions and clearing the way towards new pictorial possibilities, which these artists themselves either had not

time, or were denied the opportunity, to put into execution. Hence the freshness and the lasting immediacy of their ideas, which are still far from having been exhausted.

A further remarkable quality of the Pont-Aven School is that, although it was engaged in realizing a most ambitious collective programme, every individual member of it was able to express himself in accordance with his own principles. It is therefore wrong to look at the work of any one member simply as resembling more or less closely the manner of Gauguin, or of Bernard, and to use this as a yardstick for estimating his contribution to the Pont-Aven experiment. For what constitutes the strength of any circle of artists is, precisely, variety in unity. The Pont-Aven group, wrote Sérusier, 'was not, as might have been thought, a school consisting of a master surrounded by pupils. Its members were individuals who contributed their own ideas, and in particular their hostility to the official teaching, to the common stock.'[208]

The spirit in which the Breton group operated thus rendered possible – as an achievement parallel to the solving of the central problem, that of creating Syntheticism – the development and interpenetration of all the aesthetic trends of the period, in which the Pont-Aven School was an active influence on several planes at once. Thus Sérusier, Denis and Verkade personified the alliance of Pont-Aven and the Nabis, whose founder was Sérusier and who were closer than any other group to Pont-Aven. The engravings of Séguin recall the explorations carried on by Art Nouveau in France, Germany and England. Filiger, Bernard and Denis represented religious painting, which was among the work exhibited in the *salons* of the Rose-Croix. Slewinski, who took the good news from Pont-Aven to Poland, exerted a great influence on the young Polish painters. Finally, Verkade won the Danish public, with the notable inclusion of the poet and philosopher Joergensen, to the cause both of Pont-Aven and of his own painting.

A window had been opened on to the twentieth century. Before modern art had even begun to appear, the trail it was to travel had been blazed. The lesson of Pont-Aven was to profit the Fauves and their lineage, and Gauguin's little lecture in the Bois d'Amour concerning pure colours was to benefit Matisse and Derain rather than Sérusier and Denis. As for Anquetin's experiments in using areas of a single colour, echoes of them were to resound in the work of Henry van de Velde and even in the Picasso of the Pink and Blue Periods. The modern symbolism of colour, so ardently discussed at Pont-Aven, and the problem of suggestive colour, which preoccupied Anquetin, Bernard, Gauguin and Van Gogh – this whole nexus was taken over and utilized by the German school of Expressionism in pursuit of its own purposes. Finally, we have what may be called the most formidable *coup d'Etat* in the history of art, that associated with Kandinsky, Mondrian and Malevitch; what is this if not the outcome of that decorative autonomy of form and of the picture-surface, which latter, according to Denis, 'is essentially a flat surface covered with colours assembled in a certain order'?

How much more prophetic even than this, to us today, are the words written by Gauguin himself not long before his death – when, exhausted by illness, in his little house at Atuana with its decorative carvings, he recorded his final wishes for the guidance of future generations of artists: 'What we had to do, therefore, while not forgetting all the efforts and researches already made, including even the contributions of science, was to think of complete liberation – breaking all the windows, even at the risk of cutting one's fingers – so as to leave the next generation independent, unfettered, free to apply its genius and solve the problem. I do not say *definitively*, for what we are concerned with is precisely an art that is endless, rich in technique of every kind, fitted to express every emotion of nature and man, able to identify itself with the joys and sufferings of every individual, in every epoch. To this end we had to throw ourselves body and soul into the struggle; to fight against all the Schools (all, without distinction), not in the least by denigrating them, but by doing something different; to challenge not only official art but the Impressionists and the Neo-Impressionists; the old public and the new. It meant no longer having a wife and children to be disowned by. What do insults matter? What does poverty matter? All this as a mode of conduct, one of the possible ways a man can live. And work. A method – the method of contradiction, if you like. One must be prepared to embark on the most radical abstractions, do everything that was forbidden, and reconstruct more or less felicitously, without fear of exaggeration – even, indeed, exaggerating on purpose. One must learn afresh and then, having got the answer, learn more still; conquer all one's timidities, never mind what ridicule may be one's reward. The painter at his easel is the slave neither of the past nor of the present; neither of nature nor of his neighbour. There is only himself, and again himself, always himself.'[209]

At this distance of time, the revolutionary aspect of these declarations may look comparatively small: today, we are in a position to see how difficult it was for these creative figures to tear themselves free from the all-powerful Naturalism which held them from every side. Denis described their struggle in summary fashion – 'they spread hostility towards Naturalism'. This is true, but it is important to remember that they were concerned to defy Naturalism without denying nature. The liberty they demanded was bound to be limited, because there existed as yet no painting outside the confines of representation. Their revolt was aimed against photographic interpretation, against the slavish reproduction and blind imitation of nature. They wanted to express not so much nature as themselves; to represent both their own states of soul, and the essence of the objects painted, by means of magical lines and colours; but still, as yet, figuratively.

Another twenty years had to pass before line and colour underwent the total liberation that granted them an inherent life of their own, independently of the object, a life heralding the appearance of an abstract art. But there is no doubt that, without the generation who claimed for themselves the 'right to dare everything', abstract art would never have seen the light of day.

Notes

CHAPTER I

1 The grandchildren of Marie-Jeanne Gloanec have changed their name to Le Glouannec. The house which was formerly the inn still exists; there is a bookshop in it now. In August 1936 a plaque was put up on the outside to commemorate the time spent there by Gauguin and his friends.

2 E. Bernard, *L'Aventure de ma vie*, 1954, p. 13. See also C. Chassé's interview with the painter Henri Delavallée, who is stated to have known Gauguin and Laval at the Pension Gloanec in 1886 and to have seen a great deal of them (in *L'Amour de l'Art*, April 1938).

3 E. Bernard writes: 'On getting back to Paris I visit Cormon's studio. An artist is painting there, furiously. His work is by no means that of an Impressionist, but it is very strange and impetuous. He transforms the studio into a drawing-room surrounding his model, turning the coarse drapes which serve him as a background into luxurious hangings. He is Vincent van Gogh.' 'Notes sur l'Ecole dite de Pont-Aven', in *Mercure de France*, December 1903, p. 677.

4 S. Lövgren, analysing this copy and the original by Bernard, concludes that the former is superior: *The Genesis of Modernism*, 1959, p. 103.

5 Albert Aurier was the first to analyse the *Vision after the Sermon*; his poetic account of it forms part of the introduction to his study, 'Le Symbolisme en peinture', in *Mercure de France*, 1891, p. 155. Describing it as a master-work of the modern painting which is erecting a barrier in the path of Naturalism and Impressionism, he says that the *Vision* satisfies all the imperatives of a true work of art because it is '*idéiste, symboliste, synthé-tique, subjective, décorative*'. See p. 238 of this book.

6 Collection Mlle Henriette Boutaric, Paris.

7 S. Lövgren, p. 103, emphasizes, not without reason, that this canvas by Bernard resembles a series of highly-developed sketches executed on drawing paper; it lacks emotional depth and is entirely concentrated on the folklore aspect.

8 See Madeleine's letter, published by J. Rewald, in which she seeks to reassure her brother (evidently exasperated), by advising him to pay no attention to people 'avid for self-advertisement and popularity' and to pursue his work as an 'apostle of the good and the beautiful': 'publish your teachings and admiration will grow'. *Post-Impressionism*, 1956, p. 334.

9 Replying to R. Maurice, who urged him to record his memories of Pont-Aven, E. Bernard wrote: 'Above all, I do ask not to be classed as one of Gauguin's pupils. I was never his pupil, and it was my personality of that period that acted on his, which was still unformed.' *Souvenirs inédits*, p. 5.

10 F. Fénéon implies this in his article, 'Autre groupe impressionniste', 1889 (*Œuvres*, 1948, p. 179).

11 *Racontars de rapin* was finished in August 1902 at Atuana; the MS was not published in its entirety until 1951. Rotonchamp, in his monograph on Gauguin (1906), published only a third of it but claimed he had reproduced the whole. This caused complete publication to be delayed for half a century.

The cover of *Cahier pour Aline* is decorated with the stylized head of a Polynesian woman and is dated 1893. The first page carries a dedication: 'This notebook is dedicated to my daughter Aline. Random notes, disconnected like dreams and as fragmentary as life itself.' Long extracts from it are quoted by J. Dorsenne in *La Vie sentimentale de Paul Gauguin*, 1927. Aline never saw this notebook: she died before her father's return to France.

12 By 'the three of us', Bernard means Gauguin, Laval and himself.

13 See R. Huyghe, 'Gauguin, créateur de la peinture moderne'. Introduction to exhibition catalogue, 'Gauguin. Exposition du centenaire', Orangerie, Paris 1949, p. XX.

14 Letter to Bernard, November 1888. Malingue 1948, p. 150. An extract from this letter will be found on p. 234 of the present volume.

15 In November 1889, Bernard sent Gauguin photographs of two pictures, one of which was *The Agony in the Garden*. Gauguin's letter in reply praises this canvas, whose imaginative style he finds 'really stunning' ('*tout à fait épatant*'). He adds: 'One notices the head of a Judas who, in the photograph, looks vaguely like myself. Don't worry, I don't see any harm in that.' Letter to Bernard, November 1889. P. Gauguin 1946, p.178.

16 M. Denis, *Mercure de France*, January 1904, p. 286.

17 P. Sérusier, *ABC de la peinture, suivi d'une étude sur la vie et l'œuvre de Paul Sérusier par Maurice Denis*, Paris 1942, p. 58. The book was first published in 1921 (Editions Floury) thanks to financial help from Emmanuel de Thubert. In the next edition (1942), Sérusier's text was preceded by a detailed study by M. Denis, 'Paul Sérusier, sa vie et son œuvre'. The third edition (1950) contains letters collected by the painter's widow and annotated by Henriette Boutaric, who was due to inherit from Sérusier after her. In further references, these editions will be designated by their dates.

18 'Petite Contribution à l'histoire d'un grand peintre'. Letter from Chamaillard to Morice, *Mercure de France*, April 1906, p. 637. The letter is signed by 'A very humble pupil of Gauguin, E. de Chamaillard', with this comment from its recipient: 'In a later letter, M. de Chamaillard adds: "I saw Moret last night; he formally confirmed the information I have given you about Gauguin and Bernard and their relations at Pont-Aven in 1888. He also authorizes me to say that he will always be willing to give us his testimony if we want it."'

19 Letter from Gauguin to Bernard, July 1890. P. Gauguin 1946, p. 197. Later, Gauguin was to express less favourable judgments on Bernard, including those in *Cahier pour Aline*, and the following, which occurs in a letter of 1902 to Fontainas: 'After he had acknowledged to Van Gogh, to all who were in Brittany, and to me, in a letter which I have carefully kept – after he had acknowledged that he had drunk at my spring, he took it upon himself, in my absence, to publish a statement that I had appropriated all his researches.'

In a letter of June 1899 to Denis, Gauguin had written: 'In answer to your letter, I am sorry not to be able to say yes. Certainly it will be interesting, after an interval of ten years, to see an exhibition of the painters who appeared as a group at the Café Volpini, and, with them, all the young ones I admire, but my personality of ten years ago is of no interest today. At that time I wanted to dare everything, in some sort to *liberate* the new generation, and then to work to acquire a little talent. The first part of my programme has borne its fruit, today you can dare anything, and what's more, no one's astonished when you do. The second part, alas, has not gone so fortunately. Besides, I'm an old simpleton, the pupil of many of the painters in your exhibition; *in my absence* this would become only too clear. Much has been written on this subject, and everyone knows how

much I have stolen from my master, Emile Bernard; so much of his painting and sculpture, that (he himself has said it in print) there was nothing left for himself! Don't imagine that the thirty-odd canvases I *gave* to him, and which he sold to Vollard, were really by me: in all of them I was abominably plagiarizing Bernard.' Malingue 1948, p. 290. (The MS, shown at the exhibition 'Maurice Denis', Orangerie 1970, belongs to the family of M. Denis.)

20 R. Goldwater, *Paul Gauguin*, 1938. Goldwater adds, 'If things had been otherwise, would their meeting have been so fateful and so fruitful?'

21 For Gauguin's opinions on Syntheticism before he met Bernard, see R. Huyghe, *Le Carnet de Paul Gauguin*, 1952.

CHAPTER II

22 I was in correspondence with Dr Palaux shortly before his death, and he gave me much valuable information. In accordance with his wishes, I have had access to all the material in his possession.

23 From Tahiti, Gauguin wrote to Sérusier: 'Oh, if only I could still knock off a *trompe-l'œil* picture, as the Americans do, I might manage to sell a few canvases at good prices, but I am, and can do, what you know I am, and can do.' Sérusier, *ABC de la peinture*, 1950, p. 54.

24 E. Bernard, *L'Aventure de ma vie*, p. 30.

25 Letter to Emile Bernard, April 1890, Malingue 1948, p. 189.
A few months earlier, he had written to Bernard: 'Laval has gone to Paris and now wants to move to some different region (where, perhaps, he'll work?). Anyway, it's six months since he touched a brush.' P. Gauguin 1946, p. 169.

26 The *Still-life* by Gauguin 'signed' *Madeleine Bernard*: see G. Wildenstein, *Paul Gauguin, Catalogue*, 290 (private collection, France).

27 Gauguin to Madelaine Bernard, P. Gauguin 1946, p. 180. The vase representing Gauguin's head, the one which figures in the *Still-life with Japanese Print* (Ittleson collection, New York), is in the Museum of Decorative Arts, Copenhagen.

28 Gauguin was not pleased with this portrait. He told Monfreid about it: 'I've received (by post from Schuff) *Les Hommes du jour* [*sic*], which includes an absurd portrait of me by Schuff. That chap makes me tired, he makes my hair stand on end, what an ass, what pretentiousness! A cross and some flames, and pop! there you are, that's symbolism.' Gauguin 1950, p. 104.

29 'O the magic of genius! Contact with Gauguin has a cutting edge, it wounds you, but you treasure your wound as much as you curse it.' Introduction, catalogue of the exhibition 'Gauguin et ses amis' Paris 1951; see also the article on Schuffenecker by E. Deverin.

CHAPTER III

30 J. Rewald, *Post-Impressionism*, 1956, p. 156.

31 Paul Gauguin, 'Natures mortes', in *Essais d'Art Libre*, 1894, no. 24.

32 M. Denis, 'Paul Sérusier. Sa vie, son œuvre', in P. Sérusier, *ABC de la peinture*, 1942; see also

M. Denis, *Théories*, p. 161.

33 Undated letter from Vincent van Gogh to his brother, *Correspondance complète*, vol. III, pp. 387 and 402.

34 V. van Gogh to his brother, Arles, 1888, *Correspondance complète*, vol. III, p. 273.

CHAPTER IV

35 This means Theo, to whom Gauguin had entrusted his pictures.

36 J. Rewald, *Post-Impressionism*, 1956, p. 169.

37 E. Bernard, *Souvenirs inédits...*, 1939, p. 14.

38 The poster was exhibited at Le Bateau Lavoir in 1958. See the catalogue of the exhibition *Dessins symbolistes*, preface-manifesto by André Breton.

39 The picture was probably sent to the 'Exposition des Vingt', in Belgium.

40 E. Bernard to Aurier. J. Rewald, *Post-Impressionism*, 1956, p. 170.

41 J. Antoine, 'Impressionnistes et Synthétistes', in *Art et Critique*, 1889, 9 XI, p. 370. 'A watercolour, entitled *Eve*, represents a nude woman crouching at the bottom of a tree, which is equipped with a serpent; under this, I read: "No listen he – he liar." On what information does M. Gauguin base his supposition that Eve spoke pidgin?' Gauguin's retort, in a letter to Bernard, is equally sarcastic: 'It appears Eve didn't speak pidgin, but in Heaven's name what language did she speak, her and the Serpent?' P. Gauguin 1948, p. 172.

42 According to the catalogue, the album of lithographs by Gauguin and Bernard formed part of the exhibition and could be seen on request.

43 V. van Gogh wrote to Théo in 1888: 'It seems that in the *Revue Indépendante* there has appeared an article on Anquetin, in which he is said to be the leader of a new tendency with an even stronger leaning towards *japonaiserie*, and so on. I haven't read it, but in any case the leader of the Petit Boulevard is undoubtedly Seurat, and little Bernard has perhaps carried *japonaiserie* to a greater length than Anquetin.' *Correspondance complète*, vol. III, p. 100.

44 This refers to Theo, who was opposed to the exhibition.

45 'The critics, at this period, were accusing us of deliberately going back to baby-talk. We were indeed returning to childhood, playing stupid, which was undoubtedly the most intelligent thing to do at the time. The movement of 1890 proceeded at once from a state of extreme decadence and a ferment of renewal. It was the moment at which the swimmer, diving deep down, touches bottom and comes up.' M. Denis, *Théories*, 1912, p. 255.

46 M. Denis, in P. Sérusier, *ABC de la peinture*, 1942, p. 46; C. Chassé, *Gauguin et le Groupe de Pont-Aven*, 1921, p. 22.

CHAPTER V

47 From 1820 to 1870 a review was published in France under the title *Voyages pittoresques et romantiques dans l'ancienne France*, edited by Nodier, Taylor and Cailleux, whose ambition was to record the history of various French provinces and

pay tribute to their architecture and natural beauty.

48 Michelet visited Brittany in 1831. Describing the provinces of France, he gives the preference to Brittany (Introduction to vol. II of his *Histoire de France*). See J. Levron, 'Michelet en Bretagne', in *Nouvelle Revue de Bretagne*, 1947, no. 6. The first of Balzac's visits to Brittany took place in 1828. He stayed at Fougères and gathered material for *Les Chouans*. Stendhal was in Brittany in 1838: *Œuvres complètes. Mémoires d'un touriste*, vol. II, 1952, p. 33. Hugo visited Brittany several times in the 1830s: *Œuvres posthumes. En voyage – France, Belgique*, n.d., p. 47. Maxime du Camp and Flaubert travelled in Brittany together; Flaubert took notes which they intended to use in their joint work, *La Bretagne*. Flaubert also wrote his own account, *Par les champs et par les grèves*, 1827. See also Le Herpeux, 'Flaubert et son voyage en Bretagne', in *Annales de Bretagne*, no. 47, 1940. Aurier spent his summer holiday in 1887 at Saint-Enogat, in Brittany, with his mother and sister. See E. Bernard, *L'Aventure de ma vie*, p. 15.

49 See O. Mirbeau, 'Gauguin', in *Echo de Paris*, February 1891; J. Leymarie, *Paul Gauguin. Aquarelles, pastels et dessins en couleurs*, Phœbus, 1960, p. 10 and pl. X (watercolour version of the *Yellow Christ*); F. Dauchot, 'Le Christ jaune de Gauguin', in *Gazette des Beaux-Arts*, July–August 1954.

50 It should be added that at this time the painters used to leave Le Pouldu for Pont-Aven and stay there for some time.

51 *Si le grain ne meurt*, 1966, p. 195. Recording his memories many years after the event, Gide was wrong in giving 1888 as the date of his adventure in Brittany; it should have been 1889.

52 According to Dr Palaux, 'this amiable landlady at Les Grands-Sables, whose name is permanently linked with Gauguin's group, was born at Moëlan-sur-Mer. After having been a servant for a few years at Quimperlé she took a job in Paris. Returning to the district of her birth about 1886, with a little money saved up, she rented this hospitable inn near the beach at Les Grands-Sables.

Three months before the arrival of Gauguin and De Haan, Marie Henry had given birth to a daughter; the birth was registered at the *mairie* of Clohars-Carnoët on 4 March 1889, and the child was christened on 25 March of the same year. On 7 June 1891 a second daughter was born; according to the mother, the father was De Haan (C. Chassé, *Gauguin et son temps*, 1955). The christening took place on 8 June. In 1893 she was succeeded at the inn by Mlle Rose Trévières, and bought a villa at Biribi, near Kerfany, at Moëlan-sur-Mer. She lived there for several years with a teacher of philosophy called Mothéré.

She provided her daughters with a good education, putting them into a boarding school in Quimperlé. Both became teachers. Marie-Léa married a sailor, M. Louis Ollichon, on 8 January 1919; and in the following year Marie-Ida became the wife of a headmaster, M. Louis Cochennec, of Rosporden. Mme Ollichon moved her mother to Toulon, where she died during the last war.

The foregoing facts were confirmed and supplemented by Mme Cochennec when I visited her on 2 April 1959. They are all the more valuable in that they enable us to correct several inaccuracies in the literature on Gauguin:

(1) Before entering service, Marie Henry was a schoolgirl in an Ursuline convent. After the death of her father, a butcher at Moëlan, her education was broken off because her irresponsible guardian squandered her entire inheritance and she could no longer pay her school bills. This puts paid to the legend that Marie Henry was illiterate.

(2) Contrary to what is stated in most of the literature, the portrait of a woman which was painted by Gauguin does not represent Marie Henry. Nor does the similar portrait painted by Sérusier. In both, the sitter is undoubtedly Marie Legadu. There is, in fact, no portrait of Marie Henry except De Haan's picture *Motherhood: Marie Henry Suckling her Child* (Samuel Josefowitz collection).

(3) Ida Cochennec knew she was De Haan's natural daughter.

(4) Henri Mothéré was not Marie Henry's husband, but lived with her for several years. He looked after her children and took notes of her reminiscences. His MS is in the possession of Mme Cochennec, who kindly allowed me to make use of it.

53 The painting on the ceiling was of a woman with bare arms, seen from the back. An amorous swan (or perhaps goose) twines its neck round her. The same subject is used in a drawing (intended as a design for painting a plate) which is accompanied by the inscription 'Homis [sic] soit qui mal y pense' (the pun is Gauguin's).

54 This canvas (Narodni Galerie, Prague) was presumably inspired by the picture *Bonjour Monsieur Courbet*, which Gauguin and Van Gogh had seen at Montpellier.

55 H. Mothéré, MS already quoted (note 52). Cf. C. Chassé, *Gauguin et son temps*, 1955, p. 73.

56 Reproduced in J. Rewald, *Post-Impressionism*, 1956, p. 296; see C. Chassé, *Gauguin et son temps*, p. 79. Chassé got the opportunity of seeing the wall in 1924, after the layers of wallpaper had been removed and the paintings revealed.

57 The painting by De Haan is in Luxembourg (the city, not the museum in Paris); the *Joan of Arc* is owned by Abraham Rattner, New York; and a sketch of Filiger's *St John* is in the Galerie Le Bateau-Lavoir, Paris.

58 Gauguin, in Tahiti, wrote to Sérusier in November 1891: 'It was a good idea of mine to bring a mandoline and some music out with me, it's a first-rate relaxation for me. It was Filiger who put it into my head to take up this instrument. I think I can now beat Filiger all ends up, as a virtuoso.' P. Sérusier, *ABC de la peinture*, 1950, p. 55; also C. Chassé, *Gauguin et son temps*, 1955, p. 70.

59 Sérusier, in 1920, wrote to Chassé: 'The article by Séguin, in *L'Occident*, is full of inaccuracies, because the author has deliberately confused the two periods, before Tahiti and after.' P. Sérusier, *ABC de la peinture*, 1950, p. 154.

60 This information was given to me by

M. Louis Le Ray, who sat for this portrait as a little boy: Wildenstein, *Gauguin, Catalogue*, 388.

CHAPTER VI

61 *Correspondance complète*, III, p. 259. There is a picture by De Haan with the title *View of Paris from Theo van Gogh's window, in the rue Lepic*. The same subject was painted by Vincent when he was staying in Paris with Theo; see La Faille, *Vincent van Gogh*, 1939, p. 289.

62 It will be recalled that on hearing that an exhibition was to be put on in Volpini's premises, Gauguin wrote to Schuffenecker: 'For my part, I decline to exhibit with the *others*, Pissarro, Seurat, etc. It's our group!' P. Gauguin 1946, p. 153.

63 De Haan began his training in the studio of P. F. Greive, of whom he did a portrait (private collection, Holland). See the catalogue of De Haan's pictures, and the bibliography, in Jaworska, 'Jacob Meyer de Haan', in *Nederlands Kunsthistorisch Jaarboek*, 1967, no. 18.

64 In his study of 1962, Y. Dautier shows paired diagrams based on certain pictures by painters of the Breton group; one diagram gives the geometrical structure, the other member of the pair maps the zones of cold and warm colours and brings out their interplay. A typescript of this study was obligingly passed to me, with the author's consent, by his professor, M. André Mussat.

65 The catalogue of the sale at the Hôtel Drouot calls attention to this: 'It is not impossible that this work represents a collaboration.' Sale of 16 March 1959, p. 22, no. 164. Controversy also surrounds the paternity of *Landscape at Le Pouldu – Kerluben*, painted in 1890. There are two theories: Malingue says the picture is by Gauguin, others attribute it to De Haan and claim that Gauguin's signature was added later. See the catalogue of the exhibition 'Gauguin et ses amis', Pont-Aven, 1961, no. 12; also the interview by R. Klein on the subject of that exhibition: 'Professor Savin told us "Three of the Gauguins exhibited at Pont-Aven are fakes."' *Le Télégramme*, Lorient, 6 September 1961. The disputed landscape depicts a view near Le Pouldu which was also painted by Sérusier, Slewinski and Filiger. See Jaworska, 'Sérusier au Musée National de Varsovie', 1961.

66 Exhibition-catalogue, 'Gauguin et ses amis', 1949, no. 61*bis*. This was one of the first pictures by De Haan to be exhibited in Paris, the others being *Coffee-pot with Pears* and *Blue Jug with Four Pears*. See Malingue, 'Du nouveau sur Gauguin', in *L'Œil*, 1959, nos. 55-56.

67 To Sérusier, but to no one else, Gauguin wrote: 'What's happening to Meyer? No news from him. Has the woman managed to get her hooks into him?' P. Sérusier, *ABC de la peinture*, 1950, p. 54.

68 'After dark, they used to drape themselves in white sheets and wander about near the washing-place (*lavoir*) on the road from Clohars-Carnoët, pretending to be ghostly washerwomen, the kind who are supposed to lay malign spells on people passing by. Marie Henry, although born in the vicinity, at Moëlan-sur-Mer, involuntarily shared the bad reputation they got for themselves.'

C. Chassé, *Gauguin et son temps*, 1955, p. 67.

69 Noted verbatim from conversation with Mme Cochennec, Rosporden, 2 April 1959.

70 The mementoes of her mother which are preserved by Mme Cochennec include a pair of clogs decorated with painted flowers and a corset embroidered by Marie Poupée herself, who learnt embroidery at the convent of the Ursulines. Mme Cochennec drew attention to their small size, proving that Marie Poupée had a small foot and a slender waist. Among her mementoes of her father, De Haan, were not only his pictures but the enormous Bible he brought with him from Amsterdam.

71 C. Chassé, *Gauguin et son temps*, 1955, p. 67.

72 The judgment in the action brought by Gauguin against Marie Henry in 1894, at Quimperlé, was that the pictures were her property. See Malingue, 'Du nouveau sur Gauguin', in *L'Œil*, 1959, nos. 55-56, pp. 32-39. In 1911, when Slewinski and his wife visited Marie Henry at Kerfany to see her Gauguins, they found they numbered about twenty, according to Mme Cochennec (Rosporden, 2 April 1959).

73 This carving was exhibited at the Hôtel Drouot in Paris; see catalogue, 'Vente du mercredi 24 juin 1959', and the catalogue of the exhibition 'Gauguin sculpteur et graveur', Paris, Musée du Luxembourg, 1928, no. 8 (illustration).

74 The lithograph *At the Black Rocks*, which had been used as the frontispiece in the catalogue of the Café Volpini exhibition, also appeared on the cover of an album of drawings by Gauguin, *Documents Tahiti 1891–1893*. See also the engraving mounted in his book *Noa-Noa*, p. 186, the picture *Breton Eve* (Wildenstein, *Cat.*, 333 and 334), and the female figure on the far left in the picture *Where do we come from? Who are we? Where are we going?* (Wildenstein, *Cat.*, 561).

75 *Lost Virginity* is in the collection of Walter P. Chrysler, Jr., New York (Wildenstein, *Cat.*, 412).

76 Gauguin, *Two women* or *Flowers in her Hair*, private collection, Paris (Wildenstein, *Cat.*, 626).

77 Somerset Maugham, *The Moon and Sixpence*, London, 1929. In this fictional biography of Gauguin the author also introduces the figure of De Haan.

78 It was Slewinski's cousin, the Polish painter Jozef Chelmonski, already famous at the time, who 'detected his talent' and urged him to go to Paris and study painting (information acquired by the author in conversation with the painter Wanda Poplawska, 17 May 1958, in Warsaw).

79 After Slewinski's death the portrait was bought by Prince Kojiro Matsukata, and is now in the Museum of Modern Art, Tokyo. The question of when it was painted – late 1890 or early 1891 – is studied at length in the author's article 'Gauguin – Slewinski – Makowski', 1957. The Tokyo Museum has accepted 1891 as the correct date, whereas R. Cogniat opts for 1890 (Wildenstein, *Cat.*, 386).

80 Max Voloshin, a hitherto neglected poet, is now attracting marked attention in his own country. Victor Manuilov is preparing an edition of his poems and writing a study of him. Slewinski

painted a portrait of Voloshin about 1902, which is now in the house of the poet at Koktabiel in the Crimea. In a private collection in Brittany I have seen a rather remarkable little landscape signed Max Voloshin (Slewinski estate).

81 We owe this letter to the kindness of Professor Leon Ploszewski.

82 MS, National Library, Warsaw, no. 7140.

83 According to Mme Jadwiga Rybarska, who was a pupil of Slewinski, Gauguin repeated this fairly frequently.

84 The dedication indicates that the picture was painted in the last century, Marie Schevzoff having married the musician Le Grand in 1900. The catalogue of one of Slewinski's exhibitions makes it possible to fix the date more closely, as it includes a *Still-life in the possession of Mlle M.S.*; the exhibition having taken place in spring 1897, it may be assumed that the picture was painted in 1896. This date tallies with the information collected by Czyzewski, whose catalogue, compiled in 1925 with the help of Mme Slewinska, includes the title *Apples on the Tablecloth*, privately owned, Paris (T. Czyzewski, *Wladyslaw Slewinski*, p. 17).

85 Though it is not possible to say definitely that his relations with Van Gogh were close, it is known that Slewinski knew him, and that he was enthusiastic about his talent and possessed several of his drawings. Potocki, in 1904, published in *Sztuka* (Paris) reproductions of drawings by Van Gogh and paintings by Gauguin, all from Slewinski's collection.

86 W. Jaworska, 'Gauguin – Slewinski – Makowski', 1957. In this article I wrote in error that Gauguin's picture on a Tahitian subject, in Slewinski's possession, was called *Fatata te moua* ('At the foot of the hill'); the real title is *Fa'aara* ('Awakening'): Wildenstein, *Cat.*, 575. See B. Danielsson, 'Gauguin's Tahitian Titles', in *Burlington Magazine*, no. 769, 1967. The pastel *Little Breton Girls by the Sea (Piti-Teina)* is a sketch for, or copied from, the picture of the same title now in the Matsukata collection (Wildenstein, *Cat.*, nos. 340 and 341). The picture belonged at one time to Slewinski and is now in a private collection in London. It was on view in the exhibition 'Gauguin and the Pont-Aven Group', Tate Gallery, 1966, no. 53.

87 J. Kleczynski wrote: 'Slewinski's group aims at producing something of lasting value, something which will survive all tendencies and schools and represent imperishable values. The group's members include Slewinski, Jaworski, Mlodzianowski, Rembowski and Zaboklicki... Their intention is to create authentically pictorial works, that is to say, to endow them with an absolute decorative beauty. They banish contingencies, which are the domain of the adherents of realism.... Avoiding the fantastic, they seek to express themselves through an essentially synthetic draughtsmanship, a resolute defining of the forms in nature, bringing out the vigour of those forms; and through a fusion of all these elements, and of an equally synthetic use of colour, into a single, harmonious concord.' *Sfinks*, 1909, 16, p. 153.

88 W. Jaworska, *Gauguin – Slewinski – Makowski*, 1957, p. 177.

89 W. Jaworska, in *Swiat*, 1962, no. 24. Slewinski was made known outside his own country by the exhibition 'Gauguin and the Pont-Aven Group', at the Tate Gallery in 1966, which included fourteen of his pictures. See my 'The problems of Pont-Aven', in *Apollo*, London, 1966, no. 5, and my review of the 1966 Tate Gallery exhibition 'Gauguin and the Pont-Aven Group' in *Biuletyn Historii Sztuki*, Warsaw, 1967, no. 2.

CHAPTER VII

90 M. Denis, *Théories*, 1912, p. 161.

91 The Lycée Condorcet – one of whose pupils, from 1882 to 1889, was Marcel Proust – was at that time the only *lycée* for day-boys. The education given there included visits to theatres, concerts, museums and picture galleries, a practice not followed elsewhere. The result was that many of the pupils acquired an early interest in the arts. Lugné-Poë, while still a *lycéen*, founded a school dramatic company, with himself as producer; the sets were painted by Vuillard, Denis and Roussel; and Thadée Natanson (the future editor of the *Revue Blanche*) tried his wings as a writer. See Lugné-Poë, *La Parade. Le Sot du Tremplin*, 1930.

92 Later, in Paris, Sérusier was to join the Euterpe choir, founded by Duteil d'Ozanne, a friend of the Nabis.

93 See P. Sérusier, *ABC de la peinture*, 1942, p. 42. Opinions differ about the account given by Denis of the conversation in the Bois d'Amour, but these divergences do not affect the substance of his record. See also what Gauguin said to Van Gogh on this subject, quoted on p. 66 of this book.

94 This version was the first to be published, in the magazine *L'Occident*, October 1893; it also appears in M. Denis, *Théories*, p. 161. Ambroise Vollard, who kept in close touch with the Nabis, describes the event as follows: 'The theorist in the party was Sérusier. Having gone to Brittany one year, to spend his holidays at Pont-Aven, Sérusier had come back in a state of high enthusiasm. "I met a chap of genius there", he told his friends, "a man called Gauguin. He revealed true painting to me: If you want to make an apple, draw an O." And Sérusier triumphantly exhibited a little picture he had painted in accordance with the principles of the "Master of Pont-Aven". Truth to tell, the Nabis were at first rather cool towards this work, referred to by Sérusier as *The Talisman*. But if Gauguin was not to have any direct influence on them, at least the new ideas brought back by this disciple, from conversations with him, gave the Nabis food for thought, pending the time when each of them discovered his own path.' A. Vollard, *Souvenirs d'un marchand de tableaux*, 1938, p. 236.

95 Gauguin was nevertheless to evince a sense of rivalry in this case too, when – embittered by illness, money difficulties and lack of news from home – he began losing confidence in all his friends. He suspected Sérusier, as he had once suspected Bernard, of claiming the master's role: 'Soon, I shall be written off as a pupil of Bernard and Sérusier. In sculpture, a pupil of Paco.'

(Gauguin to Monfreid, 12 March 1897.) A year before his death, Gauguin wrote: 'One man says of my work, "It's like Van Gogh"; another, "it's like Cézanne". Bernard says it's like his; someone else says it's like Anquetin, or Sérusier. When it comes to Fathers, I've got more than you have.' (Gauguin to Monfreid, 25 August 1902.)

96 Denis wrote of Gauguin that he 'was not a professor... on the contrary, he was an intuitive. In his conversation as in his writing, there were felicitous aphorisms, profound insights and, finally a logic that staggered us.' *Théories*, 1912, p. 162.

97 Sérusier to Verkade, 14 January 1893. P. Sérusier, *ABC de la peinture*, 1950, p. 63.

98 Inviting Adam Wislicki, editor of the *Kurier Warszawski*, to visit Paris, G. Zapolska wrote: 'Come to Paris; you will find a warm welcome in my house, which is gradually becoming an enchanting nook, full of beautiful things. My whole dining-room has been painted by Paul Sérusier.... A moonlit scene with rocks, trees, human figures, ponds and Breton granite. On one wall, the blaze of the fires of St John's Eve, with a Breton dance going on. I'd like you to see it.' MS 7204, III, Public Library, Warsaw.

99 'There, I realized the dream which has been mine for twenty-five years. Without sacrificing any of my ideas, I believe this painting is accessible to the simple, the humble, those whose inheritance is the future, and Heaven.' Sérusier to Denis, 1914. P. Sérusier, *ABC de la peinture*, 1950, p. 145.

100 Séguin wrote to O'Conor in 1902: 'Bernard is following firmly in the footsteps of Benjamin Constant' ('*Bernard fait définitivement du Benjamin Constant*') (See note 103). [Benjamin Constant, French historical painter and portraitist, 1845–1902; not the other Benjamin Constant, the author of *Adolphe. Tr.*]

101 Stefan Laurysiewicz was in Paris, 1889–90; went to Russia in April 1891 to take part in organizing the French exhibition in Moscow; and then settled in Warsaw. The sustained correspondence between Zapolska and Laurysiewicz contains much information on the former's life.

102 When she left Paris, in 1895, Zapolska took her collection of pictures to Lwow. In 1900, she organized an exhibition at the Society of Friends of the Fine Arts, which included not only works by Van Gogh, Gauguin, Pissarro and Seurat, but twelve canvases by Sérusier.

103 This fact was revealed by Séguin's recently discovered letters to O'Conor, the MSS of which were kindly put at my disposal in London by Mr Denys Sutton. One of them contains this passage: 'Did I tell you... that I had been occupying my solitude by making a start at last on my big book about the Pont-Aven school, telling about all of us and our different opinions, beginning of course with Gauguin. I sent my opening pages to Maurice Denis, who was to bring them out in a new review, *Occident*.... Do you know that he was full of praise for what I had written, well earned praise.... These opening pages won't appear in *L'Occident*, and the money I got for them was only the director's way of encouraging me to go on, he's already very willing to publish the volume, but it hasn't been written yet' (3 Sep-

tember 1902). 'Maurice Denis... is willing to get hold of photographs (of works by Gauguin, etc.) for my damned book, of which the first part, "Le Pouldu", was finished a few days ago. The end of this part will amuse you and make you roar in protest. It is to start coming out either next month or in February, in *L'Occident*, with illustrations. It's more than probable that shortly after completion of the second part, "Pont-Aven", say about three months from now, I shall be paid a little money' (30 December 1902).

104 'I've lost a page from Gauguin's letters, a page dated January, in which he cracks up Tahiti and assures me nothing is easier for me than to find 3,000 francs and travel out to join him, an opinion which is not my own.' Séguin to O'Conor, 23 June 1897, MS letter, as indicated in the preceding note.

105 See cat. 'Gauguin and his friends', Copenhagen, 1956, p. 53.

106 Verkade claimed to have met Séguin in 1891 and found him living '*im Saus und Braus*' (roistering); this would appear to have been a mistaken impression, unless it refers to some very short burst of prosperity.

107 We would draw attention here to an etching, *St John the Baptist*, made by Séguin after a gouache by Filiger (sale catalogue, Drouot, 24 June 1959, no. 10).

108 The handshake, symbolizing brotherhood, was frequently mentioned by these artists at the end of their letters: 'Our handshake is as brotherly as of yore' ('*Notre poignée de mains est aussi fraternelle que jadis*'). The custom is reflected in certain works of collaboration: for an example a zinc-engraving executed either at Saint-Julien or at Slewinski's house, entitled *Woman with Figs* and inscribed '*chez Séguin à Saint-Julien*', with the signature, '*Séguin*', in pencil, below. Opinions differ about this engraving. Some writers (Harold Joachim, cat. 'Gauguin Exhibition', New York and Chicago, 1959, p. 76) say it is by Gauguin and that Séguin merely retouched it. Others, like Guérin, attribute it to Séguin (*L'Œuvre gravé de Gauguin*, 1927, vol. II, no. 88). See cat. of O'Conor sale, Drouot, 1956.

109 Séguin did not like English printmaking or English art. 'No, they did not suspect, in their solitude at Le Pouldu, that they had avoided the pitfalls of the pretentious, literary, oleograph-like pictures of the Pre-Raphaelites, the pride of such as Burne-Jones, and that the influence of Puvis de Chavannes – a baneful influence, master though he was – had failed to affect them.' A. Séguin, in *L'Occident*, 1903, no. 18, p. 300. As for the *Breton Woman on the Shore*, a proof was put up to auction at the Hôtel Drouot on 16 March 1959 at the same time as a considerable collection belonging to Mme Cochennec. From this it may be concluded that the Séguin print had formerly belonged either to De Haan or Marie Henry.

110 It has still to be elucidated whether Séguin ever executed certain mural paintings which had been commissioned from him, and, if so, what has become of them.

111 The *Nude in a Landscape* belongs to Dominique Denis, Saint-Germain-en-Laye. It appeared in the following exhibitions: 'Gauguin et ses amis', Paris 1949; Copenhagen 1956; Pont-Aven 1961; and 'Maurice Denis', Paris 1970. In the last two, the title was given as *Nude.Countess Zapolska*. This identification appears to be unfounded; the same applies to the *Female torso* by Sérusier, in which Malingue sees a resemblance to the same model.

112 Doubtless the same picture as the *Village of Douëlan*, from the Duret collections; now owned by S. Josefowitz, Lausanne. Exhibited as *The Two Cottages* in 'Gauguin and the Pont-Aven Group', Tate Gallery, 1966, no. 167.

113 The figure of a woman in Breton headdress is similarly treated in Séguin's zinc-engraving, *A Summer's Day*, reproduced in the present book, p. 147.

114 A. Séguin, 'Paul Gauguin', in *L'Occident*, 1903, no. 16, p. 166. Sérusier criticizes this study fairly severely; see note 59.

115 'And now I've settled in here at Châteauneuf, with friend Sérusier.... At last, after much suffering, and having been confined to my room for three months with a razor cut which gave me a very bad time, I'm on my feet again, in good health, getting stronger every day, proud to tell you that I am so, and in the company of a devoted friend whose intelligence has the effect of reawakening my own.' Séguin to Verkade, 14 June 1903. P. Sérusier, *ABC de la peinture*, 1950, p. 96.

116 Sérusier wrote to Denis: 'For the past week I haven't been alone here. Séguin has left Châteaulin and is staying with me. His presence not only gives me pleasant company but spurs me to work. While he is doing his drawings for *Manfred* I would be ashamed not to work, and I do work.' P. Sérusier, *ABC de la peinture*, 1950, p. 101. Séguin died before he could finish his illustrations for Byron's *Manfred*, which Vollard had commissioned from him.

117 'You are going to like what I have to tell you, and that's part of the reason why I am writing to you at once, directly after Communion. Oh, you won't be looking round your room now for your stick, to hit poor Séguin. You see that I have kept my promises, followed your advice, done what I intended.' Séguin to Verkade, 14 June 1903. P. Sérusier, *ABC de la peinture*, 1950, p. 95.

118 With Georges Desvallières, Denis founded in Paris in 1919 the Ateliers d'Art Sacré, in the rue Furstenberg. The teaching was based on the painting of the *Quattrocento*.

CHAPTER VIII

119 Catalogue of the exhibition 'Bonnard, Vuillard et les Nabis', Paris, 1955, p. 43. Filiger was represented by a single unsigned picture, *Nude Study* (collection E. Endrich, Buchau am Federsee).

120 Until recently, Filiger was unrepresented in any European museum. The collection of his gouaches and watercolours – cartoons for stained glass and mosaics – acquired in 1950 by the Musée national d'Art moderne, Paris, is hardly typical of his style. The Galerie Le Bateau-Lavoir, which specializes in Pont-Aven, has accumulated a remarkable set of Filigers, including the *Antoine de la Rochefoucauld*, 1892, and the gouache *St John*, which is probably a sketch of the picture in Marie Poupée's dining-room at Le Pouldu. The same gallery has exhibited works by Filiger on two occasions – in the exhibition 'Dessins symbolistes', 1958, nos. 16–20, and again in 1962. In the last few years Filiger has aroused considerable interest in Great Britain, as witness the fact that in 1961 a gallery in London devoted an exhibition to him alone. Filiger's gouaches and watercolours also appeared in the collective exhibition in Dallas, in 1962.

André Breton had large numbers of Filigers, but collected only his secular output. There is a batch of gouaches, acquired mainly in Brittany (among them the *Breton Fisherman's Family*, the *Martyrdom of St John the Evangelist*, and the *Christ on a Breton Common*), in the possession of Dr René Guyot, one of the biggest collectors of Pont-Aven in Europe.

My research was made easier by the fact that Filiger had an extensive network of friendships. Unable or unwilling to sell his pictures, he simply gave them away or exchanged them with his colleagues of Pont-Aven for pictures of their own. I have been able to ascertain the number of works by him left in the wills of various individuals: Slewinski, seven gouaches; Sérusier, two; O'Conor, two; De Haan and Marie Henry, nine; Bernard, one; Denis, one; Maufra, one; Moret, four; Schuffenecker, one; Verkade, two. Jean Corronc, the sculptor and collector who lived at Lorient and was a friend of Filiger, had in his collection two fine gouaches and a watercolour which were given to him by the artist. They reveal Filiger in a completely new light.

121 Dr Palaux, who often talked about Filiger with the local people, noted: 'Filiger was Marie Poupée's best customer, he liked her bitter gin. After having used his friends' studio as sleeping-quarters, he transferred his household gods to Kersellec, Kerhulé and finally Lannmarch, near the chapel of Saint-Maudet. A person who knew him well has told us that he frequently received postal orders in payment for pictures imitating Breton popular prints, gouaches of mystical inspiration, executed with ravishingly beautiful painting, which were bought by... Antoine de la Rochefoucauld, the well-known member of the Rose-Croix..., a friend of Sâr Peladan, '*prince de l'esthétique*'. Filiger also supplied designs for ceramics to the pottery firm of Heuriot, at Quimper. When he had a few banknotes in his pocket he would use them, *pour épater le bourgeois*, to light his pipe, or hire a gig and have himself driven to see one of his "very welcoming sitters", Madame K..., at Ker-en-Diavul, near Doëlan. He would park the gig at the estaminets on the way, and return in a perturbed condition to his good neighbours in the village of Saint-Maudet, trembling, and telling them that he had been violently attacked and pursued across country by enemies. His hosts, after comforting him and sharing their evening meal with him, would see him home and put him to bed.' Palaux MS.

122 Makowski, who stayed at Le Pouldu in 1917, notes in his *Journal*: 'Filiger is still living.

The youngest of them all, perhaps. It seems he is drinking less than he used to, Slewinski told me he was once invited to lunch by Filiger, long ago, at Le Pouldu, where Filiger had a small room at a farm. He found Filiger lying asleep on his bed. Tins of sardines, bread, butter and empty bottles were scattered on the floor. Presumably he had tasted the wine and then hadn't been able to resist finishing the bottle.'

123 A. Séguin to O'Conor, 24 September 1902. The situation had become slightly clearer by the following year, when Séguin wrote: 'So Filiger is cured of his passion, I'd give a lot to know how he managed it.' To O'Conor, 30 October 1903.

124 The Rose-Croix, of which group La Rochefoucauld was the 'archon', organized exhibitions of religious art during the 1890s. The exhibitors included Bourdelle, Aman-Jean, Henri Martin and Filiger. *Salon de la Rose-Croix. Règle et Monitoire*, 1891.

125 'I see Filiger has started working again and that La Rochefoucauld is helping him. So much the better. I'm the only one nobody helps. Yet I'm not envious.' Gauguin, from Papeete, 25 March 1892. Sérusier, *ABC de la peinture*, 1950, p. 60.

126 In his picture, *The Chapel of Saint-Maudet*, Filiger displays the patron of the chapel rising in the clouds, above the procession of the faithful.

127 These 'sacred proportions' (*saintes mesures*) feature prominently in the correspondence of Sérusier and Verkade; the remainder of the Nabis were more or less unresponsive to the Beuron theories. Sérusier complains of this in one of his letters to Verkade: 'Ranson and Lacombe are using the Proportions a little, but without much understanding of the theory behind them. Denis is hesitant. As for the others, they don't trouble about them, the Proportions are too remote from their conception of Art. They say that if good proportions exist, a 'gifted artist' will explain them spontaneously, without help.' P. Sérusier, *ABC de la peinture*, 1950, p. 87.

128 In one of his many *Notations chromatiques*, modelled on Byzantine mosaics, Filiger incorporated as the central element the head of a man, in the style of an Eastern patriarch; this was a portrait of Rémy de Gourmont.

129 A few years before he died, Filiger became friendly with the Le Guellecs, a Breton family, who eventually took him under their wing. Le Guellec, an innkeeper who had become a part-time minor functionary, a *secrétaire de mairie*, was often sent to different provincial localities, and always took Filiger with him. The malady from which the painter suffered had now reached such a pitch that he would allow nobody, other than the members of this family, to get near him, on the pretext that everybody was waiting for him to die and was eager to snatch his pictures. He categorically refused to see visitors, especially those who were interested in painting. If anyone did succeed in getting in, he would say: 'You've concealed your identity, your name is Vollard and you're trying to get hold of my pictures.' The last place where Filiger lived was Plougastel-Daoulas. It

was there that he was laid to rest, in the Le Guellec family vault. C. Chassé, catalogue 'Charles Filiger', Le Bateau-Lavoir, 1962.

130 The word is used allusively here; it had been used for the first time by Alphonse Germain (in *La Plume*, 1892, no. 57, p. 289), who wielded it as a term of invective against 'anti-natural deformation'; the critic in question objected violently to naive art, which he considered a sign of incompetence, devoid of breeding and naturalness. Jarry is quoting Filiger as an example with which to defend 'naivety' in art.

131 Among the effects included in Slewinski's will, we found a picture painted and signed by his wife Eugénie, a still-life of fruit on a silver dish. On the wall in the background a landscape by Filiger is easily recognizable. This detail confirmed my supposition that this picture, with others formerly in the possession of Eugénie's family, had originally belonged to Slewinski. See my article, 'Charles Filiger', 1965.

132 In 1891, Gauguin painted *Ia orana Maria* ('Hail Mary') in which a Maori woman with a child, surrounded by other female figures, represents a Tahitian Madonna.

133 Verkade wrote: 'My friend Sérusier often spoke to me of a book by Balzac, *Séraphita*, in which the author expounds the philosophy of the Swedish philosopher Swedenborg.... Of all the books I had read, *Séraphita* was the first in which God was spoken of with enthusiasm as the Supreme Good.... What Balzac says in it recalls the finest things said by the Christian mystics on the subject of prayer. No doubt he was inspired by their works, so that in reading *Séraphita* I drank for the first time at the spring of Christian mysticism.' *Le Tourment de Dieu*, 1926, p. 107.

134 Verkade, *Le Tourment de Dieu*, 1926, p. 116. His *St Sebastian* was included in the exhibition 'Gauguin and his friends', Copenhagen, 1956, no. 132, and also in 'Die Nabis und ihre Freunde', Mannheim, 1963–4, no. 300.

135 Later, Verkade and Ballin played a part in Joergensen's conversion.

136 A. Humbert, *Les Nabis et leur époque*, 1954, p. 99. The Beuron school was invited to take part in an Art Nouveau exhibition in Vienna. Receiving a commission for a picture to be entitled *Original Sin*, Verkade was embarrassed, lacking a female model. To his astonishment, the picture was bought for 1,000 crowns and hung in the Palais Wittgenstein.

137 Verkade, *Der Antrieb ins Vollkommene*, quoted in C. Chassé, *Les Nabis et leur temps*, p. 143. Having met Verkade in Munich about this time, Sérusier wrote to Denis: 'When I arrived I found Fr. Willibrord sailing pretty much on the wrong tack. Happy as a bird let out of its cage, he stuffed himself with forbidden fruit, painted some academic pictures which were very so-so and some still-lifes inferior to those he was doing when he first reached Paris. He complained that Fr Didier had frozen his sensibility, and wanted to warm it up again at the curves of a Munich girl. He had been commissioned to paint, for Beuron, a Virgin flanked by two angels offering flowers to her. Working from nature, he had turned his angels

into a couple of shopgirls whose busts and haunches were hardly seraphic. Luckily, he went to Beuron for Christmas and took his project for the painting with him.... I spent 1 January there. Trial – seeing the picture on the spot – proved decisive. He acknowledged that Fr Didier's discoveries and rules were essential to monumental religious art. Since then, he has sacked his models and picked up his compasses. I'm delighted.' P. Sérusier, *ABC de la peinture*, 1950, p. 132.

138 In his book *Etapes d'un moine peintre*, Verkade devotes several pages to Ballin, at the time when the latter was moving towards Catholicism; he describes the rarefied mystical atmosphere in which the process of his friend's conversion unfolded in Italy. Verkade, *Le Tourment de Dieu*, 1926, p. 194.

139 Everything left by Ballin under his will, including the *Self-portrait on Gold Ground*, is in the possession of the Bredholt-Ballin family in Denmark. Since 1955, Ballin's pictures have appeared in the exhibitions devoted to the Nabis and to Gauguin and his group. See cat. 'Bonnard, Vuillard et les Nabis', Paris, 1955; 'Gauguin and his friends', Copenhagen, 1956; 'Die Nabis und ihre Freunde', Mannheim, 1964; 'Gauguin and the Pont-Aven Group', London, 1966.

CHAPTER IX

140 A fisherman at Le Bas-Pouldu, Alexandre Goulven, now a very old man, has a curious portrait of his mother which was painted by Moret on a piece of plywood, probably the lid of a cigar-box.

141 The canvas is signed and dated but the date is hard to read; one hesitates between 1890 and 1892. Among the many members of the Gloanec (now Le Glouannec) family are the owners of several other pictures by Moret.

142 Gauguin, already getting on bad terms with Laval, wrote to Bernard in 1890, from Le Pouldu: 'If you see Laval, tell him Chamaillard would like news of him; he can't bring himself to believe it's just laziness.' P. Gauguin 1946, p. 200. Sérusier wrote regretfully to Verkade, in April 1902: 'I see Chamaillard too, he's still working away at his painting, but always in a realistic and impressionistic key.' P. Sérusier, *ABC de la peinture*, 1950, p. 94.

143 Apollinaire had already shown his interest in Chamaillard, notably in his review of the Salon d'Automne in *L'Intransigeant*, 16 November 1913, reproduced by L. C. Breunig in *Chroniques d'art*, 1960. We are indebted for this information to Professor Michel Décaudin, of the University of Toulouse.

144 Cat. 'Gauguin, Exposition du Centenaire', Paris, Orangerie, 1949, p. 102. See also cat. 'Gauguin et le Groupe de Pont-Aven', Quimper, 1950, p. 59.

145 The exhibition took place in 1894. C. Mauclair gave it an encouraging notice in the *Mercure de France*. Two years before the exhibition, Le Barc de Boutteville had written to Maufra: 'Courage therefore, my dear friend. Seriously, without flattery, I believe in your future, and in view of what you have achieved already you can't

give up.' A. Alexandre, *Maxime Maufra*, 1926, p. 90.

146 I have not seen any of Maufra's lithographs. Hofstätter, in his thesis, detects in them a strong resemblance to Armand Séguin.

147 Maufra did not regard Brittany merely as a source of subjects for pictures. In an article (*L'Express de Brest*, 1890), he demanded respect for Breton customs, the creation of a Breton museum and theatre, and the protection and performance of Breton folk-music. It was he who instigated the production of the *Mystère de saint Guénolé*, in which the actors were workers, peasants and shop-assistants. The sets (of which I have not been able to discover any trace) were also by Maufra.

148 According to Wildenstein, *Cat.*, 406, Gauguin gave Loiseau the picture *Flowers, blue iris, oranges and a lemon*.

149 The resemblance between Loiseau and Monet was pointed out by Thadée Natanson in the *Revue blanche*, 1898, no. 118.

CHAPTER X

150 Catalogues of the collective exhibitions at Quimper, 1950, nos. 121–8; Quimper, 1958, nos. 51–52; Pont-Aven, 1961, nos. 85–92; Tate Gallery, 1966, nos. 243–4. The 1950 catalogue contains a biographical entry in which no Christian name is given and the dates of birth and death are wrong: 'We know almost nothing about his life. We know only that he was often in Gauguin's company, and that he lived at Pont-Aven, among the general entourage of Gauguin's disciples and friends.' This note, plus the artist's first name, is reproduced in C. Chassé, *Les Nabis et leur temps*, 1960, p. 167. Jourdan achieved museum status in 1955; his picture *Rain on the Bois d'Amour* was bought by the Musée national d'Art moderne, Paris. This was the occasion for an article by Agnès Humbert in the *Revue des Arts*, 1955, no. 3.

151 Guy Jourdan, who owns a large drapery store and a dressmaking house, lives in Paris with his wife, son and grandchildren. He has reverently preserved fourteen pictures by his father; other canvases are owned by the painter's daughters, Marthe and Renée, and his other son, Yan, a sculptor.

152 I have succeeded in discovering forty-two pictures by Jourdan in private collections, and have taken photographs and prepared a catalogue.

153 Julie Correlleau, who died in 1964, was famous for her beauty; was the wife of a painter; and managed the Hôtel de la Poste, Pont-Aven, until the time of her death. The painters who stayed there used to give her their pictures either as presents or to pay their bills. The Correlleau collection is much visited by tourists, for whom there are also the attractions of an excellent cuisine and a picturesque bar. Jourdan spent a long time here; Julie Correlleau charged him a friend's prices or, at times, nothing at all. The Hôtel de la Poste possesses two canvases by him, and the portrait of him by Correlleau to which reference is made in the text.

154 Notes taken by the author in conversation with Jean Corronc, Lorient, 8 April 1959.

155 In one of his letters to his son Guy (1921), we read: 'If I were… master of my situation, you would certainly have had more of an education and upbringing. Still, I comfort myself with the knowledge that you all possess occupations which will give you a living, whereas I, with my art and my higher education, am never sure how I shall provide for the morrow. That's the artist's life. Others besides me have become famous and died in poverty…. You'll always give me the greatest pleasure by writing to me, and I'll answer almost by return and give you the local news. You, at least, have never forgotten your father, who has loved you all; unfortunately events have been stronger than I am.' MS in the keeping of M. Guy Jourdan, who kindly gave me access to the whole of the painter's correspondence.

Guy Jourdan, in our conversation of 20 July 1961, said: 'People in Brittany are spiteful and envious, they speak ill of my father – they say he was a drunk, a tramp and an idler. They say these things because they don't understand anything and don't know that he sacrificed everything – including us – to his art. Our father was the most generous of men, he loved us, as we loved him. But an artist must think of other things, he needs freedom and independence. He was unlucky, that's all.'

156 L. Tual, article in *La Dépêche de Brest*, 1924. Jourdan cannot have met Gauguin earlier than 1888, between February and October. Gauguin left for Panama and Martinique on 10 April 1887, returned to Paris in November of the same year and went to Pont-Aven in February 1888. This would confirm the frequent presence of Bernard in his company, whereas the meeting between Gauguin and Bernard in 1886 was brief and negligible.

157 These 'repeats', which are to be found in private hands in the district of Pont-Aven and Moëlan – especially at inns where Jourdan paid for his meals with pictures – would not be very difficult to distinguish from the original versions (which are equally scattered), if one could lay one's hands on them. On the whole, they lower the standard of the painter's achievement. Examples are *The Aven* (*Le Hénan*), 1926, Guy Jourdan collection; *The Bélon at Kerfany*, 1927, Dr Guyot collection; *The River Aven*, 1927, Anne Sanceo collection: three pictures of the same subject, identically interpreted, with a narrow sandbank dividing the canvas diagonally. The colour is identical as well. The first two maintain a certain freshness of invention, the third is rather insipid and lacking in vigour. There are four versions of the *Chapel of Saint-Léger at Riec*: one belonging to M. Guyot, another to Julie Correlleau, a third to Mme Le Corre, at Pont-Aven (this one is in the form of a fire-screen), and a fourth in a private collection in Paris. Several other examples could be quoted.

158 'Exposition historique de l'art de la gravure au Japon', at the Bing establishment, Paris, 1888. *Le Japon artistique* was appearing at the time; it was intended to popularize the imaginative, evocative prints of the Tokugawa period (1603–

1867), often referred to by Van Gogh in his letters.

159 Japanese woodcuts, when mounted on a vertical roll, as is the case with the *kakemono*, for example, have 'margins' which are part of the mount. Possibly Jourdan was attempting something similar in those of his paintings which were intended to make fire-screens.

160 *Storm at Sea* (Mlle Jobert collection), and *Waves* (A. Coadou collection, Pont-Aven), are composed from the same elements: foaming waves with uniformly curling white crests. But their horizontal arrangement, their more natural colouring, and the lighting, are far removed from the 'Oriental' stylization of the *Wreck at the Signal Station*.

161 *The Stoning of Three Breton Women*, long thought to be a Sérusier, was identified by a daughter of Lacombe's as the work of her father. Information provided by Mlle H. Boutaric.

162 Gauguin to Willumsen (see *Les Mages*, 15 March 1918; text reproduced by S. Lövgren, 1959, p. 163). Willumsen gives the following description of his visit to Gauguin: 'The only object I saw in his room was a small sculpture on the mantelpiece; it was a woodcarving and had just been finished…. It was of a woman, in an exotic style. Perhaps it was some Tahitian fantasy then occupying Gauguin's mind. The legs were left unfinished. Gauguin called it *La Luxure* ['Sensuality'], perhaps because the woman is smelling a flower. Gauguin gave it to me in exchange for one of my pictures from Brittany.' J. Rewald, *Post-Impressionism*, 1956.

CHAPTER XI

163 In 1889, O'Conor exhibited three pictures at the Salon des Indépendants; in 1890, ten. After a long interval he reappeared in 1904, and from then on exhibited regularly as a member of the Indépendants and of the Salon d'Automne, where he was still exhibiting as late as 1930.

164 See the following catalogues: Quimper, 1950, no. 138; Copenhagen, 1956, nos. 101–4; Quimper, 1950, no. 77; Saint-Denis, 1961, no. 51; Pont-Aven, 1961, nos. 127–35; Tate Gallery, 1966, nos. 295–304. Before the Second World War O'Conor had a one-man exhibition in Paris, consisting of fifteen canvases and a number of drawings (Galerie Bonaparte, 1937).

165 Thanks possibly to Clive Bell, O'Conor was represented at the 'Exhibition of Works by Irish Painters' in the Guildhall, 1904.

166 *Seascape with Red Rocks* (*Souvenir de Pont-Aven*), private collection, Paris; *The Red Rocks*, 1898, private collection, Nantes; *Red Rocks and Foam, Brittany*, private collection, London (exhibited in 1964 at Roland, Browse & Delbanco, London, no. 21).

167 Séguin to O'Conor, 12 March 1903. Relating his meeting with Sérusier, Séguin comments on some points of a theory to which Sérusier was trying to convert his colleagues in Brittany, and also the Nabis: 'His theories about numbers, which were worked out at Beuron, interest me. I like his understanding of the countryside which surrounds him and which has given him some ideas, correct ones in my opinion, such as this:

"For translating Brittany, variety in colour is a fault; essentially, every landscape is established by only three colours, the importance of the foreground is really non-existent and is simply a painter's device." O'Conor, O'Conor, don't roar, there's a certain truth in all this.' Séguin to O'Conor, 20 June 1903.

168 O'Conor received from Gauguin a coloured monotype, *The Angelus in Brittany*, with the dedication '*For my friend O'Conor, One man of Samoa. Paul Gauguin.*' Gauguin also made him a gift of a first proof of *Manao Tupapau*, with the dedication '*A l'artiste O'Conor Aita Armoe. Paul Gauguin.*'

169 O'Conor found in his studio several canvases which Gauguin had started but abandoned, and was pleased to see that Gauguin had used one of his drawings as an element in some of them (see Matthew Smith, cat. 'Two Masters of Colour').

170 After his engagement to a young Swedish painter was broken off, O'Conor lived alone. Late in life, he married Renée Honta, also a painter.

171 Slewinski's letters to O'Conor make it clear that whenever they were unable to meet they kept in touch by post, informing each other of their whereabouts and, in particular, of their work in progress. Certain passages show that they made efforts to exhibit together. Just as Séguin persuaded O'Conor, in 1897, to exhibit with the Groupe des Vingt in Belgium (see 'Le Groupe des XX et son temps', Rijksmuseum Kröller-Müller, Otterlo 1962, and M. O. Maus, *Trente années de lutte pour l'art*, 1926, pp. 227 and 335), Slewinski urged him to take part again, after an interval of fourteen years, in the annual exhibitions of the Salon des Indépendants. Slewinski wrote to him in 1904: 'Dear O'Conor, Yesterday I saw one of the organizers of the Indépendants, M. de la Quintine, who told me the Society would be very pleased to see you among the exhibitors and promises that you will be favourably hung, in a group of about fifteen painters, one of whom will be myself. A word about this is supposed to be on the way, but in case you haven't had the letter yet I am writing to you myself.... I'm sending in six canvases and I want to get through this exhibition chore as quickly as possible, because I want to work and it does hold one up so. I hope you'll send something in too.'

We are acquainted with two pictures which belonged to O'Conor: *Still-life with Apples* (private collection, Paris) and *Flowers in a Delft Vase* (private collection, Chemillé); the latter is dedicated '*A R. O'Conor WS 1895*'.

172 An interesting detail, one that deserves to be followed up, in O'Conor's biography is his relationship with the Russian collector Morozov. There is in the Hermitage a canvas by O'Conor, dated 1905 (*Rest*, 37 × 62 cm, no. inv. 8909), from the Morozov collection. At that time, Morozov was looking for contemporary pictures in Paris.

173 In 1962 I found, in a provincial antique dealer's shop in France, the following items which had formed part of O'Conor's estate: a wooden snuff-box, carved in Tahiti by Gauguin; a ceramic case, made and signed by Georges Rouault; a number of drawings by Gauguin and a letter from him to O'Conor (from Atuana); a few pictures by Filiger; lithographs by Redon, etc.

CHAPTER XII

174 *Le Groupe des XX*, Brussels, 1887. See also Chapter I of this book.

175 E. Dujardin, 'Aux XX et aux Indépendants. Le Cloisonnisme', in *Revue Indépendante*, March 1888, pp. 487–92. Dujardin was one of the habitués of the Café d'Orient, which Mallarmé frequented after the death of Manet. With his excellent musical education – he was a pupil of the Conservatoire at the same time as Debussy – Dujardin was the man who consolidated Wagner's position in Paris on the philosophical and aesthetic plane; after which, with the help of several wealthy enthusiasts whom he had won to the cause, he founded in 1884, in collaboration with Teodor de Wyzewa, the *Revue wagnérienne*. Dujardin was a friend of Toulouse-Lautrec, Jacques-Emile Blanche and Anquetin. Van Gogh considered that to hail Anquetin as the originator of *cloisonnisme* was to deprive Bernard of his just deserts, because 'little Bernard has perhaps carried *japonaiserie* to great lengths than Anquetin'. V. van Gogh to his brother, June 1888, *Correspondance complète*, vol. III, p. 100.

176 To the best of our knowledge, the Japanese did not use a master-block but cut a separate block in relief for each colour.

177 Makowski, arriving in Brittany for the first time in 1913, noted in his *Journal*: 'Countryside lends itself greatly to the study of construction. No indecisive lines or shapes. Rigorous form and a markedly architectonic character.' Makowski, 1961, p. 87.

178 *Le Japon artistique. Documents d'Art et d'Industrie*, Paris 1888, p. 13. Siegfried Bing was the real propagator of Japanese art in France. His shop, with its stock of *japoneries*, was visited by the entire *élite* of Paris. In spring 1888, he put on an exhibition of *Ukiyo-e*. In the same year he began publishing *Le Japon artistique*, of which three volumes appeared in all, on the history and theory of Japanese art.

179 V. van Gogh's letters to his brother, 1887–8, *Correspondance complète*, III.

180 Goncourt wrote (25 May 1888): 'Oh, if only I had a few more years to live, I would love to write a book on Japanese art.... The book would be made up of four studies: one on Hokusai, the modernist who renovated the old art of Japan, one on Utamaro, the Watteau of that country, one on Korin and another on Ritsuô, two famous artists in lacquer. To these four studies I would perhaps add one on Gakutei, the great *surimono* artist, the man who, in a delicate colour-impression, succeeds in combining the charm of the Persian miniature with that of the medieval miniature.' E. and J. de Goncourt, *Journal*, III, 1956, p. 791. Goncourt published only two of these projected studies: *Utamaro, le peintre des maisons vertes*, 1891, and *Hokusai, l'art japonais au XVIIIe siècle*, 1896.

181 In this book I have frequently pointed to the influence of Japan on the painters with whom we are concerned. Bernard was to say, in his 'Notes' on the *Vision after the Sermon*, that the wrestlers' attitudes were borrowed from an album; he was alluding to one of the books of prints (*Mangwa*) which were fairly well known at that period. After his visit to Van Gogh – who was particularly fascinated by Japan at the time – Gauguin's fondness for Japanese art steadily increased. At Pont-Aven, everybody was preoccupied with Japan, and the painters' admiration for the art of the Far East was expressed in their canvases, as can be seen in *Still-life with Japanese Print* by Gauguin, *Self-portrait on a Background in the Japanese Style* by De Haan, *Memories of Saint-Morice* by Slewinski and *Wreck at the Signal Station* by Jourdan.

182 Gauguin to V. van Gogh, Pont-Aven, September 1888; see J. Rewald, *Post-Impressionism*, p. 202, n. 22.

183 Octave Mirbeau wrote to Claude Monet: 'I've had a heartrending letter from Mallarmé about poor Gauguin. He's in the most wretched poverty.... Gauguin came to see me. An attractive character, genuinely tormented by the suffering which art involves. And he has a fine look about him. I took to him strongly. In his apparently somewhat simple, rough nature it is easy to detect a very interesting cerebral side. He is desperately keen to know what you think of his development towards complication of the idea within simplification of the form. I told him you had greatly liked his *Jacob Wrestling with the Angel* [*Vision after the Sermon*], and his ceramics. I did well to do so; it gave him pleasure.' Mirbeau to Monet, January 1891. 'Lettres à Claude Monet', in *Cahiers d'Aujourd'hui*, 1922, no. 9.

184 The experience acquired in painting *Breton Women* enabled Bernard to carry *cloisonnisme* to its furthest limit, notably in *Buckwheat* and the *Breton Women* of 1892 (Josefowitz collection, Lausanne), *Seated Women* (Leon A. Mnuchine collection, New York) and *Women by the Sea* (Rouat collection, Riec-sur-Bélon).

185 'At Le Barc de Boutteville's exhibitions from late 1891 onwards, flat colour no longer appeared with the same rigour: forms were no longer bounded by black lines, unmixed colours were no longer exclusively employed.... The artistic public which has seen Symbolist painting only in exhibitions later than 1891, knows nothing of its purely theoretical and speculative manifestations, those of its early days.' M. Denis, *Théories*, p. 21.

186 What Gauguin thought of the work of Redon and Moreau may be gathered from the article he wrote in reply to 'Le Monstre', the study by J.-K. Huysmans in his book *Certains* (1889). Whereas Huysmans regards Redon's creatures as the progeny of an 'unhealthy imagination', and calls them 'monsters', Gauguin writes: 'I fail to see that Odilon Redon is a maker of monsters. They are imaginary beings. He is a dreamer, a man of imagination.... All his plants – embryonic and essentially human creatures – have lived among us; they have undoubtedly experienced their share of suffering.... In all his work I see only a very human, in no way monstrous, language of the heart.'

With Redon's 'symbolism of the heart', Gauguin contrasts Moreau the 'goldsmith': 'Gustave Moreau is a craftsman, an adept with his chisels, his work has something about it of illustrations for old tales.' P. Gauguin, 'Huysmans et Redon'; see J. Loize, 'Un inédit de Gauguin', in *Les Nouvelles Littéraires*, 7 May 1953. A remarkable fact is that Gauguin, though he admired Redon's style, never borrowed from it at all – with the possible exception of a few slight reminiscences in certain decorative compositions with a floral content. The portrait of Moréas, which Gauguin endowed with Symbolist trappings in the style of Redon and with the sub-title 'Be a Symbolist!', is merely a satirical squib; at the same time, however, it constitutes a rejection of Redon's kind of Symbolism.

187 E. Delacroix, *Journal*, 12 October 1853.

188 C. Baudelaire, *Salon de 1859*, chap. III: 'La Reine des Facultés'.

189 H. Heine, *Der Salon I*, Rotterdam, p. 27. See also T. de Visan, 'Le Romantisme allemand et le Symbolisme français', in *Mercure de France*, December 1910, p. 577.

190 A. Aurier, *Œuvres posthumes*, p. 302.

191 J. de Rotonchamp, *Paul Gauguin*, 1925, p. 140.

192 M. Denis, *Théories*, p. 259.

193 A. Schopenhauer, *Parerga und Paralipomena*, 1891. W. H. Wackenroder, for his part, wrote: 'Music... depicts human feelings in a superhuman way.... In the mirror of sounds, the human heart becomes acquainted with itself.' J. L. Tieck and W. H. Wackenroder, *Phantasien über Kunst. Franz Sternbalds Wanderungen*, 1890, p. 72.

194 H. Mahaut, 'Notes synthétiques de Paul Gauguin', in *Vers et Prose*, VI, 1910. Gauguin continues: 'Painting is the most beautiful of all the arts; in it all sensations are resumed, at the sight of it everybody, as his imagination pleases, can create romance, and at a single glance have his soul invaded by the most profound memories; no effort of recollection, everything resumed in a single instant. A complete art, summing up and completing all the others.'

195 The speed with which he became acclimatized in this milieu is attested by the fact that, with Jules Renard, he was invited to be a witness in the duel between Leclercq and Darzens. J. Renard, *Journal*, 31 December 1890 (edition of 1935, p. 56).

196 C. Chassé relates an anecdote which he had from Sérusier: 'When Gauguin and Sérusier had arrived in Paris, on their return from Le Pouldu, the Symbolists, of whom they had known almost nothing till now, passed word to them that they would be glad to meet them for a chat at the Café Voltaire.... Art and literature were discussed in their presence. The principles of Symbolism were expounded to them, and they were given to understand that they themselves were Symbolists without knowing it. To cut a long story short, by the end of the evening they had been crowned as Symbolists in painting. But afterwards, when Gauguin and Sérusier walked out together into the Place de l'Odéon, the former said: "Right, so we're Symbolists now! Did you understand a single word of these doctrines?" "Nothing at all", answered Sérusier. "Nor did I", said Gauguin; "still, Symbolism's all right."' C. Chassé, *Gauguin et son temps*, 1955, p. 125.

197 The portrait of Mallarmé with a symbolic raven above his head (borrowed from a drawing by Manet reproduced in Edmond Bazire's book) was an allusion to the poem by Poe which Mallarmé translated. 'The Raven' (or rather 'Le Corbeau') was recited at a banquet given in honour of Gauguin, with Mallarmé presiding, on 23 March 1891 at the Café Voltaire, and again, as a curtain-raiser, in a programme which was given at the Vaudeville by the Théâtre de l'Art, and which had been got up as a benefit for Verlaine and Gauguin, on 21 May 1891. (The recitation was by Marguerite Moreno.)

198 'A young colleague of mine, a man of heart as well as great talent, who is friendly with the painter, sculptor and ceramicist Gauguin – you know who the colleague is! – has begged me to put a request to you, as the only man capable of doing something effective in the matter. That rarely gifted artist, who, I think, has been spared

but few tortures in Paris, feels the need to concentrate his powers in isolation and in something like the wild state.... But – an article will be necessary.' Mallarmé to Mirbeau, 15 January 1891; Mondor, *La Vie de Mallarmé*, 1941, p. 549.

199 Mallarmé to Gauguin, 24 February 1891. See Rotonchamp, *Paul Gauguin*, 1925, p. 91; Mondor, *La Vie de Mallarmé*, 1941, p. 604.

200 C. Morice, *Paul Gauguin*, 1920, pp. 27 and 153.

201 'To *name* an object is to destroy three-quarters of the enjoyment afforded by the poem; the poem consists of the happiness of guessing, little by little; to *suggest* the object is the ideal, the dream. The perfect use of this mystery is what constitutes Symbolism: the gradual evocation of an object in order to reveal a psychic state, or conversely, to choose an object and elicit from it a psychic state by means of a series of decipherments.' J. Huret, 'Enquête sur l'évolution littéraire', in *Echo de Paris*, March-April 1891.

202 C. Morice, 'Paul Gauguin', in *Mercure de France*, December 1893, p. 294.

203 Denis and Sérusier did not employ nuances until later, when, with Vuillard and Bonnard, they belonged to the Nabis. Another characteristic fact is that Bernard's illustrations for *Les Fleurs du Mal* were done after he had put Syntheticism behind him for good.

204 See cat. 'Gauguin et le Groupe de Pont-Aven', Quimper, 1960, p. 50.

205 Aurier came to know the Pont-Aven group through Bernard at Saint-Briac, and subsequently, at Bernard's request, became the patron of the exhibition at the Café Volpini. See A. Aurier, 'Concurrence', in *Le Moderniste*, 1889, no. 10.

206 E. Bréhier, *La Philosophie de Plotin*, 1928, p. 85.

207 A. Séguin, 'Paul Gauguin', in *L'Occident*, 1903, no. 18.

208 P. Sérusier, *ABC de la peinture*, 1950, p. 154.

209 P. Gauguin, *Racontars de rapin*, 1951, p. 76.

PHOTOGRAPHIC SOURCES

Albright-Knox Art Gallery, Buffalo; Bayerische Staatsgemäldesammlungen, Munich; Bibliothèque des Arts, Lausanne; Arthur G. Altschul, New York; Henriette Boutaric, Paris; Jan Bredholt, Copenhagen; Dr René Guyot, Clohars-Carnoët; W. J. Holliday, Indianapolis; Samuel Josefowitz, Lausanne; Mrs Werner Josten, New York; Guy Jourdan, Paris; Paul Mellon, Washington; Emery Reves; Folkwang Museum, Essen; Galerie Jean-Claude Bellier, Paris; Galerie Le Bateau-Lavoir, Paris; Galerie Les Deux-Iles, Paris; Giraudon, Paris; Gravier, Pont-Aven; Hirschl & Adler Galleries, New York; Wladyslawa Jaworska, Warsaw; Tadeusz Kazmierski, Warsaw; The Minneapolis Institute of Arts, Minneapolis; Museum of Upper Silesia, Bytom; Musée de Peinture et de Sculpture, Grenoble; Pushkin Museum, Moscow; Musée des Beaux-Arts, Rennes; Musées Royaux des Beaux-Arts, Brussels; National Museum, Wroclaw; National Gallery of Scotland, Edinburgh; Öffentliche Kunstsammlung, Basle; Rijksmuseum Kröller-Müller, Otterlo; Roland, Browse & Delbanco, London; Stedelijk Museum, Amsterdam; Institut Sztuki, Akademia Nauk, Warsaw; Taylor & Dull, New York; Marc Vaux, Paris; Vincent van Gogh Foundation, Amsterdam; J. F. Willumsens Museum, Frederikssund.

Bibliography

I CATALOGUES: GROUP EXHIBITIONS

1889 'Groupe Impressionniste et Synthétiste. Exposition de peinture', Paris, Café des Arts (Café Volpini).

1892 'Symbolistes et Impressionnistes', Paris, Le Barc de Boutteville (preface G. A. Aurier).

1892 'Salon de la Rose-Croix', Paris, Galerie Durand-Ruel, March–April (including Filiger, Bernard).

1933 'Seurat et ses amis. La suite de l'Impressionnisme', Paris, Galerie Beaux-Arts, December–January (including Maufra, Moret, Loiseau).

1934 'Gauguin, ses amis, l'Ecole de Pont-Aven et l'Académie Julian', Paris, Galerie Beaux-Arts, February–March (preface M. Denis, catalogue R. Cogniat).

1938 'Exposition Georges-Daniel de Monfreid et son ami Paul Gauguin', Paris, Galerie Charpentier, 19–31 October (preface M. Denis).

1943 'L'Ecole de Pont-Aven et les Nabis', Paris, Galerie Parvillée, May–June (preface M. Denis).

1949 'Les Nabis', Vienna, Palais Lobkowicz.

1949 'Gauguin et ses amis', Paris, Galerie Kléber (preface and catalogue M. Malingue).

1949 'Gauguin, Exposition du Centenaire', Paris, Orangerie.

1949 'Carrière et le symbolisme', Paris, Orangerie, December–January (1950) (preface M. Florisoone, catalogue J. Leymarie).

1950 'Gauguin et le Groupe de Pont-Aven', Quimper, Musée des Beaux-Arts, July–September (preface R. Huyghe, catalogue G. Martin-Méry).

1951 'Gauguin et ses amis. Œuvres de Daniel de Monfreid', Paris, Galerie André Weil, June (preface R. Rey).

1951 'Les peintres de "La Revue Blanche". Toulouse-Lautrec et les Nabis', Berne, Kunsthalle.

1951 'Toulouse-Lautrec, ses amis, ses maîtres', Albi, Musée Toulouse-Lautrec, August–October.

1953 'Exposition d'œuvres de Paul Gauguin et du Groupe de Pont-Aven', Pont-Aven, Hôtel de Ville, August–September (preface T. Briant).

1954 'Paris in the Nineties', London, Wildenstein Gallery, May–June.

1954 'Paris 1900', Vevey, Musée Jenisch, July–September (preface F. Daulte, foreword J. Salomon).

1955 'Bonnard, Vuillard et les Nabis (1888–1903)', Paris, Musée national d'Art moderne, June–October (preface Jean Cassou, catalogue B. Dorival and A. Humbert).

1956 'Gauguin and his friends. An exhibition of the Pont-Aven Group', Copenhagen, Winkel & Magnussen, June (preface H. Rostrup).

1958 'Hommage à Sérusier et aux peintres du Groupe de Pont-Aven', Quimper, Musée des Beaux-Arts, July–September (introduction P. Quiniou, preface C. Chassé).

1958 'Dessins symbolistes', Paris, Galerie Le Bateau-Lavoir (preface A. Breton).

1959 'Exposition et vente du mercredi 14 juin', Paris, Hôtel Drouot.

1960 'Les amis de van Gogh', Paris, Institut Néerlandais.

1961 'La Bretagne', Saint-Denis, Musée Municipal d'Histoire et d'Art, April–May (foreword J. Marcenac, preface O. Frandisse).

1961 'Gauguin et ses amis', Pont-Aven, Hôtel de Ville, August–September (preface and catalogue M. Malingue).

1961 'Painters at Pont-Aven', New York, Hirschl and Adler Galleries.

1962 'The Outline and the Dot. Two Aspects of Post-Impressionism', Dallas, Museum of Fine Arts, March (preface B. Delabano).

1962 'Le Groupe de Pont-Aven', Paris, Galerie Mons.

1962 'The Nabis and their Circle', Minneapolis, Institute of Arts, December (preface F. Selvig).

1963 'Gauguin et son entourage', Pont-Aven.

1963 'Die Nabis und ihre Freunde', Mannheim, Kunsthalle, October–January (1964) (preface H. Fuchs).

1964 'Peintres de la Bretagne, de Gauguin à nos jours', Vannes, Musée des Beaux-Arts (preface H. de Parcevaux).

1965 'Neo-Impressionists and Nabis in the Collection of Arthur G. Altschul', Yale University Art Gallery, New Haven.

1966 'Gauguin and the School of Pont-Aven', London, Tate Gallery, January–February (preface D. Sutton, catalogue R. Pickvance).

1966 'Pont-Aven. Gauguin und sein Kreis in der Bretagne', Zurich, Kunsthaus, March–April (introduction R. Wehrli, preface D. Sutton, catalogue R. Pickvance, appendix to catalogue F. A. Baumann). See preceding entry.

1966 'Rétrospective: Henry Moret – Emile Jourdan – Roderic O'Conor – Wladyslaw Slewinski. Documents inédits sur l'Ecole de Pont-Aven', Vannes, Musée des Beaux-Arts, July–September (preface H. de Parcevaux).

1966 'Pont-Aven und Nabis', Munich, Galleria del Levante, November–January (1967).

1969 'Les Nabis et leur temps', Geneva, Galerie Krugier, November.

1971 'The Nabis', Philadelphia, Hetzel Union Building Gallery (introduction G. Mauner).

1971 'De Pont-Aven aux Nabis, Rétrospective, 1888–1903' (Société des Artistes Indépendants), Paris, Grand Palais, April–May.

1971 'Autour de Gauguin', Pont-Aven, Société de Peinture, June–September.

II CATALOGUES: INDIVIDUAL EXHIBITIONS

ÉMILE BERNARD

1901 'Emile Bernard. Exposition. Paris, Bretagne, Egypte', Paris, Gallerie Vollard, June (preface Roger Marx).

1910 'Exposition Emile Bernard', Paris, Musée Beaudouin, February (preface M. Marten).

1912 'Exposition Bernard', Paris, Galerie R. Levesque, December (preface P. Jamot).

1943 'Exposition Emile Bernard', Paris, Galerie Charpentier (preface P. Jamot).

1944 'Œuvres de Pont-Aven (1888–93 et 1940–41) du peintre Emile Bernard', Toulouse, Galerie d'Art Méda, December (prefaced by extracts from articles by A. Alexandre, P. Jamot, G. Apollinaire, etc.).

1957 'Exposition Emile Bernard à Pont-Aven (1885–97)', Paris, Galerie La Gravure, December (preface P. Mornand).

1958 'Exposition exceptionnelle de quelques œuvres d'Emile Bernard, ami de Toulouse-Lautrec et inspirateur de Gauguin', Carcassonne, December–February (1959) (organized by J. Aurifeille).

1959 'Emile Bernard. Epoque de Pont-Aven, 1883–93', Paris, Galerie Durand-Ruel, April–May (preface H. Perruchot).

1960 'Emile Bernard dans la maison de van Gogh', Auvers-sur-Oise, October.

1962 'Emile Bernard. Pont-Aven-Orient. Peintures', Paris, Galerie J.-C. et J. Bellier, June–July (preface L. Hautecœur).

1963 'Emile Bernard', New York, Hirschl and Adler Galleries, February–March.

1964 'Emile Bernard', Milan, Galleria del Levante.

1967 'Emile Bernard', Bremen, Kunsthalle.

HENRI-ERNEST PONTHIER DE CHAMAILLARD

1901 'Exposition Chamaillard', Paris, Galerie Bernheim-Jeune (preface A. Alexandre).

1930 'Chamaillard', Paris, Galerie Georges Petit.

MAURICE DENIS

1945 'Maurice Denis', Musée national d'Art moderne, Paris (prefatory material: letter from A. Gide, foreword by P. Bonnard, extracts from the *Journal* of M. Denis).

1945 'Maurice Denis, ses maîtres, ses amis, ses élèves', travelling exhibition of the Musées Nationaux (Cambrai, Dijon, Nice, etc.), 1945–6 (preface G. Salles).

1970 'Maurice Denis', Paris, Orangerie, June–August (preface L. Hautecœur).

CHARLES FILIGER

1893 'Charles Filiger', Paris, Le Barc de Boutteville.

1894 'Charles Filiger', Paris, Le Barc de Boutteville.

1961 'First Exhibition in London of the Pont-Aven Painter Charles Filiger', London, The Reid Gallery (preface P. Cabanne).

1962 'Charles Filiger', Paris, Galerie Le Bateau-Lavoir (preface C. Chassé).

PAUL GAUGUIN

For exhibitions of Gauguin's Breton period, see Section I.

GUSTAVE LOISEAU

1898 'Paysages de G. Loiseau', Paris, Galerie Durand-Ruel, April.

1942 'Exposition de tableaux par Gustave Loiseau', Paris, Galerie Durand-Ruel, June–July.

1951 'G. Loiseau', Paris, Galerie Durand-Ruel, May–June (preface R. Domergue).

1955 'Loiseau et Maufra', Geneva, Galerie Motte, March.

1957 'G. Loiseau', Paris, Galerie Durand-Ruel, May (preface R. Barotte).

MAXIME MAUFRA

1894 'Exposition Maufra', Paris, Le Barc de Boutteville, March (preface F. Jourdain).

1955 'Loiseau et Maufra', Geneva, Galerie Motte, March.

1960 'Maxime Maufra - Emile Dezaunay', Nantes, Amis du Musée, July–September (preface L. Benoist, J. Lanoë).

1961 'Exposition M. Maufra', Paris, Galerie Durand-Ruel, March (preface H. de Parcevaux).

HENRY MORET

1959 'Rétrospective Henry Moret', Galerie Durand-Ruel, March (preface H. Hugault).

RODERIC O'CONOR

1937 'Exposition O'Conor', Paris, Galerie Bonaparte.

1956 'Exposition et vente O'Conor', Paris, Hôtel Drouot, 6–7 February (preface J. Caillac).

1956 'Two Masters of Colour, Matthew Smith and Roderic O'Conor', London, Roland, Browse & Delbanco, April–May.

1957 'Roderic O'Conor', London, Roland, Browse & Delbanco.

1961 'Roderic O'Conor', London, Roland, Browse & Delbanco.

1964 'Roderic O'Conor – Norman Adams', London, Roland, Browse & Delbanco, April–May.

1971 'Roderic O'Conor – a selection of his best work', London, Roland, Browse & Delbanco, June–July.

ÉMILE SCHUFFENECKER

1896 'Exposition Schuffenecker', Paris, Librairie de l'Art Indépendant.

1944 'Un méconnu, Emile Schuffenecker. Exposition rétrospective', Paris, Galerie Berri-Raspail, March–April (preface M. Gautier).

1963 'Emile Schuffenecker, 60 pastels, 40 dessins', Paris, Galerie les Deux-Iles, May–June.

ARMAND SÉGUIN

1895 'Armand Séguin. Œuvres nouvelles chez Le Barc de Boutteville', Paris, February–March (preface Paul Gauguin).

PAUL SÉRUSIER

1907 'Paul Sérusier', Paris, Galerie Druet.

1914 'Paul Sérusier', Paris, Galerie Druet.

1919 'Paul Sérusier', Paris, Galerie Druet, November (preface M. and A. Leblond).

1964 'P. Sérusier. Gouaches – Aquarelles – Dessins – Lithos – Photographies – Correspondance – Palettes – Disque', Paris, Galerie Durand-Ruel, April–May.

WLADYSLAW SLEWINSKI

1897 'Wladyslaw Slewinski', Warsaw, Salon Krywult.

1898 'Exposition des œuvres de M. W. Slewinski', Paris, Galerie Georges Thomas (preface Z. Przesmycki).

1899 'Wladyslaw Slewinski', Warsaw, Salon Krywult.

1905 'Wladyslaw Slewinski', Warsaw, Salon Krywult.

1907 'Wladyslaw Slewinski', Lwow, Society of the Friends of the Fine Arts (preface J. Kasprowicz).

1908 'W. Slewinski', Warsaw, Society for the Encouragement of the Fine Arts.

1909 'W. Slewinski', Warsaw, Society for the Encouragement of the Fine Arts.

1925 'W. Slewinski', Warsaw.

1958 'W. Slewinski', Wroclaw, Silesian Museum (unsigned preface).

JAN VERKADE

1894 'Jan Verkade', Copenhagen, Bredgade.

III THE PONT-AVEN SCHOOL, THE NABIS AND GAUGUIN'S BRETON PERIOD

1885 E. Bernard, 'Les Ateliers', in *Mercure de France*, February, XIII, p. 203.

1888 E. Dujardin, 'Aux XX et aux Indépendants. Le Cloisonnisme', in *Revue Indépendante*, March.

1889 P. Adam, 'L'Art symboliste', in *La Cravache*, 23 March.

1889 G. A. Aurier, 'Concurrence', in *Le Moderniste*, 27 June, no. 10.

1889 J. Antoine, 'Impressionnistes et synthétistes', in *Art et Critique*, 9 November.

1891 O. Mirbeau, 'Gauguin', in *Echo de Paris*, 15 February.

1891 T. de Wyzewa, 'Le nouveau Salon du Champ-de-Mars', in *L'Art dans les Deux Mondes*, 13 June.

1891 G. A. Aurier, 'Le Symbolisme en peinture. Paul Gauguin', in *Mercure de France*, no. 15.

1892 G. A. Aurier, 'Les Symbolistes', in *Revue Encyclopédique*, 1 April (reproduced in his *Œuvres posthumes*, Paris, 1893).

1892 G. Geffroy, *La Vie artistique*, vol. I, Paris, Floury.

1893 T. Natanson, 'Un groupe de peintres chez Le Barc de Boutteville', in *La Revue Blanche*, no. 25.

1893 C. Morice, 'Paul Gauguin', in *Mercure de France*, no. 48.

1893 M. Maufra, 'Gauguin et l'Ecole de Pont-Aven, par un de ses admirateurs de l'Ecole de Pont-Aven', in *Essais d'Art Libre*, November.

1894 P. Gauguin, 'Natures mortes', in *Essais d'Art Libre*, January.

1894 A. Jarry, 'Minutes d'art, 6e exposition chez Le Barc de Boutteville', in *Essais d'Art Libre*, February–April.

1894 C. Mauclair, 'Lettre sur la peinture', in *Mercure de France*, July.

1894 J. Leclercq, 'La Lutte pour les peintres', in *Mercure de France*, November (in reply to Mauclair's letter).

1894 G. Zapolska, ['Letters from Paris' (Letter IV)], Warsaw, *Przeglad Tygodniowy*, no. 30.

1895 E. Bernard, 'Lettre ouverte à M. Camille Mauclair', in *Mercure de France*, June (see also the answer by J. Leclercq in *Mercure de France*, July 1895).

1896 A. Mellerio, 'Le Mouvement idéaliste en peinture', Paris, Floury.

1902 F. Fagus, 'Bonnard, Denis, Maillol, Roussel, Vallotton, Vuillard', in *La Revue Blanche*, no. 216.

1903 A. Séguin, 'Paul Gauguin', in *L'Occident*, nos. 16 and 18.

1903 C. Morice, 'Quelques opinions sur Paul Gauguin', in *Mercure de France*, November.

1903 E. Bernard, 'Notes sur l'Ecole dite de Pont-Aven', in *Mercure de France*, November.

1903 D. de Monfreid, 'Gauguin', in *Ermitage,* December.

1904 C. Morice, 'Les Gauguin du Petit-Palais et de la rue Laffitte', in *Mercure de France,* February, XLIX.

1904 J. Meier-Graefe, *Entwicklungsgeschichte der modernen Kunst,* (vol. I, chapter on 'Die Schule von Pont-Aven'), Stuttgart, Hoffmann; English translation, *The Development of Modern Art,* London 1908.

1905 E. Bernard, 'Paul Gauguin et Vincent van Gogh', in *La Rénovation Artistique,* May–October.

1906 C. Morice, 'XXᵉ Salon des Indépendants', in *Mercure de France,* April, LX.

1906 J. de Rotonchamp (see 1925).

1906 E. Bernard, 'Documents pour l'histoire du symbolisme pictural en France', in *La Rénovation Esthétique,* October–December.

1910 C. Morice, 'Art Moderne', in *Mercure de France,* December.

1912 M. Denis, *Théories 1890–1910. Du symbolisme et de Gauguin vers un nouvel ordre classique,* Paris, Bibliothèque de l'Occident.

1914 M. Facy, 'Gauguin et la Bretagne', in *Brittia,* May.

1918 P. Gauguin, *Avant et après,* Leipzig, Kurt Wolf; republished Paris, Crès, 1923. See also 1950.

1919 G. Careil, 'Gauguin en Bretagne', in *Le Fureteur Breton,* November–December.

1920 A. Alexandre, *Paul Gauguin. Sa vie et le sens de son œuvre,* Paris, Bernheim-Jeune.

1920 C. Morice, *Gauguin,* Paris, Floury.

1921 C. Chassé, *Gauguin et le Groupe de Pont-Aven, Documents inédits,* Paris, Floury.

1921 P. Sérusier, *ABC de la peinture,* Paris, Floury.

1922 C. Chassé, 'Gauguin et Mallarmé', in *L'Amour de l'Art,* August.

1924 A. Gide, *Si le grain ne meurt,* Paris, NRF.

1925 J. de Rotonchamp, *Paul Gauguin,* Weimar, 1906; French edition, Paris, Crès, 1925.

1925 G. Kahn, 'Paul Gauguin', in *L'Art et les Artistes,* November.

1926 R. Rey, 'A propos de peintures murales exécutées par Gauguin au Pouldu', in *Bulletin de la Société de l'histoire de l'Art Français.*

1926 Dom Willibrord Verkade [Jan Verkade], *Le Tourment de Dieu. Etapes d'un moine peintre,* Paris, Librairie de l'Art Catholique.

1928 L. Tual, *Mademoiselle Julia de Pont-Aven,* Concarneau.

1934 M. Denis, 'L'Epoque du symbolisme', in *Gazette des Beaux-Arts,* March.

1935 D. Catton Rich, 'Gauguin in Arles', in *Bulletin of the Art Institute of Chicago,* March.

1936 E. Bernard, 'Le Symbolisme pictural 1886–1936', in *Mercure de France,* June.

1936 H. Hahnloser-Bühler, *Félix Vallotton et ses amis,* Paris, Sedrowski.

1937 E. Bernard, 'Gauguin et Emile Bernard', in *Le Point,* October.

1938 C. Chassé, 'De quand date le synthétisme de Gauguin?', in *L'Amour de l'Art,* April.

1938 R. J. Goldwater, *Primitivism in Modern Painting* (chapter on 'Gauguin and the School of Pont-Aven'), New York, Harper.

1938 J. Rewald, *Gauguin,* Paris, Hypérion.

1939 E. Bernard, *Souvenirs inédits sur l'artiste peintre Paul Gauguin et ses compagnons lors de leur séjour à Pont-Aven et au Pouldu,* Lorient, Imprimerie du 'Nouvelliste de Morbihan'.

1941 A. A. Wallis, *The Symbolist Painters of 1890,* New York, University Press.

1942 P. Sérusier, *ABC de la peinture,* 2nd edn, followed by 'Etude sur la vie et l'œuvre de Paul Sérusier', by M. Denis, Paris, Floury (1st edn 1921).

1943 B. Dorival, *Les Etapes de la peinture française contemporaine* (vol. I, chapter on 'Gauguin et le groupe de Pont-Aven'), Paris, Gallimard.

1943 M. Malingue, *Gauguin,* Monaco, Documents d'Art.

1945 'Gauguin et le Groupe de Pont-Aven', in *Les Horizons de France.*

1946 E. Bernard, 'Mémoire sur l'histoire du symbolisme pictural de 1890', in *Maintenant,* April.

1946 C. Chassé, 'Importance pour la Bretagne de l'Ecole de Pont-Aven', in *Nouvelle Revue de la Bretagne,* no. 2.

1946 R. Goldwater, 'Gauguin's "Yellow Christ"', in *Gallery Notes,* XI, Buffalo, Albright Art Gallery.

1946 A. Meyerson, 'Van Gogh and the School of Pont-Aven', Stockholm, *Konsthistorisk Tidskrift,* December.

1946 P. Gauguin, *Lettres de Gauguin à sa femme et à ses amis,* collected, annotated and introduced by M. Malingue, Paris, Grasset.

1947 C. Maltese, 'Gauguin e la pittura giapponese', in *Emporium,* January.

1947 C. Chassé, *Le Mouvement symboliste dans l'art du XIXᵉ siècle,* Paris, Floury.

1948 M. Malingue, *Gauguin, le peintre et son œuvre,* Paris, Presses de la Cité (foreword by Pola Gauguin).

1950 A. Rattner, I. Levy, [article on the discovery of the frescoes at Marie Henry's inn], *Life,* New York, 1 May.

1950 P. Sérusier, *ABC de la peinture,* 3rd edn, followed by *Correspondance inédite* collected by Mme P. Sérusier and annotated by H. Boutaric, Paris, Floury.

1950 D. Sutton, 'The Symbolist Exhibition in Paris', Amsterdam, *Maandblad voor Beeldende Kunsten,* July.

1950 P. Gauguin, *Lettres de Gauguin à Daniel de Monfreid,* preceded by an 'Hommage' by V. Segalen; edited and annotated by A. Joly-Segalen, Paris, Falaize (1st edn, Crès, 1918).

1950 B. Dorival, 'Un an d'activité au Musée d'Art Moderne', in *Musées de France,* December.

1951 H. P. Bowie, *On the Laws of Japanese Painting,* New York, Dover.

1951 P. Gauguin, *Racontars de rapin,* Paris, Falaize.

1953 C. Estienne, *Gauguin,* Geneva, Skira.

1954 F. Dauchot, 'Le "Christ jaune" de Gauguin', in *Gazette des Beaux-Arts,* July.

1954 P. Gauguin, *Lettres de Paul Gauguin à Emile Bernard, 1888–1891,* preface by M. A. Bernard-Fort, and extracts from *L'Aventure de ma vie,* Geneva, Cailler.

1954 H. H. Hofstätter, 'Die Entstehung des "Neuen Stils" in der französischen Malerei um 1890', Freiburg im Breisgau (doctoral thesis, duplicated).

1954 A. Humbert, *Les Nabis et leur époque (1888–1900),* Geneva, Cailler.

1954 R. Huyghe, *Paul Gauguin,* Paris, Flammarion.

1955 C. Chassé, *Gauguin et son temps,* Paris, Bibliothèque des Arts.

1955 H. Dorra, 'Emile Bernard et Paul Gauguin', in *Gazette des Beaux-Arts,* April.

1956 H. Read, 'Gauguin, Return to Symbolism', in *Art News Annual,* no. 25.

1956 J. Rewald, 'Post-Impressionism from Van Gogh to Gauguin', New York, Museum of Modern Art.

1957 W. Jaworska, 'Gauguin – Slewinski – Makowski', in *Sztuka i Krytyka,* Warsaw, nos. 3–4.

1957 P. Mornand, *Emile Bernard et ses amis,* Geneva, Cailler.

1958 G. Wildenstein, ed. 'Gauguin, sa vie, son œuvre'. A collection of articles, studies and historical material. Contributors: U. F. Marks Vandenbroucke, H. Rostrup, Y. Thirion, Jénot, J. Loize, G. Wildenstein, G. Le Bronnec. In *Gazette des Beaux-Arts,* Paris, January–April (special number).

1958 V. van Gogh. *The Complete Letters of Vincent van Gogh,* London, Thames and Hudson, and Greenwich, Conn., New York Graphic Society. See 1960.

1958 R. Puig, *Gauguin, de Monfreid et leurs amis,* Perpignan, Editions de la Tramontane.

1959 C. Chassé, 'Le Sort de Gauguin est lié au krach de 1882', in *Connaissance des Arts,* Paris, February.

1959 M. Bodelsen, 'The Missing Link in Gauguin's Cloisonism', in *Gazette des Beaux-Arts,* May-June.

1959 F. Hermann, 'Die "Revue Blanche" und die Nabis', Zurich (doctoral thesis, duplicated).

1959 S. Lövgren, *The Genesis of Modernism. Seurat, Gauguin, Van Gogh and French Symbolism in the 1880s,* Stockholm, Almquist & Wiksell.

1959 M. Malingue, 'Du nouveau sur Gauguin', in *L'Œil,* nos. 55–56.

1959 H. R. Rookmaaker, *Synthetist Art Theories. Genesis and Nature of the Ideas on Art of Gauguin and his Circle,* Amsterdam, Swet & Zeitlinger.

1960 C. Chassé. *Les Nabis et leur temps,* Paris, Bibliothèque des Arts.

1960 J. Cassou, E. Langui and N. Pevsner, *The Sources of Modern Art,* London, Thames and Hudson.

1960 V. van Gogh. *Correspondance complète de Vincent van Gogh,* Paris, Gallimard, Grasset. English translation, see 1958.

1960 J. Leymarie, *Paul Gauguin – aquarelles,*

pastels et dessins en couleurs, Basle, Phœbus.

1960 *Les sources du XX^e siècle. Les arts en Europe de 1884 à 1914*, Paris, Musée national d'Art moderne.

1961 T. Makowski, *Journal*, Warsaw, PIW.

1962 Y. Dautier, 'A propos de quelques collections bretonnes. Sérusier et les peintres du Groupe de Pont-Aven', Rennes (diploma thesis, duplicated).

1963 P. Gauguin, *Cahier pour Aline*, complete facsimile edited by S. Damiron, Paris, Société des Amis de la Bibliothèque d'Art et d'Archéologie de l'Université de Paris.

1964 Bacon, 'Décors d'appartements au temps des Nabis', in *Art de France*.

1965 C. Chassé, *Gauguin sans légendes*, Paris, Editions du Temps.

1966 W. Jaworska, 'The Problems of Pont-Aven', in *Apollo*, London, May.

1966 W. Jaworska, 'Ze Studiow nad Szkola Pont-Aven', in *Rocznik Historii Sztuki*, Warsaw, vol. VI (summary in French).

1968 F. Cachin, *Gauguin*, Paris, Le Livre de Poche.

1969 G. L. Mauner, 'Gauguin of the School of Pont-Aven. Concerning the attribution of two panels in Stockholm', in *Gazette des Beaux-Arts*, Paris, November.

Manuscripts

Letters from Filiger to O'Conor, private collection, Chemillé.
Letters from Filiger to Jean Corronc, Jean Corronc collection, Lorient.
L. Palaux, 'Quelques hôtes illustres au Pouldu', Palaux family collection.
'Souvenirs dictés par Marie Henry, écrits par Henri Mothéré, concernant les peintres de Pont-Aven et la vie dans l'auberge du Pouldu', Cochennec family collection, Rosporden.
Letters from Séguin to O'Conor (1895–1903), private collection, London.

IV INDIVIDUAL PAINTERS

LOUIS ANQUETIN

1905 E. Bernard, 'Louis Anquetin', in *La Rénovation Esthétique*, September.

1923 P. Ladoué, 'Louis Anquetin', in *L'Art et les Artistes*.

1933 E. Bernard, 'Louis Anquetin', in *L'Art et les Artistes*.

1934 E. Bernard, 'Louis Anquetin', in *Gazette des Beaux-Arts*, February.

1969 G. Busch, 'Louis Anquetin, "Der Windstoss auf der Seinebrücke"', in *Neue Zürcher Zeitung*, 2 November.

MOGENS BALLIN

1936 P. Schindler, *M. F. Ballin*, Copenhagen.

1947 *Weilbach's Kunstnerleksikon*, vol. I, Copenhagen.

ÉMILE BERNARD

1891 J. Daurelle, 'Chez les jeunes peintres', in *L'Echo de Paris*, 28 December (interview with E. Bernard).

1893 F. Jourdain, 'Notes sur le peintre Emile Bernard', in *La Plume*, p. 392.

1901 C. Anet, 'Œuvre d'Emile Bernard', in *La Revue Blanche*, no. 194.

1904 E. Bernard, 'Odilon Redon', in *L'Occident*, May.

1904 E. Bernard, 'Paul Cézanne', in *L'Occident*, July.

1905 From May 1905 to June 1910 Emile Bernard was the editor of *La Rénovation Esthétique*. To sign the articles he wrote for it he used either his own name or one of his pseudonyms, J. Dorsal, F. Lepeseur, F. L., H. Lebreton, etc. See: 'Paul Gauguin et Vincent van Gogh', May–October 1905; 'Documents pour l'histoire du symbolisme pictural en France', October–December 1906; 'Souvenirs', November 1907, April 1909.

1906 L. de Monguerre, 'Les Artistes rénovateurs – Emile Bernard', in *La Rénovation Esthétique*, March.

1907 E. Lormel, 'L'Individualisme et l'école traditionaliste', in *La Rénovation Esthétique*, August.

1909 M. Marten, 'Sur l'œuvre d'Emile Bernard', in *Vers et Prose*, vol. XVIII.

1910 E. Bernard, *L'Esthétique fondamentale et traditionnelle d'après les maîtres de tous les temps*, Paris.

1912 P. Jamot, 'Emile Bernard', in *Gazette des Beaux-Arts*.

1917 P. Jamot, 'Emile Bernard illustrateur', in *Gazette des Beaux-Arts*.

1920 E. Bernard, 'De l'impressionnisme et du symbolisme à l'art classique' (lecture delivered at the Hôtel Jean Charpentier, Paris, 4 January).

1924 E. Bernard, 'Souvenirs sur van Gogh', in *L'Amour de l'Art*, December.

1925 L. Gentina, *Emile Bernard e il ciclo umano*, Venice.

1926 Ciolkowski, 'Emile Bernard', in *L'Art et les Artistes*, May.

1939 P. Mornand, 'Emile Bernard, peintre et poète de l'amour mystique et charnel', in *Courrier Graphique*, June.

1942 *Lettres à Emile Bernard*, Brussels.

1943 M. Denis, 'Hommage à Emile Bernard' (unpublished text of a lecture delivered in Paris, in Bernard's studio, 4 July).

1944 C. Mauclair, 'Introduction pour la rétrospective E. Bernard' (unpublished).

1946 F. de la Flicke, 'Emile Bernard', in *Horizon, revue des lettres*, Nantes.

1946 M. Malingue, 'Emile Bernard, cet initiateur', in *Les Arts et les Lettres*, July.

1947 Auriant, 'Souvenirs sur Emile Bernard', in *Maintenant*, no. 7.

1952 E. Bernard, 'L'Affaire Vincent', in *Cahiers d'Art – Documents*, nos. 16–17.

1952 'Relations d'Emile Bernard avec Toulouse-Lautrec', in *Cahiers d'Art – Documents*, no. 18.

1952 'Les Archives d'Emile Bernard', in *Cahiers d'Art – Documents*, no. 21.

1952 'Les Archives d'Emile Bernard: Mémoire pour l'histoire du symbolisme en 1890', in *Cahiers d'Art – Documents*, nos. 26-8, 33, 1952–53.

1954 *Lettres de Paul Gauguin à Emile Bernard 1888–1891*, preface by M. A. Bernard-Fort, with extracts from *L'Aventure de ma vie*, Geneva, Cailler.

1955 H. Dorra, 'Emile Bernard et Paul Gauguin', in *Gazette des Beaux-Arts*, April.

1957 H. Perruchot, 'Emile Bernard et Cézanne', in *Jardin des Arts*, 27 January.

1957 H. Perruchot, '12, rue Cortot', in *Pensée Française*, 15 February.

1957 P. Mornand, *Emile Bernard et ses amis*, Geneva, Cailler.

1958 F. Jourdain, 'Emile Bernard, le bon génie de Gauguin', in *Connaissance des Arts*, no. 78.

1959 G. Carré, 'Exposition exceptionnelle de quelques œuvres d'Emile Bernard', in *L'Indépendant de Perpignan*, 7 January.

1959 'Emile Bernard', documentation collected and arranged by P. Cailler, in *Cahiers d'Art – Documents*, no. 100.

1959 Emile Bernard, 'Sur l'art de notre temps et des autres', MSS, E. Bernard family collection.

1963 J. Rewald, 'Emile Bernard', in *Nouveau Dictionnaire de la peinture moderne*, Paris, Hazan.

J. J. Luthi, *Emile Bernard l'initiateur*, Geneva, Cailler (forthcoming).

H. ERNEST PONTHIER DE CHAMAILLARD

1901 C. Morice, 'Chamaillard', in *Mercure de France*, p. 728.

1901 F. Fagus, 'Un meuble de Chamaillard', in *La Revue Blanche*, no. 182.

1914 G. Apollinaire, 'Préface à l'exposition de Chamaillard', MS, R. Guyot collection, Clohars-Carnoët (the outbreak of war prevented the exhibition from taking place). See W. Jaworska, 'Guillaume Apollinaire et Ernest de Chamaillard. Présentation d'un manuscrit inédit' (with complete text), in *La Revue des Lettres Modernes (Série G. Apollinaire)*, Paris 1968.

1925 A. Salmon, 'Chamaillard et le Groupe de Pont-Aven', in *L'Art Vivant*, July.

1932 A. Salmon, 'L'Ecole de Pont-Aven. A l'occasion de la mort de Chamaillard', in *L'Art d'aujourd'hui*, I, pp. 98–116, 280–300.

MAURICE DENIS

1890 M. Denis, 'Définition du néo-tradition-nisme', in *Art et Critique*, 23 and 30 August.

1891 J. Daurelle, 'Chez les jeunes peintres', in *Echo de Paris*, 28 December.

1904 M. Denis, 'Lettre', in *Mercure de France*, January.

1904 M. Voloshin, 'Salon d'Automne. Maurice Denis', in *Viessy*, St Petersburg, no. 12.

1910 A. Alexandre, 'Un peintre mystique au Moyen-Age – Maurice Denis', in *L'Art et les Artistes*.

1912 M. Denis, *Théories, 1890–1910. Du symbolisme et de Gauguin vers un nouvel ordre classique*, Paris, Bibliothèque de l'Occident.

1922 M. Denis, *Nouvelles théories sur l'art moderne, sur l'art sacré (1914–21)*, Paris, Rouart et Watelin.

1924 F. Fosca, *Maurice Denis et son œuvre*, Paris, Les Peintres Français Nouveaux.

1925 M. Denis, *Aristide Maillol*, Paris, Crès.

1925 M. Denis, *Carnets de voyage en Italie 1921–22*, Paris, Beltrand.

1929 M. Brillant, *Maurice Denis*, Paris, Les Artistes Nouveaux.

1939 M. Denis, *Histoire de l'art religieux*, Paris, Flammarion.

1942 M. Denis, 'Paul Sérusier, sa vie, son œuvre', in P. Sérusier, *ABC de la peinture*, 2nd edn, Paris, Floury.

1945 S. Barazetti-Demoulin, *Maurice Denis*, Paris, Grasset.

1945 P. Jamot, *Maurice Denis*, Paris, Plon.

1945 M. Brillant, *Portrait de Maurice Denis*, Paris, Blond et Gay.

1957 M. Denis, *Journal 1884–1943* (vols. I–III), Paris, La Colombe.

1959 P. Jouve, *Notice sur la vie et les travaux de Maurice Denis*, Paris, Firmin-Didot.

1964 M. Denis, *Du symbolisme au classicisme. Théories*. Writings collected and introduced by O. Revault d'Allonnes, Paris, Hermann.

1970 A. Terrasse, *Maurice Denis. Intimités*, Paris, Bibliothèque des Arts.

CHARLES FILIGER

1894 A. Jarry, 'Filiger', in *Mercure de France*, no. 57.

1947 Auriant, 'XII lettres inédites de Charles Filiger', in *Maintenant*, no. 6.

1953 A. Breton, *La Clé des champs*, Paris, Editions du Sagittaire.

1957 T. Makowski, in *Sztuka i Krytyka*, Warsaw, nos. 3–4.

1958 A. Breton, 'Préface-Manifeste', catalogue of exhibition 'Dessins symbolistes', Paris, Galerie du Bateau-Lavoir.

1961 T. Makowski, *Journal*, Warsaw, PIW, p. 172.

1962 P. Cabanne, 'Révélation de Filiger. Ami de Gauguin et de Jarry, détient-il les clés d'un art magique?', in *Arts*, no. 890.

1962 A. Chastel, 'Deux symbolistes', in *Le Monde*, 16 November.

1965 W. Jaworska, 'Charles Filiger', in *Biuletyn Historii Sztuki*, Warsaw, no. 1.

Letters from Filiger to O'Conor, MSS, private collection, Chemillé.

Letters from Filiger to Jean Corronc, MSS, private collection, Lorient.

PAUL GAUGUIN

For books and articles on Gauguin's Breton period, see section III of this bibliography. See also:

1927 M. Guérin, *L'Œuvre gravé de Gauguin*, 2 vols., Paris, Floury.

1956 J. Rewald, *Post-Impressionism from Van Gogh to Gauguin*, New York, Museum of Modern Art.

1964 G. Wildenstein and R. Cogniat, *Paul Gauguin, Catalogue*, 2 vols., Paris, Les Beaux-Arts.

1966 M. Bodelsen, 'The Wildenstein-Cogniat Gauguin Catalogue', in *The Burlington Magazine*, London, January.

VINCENT VAN GOGH

1911 *Lettres de V. van Gogh à Emile Bernard*, Paris, Vollard.

1942 C. M. Brooks, *Vincent van Gogh. A Bibliography (1890–1940)*, New York, Museum of Modern Art.

1943 E. Schreyer, 'Far Eastern Art and French Impressionism', in *The Art Quarterly*, VI, p. 117.

1946 A. Meyerson, 'Van Gogh and the School of Pont-Aven', Stockholm, *Konsthistorisk Tidskrift*, December.

1949 G. Jedlicka, 'Vincent van Gogh. Sommerabend bei Arles', in *Hauptwerke des Kunstmuseums Winterthur*, Winterthur.

1951 W. Weisbach, 'La Berceuse', *Sonntagsblatt der Basler Nachrichten*, Basle, no. 6.

1951 W. Weisbach, *Vincent van Gogh – Kunst und Schicksal*, 2 vols., Basle, Benno Schwabe.

1952 'E. Bernard et V. van Gogh', in *Cahiers d'Art – Documents*, no. 16.

1953 E. Bernard, 'L'Enterrement de van Gogh', in *Cahiers d'Art – Documents*, no. 29.

1956 J. Rewald, *Post-Impressionism from Van Gogh to Gauguin*, New York, Museum of Modern Art.

1958 V. van Gogh, *The Complete Letters of Vincent van Gogh*, 3 vols., London, Thames and Hudson, and New York, New York Graphic Society.

1959 S. Lövgren, *The Genesis of Modernism. Seurat, Gauguin, Van Gogh and French Symbolism in the 1880's*, Stockholm, Almqvist & Wiksell.

1966 W. Jaworska, 'Van Gogh et l'Ecole de Pont-Aven', in *Rocznik Historii Sztuki*, Warsaw, vol. VI (summary in French).

1970 J. B. de La Faille, *The Works of Vincent van Gogh, his paintings and drawings*, Amsterdam, Meulenhoff International, and London, Weidenfeld & Nicolson. (Revised edition of the four-volume catalogue raisonné published in 1928.) This monumental work is the only one which includes a complete bibliography and a list of the chief exhibitions of Van Gogh's works.

JACOB MEYER DE HAAN

1952 F. Dauchot, 'Meyer de Haan en Bretagne', in *Gazette des Beaux-Arts*, no. 12.

1959 M. Malingue, 'Du nouveau sur Gauguin', in *L'Œil*, no. 55–56.

1960 J. Leymarie, 'Paul Gauguin – aquarelles, pastels et dessins en couleurs', Basle, Phoebus, p. 14.

1966 W. Jaworska, 'Jacob Meyer de Haan', in *Rocznik Historii Sztuki*, Warsaw, vol. VI (summary in French).

1967 W. Jaworska, 'Jacob Meyer de Haan', in *Nederlands Kunsthistorisch Jaarboek*, no. 18.

ÉMILE JOURDAN

1920–30 Four letters from Emile Jourdan to his son Guy, MS, Jourdan family collection.

1924 L. Tual, 'Des tableaux de Gauguin au Pouldu. (Au Restaurant de la Plage – Les amateurs éclairés – Les souvenirs du Maître Emile Jourdan – La regrettée pension Gloanec de Pont-Aven)', in *Dépêche de Brest*.

1943 F. Dauchot, 'Jourdan, peintre de Pont-Aven', in *Panorama*, 5 August.

1955 A. Humbert, 'A propos d'une nouvelle acquisition' (namely the picture *Rain at the Bois d'Amour*, by Jourdan, purchased by the Musée national d'Art moderne, Paris), *La Revue des Arts*, no. 3.

1957 T. Makowski, in *Stzuka i Krytyka*, Warsaw, no. 3–4.

GUSTAVE LOISEAU

1930 Thiébault-Sisson, *Gustave Loiseau*, Paris, Georges Petit.

MAXIME MAUFRA

1888 A. Maillard, *L'Art à Nantes*, Paris, Monnier.

1894 C. Mauclair, 'Exposition Maufra', in *Mercure de France*, no. 51.

1901 C. Saunier, 'Maxime Maufra', in *La Revue Blanche*, no. 188.

1903 C. Morice, 'Le Salon d'Automne', in *Mercure de France*, no. 168.

1908 V. E. Michelet, *Maufra peintre et graveur*, Paris, Floury.

1926 A. Alexandre, *Maufra, peintre marin et rustique, 1861–1918*, Paris, Georges Petit.

1926 E. Sarradin, 'Maufra', in *L'Art et les Artistes*, Paris.

1953 R. Cogniat, *Seurat et ses amis* (chapter: 'Maxime Maufra'), Paris.

DANIEL DE MONFREID

1903 D. de Monfreid, 'Gauguin', in *Ermitage*, December.

1938 M. Denis, Introduction to catalogue of exhibition 'Georges Daniel de Monfreid et son ami Paul Gauguin', Paris, Galerie Charpentier.

1950 *Lettres de Gauguin à Daniel de Monfreid*, prefaced with an *hommage à Gauguin* by V. Segalen; edition prepared and annotated by A. Joly-Segalen, Paris, Falaize (1st edn, Crès, 1918).

1951 J. Loize, *Les amitiés du peintre Georges Daniel de Monfreid et ses reliques de Gauguin*, Paris.

1958 R. Puig, *Gauguin, De Monfreid et leurs amis*, Perpignan, Editions de la Tramontane.

HENRY MORET

1904 C. Morice, 'Exposition de M. Henry Moret. Galerie Durand-Ruel', in *Mercure de France*, no. 172.

1937 R. Maurice, 'Henri Moret', in *Nouvelliste du Morbihan*, 20 August.

RODERIC O'CONOR

1895–1903 Letters from Armand Séguin to O'Conor 1895–1903, MSS, private collection, London.

1908 W. S. Maugham, *The Magician*, London, Heinemann.

1915 W. S. Maugham, *Of Human Bondage*, London.

1932 A. Bennett, *The Journals* (pp. 225, 230, 234), London, Desmond Flower.

1956 J. Russell, 'O'Conor', in *The Sunday Times*, 15 April.

1956 C. Bell, *Old Friends*, London, Chatto and Windus, pp. 163–7.

1960 D. Sutton, 'Roderic O'Conor', in *The Studio*, November, no. 811.

1963 W. Buchanan, *James Wilson Morrice – A Biography*, London, pp. 32, 212, 239.

1964 T. Mullaly, 'Motion in Colours of O'Conor and Adams', in *The Daily Telegraph*, 8 April.

ÉMILE SCHUFFENECKER

1888 Letter from Schuffenecker to Gauguin, 11 December, MS, Pola Gauguin collection.

1893 Letter from Louis Roy to Schuffenecker, 26 December, MS, private collection, Paris.

1906 C. Morice, 'Le XXIIᵉ Salon des Indépendants', in *Mercure de France*, no. 212.

1934 C. Kunstler, 'Emile Schuffenecker', in *L'Intransigeant*, 14 February.

1935 E. Deverin, 'Un ami de Gauguin: Schuffenecker', in *Les Marges*, no. 215.

1935 E. Campagnac, 'Paul Gauguin et Emile Schuffenecker', in *Le Matin*, 10 February.

1935 M. Boudot-Lamotte, 'Le peintre et collectionneur Emile Schuffenecker', in *L'Amour de l'Art*.

ARMAND SÉGUIN

1893 T. Natanson, 'IXᵉ exposition de la Société des Artistes Indépendants', in *La Revue Blanche*, no. 18.

1895 C. Mauclair, 'Choses d'art', in *Mercure de France*, no. 63.

1895 P. Gauguin, 'Armand Séguin. Préface inédite au catalogue de l'exposition des œuvres d'Armand Séguin', in *Mercure de France*, February.

1895 T. Natanson, 'Armand Séguin', in *La Revue Blanche*, no. 41.

1895 M. Denis, 'A propos de l'exposition Séguin', in *La Plume*, March.

1895–1903 Letters from Armand Séguin to O'Conor, 1895–1903, private collection, London.

1903 A. Séguin, 'Paul Gauguin', in *L'Occident*, nos. 16 and 18.

1904 L. A. Bertrand, *Gaspard de la nuit. Fantaisies à la manière de Rembrandt et de Callot, illustré par 213 bois d'Armand Séguin*, Paris, Vollard.

1963 Catalogue, 'Die Nabis und ihre Freunde', Mannheim, Kunsthalle, 1963–64 (see no. 227, fan by Séguin).

PAUL SÉRUSIER

1893 T. Natanson, 'Un groupe de peintres chez Le Barc de Boutteville', in *La Revue Blanche*, no. 25.

1894 G. Zapolska, [Paris letter], in *Przeglad Tygodniowy*, Warsaw, no. 30. See also J. Czachowska, in *Sztuka i Krytyka*, Warsaw, no. 3–4.

1896 A. Mellerio, *Le Mouvement idéaliste en peinture* (chapter on 'Paul Sérusier'), Paris, Floury.

1900 G. Zapolska, Preface to catalogue of exhibition of collection of G. Zapolska, Lwow, TPSP (in Polish).

1906 C. Morice, 'Le XXIIᵉ Salon des Indépendants', in *Mercure de France*, no. 212.

1914 P. Fierencs, 'Sérusier', in *Durandal*, April.

1920 E. de Thubert, 'Sérusier', in *La Douce France*, February.

1921 Didier Lenz (Father Desiderius), *Les saintes mesures* (tr. by Sérusier), Paris (republished 1942).

1927 C. Chassé, 'Paul Sérusier', in *L'Art et les Artistes*.

1927 M. and A. Leblond, 'Sérusier', in *L'Art Vivant*, 6 November.

1932 E. de Thubert, 'Sérusier', in *Art et Decoration*.

1937 J. Dupont, 'Sérusier', in *Art Sacré*, January.

1938 C. Escholier, 'Sérusier' (thesis, Ecole du Louvre).

1942 P. Sérusier, *ABC de la peinture*, 2nd edn, followed by 'Etude sur la vie et l'œuvre de Paul Sérusier' by M. Denis, Paris, Floury.

1942 C. Estienne, 'Sérusier et le Père Verkade', in *Beaux-Arts*, 30 December.

1950 P. Sérusier, *ABC de la peinture*, 3rd edn, followed by *Correspondance inédite* collected by Mme P. Sérusier, with notes by H. Boutaric, Paris, Floury.

1961 W. Jaworska, 'Sérusier au Musée National de Varsovie', in *Bulletin du Musée National de Varsovie*, Warsaw, no. 4.

1962 Y. Dautier, 'A propos de quelques collections bretonnes. Sérusier et les peintres du Groupe de Pont-Aven', Rennes (thesis, typescript).

M. Guichetou, *Paul Sérusier*, Geneva, Cailler (forthcoming).

WLADYSLAW SLEWINSKI

1897 G. T., 'L'exposition Slewinski', in *Le Temps*, no. 30.

1904 M. Voloshin, 'Salon d'Automne. Slewinski', St Petersburg, *Viessy*, no. 12.

1904 A. Potocki, 'Les Indépendants', in *Sztuka*, Paris, no. 1.

1904 W. Slewinski, letter to the editor on Gauguin, in *Sztuka*, Paris, no. 1.

1908 Letter from Slewinski to O'Conor, Munich, 8 January 1908, MS, private collection, Chemillé.

1928 T. Czyzewski, *Wladyslaw Slewinski*, Warsaw, Gebethner & Wolf.

1949 D. Sutton, 'The Paul Gauguin Exhibition', London, *The Burlington Magazine*, October.

1961 T. Makowski, *Journal*, Warsaw, PIW.

1961 Z. Kepinski, *Polski Impresjonizm*, Warsaw, Arkady.

1962 M. Fijalkowski [*Sourires des années passées*], Katowice, Slask.

1966 I. Grzesiuk, typescript thesis on the still-lifes of W. Slewinski, University of Warsaw.

Articles published in Poland

1897 J. Krakow, 'Wladyslaw Slewinski', in *Przeglad Tygodniowy*, Cracow, no. 27.

1906 Viator, 'Wladyslaw Slewinski', in *Slowo Polskie*, Warsaw, no. 53.

1907 G. Gwozdecki, 'Slewinski', in *Nasz Kraj*, Lwow, vol. III.

1907 Kasprowicz, letter to Slewinski, preface to cat. of exhibition at Lwow.

1908 A. Potocki, 'Wladyslaw Slewinski', in *Sztuki Piekne*, Warsaw, I.

1925 J. Kleczynski, 'Corot i Slewinski', in *Kurier Warszawki*, Warsaw, 20 September.

1925 W. Husarski, 'Wladyslaw Slewinski', in *Wiadomosci Literackie*, Warsaw, no. 37.

1925 K. Winkler, 'Wladyslaw Slewinski', in *Kurier Poranny*, Warsaw, no. 259.

1925 S. Popowski, 'Wladyslaw Slewinski', Warsaw. Guide to the exhibition.

1925 K. Maszkowski, 'Chez Madame Charlotte', in *Sztuki Piekne*, Warsaw, II.

1927 T. Dobrowolski, 'Wl. Slewinski', in *Ilustrowany Kurier Codzienny*, Cracow, no. 44; *Kurier Literacko-Naukowy*, no. 7.

1935 T. Czyzewski, 'Wladyslaw Slewinski', in *Glos Plastykow*, Cracow, nos. 1–6.

1935 K. Mitera, 'Wladyslaw Slewinski', in *Glos Plastykow*, Cracow, nos. 1–6.

1935 A. Potocki, 'Wladyslaw Slewinski', in *Glos Plastykow*, Cracow, nos. 1–6.

1966 A. Markowski, 'Wladyslaw Slewinski', in *Ty i ja*, Warsaw, no. 11.

JAN VERKADE

1920 Dom Willibrord Verkade [Jan Verkade], *Die Unruhe zu Gott. Erinnerungen eines Malermönchs*, Freiburg im Breisgau, Herder; Fr. tr. *Le tourment de Dieu. Etapes d'un moine peintre*, Paris, Rouart et Watelin, 1923; 2nd edn, Paris, Librairie de l'Art Catholique, 1926.

1921 R. P. Kreitmaier, S. J., *Beuroner Kunst*, Freiburg im Breisgau.

1924 L. Gongand, 'Les Etapes religieuses d'un maître peintre', in *La Vie et les Arts Liturgiques*.

1932 Father Gallus Schwind, *P. Desiderius Lenz*, Beuron, Kunst Verlag.

1933 Dom Willibrord Verkade [Jan Verkade], *Der Antrieb ins Vollkommene. Erinnerungen eines Malermönchs*, Freiburg im Breisgau, Herder.

1942 C. Estienne, 'Sérusier et le Père Verkade', in *Gazette des Beaux-Arts*, December.

1949 B. Dorival, 'Le portrait de Dom Verkade par Maurice Denis', in *Musées de France*.

1954 E. Endrich, *P. Willibrord Verkade und die Nabis*, postscript to *Die Unruhe zu Gott*, new edn, Beuron, Kunst Verlag.

1956 L. Gans, 'Jan Verkade... 1891–1910', in *Nederlands Kunsthistorisch Jaarboek*, no. 7.

JENS FERDINAND WILLUMSEN

1918 P. Gauguin, 'Lettre de Gauguin à Willumsen, Pont-Aven 1890', in *Les Mages*, 15 March. (Reproduced in appendix of S. Lövgren, *The Genesis of Modernism*.)

1946 M. Kruuse, *J. F. Willumsen*, Copenhagen.

1957 M. Bodelsen, *Willumsen in Paris*, Copenhagen, Gads Forlag.

1953 J. F. Willumsen, memoirs, Copenhagen.

1958 O. Holaas, 'J. F. Willumsen', in *Kunsten Idag*, XLIV, Oslo.

1962 S. Schultz, *J. F. Willumsens Museum*, Catalogue, Frederikssund.

V THEORETICAL, PHILOSOPHICAL AND HISTORICAL LITERATURE CONNECTED WITH THE SYMBOLIST EPOCH

1819 A. Schopenhauer, *Die Welt als Wille und Vorstellung*. 1819; *Le monde comme volonté et comme représentation*, Paris, Alcan, 1888–90.

1863 J. Matter, *Emmanuel de Swedenborg . Sa vie, ses écrits et sa doctrine*, Paris, Didier.

1880 E. Taboureux, 'Claude Monet', in *La Vie Moderne*, 12 June.

1883 J.-K. Huysmans, *L'Art moderne*, Paris, Plon.

1886 J. Moréas, 'Le Symbolisme', in *Figaro Littéraire*, 18 November (the Symbolists' manifesto).

1888 S. Bing, *Le Japon artistique. Documents d'art et d'industrie*, Paris.

1888 E. Verhaeren, 'L'Exposition des XX à Bruxelles', in *Revue Indépendante*, March.

1889 J.-K. Huysmans, *Certains*, Paris, Tresse et Stock.

1889 G. Kahn, 'L'Art français à l'Exposition', in *Vogue*, no. 2.

1889 J. Moréas, *Les premières armes du symbolisme*, Paris.

1889 C. Morice, *La Littérature de tout à l'heure*, Paris, Perrin.

1889 E. Schuré, *Les grands Initiés*, Paris, Perrin.

1890 G. d'Alviella, 'La migration des symboles', in *Revue des Deux Mondes*, LX.

1891 J. Leclercq, 'Aux Indépendants', in *Mercure de France*, May.

1892 W. G. C. Byvanck, *Un Hollandais à Paris en 1891*, Paris, Perrin.

1892 F. Fénéon, 'Rose-Croix', in *Le Chat-Noir*, 19 March.

1892 A. Germain, 'L'Idéal et l'idéalisme. Salon de la Rose-Croix', in *L'Art et l'Idée*.

1892 R. de Gourmont, 'Le Symbolisme', in *La Revue Blanche*, no. 9.

1892 P. Valin, 'Ceux de demain. Les jeunes et leurs revues', in *L'Art et l'Idée*.

1895 E. Schuré, *Richard Wagner. Son œuvre et son idée*, Paris, Perrin.

1895 T. de Wyzewa, *Nos maîtres. Etudes et portraits littéraires*, Paris, Perrin.

1896 F. Delphi, *Les Peintres en Bretagne*, Paris, Editions de l'Art et des Auteurs.

1896 R. de Gourmont, *Le Livre des masques*, Paris, Mercure de France (1896–8).

1898 H. Lichtenberger, *Richard Wagner poète et penseur*, Paris, Alcan.

1898 J. Meier-Graefe, *Félix Vallotton*, Paris, Sagot.

1899 A. Symons, *The Symbolist Movement in Literature*, London, Heinemann.

1901 J.-K. Huysmans, *A rebours*, Paris, Bibliothèque Charpentier, 1901; new edn, Charpentier-Fasquelle, 1929.

1901 H. de Régnier, *Figures et caractères*, Paris, Mercure de France.

1902 G. Kahn, *Symbolisme et décadents*, Paris.

1903 S. Bing, 'L'Art Nouveau', in *The Craftsman*, vol. V, October.

1903 T. de Wyzewa, *Peintres de jadis et d'aujourd'hui*, Paris, Perrin.

1906 R. Richter, *Kunst und Philosophie bei Richard Wagner*, Leipzig, Meyer.

1907 J. Meier-Graefe, *Impressionisten*, Munich-Leipzig, Piper.

1907 J. Peladan, *Les Idées et les formes. Introduction à l'esthétique*, Paris, Sansot.

1908 V. Pica, *Gli impressionisti francesi*, Bergamo.

1911 A. Barre, *Le Symbolisme. Essai historique sur le mouvement symboliste en France de 1885 à 1900*, Paris, Jouve.

1919 J. et G. Bernheim, *L'Art moderne et quelques aspects de l'art d'autrefois*, poems by H. de Régnier, appreciations by L. Cousturier, T. Natanson, O. Mirbeau, E. Faure. Published by F. Fénéon, Paris, Bernheim-Jeune.

1919 A. Poizat, *Le Symbolisme de Baudelaire à Claudel*, Paris, Renaissance du Livre.

1920 L. Daudet, *Souvenirs des milieux littéraires* (vol. I: *Salons et journaux*), Paris, Nouvelle Librairie Nationale.

1921 G. Mourey, *Essai sur l'art décoratif français moderne*, Paris, Ollendorf.

1922 E. Cassirer, 'Der Begriff der symbolischen Form im Aufbau der Geisteswissenschaften' (lecture), Berlin, Warburg-Institut.

1922 A. Fontainas, L. Vauxcelles and A. George, *Histoire générale de l'art français de la Révolution à nos jours* (vol. I, chapter on the Pont-Aven group), Paris, Librairie de France.

1922–4 O. Mirbeau, *Des artistes*, Paris, Flammarion (vols. I–II).

1923 T. Duret, *Les Peintres impressionnistes*, Paris, Floury.

1924 J. Wesley Beatty, *The Modern Art Movement*, Pittsburgh, Carnegie Institute.

1925 E. Michalski, 'Die entwicklungsgeschichtliche Bedeutung des Jugendstils', in *Repertorium für Kunstwissenschaft*, Berlin, vol. 46.

1926 M. O. Maus, *Trente années de lutte pour l'art, 1884–1914*, Brussels, Librairie de l'Oiseau Bleu.

1927 E. Cassirer, 'Das Symbolproblem und seine Stellung im System der Philosophie', in *Zeitschrift für Aesthetik*, vol. XXI.

1927 J. Charpentier, *Le Symbolisme*, Paris, Les Arts et les Livres.

1928 A. Antoine, *Mes souvenirs sur le Théâtre Antoine et sur l'Odéon*.

1928 J. E. Blanche, *De Gauguin à la revue nègre*, Paris.

1928 A. Fontainas, *Mes souvenirs du symbolisme*, Paris, NRF.

1929 A. Basler et C. Kunstler, *La peinture indépendante en France*, Paris, Crès.

1929 S. Zahorska, 'Die Umwertung des Impressionismus', in *Zeitschrift für Ästhetik und Kunstwissenschaft*.

1930 E. R. Jaensch, *Über den Aufbau des Bewusstseins*, Leipzig, Barth.

1930 A. F. Lugné-Poë, *La Parade. Souvenirs et impressions de théâtre* (I. *Le sot du tremplin*; II. *Acrobaties*; III. *Sous les étoiles*), Paris, Gallimard, 1930–3.

1931 R. Rey, *La Renaissance du sentiment classique dans la peinture française à la fin du XIXe siècle. Degas, Renoir, Gauguin, Cézanne, Seurat*, Paris.

1932 P. Chauveau, *Alfred Jarry, ou La Naissance, la vie et la mort du Père Ubu*, Paris, Mercure de France.

1936 J. Renard, *Journal*, Paris, Gallimard.

1936 E. Bonniot, 'Les Mardis de Mallarmé', in *Les Marges*, 10 January.

1936 A. Jaulme et H. Moncel, *Le Mouvement symboliste. Etude bibliographique et iconographique*, Paris, Bibliothèque Nationale.

1936 A. Marie, *La Forêt symboliste*, Paris, Firmin-Didot.

1936 I. Knox, *The Aesthetic Theories of Kant, Hegel and Schopenhauer*, New York, Columbia.

1937 P. Francastel, *L'Impressionnisme. Les ori-*

gines de la peinture moderne de Monet à Gauguin, Paris, Les Belles-Lettres.

1937 A. Vollard, *Souvenirs d'un marchand de tableaux*, Paris, Albin Michel.

1938 T. R. Bowie, 'Relationship between French Literature and Painting in the XIX Century'. Catalogue of an exhibition, Columbus Gallery of Fine Arts, Ohio, April–May.

1938 J. Rewald, *Maillol*, Paris, Hypérion.

1939 A. S. Hartrick, *A Painter's Pilgrimage through Fifty Years*, Cambridge University Press.

1939 'Suzanne Valadon par elle-même', in *Prométhée*, March.

1939 P. Valéry, *Existence du symbolisme*, Maestricht, Stols.

1939 L. Venturi, *Les Archives de l'Impressionnisme*, Paris – New York, Durand-Ruel (2 vols.).

1939 G. Woolley, *R. Wagner et le symbolisme français*, Paris, PUF.

1941 C. Chassé, 'La Bretagne et l'art. Visages de la Bretagne', in *Horizons de France*.

1941 H. Mondor, *Vie de Mallarmé*, Paris, Gallimard.

1942 L. Hautecœur, *Littérature et peinture en France*, Paris, Colin.

1943 C. M. Bowra, *The Heritage of Symbolism*, London, Macmillan.

1944 R. Dupouy, *La Peinture en Bretagne au cours des XIXᵉ et XXᵉ siècles*, Paris, Les Belles-Lettres.

1944 P. Fort, *Mes mémoires 1872–1944*, Paris, Flammarion.

1944 F. Francavilla, *Il simbolismo*, Milan, Ultra.

1944 U. E. Johnson, *Ambroise Vollard – Editeur. An Appreciation and Catalogue*, New York.

1945 S. Johansen, *Le Symbolisme. Etude sur le style des symbolistes*, Copenhagen, Munksgaard.

1946 J. Rewald, *The History of Impressionism*, New York, Museum of Modern Art.

1946 F. Vallotton, *La Vie meurtrière*, Geneva-Paris.

1947 G. Bazin, *L'Epoque impressionniste*, Paris, Tisné.

1948 F. Fénéon, *Œuvres*, introduction by Jean Paulhan, Paris, Gallimard.

1948 U. Christoffel, *Malerei und Poesie. Die symbolistische Kunst des XIX. Jahrhunderts*, Vienna.

1948 T. Natanson, *Peints à leur tour*, Paris, Albin Michel.

1948 E. Puckett-Martin, 'The Symbolist Criticism of Painting. France 1880–95', Bryn Mawr College (thesis).

1949 J. E. Blanche, *La Pêche aux souvenirs*, Paris, Flammarion.

1949 F. B. Blanshard, *Retreat from Likeness in the Theory of Painting*, New York, Columbia University Press.

1949 M. Florisoone, 'Carrière et le symbolisme français', Paris (preface to exhibition catalogue).

1949 C. E. Gauss, *The Aesthetic Theories of French Artists. 1855 to the Present*, Baltimore, Johns Hopkins.

1949 N. Pevsner, *Pioneers of Modern Design from William Morris to Walter Gropius*, New York, Museum of Modern Art.

1949 M. Raynal, *De Baudelaire à Bonnard*, Geneva, Skira.

1950 J. Gengoux, *Le Symbolisme de Mallarmé*, Paris, Niger.

1950 E. H. Gombrich, *The Story of Art*, London–New York, Phaidon.

1950 A. G. Lehmann, *The Symbolist Aesthetic in France 1885–95*, Oxford, Blackwell.

1950 C. Pissarro, *Lettres à son fils Lucien*, Paris, Albin Michel.

1950 A. M. Schmidt, *La Littérature symboliste (1870–1900)*, Paris, PUF.

1950 L. Venturi, *Impressionists and Symbolists*, New York, Scribner.

1950 D. Wild, *Moderne Malerei. Ihre Entwicklung seit dem Impressionismus, 1880–1950*, Zurich, Büchergilde.

1951 K. Cornell, *The Symbolist Movement*, New Haven, Yale Romantic Studies, II.

1951 P. Francastel, *Peinture et société. Naissance et destruction d'un espace plastique. De la Renaissance au cubisme*, Lyon, Audin.

1951 A. M. Hammacher, 'Symbolisme en Abstractie', in *De Groene Amsterdammer*.

1951 H. F. Lenning, *Art Nouveau*, The Hague, Martinus Nijhoff.

1951 B. S. Myers, 'Development of Modern Art – Symbolism,' in *American Artist*, November.

1951 T. Natanson, *Le Bonnard que je propose*, Geneva, Cailler.

1951 H. Sedlmayr, *Verlust der Mitte. Die bildende Kunst des XIX. und XX. Jahrhunderts als Symptom und Symbol der Zeit*, Salzburg.

1952 C. Lancaster, 'Oriental Contribution to Art Nouveau', in *Art Bulletin*, XXXIV, no. 4.

1952 E. P. Martin, *The Symbolist Critics of Painting in France*, University of Michigan.

1952 F. Novotny, *Die grossen französischen Impressionisten. Ihre Vorläufer und ihre Nachfolger*, Vienna, Schroll.

1952 H. Read, *The Philosophy of Modern Art*, London, Faber.

1952 L. Venturi, 'Prémisses théoriques de l'art moderne', in *Preuves*, II.

1953 E. Cassirer, *The Philosophy of Symbolic Forms*, New Haven, Yale University Press (vols. I-II, 1953-6).

1953 K. Jaspers, *Strindberg und van Gogh. Versuch einer pathologischen Analyse unter vergleichender Heranziehung von Swedenborg und Hölderlin*, Berlin.

1954 A. H. Barr, Jr. *Masters of Modern Art*, New York, Museum of Modern Art.

1954 R. Cogniat, *Histoire de la peinture* (vol. II), Paris, Nathan.

1954 D. Cooper, *The Courtauld Collection of Paintings, Drawings, Engravings and Sculpture*, London.

1954 W. Haftmann, *Malerei im 20. Jahrhundert*, Munich, Prestel.

1954 H. Meyer, 'Rilkes Cézanne-Erlebnis', in *Jahrbuch für Aesthetik und allgemeine Kunstwissenschaft*, Bonn.

1955 G. Michaud, *La Doctrine symboliste*. Paris, Nizet, Documents.

1955 E. Panofsky, *Meaning in the Visual Arts*, Garden City, N. Y., Doubleday.

1955 B. Polak, *Het Fin-de-siècle in de Nederlandse Schilderkunst. De symbolistische Beweging 1890-1900*, The Hague, Martinus Nijhoff.

1956 C. Baudelaire, *Œuvres complètes*, 1 vol., Paris, Gallimard.

1956 E. and J. de Goncourt, *Journal. Mémoires de la vie littéraire*, complete text edited and annotated by Robert Ricatte, Paris, Flammarion-Fasquelle.

1956 S. T. Madsen, *Sources of Art Nouveau*, New York, Wittenborn.

1956 T. Munro, 'Suggestion and Symbolism in Art', *Journal of Aesthetics and Art Criticism*, New York, XV, no. 2.

1957 J. Scherer, *Le 'Livre' de Mallarmé. Première recherches*, preface by H. Mondor, Paris, Gallimard.

1957 P. Selz, *German Expressionist Painting*, Berkeley, University of California Press.

1958 P. Delsemme, *Un théoricien du symbolisme, Charles Morice*, Paris, Nizet.

1959 J. Lethève, *Impressionnistes et symbolistes devant la presse*, Paris, Colin.

1959 P. Selz, *Art Nouveau. Art and Design at the Turn of the Century*, New York, Museum of Modern Art.

1959 E. Souffrin-Le Breton, 'La Rencontre de Wilde et de Mallarmé', in *Revue de Littérature Comparée*, October–December.

1960 M. Decaudin, *La Crise des valeurs symbolistes*, Toulouse, Privat.

1960 W. Hoffmann, *Das irdische Paradies. Kunst im neunzehnten Jahrhundert*, Munich.

1960 A. G. Lehmann, 'Un aspect de la critique symboliste', in *Cahiers de l'Association Internationale des Etudes Françaises*, no. 12.

1961 C. R. Hausman, 'Art and Symbol', in *The Review of Metaphysics*, New Haven, December.

1961 O. Redon, *A soi-même. Journal (1867–1915)*, Paris, Corti.

1963 C. Bouleau, *Charpentes. La géometrie secrète des peintres*, Paris, Seuil. English edn, *The Painter's Secret Geometry*, London and New York 1963.

1963 H. H. Hofstätter, *Geschichte der europäischen Jugendstilmalerei*, Cologne, DuMont Schauberg.

1963 J. Starzynski, 'Delacroix, Baudelaire et l'art du XXᵉ siècle', in *Médiations*, no. 6.

1964 *Mallarmé – Whistler. Correspondance*, collected, arranged and annotated by C. P. Barbier, Paris, Nizet.

1965 A. Breton, *Le Surréalisme et la peinture*, Paris, Gallimard.

1965 H. H. Hofstätter, *Symbolismus und die Kunst der Jahrhundertwende*, Cologne, DuMont Schauberg.

1970 F. Fénéon, *Œuvres plus que complètes*, ed. Joan U. Halperin, 2 vols., Geneva-Paris, Droz.

1970 S. Jarocinski, *Debussy. L'Impressionnisme et le symbolisme*, Fr. tr., Paris, Seuil.

257

List of illustrations

Works by artists who did not belong to the group are listed among the Documentary Illustrations, on p. 262.
The medium is oil on canvas except where specified.

FRANCESCO MOGENS BALLIN

175 *Breton Girl*
Watercolour. 32.5 × 24.5 (12³/₄ × 9⁵/₈)
Esther Bredholt, Copenhagen

176 *Breton Boy*
Watercolour. 27 × 23.5 (10⁵/₈ × 9¹/₄)
Esther Bredholt, Copenhagen

177 *Self-portrait*
Gouache on gold ground. 15 × 12 (5⁷/₈ × 4³/₄)
Esther Bredholt, Copenhagen

Breton Girl
Watercolour. 27 × 23.5 (10⁵/₈ × 9¹/₄)
Esther Bredholt, Copenhagen

178 *Still-life*
37.5 × 45 (14³/₄ × 17³/₄)
Esther Bredholt, Copenhagen

Breton Landscape
45 × 59 (17³/₄ × 23¹/₄)
Esther Bredholt, Copenhagen

Breton Landscape
56 × 64 (22 × 25¹/₄)
Esther Bredholt, Copenhagen

Breton Landscape
37 × 46.5 (14⁵/₈ × 18¹/₄)
Esther Bredholt, Copenhagen

ÉMILE BERNARD

14 *Adoration of the Shepherds* 1885
Woodcut
Michel-Ange Bernard-Fort, Paris

19 *Breton Women in Green Meadow* 1888
74 × 92 (29¹/₈ × 36¹/₄)
M. Denis family, Saint-Germain-en-Laye

35 *Self-portrait*
46 × 38 (18¹/₈ × 15)
Galerie Durand-Ruel, Paris

36 *Apple-picking* 1890
46 × 55 (18¹/₈ × 21⁵/₈)
Galerie Durand-Ruel, Paris

The Corn Harvest 1891
73 × 92 (28³/₄ × 36¹/₄)
Private collection

Still-life on Round Table
65 × 80.5 (25⁵/₈ × 31³/₄)
Mr. and Mrs. Arthur G. Altschul, New York

37 *Buckwheat* 1888
73 × 90 (28³/₄ × 35¹/₂)
M. and Mme Samuel Josefowitz, Lausanne

38 *Breton Women Going to Church* 1892
75 × 100 (29¹/₂ × 39³/₈)
Galerie Durand-Ruel, Paris

Breton Women with Umbrellas 1892
83 × 117 (32³/₄ × 46¹/₈)
Private collection

39 *Breton Women on a Wall* 1892
81 × 116 (31⁷/₈ × 45³/₄)
M. and Mme Samuel Josefowitz, Lausanne

40 *Landscape* 1889
54 × 65 (21¹/₄ × 25⁵/₈)
Private collection

Breton Women Putting out their Washing, Pont-Aven 1888
89 × 116 (35 × 45³/₄)
Galerie Durand-Ruel, Paris

Public Square in Brittany 1887
33 × 41 (13 × 16¹/₈)
Galerie Durand-Ruel, Paris

49 *Emile Schuffenecker* 1896
Drawing
Galerie Les Deux-Iles, Paris

54 *Mme Schuffenecker at Home* 1888
32 × 39 (12⁵/₈ × 15³/₈)
M. and Mme Samuel Josefowitz, Lausanne

55 *Emile Schuffenecker at Pont-Aven*
54 × 65 (21¹/₄ × 25⁵/₈)
Galerie Durand-Ruel, Paris

62 *Van Gogh Painting*
Drawing. 14.5 × 14 (5³/₄ × 5¹/₂)
Galerie Durand-Ruel, Paris

69 *Self-portrait : à son copaing Vincent* 1888
46 × 55 (18¹/₈ × 21⁵/₈)
Vincent van Gogh Foundation, Amsterdam

80 *Reverie* Illustration from the catalogue of the exhibition at the Café Volpini 1889

82 Illustration (signed Ludovic Nemo) from the catalogue of the exhibition at the Café Volpini, 1889

110 *Still-life with Begonias*
50 × 61 (19³/₄ × 24)
Galerie Durand-Ruel, Paris

231 *A Nightmare c.* 1888 (perhaps by Gauguin)
Drawing. 18 × 25 (7¹/₈ × 9⁷/₈)
Musée du Louvre, Cabinet des Estampes

HENRI-ERNEST PONTHIER DE CHAMAILLARD

188 *Breton Landscape*
88 × 115 (34⁵/₈ × 45¹/₄)
Musée des Beaux-Arts, Rennes

189 *Farm at Pont-Aven* 1890
Watercolour. 10 × 7 (4 × 2³/₄)
Dr René Guyot, Clohars-Carnoët

190 *Coastal Scene with Cottage* 1891
80 × 51 (31¹/₂ × 20¹/₈)
Le Naour family, Pont-Aven

Stream at Pont-Aven 1890
Watercolour. 10 × 7 (4 × 2³/₄)
Dr René Guyot, Clohars-Carnoët

MAURICE DENIS

149 *Self-portrait* April 1889
33 × 24 (13 × 9¹/₂)
M. Denis family, Saint-Germain-en-Laye

150 *Noli Me Tangere* 1892
34.6 × 23 (13⁵/₈ × 9)
Mr and Mrs Arthur G. Altschul, New York

The Ascent to Calvary 1889
M. Denis family, Saint-Germain-en-Laye

151 *Breton Dance*
41 × 33 (16¹/₈ × 13)
M. and Mme Samuel Josefowitz, Lausanne

152 *Procession under the Trees* 1892
56 × 81.5 (22 × 32¹/₈)
Mr and Mrs Arthur G. Altschul, New York

First Communion
Oils and pencil. 20.5 × 29.5 (8¹/₈ × 11⁵/₈)
Mr and Mrs Arthur G. Altschul, New York

153 *April* 1892
37.5 × 61 (14³/₄ × 24)
Rijksmuseum Kröller-Müller, Otterlo

154 *Breton Women with Long Shawls* 1895
M. Denis family, Saint-Germain-en-Laye

The Barrel of Cider 1894
M. Denis family, Saint-Germain-en-Laye

155 *The Pardon at Le Guidel (Cider)*
72 × 91 (28³/₈ × 35⁷/₈)
M. and Mme Samuel Josefowitz, Lausanne

156 *Self-portrait* 1895
Drawing
M. Denis family, Saint-Germain-en-Laye

The Painter's Wife, Marthe Denis 1893
45 × 54 (17³/₄ × 21¹/₄)
Pushkin Museum, Moscow

CHARLES FILIGER

34 *Portrait of Emile Bernard* 1893
30 × 25 (11³/₄ × 9⁷/₈)
Galerie Le Bateau-Lavoir, Paris

160 *Antoine de La Rochefoucauld* 1896
Gouache. 40 × 22.5 (15³/₄ × 8⁷/₈)
Galerie Le Bateau-Lavoir, Paris

Breton Fisherman's Family
Gouache. 28 × 20 (11 × 7⁷/₈)
Dr René Guyot, Clohars-Carnoet

161 *Breton Cow-herd*
Gouache. 39.5 × 16.5 (15¹/₂ × 6¹/₂)
M. and Mme Samuel Josefowitz, Lausanne

162 *Christ on a Breton Common*
Gouache. 28 × 23 (11 × 9)
Dr René Guyot, Clohars-Carnoët

259

Index

263